THE BUILDINGS OF ENGLAND
SHROPSHIRE
NIKOLAUS PEVSNER

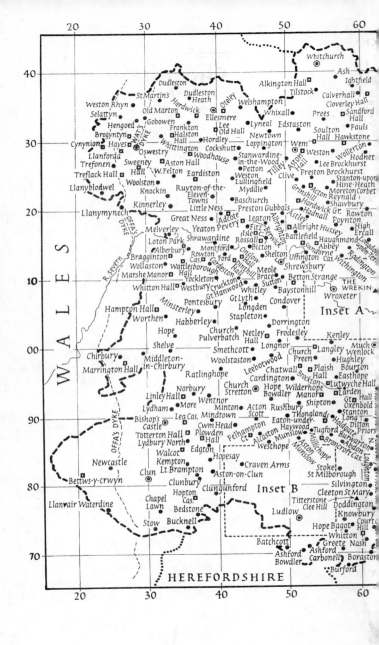

Shropshire

Inset B

Wistanstow • Diddlebury • Heath
CheneyLongville • Clee St Margaret •
Halford • Elsych • Cold
Craven Arms • Culmington • Weston
Sibdon Carwood • Stokesay • Stanton Lacy • Hopton Cangeford
Onibury • Downton Hall • Crowleasowes
Ferney Hall • Stokesay Court • Middleton • Bitterley
Bromfield • Oakley Pgk • Ludlow • Henley Hall
Ludford • Steventon • Caynham

Miles
0 — 10

Inset A

Upton • Wrockwardine • Hadley • Wrockwardine Wood
Longner Magna • Orleton • Wellington • Ketley • St George's
Attingham Hall • Uppington • THE • Arleston • Oakengates
Atcham • Wroxeter • WREKIN • Lawley • Priorslee
Cronkhill • Charlton Hill • Lt. Wenlock • Dawley
Berrington • Eaton • Stirchley
Eyton-on-Severn • Constantine
Mascott Cound • R.Severn • Leighton • Buildwas
Pitchford • Cressage • Sheinton • Madeley
Harnage • Ironbridge • Jackfield
Golding • Belswardine Hall • Benthall • Coalport
Acton Burnell • Harley • Broseley

CHESHIRE

Woore • Adderley • Bearstone
Shavington • Norton-in-Hales
Styche Hall • Brand Hall
Tunstall Hall
Buntingsdale • Market Drayton
Cheswardine
Stoke-upon-Tern • Hinstock
Child's Ercall • Sambrook
eplow • Caynton Ho. • Chetwynd
t Bolas • Meeson • Tibberton • Edgmond
Waters Manor • Cherrington • Longford • Newport
pton • Preston-upon- • Church Aston
innersley • the-Weald-Moors • Lilleshall • Woodcote
Eyton-upon-the-Weald-Moors
Apley Cas.
wellington • Oakengates • Sheriffhales
Inset A • Shifnal • Ruckley Grange • Boscobel Ho.
Dawley • Tong • Whiteladies
~Ironbridge • Kemberton • Hatton Grange • Donington
Broseley • Ryton • Albrighton
Barrow • Norton • Beckbury • Boningale
illey • Linley • Pepper Hill
Astley Abbots • Stockton • Badger
on Round • Apley Park • Chesterton
orville • Aldenham • Stanley Hall • Worfield
Pk • Davenport Ho. • Ludstone
Upton • Tasley • Bridgnorth • Hall
Cressett • Eardington • Claverley
etton • Quatford • Broughton
on George • Glazeley • Dudmaston Hall
enton • Chelmarsh • Quatt • Tuck Hill
Deuxhill • Coton • Kingsnordeley
Sidbury • Billingsley • Hall
Stottesdon • Alveley
Detton • Highley
ow • Hall • Kinlet
pton • Neen Savage
fers • Cleobury Mortimer
son • Mawley Hall
Reaside Manor Farm
Neen Sollars

WORCESTERSHIRE

STAFFORDSHIRE

Donnington Wood
Sutton Maddock

THE BUILDINGS OF ENGLAND

Shropshire

BY

NIKOLAUS PEVSNER

★

PENGUIN BOOKS

PENGUIN BOOKS

Published by the Penguin Group
Penguin Books Ltd, 27 Wrights Lane, London w8 5tz, England
Penguin Putnam Inc., 375 Hudson Street, New York, New York 10014, USA
Penguin Books Australia Ltd, Ringwood, Victoria, Australia
Penguin Books Canada Ltd, 10 Alcorn Avenue, Toronto, Ontario, Canada m4v 3b2
Penguin Books (NZ) Ltd, 182–190 Wairau Road, Auckland 10, New Zealand

Penguin Books Ltd, Registered Offices: Harmondsworth, Middlesex, England

—

First published 1958
Reprinted 1974, 1979, 1985, 1989, 1993, 1998

—

ISBN 0 14 0710.16 7

—

—

Made and printed in Great Britain
by Butler & Tanner Ltd, Frome and London
Set in Monotype Plantin

FOR ALEC
AFTER TWENTY-FIVE YEARS

CONTENTS

★

★

Map References

The numbers printed in italic type in the margin against the place names in the gazetteer of the book indicate the position of the place in question on the index map (pages 2–3), which is divided into sections by the 10–kilometre reference lines of the National Grid. The map contains all those places, whether towns, villages, or isolated buildings, which are the subject of separate entries in the text.

The first two figures of the reference number indicate the grid position of the place in question *East* of the Grid datum point near Land's End: the last two figures its grid position *North* of that point. Thus, for example, Norbury (reference 3090) will be found in the map square bounded by grid lines 30 and 40 *east* and 90 and 00 *north* of the south-west (bottom left hand) corner of the map; Lilleshall (reference 7010) in the square bounded by grid lines 70 and 80 *east* and 10 and 20 *north*.

FOREWORD

Work on this volume was undertaken chiefly in 1955. It was, in spite of a week of floods, exceptionally pleasurable, thanks in part to Dean Cranage's admirable volumes on Shropshire churches, in part to Miss Mary Littlemore's exemplary preparation of all that was needed for my travelling and writing, in part to the great kindness and helpfulness of the owners of many houses, and in part to the delights of Shropshire scenery. I want to thank those owners of houses warmly and at the same time proclaim emphatically that inclusion of a house in this volume of mine does not in any way imply that it is open to the public. Many rectors and vicars have also gone to much trouble to answer difficult questions. In addition I had as usual the benefit of the photograph collection of the National Buildings Record and of the unpublished lists of buildings of architectural and historical interest which it is the statutory duty of the Ministry of Housing and Local Government (here abridged MHLG) to compile. Mr G. S. Goodhart-Rendel and Sir Thomas Kendrick have once more given me permission to make use of their Victorian church and Victorian stained glass indexes (here marked GR and TK). My thanks are due also to Mr J. L. Hobbs the City Librarian of Shrewsbury for many answers, Mr Jon Manchip White for the parts of the introduction and gazetteer dealing with prehistoric and Roman antiquities, Mr Terence Miller for the page on geology in the Introduction, Mr George Chettle and Mr S. E. Rigold of the Ministry of Works for help on Moreton Corbet and Lilleshall, Mr J. T. Smith of the Royal Commission on Historical Monuments for permission to publish yet unpublished results on Stokesay and the medieval houses of Shrewsbury, Mr Christopher Gotch for information on Robert Mylne in Shropshire, Mr Peter Clarke for information on North Shropshire places and people, Mr Christopher Pemberton for help on Shrewsbury School and one or two other topics, and George Trevelyan of Attingham Park for never-flagging sympathy and enthusiasm. In addition, I find it a pleasure as well as a duty to express my gratitude to those who by financial support have made the publication of this volume possible. They are in the first place the Leverhulme Trust, in the second the Walker Trust, Shrewsbury, and in the third a number of American members of the Attingham summer schools on British Country Houses.

Their names are Miss Elinor Merrell, Mrs Folwell B. Coan, Mrs Florence B. Pyne, Miss Edith A. Standen, Miss Edith Blair Gambrill, Mr H. B. Heider, Miss Josephine C. Howell, Miss Esther Jackson, Mr Bertram K. Little, Miss Helen Moore Williams, Miss Margaret L. Pulitzer, Miss Clare Eames, Miss Josephine B. Jones, Miss Anne Wells Rutledge, Miss Elizabethe D. Baker, Mr John Davis Hatch Jr, Miss Jeannette M. Lowe, Mr Hermann G. Place, Mrs Eleanor Woodford, Miss Barbara Wriston, Miss Gertrude D. Howe. Mr Richard Howland, President of the National Trust for Historic Preservation, U.S.A., not only contributed himself, but also was so kind as to collect the contributions of his compatriots.

Everything mentioned in this volume I have seen myself, except for church plate and odd items marked by brackets. What is included and excluded follows the established principles of the series. No church bells, no plain fonts, no plain church roofs, few church chests and chairs and few coffin lids with foliated covers and – alas – not all church plate prior to c. *1830* will be found. Little is said about canal architecture, too little about railway stations and the interiors of Nonconformist chapels. As for Victorian and later buildings, a selection only is referred to, and that selection can be called arbitrary in so far as it is frankly mine – based on what I regard as architecturally specially interesting or important. So omissions in this field are often deliberate omissions.

In other fields they may not be, and I shall be personally grateful to any user of this volume if he will point out to me what he or she regards as omissions and also what mistakes he or she has found.

INTRODUCTION

THE greatest attraction of Shropshire is that it does not attract too many. It has its holiday haunts and its hikers' haunts, but it is not a county of crowds – neither of tourists nor of natives (though recently of servicemen). In area Shropshire comes sixteenth in England, in population thirty-sixth. There is no large city in the county. Shrewsbury has a mere 45,000 inhabitants, even if it appears bigger. There is no big industry either, and one meets industrial landscape only in patches. For that reason the visual dangers of large-scale council housing have on the whole been averted. And for the same reason there has been little destruction in the Second World War. Those who visit Shropshire and come back are enthusiastic as a rule about landscape – and landscape should always come before buildings.

Shropshire borders on eight counties, three of them Welsh. LANDSCAPE and buildings participate in the characteristics of all of them. The result is a very great variety, from the green and well wooded hills of the s, and the noble bare hills of the w, whole chains running parallel in a sw direction, Longmynd and Wenlock Edge (so different from one another: the one grand, the other gentle) to the separate, equally bare eminences like Caer Caradoc and further NE Wrekin, and like Burn Clee and Titterstone Clee, to the red cliffs along the Severn by Bridgnorth and up N to Ironbridge, where they close in and form the Severn Gorge, to the outlying ridges further N such as Grinshill Hill and the red Hawkstone Ridge, and to the Welsh hills in the NW with grey stone walls and grey cottages, and so to the plain in the NE and N with the canal and brick houses and black and white houses and quite a number of worth-while small towns. To the eye this contrast of red brick and black and white, of red stone and buff stone and grey stone is the dominant colour impression. Its principal cause is, needless to say, GEOLOGY. Geologically speaking the situation is this: Shropshire is divided along a rather sinuous west-to-east line through Shrewsbury and Wellington into a northern lowland and a southern upland.

South of the Severn, upland Shropshire may be regarded as an outlying patch of the ancient rocks of Wales, in which the mosaic-complex of archaean and older palaeozoic age stands up

often as isolated hills such as the Wrekin, Caer Caradoc, and the
1b Stiperstones, while the younger palaeozoic cover-rocks lie
almost horizontally above, in Clun Forest and the Clee Hills.
As a rough guide to this ancient structure it is useful to imagine a
journey across the county from the south-east corner towards,
say, Welshpool in Montgomeryshire. Such a traverse would pass
over a series of rock-formations whose age at first increases to
the north-west as far as the Longmynd, and then symmetrically
but more rapidly decreases up to the county boundary. Thus
from the Carboniferous coalfield of the Forest of Wyre one steps
down, in the geological sense, on to a wide expanse of Old Red
Sandstone as far as Corvedale; then from below emerge the
Silurian shales and limestones of Wenlock Edge and Apedale,
the old closely-folded rocks of Church Stretton, and the great
archaean 'island' of the Longmynd. Thence to the north-west
the sequence is reversed until the Old Red rocks re-appear on
the east side of the Long Mountain. It is a great geological arch
that has been worn and broken down by natural erosion to
show the multiplication of layers, each with its peculiar and
characteristic physical expression.

All these layers contain, together with much soft shale, an
abundance of hard stone. Among the oldest groups much of it
is too hard, or too splintery, to be of use except as road metal;
and in the younger strata of the south-east, shale, marl, and
soft sandstone predominate. But in the main central part of
upland Shropshire a good freestone quarry could be opened
close to any site and be fairly sure of getting a satisfactory build-
ing material. Thus it happens that we find a great range of build-
ing stone of local provenance – Chatwall Sandstone; Soudley
Sandstone, a banded brown rock used in Hope Bowdler church;
Hoar Edge Grit and Flags, the one turning up at Uriconium
along with much red sandstone from nearer at hand, and the other
in the roof slabs of Wenlock Priory; Stanton Lacy Slabs; Ketley
Stone; Wenlock Limestone, full of fossil corals, shells, and sea-
lilies; and a dozen others. Almost the only importations into this
region of hard rocks are the ornamental stones, either true
marble from overseas, or Purbeck Marble from the Channel
coast, or alabaster from Derbyshire. Even these need not have
been brought in, for Wenlock Limestone will polish, and Clee
Hill Marble can be seen at Downton Hall and at Hopton.

Lowland Shropshire north of Shrewsbury and the Severn
forms part of the 'Red Midlands' of England, where a blanket
of soft sandstones and marls covers the hard-rock floor. Topo-

graphically this lowland is the south end of the Cheshire Plain, in which much of the true rock surface is covered by irregular strips and patches of gravel, sand, and clay, deposited by the ice sheets that passed over this country half a million years ago. These superficial deposits, together with the red marls and clays below, provide all the materials for making bricks, and so determine an important element in the local architecture, the brick or half-timbered building, of which the churches at Petton and Cockshutt and Melverley are examples. But north Shropshire 16 east of the Welsh March is not quite without a supply of good freestone, for in the middle of the lowland comes a hard, well cemented rock – Grinshill Stone; and further west, about Erbistock, a red and mottled purple variety – Cardeston Stone. Grinshill has been worked for hundred of years as 'Red' or 'White' and both kinds appear in Shrewsbury buildings, not always showing their proper colour, but rather a range from beige through browns and reds to green. To the geologist this association of red-brown tints with greens and near-white is a normal characteristic of ancient desert sands and dusts, the expression in colour of oxidation- or reduction-processes working on scattered iron-bearing mineral grains and ultimately staining the whole rock.

This geological division of Shropshire is of course a broad generalization without exclusive categories, and in such a small area with easy communication the division is bound to be blurred. Nevertheless there is a richness of building stone in the south and a relative poverty in the north. Between the two regions there is one additional link. This is the occurrence in the 'upland' of an enclave of the 'lowland' based upon the Old Red instead of the New Red Sandstone formation. The same red (or 'pseudo-red'!) rocks occur in both; Broncroft Castle might almost be built of Grinshill Stone, but is of a rock a hundred million years older, the red rock of Clun and Ludlow. To complete the likeness the brick-and-timber fashion reappears in the rolling country round the foot of the Clee Hills, as at Bitterley and Chetton, and the Moor Farm, Stoke St Milborough.

So much for geology. Now to EARLY HUMAN HABITATION. The evidence for Shropshire is scanty. Throughout the successive phases of the Old Stone Age, Middle Stone Age, New Stone Age, and Bronze Age the county appears to have been to all intents and purposes an uninhabited wilderness. From the point of view of the archaeologist it can claim to be one of the least interesting localities in the whole of the British Isles.

Why was Shropshire so sedulously avoided by our early ancestors? It seems clear that the chief factor must have been the inhospitable nature of its terrain. When one considers its gracious and fertile aspect to-day, it is difficult to believe that it was once unsuitable for human habitation; but such is in fact the case. The area was composed partly of Glacial and Triassic clays of a type abhorred by early cultivators, partly of dense and damp oak woodland which effectively resisted every attempt at penetration. Even the adventurous tribesmen who acted as commercial carriers between the Lowland and Highland Zones gave Shropshire a wide berth, and only a few stray implements and a thin scatter of Bronze Age barrows along one of its ridgeways testify to its human occupation until the onset of the Early Iron Age.

With the coming of the Iron Age the picture changes. The new farmers and pioneers set to work with a will and successfully attacked the clay and oakland with their stout axes and wheeled ploughs. On the dry hill-tops they constructed forts and look-out posts. Two of these forts, Old Oswestry and the Wrekin, were of tremendous size and formidable appearance. They still form prominent landmarks.

Everywhere in Britain the tribesmen of the Iron Age grouped themselves into local clans. Shropshire now atoned for its barren past by becoming the centre of a thriving native tribe known as the Cornovii. In the two centuries before the Roman conquest the Cornovii waxed increasingly powerful and numerous, spilling over from their Shropshire homeland into Cheshire, Herefordshire, and the neighbouring foothills of Wales.

It was up the Celtic trackways that the ROMAN armies marched after their landing in Kent in A.D. 43. The Fourteenth and Twentieth Legions, which constituted the central column of the invading forces, thrust their way through the Midlands into the territory of the Cornovii. The two legions saw much bitter fighting against their determined opponents, but by A.D. 48 they had established an advanced base at Viroconium, the modern town of Wroxeter. A number of legionary tombstones survive to attest the existence of the military encampment, but its actual site has not yet been located.

4 Viroconium was designed to be the spearhead of the Roman advance into Wales. It was from this point that the brilliant and ruthless general Ostorius Scapula overran the Degeangli and the Ordovices of North Wales. At the same time his comrades of the Second Legion, stationed at Glevum (Gloucester), sallied

into South Wales to engage the fierce Silures. Setting out north-westwards from Wroxeter, Ostorius drove a wedge between the Celts of North Wales and the troublesome Brigantes of North Britain under their crafty queen Cartimandua. In A.D. 51–2 Ostorius encountered and broke the Ordovices under Caractacus, and not long afterwards the last son of King Cymbeline was betrayed by Cartimandua to his enemies and sent in chains to Rome.

By A.D. 75 the pacification of North Wales had made such progress that the advanced base could be moved further north to Deva (Chester). The country of the Cornovii and its hinterland had become so tranquil that the Roman authorities could begin to carry out the erection of an imposing township on the classical model. This was part of a systematic policy of urbanization, and to create the necessary population for the new town the local tribesmen were forced or persuaded to leave their upland strongholds and begin a new life on the plains. It may well be that the nearby hill-fort on the Wrekin had served as the capital of the Cornovii, and that its inhabitants became the first citizens of Viroconium Cornoviorum: Uricon of the Cornovii. The more gregarious tribesmen had already begun to build a number of shops and houses as early as c. A.D. 60, but by A.D. 90 the building of the city was begun in earnest, and further details of its architectural development and domestic history from this juncture are given under Wroxeter (p. 328).

Simultaneously with the creation of the military encampment, surveyors and road-gangs had gone to work to provide a road to link Viroconium with its base at London. This famous road, later known as Watling Street, ran due E from Wroxeter through Uxacona (Oakengates) and Pennocrucium (Penkridge) before swinging S through St Albans to London. A second road joined Viroconium to Deva in the N, and a third ran southwards through Bravonium (Leintwardine) and Magnis (Kenchester) to the other important legionary fortresses of Glevum (Gloucester) and Isca (Caerleon).

From Wroxeter a road went due W into the mountains of Montgomeryshire. Its ultimate destination was the highland fortress of Caerflos (Forden Gaer), which appears to have been established by a great Governor of Britain called Sextus Julius Frontinus. Along this road travelled the consignments of minerals which the Romans had begun to extract from this part of the Welsh hills as soon as they had established themselves at Wroxeter. North of the road lay the copper-fields whose effective

centre was Llanymynech in Shropshire, where the remains of
extensive working between the C2 and C4 A.D. can still be seen.
South of the road lay the lead-mines, which have yielded lead-
pigs bearing the names of the Emperor Hadrian and of the
Twentieth Legion.

Viroconium flourished until c. A.D. 250, when its prosperity
was curtailed by the unsettled political and economic conditions
of the late stages of the Roman occupation. It then relapsed into
an undistinguished and sordid state, and by the C5 it had become
hopelessly dilapidated and was quickly abandoned after the
departure of the legions from Britain. In Anglo-Saxon times the
local capital of the district was established at Shrewsbury, five
miles away, and deserted Viroconium was plundered of its stone
to build the Saxon town.

In the late C8 the western boundary of the Kingdom of
Mercia was defined by King Offa, who occupied the throne for
a period of no less than thirty-nine years, in a dramatic fashion.
He constructed a celebrated dyke, which can still be traced down
the entire length of the Marches from the Irish Sea to the Bristol
Channel. It was dug in the gaps which lay between the inter-
mittent natural barrier of the forests in order to prevent the
Welsh from entering Mercian territory across stretches of open
country. A short but well-defined section of Offa's Dyke lies
across the westernmost tip of Shropshire, and the remains of a
smaller defensive dyke known as Wat's Dyke can be detected
in the same area, running behind Offa's Dyke as far as Old
Oswestry hill-fort before it finally peters out.

As regards ANGLO-SAXON ART AND ARCHITECTURE,
Shropshire has nothing of more than local interest. Some
masonry and windows at Stanton Lacy, Diddlebury, and
Wroxeter, the chancel arch and chancel at Barrow, some parts
of crosses with foliage scrolls and interlace at Wroxeter and
Diddlebury are all that need here be mentioned. Tympana at
6a Stottesdon and Uppington, if not Saxon, are entirely in the
Saxon tradition. Of the excavations at Much Wenlock and St
Mary Shrewsbury which uncovered Saxon buildings nothing
was left exposed. Much Wenlock, probably a C7 church, had
an apse set in a square-ended wall. Shrewsbury was apsed too.

The Conqueror gave large parts of the county to his second
cousin Roger de Montgomery, who was made Earl of Shrews-
bury. Shropshire then was almost in the nature of a palatinate.
Roger built Shrewsbury Castle in its first form and founded the
Cluniac Priory of Wenlock and the Benedictine Abbey at Shrews-

bury across the river. At the end of his life, in 1094, he entered this latter foundation as a monk, died three days later, and was buried in the nave. The abbey as we see it to-day is no more than a fragment, the nave, aisles, and parts of the transepts, and a fragment very badly treated by the Victorians (before *Pearson* came). The monastic buildings were razed in 1836 to make a road. Yet in some places one can still get an impression of the formidable style of EARLY NORMAN ARCHITECTURE, colossal round piers in the nave as well as above in the gallery, 5a both short and sturdy, and no elegancies of carving, no elegancies of moulding. The abbey is the principal architectural monument of before 1100 in the county. Next in importance comes the parish church of Much Wenlock, also Early Norman. The most interesting feature here is the fully preserved w front hidden by the Transitional w tower. Early Norman evidence is not absent in smaller buildings either, but nowhere very telling – herringbone masonry at Clee St Margaret, Diddlebury, Rushbury, Sidbury, Stanton-upon-Hine-Heath, very primitive figure carving at Linley and in some fonts, and so on. The vast majority of what survives of NORMAN ARCHITECTURE in Shropshire however is late, probably after 1150, and often Transitional. Dates are of course rare, and for establishing a stylistic order there is little to go by. The value of round as against pointed arches is very doubtful. In France pointing occurs here and there from the early C12 onwards, and it seems that the advantage of pointing had soon been recognized. That is why it was used especially in vaults where heavy weights had to be carried (Burgundy, Provence, the nave at Durham). I have counted Norman features (excluding fonts) in just under 100 churches, often no more than some odd windows or a doorway preserved, when all else was brought up to date.

Of what remains in these five score churches, the following for various reasons deserve special attention. St Mary at Shrewsbury and St Lawrence at Ludlow, because Norman evidence shows that they were already in the C12 churches of considerable size, St Mary with a big w tower, St Lawrence with a big crossing tower. Then Heath Chapel, because it is so complete an 7a example of the small Norman parish church. Linley is almost as completely preserved. Then the chapel of Ludlow Castle, 7b because it has for no evident reason a circular nave and had a polygonal apse, the parish church at Much Wenlock, because of its interesting w wall, and Bromfield, because it is part of a monastic church of before 1150. And finally Edstaston, because

10a of its specially ornate doorway, Stirchley, because of its specially ornate chancel arch, and Caynham, because of the unusual feature of a tripartite chancel arch.*

The rest of interesting work is all Late Norman to E.E., that is essentially TRANSITIONAL. These are the criteria of the process as they arise in Shropshire. Decoration tends to turn Baroque, a transformation well-known e.g. in Germany, but not always recognized in England. There is a glut of geometrical motifs in the decoration, zigzags on the face of arches as well as on their underside, combinations of zigzag with crenellation, crenellation with triangular merlons, and so on. The scallop capitals of the Norman style change into a more three-dimensional and more organic form and assume a trumpet or cornucopia shape. The volute capital also reaches out for more organic associations and takes on either the water-leaf or the crocket type, both resembling curling leaf shapes, and soon emerges as the stiff-leaf capital, with the leaves first upright and later more freely moving about. The shafts of responds or piers tend to become slenderer and emphasize that tendency by keeling or by the adding of a fillet.‡ So, when all these features come together, imperceptibly the Early English style is reached.

Nowhere is the development towards a Baroque in the Late Norman style more evident than in a comparison between the two most brilliant examples of C12 sculpture in Shropshire. They must both be regarded as representatives of the flourishing
6b school of Hereford: the tympanum of Aston Eyre, and the
24 fragment of the well-house at Much Wenlock Priory. The former may date from c. 1150, the latter from as late as c. 1190. Both have the cable-like folds of the draperies which characterize the Hereford school. But at Aston Eyre all is still direct, whereas at Wenlock thick, three-dimensional convolutions are introduced in the draperies and repeated in the lush foliage above. In architecture also Wenlock offers the most striking example of Late Norman effusiveness: the wall of the chapter house. The same style can be found at Haughmond and Lilleshall abbeys.

Altogether the vigour of architectural activity in Shropshire from about 1180 and 1190 onwards can best be appreciated in

* Clee St Margaret combines the pointed arch with decidedly Early-Norman-looking details. A few churches may also be mentioned in this note for the strange introduction of a doorway in the s wall, E of the main entrance, but w of the chancel. They are Cardington, Clunbury, and Lilleshall parish churches.

‡ Another sign is the circular pier with the square abacus – at Buildwas, Clun, High Ercall, Shawbury, and – very primitive – at West Felton.

monastic remains. The county is uncommonly rich in ruins of monastic houses, some visually impressive like Wenlock and Haughmond, some as concealed as the one rib-vaulted chapel of Alberbury, now part of a farmhouse. This is as late as *c.* 1225. Bromfield has already been mentioned as Norman of an earlier date. So has Buildwas. But the others, and Chirbury, Lilleshall, and Whiteladies are all of the years with which we are here concerned.

The Priory of Wenlock and the Abbey at Shrewsbury were the earliest Norman MONASTIC FOUNDATIONS, the former, as has already been said, Cluniac, the latter Benedictine. Bromfield was also Benedictine (founded 1155), and there was a small Benedictine cell at Morville. Haughmond (1130–8), Chirbury (*c.* 1190) and Alberbury (*c.* 1228) were established for Augustinian Canons. Lilleshall began *c.* 1148 as a house of Arroasian Canons and soon became Augustinian. Finally Buildwas which was established in 1135 for the order of Savigny but became Cistercian in 1147. As for Whiteladies, the most probable explanation of the name is that this was a house of Augustinian Canonesses.*

Buildwas is one of the most important Cistercian ruins of the 8a West of England. Building must have begun about 1160 and been carried on into the late C12. The chancel is rib-vaulted, the nave unvaulted. Detail in the E part is more internationally Cistercian than in the W parts, where it returns to Anglo-Norman usage. The plan is the standard Cistercian one: the plan of Fontenay (begun in 1139), with a straight-ended chancel and attached to the E sides of either transept two shorter also straight-ended chapels. The angularity must have appealed to the English with their Anglo-Saxon tradition of straight-ended churches. In Shropshire both Lilleshall and Haughmond took it over, and it is known that the EARLY ENGLISH STYLE for cathedral and monastery and for the parish church made it standard – in complete contrast to France, the Netherlands, Germany, and so on.

Shropshire is not a county rich in E.E. work, but a few places have work which no architectural history of medieval England can miss. The most ambitious and complete example is what still stands of Much Wenlock priory church. The chancel, also straight-ended, exists only in foundations, but transepts and 12a

* Of monastic establishments of which no traces remain only Wombridge near Oakengates, Halston (Hospitalers), and Stanton Long (Templars) need be mentioned.

nave with aisles can easily be made to come to life again. Piers
with four major and four minor shafts, rib-vaults in the aisles,
tall triforium and clerestory, and a fine W front, a rich yet
11a limpid composition. The new arcades built at St Mary's Shrews-
bury c. 1200 were even richer, with four triple shafts, that is
11b twelve shafts, to the piers and the lushest of stiff-leaf capitals.
The type of pier is characteristic of the West Country from Wells
to Lichfield and Chester. Work in other places needs no more
than a few hints: the porches at Cleobury Mortimer (tunnel-
vaulted) and Kinlet, the rib-vaulted porch at Shifnal and the
curious way in which its upper storey is made to cover one low
rib-vaulted bay of the aisle, the finely proportioned chancel of
Cheswardine with its lancet windows, and the perfect chapels
close to the mansions of Longnor and Acton Burnell, the latter
of c. 1280.

I use the word mansions here, though in the case of Longnor
it is not known whether what the chapel belonged to was a
house or a castle. Acton Burnell, however, though the residence
of a mighty politician and courtier, was emphatically not a
castle but a house, even if a well fortified one. We must here for
a moment leave ecclesiastical and look at SECULAR ARCHI-
TECTURE. Shropshire was of necessity a castle county. The
proximity of the hostile Welsh made the provision of a chain of
fortresses necessary. The majority of the CASTLES has dis-
appeared, though mounds or mottes survive in some cases where
there is no masonry left (Caus near Westbury, etc.). The most
important remaining Norman buildings belonging to castles are
the gatehouse keep and the circular chapel of Ludlow Castle,
and the walls of Shrewsbury Castle. In addition there are keeps,
more or less complete or more or less fragmentary, at Bridg-
north (leaning beyond belief), Clun, Wattlesborough, Hopton,
Alberbury, Ruyton, Lea Castle, Shrawardine, and Oswestry.
Of the C13 the most impressive remains are the two round
towers at Shrewsbury and the two round towers of the gate-
house at Whittington.* At Whittington licence was given in
1220. At Shrewsbury Henry III began the extended town walls
at the same time. Attached to these one square tower is still up
and a considerable part of a second. At Ludlow there is also a
fragment of a wall-tower. The walls here were begun in 1233.
But the plan of the town is older – and as a planned town of the
early C12, with a grid of streets still clearly noticeable, Ludlow
must be remembered.

* A semicircular tower also at Holdgate.

But to return to Acton Burnell, the great national and indeed 40a more than national importance of this and another Shropshire building, Stokesay, is that they are not castles but fortified 40b houses. Stokesay is undated but was apparently built *c.* 1260–80, and anyway before 1291, when licence was given to crenellate a keep-like tower which was then added. Acton Burnell was licensed in 1284. Stokesay was built by the son of a Ludlow merchant, Acton Burnell by the King's Lord Chancellor and Bishop of Bath and Wells. The two houses represent two different approaches to the problem of how to live more comfortably in a somewhat more settled and secure country. Stokesay's is the bolder approach. There was an older tower there, and that perhaps encouraged Laurence of Ludlow to build a hall-range with large transomed windows not only to the court or bailey, but also to the moat, i.e. the outer world. At Shrewsbury Castle at the same time a large new Hall was built, but the windows there are narrow lancets. At Ludlow the date is a little later, early C14, and the windows are as large as at Stokesay or larger. At Ludlow also there is an early case of the existence of the standard English arrangement of screens passage and the three doors to kitchen, buttery, and pantry.*

Acton Burnell is not an attempt to do without a keep proper or a strongly fortified curtain wall as Stokesay had been. At Acton Burnell the keep itself is converted into what has been called a tower-house, a building large enough to allow for the comforts of a house, yet strong enough to act as a keep if necessary. The building is oblong with four angle turrets; it was crenellated, but the Hall had the same large transomed windows as Stokesay, and there certainly was no moat nor an outer fortified wall. The only contemporary building close to the house is the gables of a huge stone barn, 157 ft long.‡

It is another sign of the growing sense of ease represented by Stokesay and Acton Burnell that the details of their architecture

* Another C14 survival of the same feature in Shropshire is at the Old Rectory at Edgmond.

‡ Of minor domestic architecture of this period the walls and window surrounds of the hall of Vaughan's Mansion at Shrewsbury, the houses of Upper Millichope Farm, Great Oxenbold, and parts of Aston Botterell, and perhaps Aston Eyre may be mentioned. Shrewsbury possessed more stone mansions than can now be seen even in fragments. One of them, Chartham House, was, according to Mr J. T. Smith, the only provincial town house to be granted a royal licence to crenellate. The house identified by Mr Smith as Benet's Hall (in Pride Hill) is of the mid C13, Vaughan's Mansion (*see* Music Hall) of the early C14.

were given aesthetic value. Earlier castles may impress us, but they were not designed to appeal to the aesthetic sense. Stokesay and Acton Burnell are architecture, the gate keep at Ludlow is utilitarian building. The windows at Stokesay and Acton Burnell are part of the same architectural development as we follow in churches and are indeed indispensable to us now to understand in detail certain changes in the late C13. The early C13 is characterized by the lancet window, the second half of the century by the wider window divided into two or more lights and provided with bar tracery, that is such forms as an un-cusped circle or a circle cusped into a quatrefoil or sexfoil, or a quatrefoil or a trefoil left unencircled. Now the earliest case in Shropshire of bar tracery – a plain uncusped circle – is the hall at Stokesay, and the next stage, where the arches of the two lights are cusped and there is a freer form, a cusped trefoil, above, is represented by Acton Burnell Castle. The little church 12b at Acton Burnell has similar forms – all entirely up-to-date nationally. The details are for good reasons remarkably similar to those of the Bishop's Palace at Wells with its splendid Hall and Chapel. The simplicity of the first generation of bar tracery does not satisfy any longer. What one calls Geometrical tracery, because the simplest of geometrical shapes was sufficient to achieve the noblest beauty, is gradually replaced by more capricious, sometimes perverse forms, and the DECORATED STYLE has replaced the Early English.

At Acton Burnell there are three cusped stepped lancet lights under one arch and three cusped stepped lancet lights with three encircled trefoils above. Soon more playful forms appeared: three lancet lights of equal height and two spheric triangles side by side above (Ryton), three lancet lights with arch-heads standing on their heads and a crowning arch-head on top (a Wells form; used at Munslow, Shifnal, Wenlock parish church, and – in a piquant two-light variety – at the Infirmary Hall at Haughmond), intersected tracery made deliberately illogical by breaking the intersections at the top and inserting a sexfoiled or quatrefoiled circle (Kinlet, Stottesdon, Chelmarsh, Pontesbury) or a spheric triangle (Edstaston). Shropshire did not accept the most sophisticated kinds of flowing tracery. The only examples worth quoting are the windows in the form of spheric triangles at Alberbury, St Mary Shrewsbury, and Moreton Corbet and what goes on in them,* the odd star-shapes at Worfield, and the N

* The origin is probably the W window of the Berkeley Chapel at Bristol Cathedral, built c. 1300–5.

aisle at Ludlow parish church with typically Herefordshire details. Ludlow incidentally has a hexagonal porch. The only other in the country is at St Mary Redcliffe, Bristol. All these vagaries belong to the years about and after 1330. Secure dates are again rare.

One would welcome them; for they would help to determine the boundary between the Decorated and the PERPENDICULAR STYLE. But there again we are reduced to guesses. At Battlefield, a church begun only in 1406–9, purely Dec reticulated tracery stands side by side with purely Perp. Battlefield was Henry IV's gift of expiation for the bloody battle of Shrewsbury. Tong was made collegiate in 1410, and that no doubt marks the beginning of the Perp church. At Ludlow much rebuilding 15 went on in the C15, the chancel was complete by 1447; the rest followed. These are our principal dates. The w parts and especially the magnificent w window of Shrewsbury 13t Abbey are no doubt earlier; Dean Cranage agrees with those who call them c. 1360–70. That would then be the beginning of the Perp in Shropshire. The buildings just mentioned are the only ones of importance in the county during the later Middle Ages – a strange fact, considering the county's prosperity. Perp contributions to Shrewsbury architecture are minor except for the two fine aspiring needle spires of St Mary (138 ft) and St Alkmund. The only place where the style appears anything like as swagger as in East Anglia or Somerset or the Cotswolds is at Ludlow. Here the familiar glasshouse illusion is achieved, and here a tower was driven so high as to dominate the whole 14t countryside around, as if it were a Bell Harry (166 ft). There are other good sturdy Perp towers with the enrichment of a quatre-foil frieze below the battlements (Cheswardine, c. 1470, etc.), but that is not much.

A few more words on TOWERS and spires. Stone spires are extremely rare. Outside Shrewsbury there are only Worfield, the spirelet at Tong, and the never completed spire of Cul-mington. More were intended, but never built. Timber spires were erected at and around Cleobury Mortimer, at Coreley, Nash, and Neen Sollars, etc. They are mostly shingled. TIMBER altogether was a popular material in church building in Shrop-shire and one which, in domestic architecture, was to increase in importance and refinement right into the C17. There are even two completely timber-framed churches preserved, Melverley 16 and Halston. It is impossible to determine their dates. Of ele-ments of church architecture, there are plenty of belfries

constructed of wood over the W ends of naves, there are a few of the rather jaunty-looking two-stepped pyramid roofs (Clun, Hopesay, More), there are fine porches (Milson, Munslow, Lydbury North, etc. – and so on to Cardington 1639, Loppington 1658, and the lychgate at Clun which is of 1723), and there are finer ROOFS. They again cannot compete with East Anglia or Somerset, but they repay attention all the same. The simplest form is the straightforward trussed rafter roof (those at Church Stretton and in the transept at Wistanstow Dean Cranage dates C13), i.e. a roof usually looking seven-sided from below, as it consists of short vertical struts l. and r., then short parts of the rafters appearing, then straight braces, and then, at the top, part of the collar-beam appearing which runs on, invisible from below, to hold the rafters together. The finest roofs in the county are either roofs with very low pitch and moulded beams and carved bosses and sometimes panels with quatrefoils in the interstices (Ellesmere S chapel; St Mary Shrewsbury nave, etc.) or roofs with collar-beams and arched braces and wind-braces cusped so 14a as to form quatrefoil and similar shapes (e.g. Alberbury, Hopesay, Clun; one of them, at Wistanstow, is dated 1630). Hammerbeam roofs came later and the best of them are of the Elizabethan period or even the C17.

From the roofs to the FITMENTS AND FURNISHINGS. Here again little is of more than county interest – no Screens to compare with the SW, no specially important Stalls (the best at 27 Ludlow and Tong – Ludlow with plenty of Misericords), and hardly any fonts after the Norman ones, of which some such as 23 Stottesdon are excellent and many at least individual and of some ambition, and after a few exceptional E.E. ones, especially that at Acton Burnell. Pre-Reformation Plate seems to be confined to a Paten at Harley, a Pyx at Broughton, a Chalice at Shifnal, two foreign pieces (St Mary Shrewsbury) and some altered pieces (Fitz, Kemberton, Smethcott). To these may be 30a added the beautiful Standing Cup at Tong of a few years after the Reformation. Of medieval Embroidery there is only a Frontal at Alveley and a Dorsal at Claverley. Of Chests the best is at Neenton (C15), of iron work on Doors at Edstaston and Worfield. The date of this is C12 or C13, and there is more of the same period in other churches. Finally, as regards Stained Glass, Shropshire has – it is true – the fine Dec Jesse Window at St Mary Shrewsbury (of c. 1330–50), much C15 work at Ludlow, and minor English work at Atcham, Donington, etc., but most of the good or specially interesting glass is foreign and reached

the county only in the C19. That is the case of the glass from
Trier at St Mary Shrewsbury (1479), from Altenberg (life of 29
St Bernard of Clairvaux, (early C16) at St Mary Shrewsbury),
from Liège and Normandy (again St Mary Shrewsbury; also
Battlefield). Wall Painting of interest is confined to one church:
Claverley (Battles of Virtues and Vices; c. 1200), Sculpture to 25a
one piece, possibly not English, the Pietà at Battlefield. 26b

That leaves church MONUMENTS. The place to visit in
Shropshire for medieval monuments is Tong. There are six
monuments to members of the Vernon family here dating from 33
between 1450 and 1520, one of them being connected with a
whole large chantry chapel, and one being of a type known
abroad but unique in England, the frontal demi-figure of Arthur 34a
Vernon, M.A. Cantab., placed on a bracket in the chapel. The
others are stone or alabaster, those of alabaster being usually
more competently and adroitly done, as is also the case in other
churches in the county. Of stone monuments one of the later
C13 and two of the early C14 deserve notice because of icono-
graphical peculiarities, the tomb-chest at Albrighton with its
display of heraldry, and coffin-lids at Shrewsbury Abbey with a
figure below the head of a large foliated cross, and at Preston
Gubbals with the bust of a man with a foliated cross-head on his
breast. Of the time of the Vernon tombs the stone monument to
Sir Robert Corbet at Moreton Corbet † 1513 might be
mentioned, and the alabaster monuments to Sir John Blount at 34b
Kinlet and William Charlton at the Abbey at Shrewsbury.
They died in 1531 and 1544 respectively, yet the earlier has only
indications of the new Italian fashion, and the later has none at
all. Of alabaster also are a number of incised slabs in various
churches, ranging from one of the C13 at Tong to several
Elizabethan ones. No brass in the county is of outstanding merit.*
But – Shropshire being a timber county – there are three oaken
effigies, two of the late C13, the third of the early C14. They are
at Berrington, Pitchford, where the figure is 7 ft long, and Eaton-
under-Haywood.‡

So we are once again back with oak. Shropshire is one of the
black-and-white counties, counties in which much of the cottage
architecture, but also larger farmhouses and occasionally
country as well as town mansions, are of timber. TIMBER-
FRAMED CONSTRUCTION is a technique of prefabrication. 49b
The preparing of the parts took place away from the building

* The earliest are at Burford (c. 1370) and Acton Burnell († 1382).
‡ Late C13 stone effigies are at Holy Cross Shrewsbury and Leighton.

site – for the roof of Westminster Hall, e.g., at Farnham in Surrey – and on the site no more was needed than the assembling of the numbered parts. The most elementary construction is with crucks, very large naturally curved timbers set up so that they meet at the top to form a roof ridge. Walls and roof are thus structurally one. When they are separated, the wall consists of vertical posts framed into horizontal rails. Diagonal struts or braces can be added as a strengthening. They were soon to be made the vehicle for ornamental effects.

The dating of timber-framed buildings on grounds other than ornamental motifs is a very dubious job. That town houses were mostly timber-built (in London right into the c17) is certain. The rich families in Shrewsbury on the other hand preferred to build in stone as early as the c14 (Vaughan's Mansion). In the country of course no ambitious building could be of timber until security was well established. What then of existing buildings goes back to the Middle Ages? And how can pre-Reformation timber-framing be recognized? Two refinements of timber-framed architecture can be assumed as existing as early as the c14, the oversailing upper floor on brackets, i.e. the ends of the beams, and the diagonal strut to keep uprights and horizontals at the exact angle. But whether narrowly placed uprights or rather square panels came first, no one has as yet decided. Could radio-carbon help?

Now, as for actual examples, at Shrewsbury there is reason to attribute three houses to an earlier date than the Reformation, the Henry Tudor House in which Henry VII slept before 42b Bosworth, the King's Head Inn, and the Abbot's House. The two former (and a house at Oswestry) are the only ones with surviving traceried windows. The Abbot's House has blank tracery on the angle post. Some more houses at Shrewsbury, a row in Wyle Cop (Mytton's Mansion) and the Golden Cross Inn are also assigned to the c15, as is the Vicarage at Claverley. In the countryside the earliest example of black-and-white, accord-
42a ing to Crossley, is the upper part of the gatehouse at Bromfield.*
But the earliest dated example is as late as 1524, part of Albright Hussey – and there the date is no longer there to inspect. The

* It is hard to find a place to mention in this Introduction St Winifred's Well at Woolston, a Holy Well with delightful little buildings. It might as well be done here, because above the stone-lined well-chamber stands a timber-framed cottage. One should assume a pre-Reformation origin for it. The well chamber is continued into the open by two stone-lined basins, one a little below the other. The water flows through, stairs lead down into the basins, and the whole, away from any road, is an enchanted spot.

details are moreover at least partly later than 1524. Nothing was and is easier than to substitute one infilling or even one infilling material for another. Brick replacement for wattle and daub is done all the time to this day. So a more ornate for a simple panel could be introduced without effort.

Brick did not apparently reach Shropshire until the late years of Henry VIII. Of DOMESTIC STONE BUILDING during the later Middle Ages the most attractive example by far is the Prior's Lodging at Much Wenlock, very unusual compositionally, because part of a cloistered layout, but, with its long glazed front galleries or cloisters or *porticus* (in the Roman 41b sense) repeated on two storeys, very impressive and oddly modern. The whole front has virtually no wall – only mullions and glass. It was a usual thing for abbots and priors of the older orders to build lavishly in the thirty years before the Reformation (Forde Abbey, St Osyth, Muchelney, etc.). There is nothing comparable in Shropshire in secular building. As for the Friars, they certainly did build and flourish, but the only surviving evidence of their houses is a rather inarticulate fragment of the Greyfriars at Shrewsbury. They had settled in 1245, the Blackfriars before 1232, the Austin Friars in 1298. There were also houses of the Greyfriars at Bridgnorth (settled 1244) and of the Austin Friars and the Carmelites at Ludlow (before 1282 and 1349).

Nothing of these buildings can be seen any longer. The wrath of the Reformation turned against them more than the others. Once the crises of the Reformation were over, with the coming of the ELIZABETHAN AGE more or less, Shropshire settled down to a period of great prosperity. Those who commissioned building and decoration and the monuments in the churches were now the clothiers as often as the old nobility. The most expensive town HOUSES were the clothiers', and it is perhaps worth some stress that they did not change from timber to stone as they grew richer and more settled, but from stone to timber. To them timber was the more welcome material, because it made a more ostentatious display possible and allowed certain fineries of which in stone they would not have been capable. The Elizabethan style is an odd mixture of naive and demonstrative bad taste with a love of the complicated and involved. Black-and-white, as it developed during the reign of Queen Elizabeth I, was an ideal medium to carry those qualities.

The development of forms can best be followed at Shrewsbury. The earlier houses (1 Milk Street 1568, Old House,

Drapers' Hall, and a house of 1570 in The Square, which no longer exists) use as their principal decorative motifs slender twisted shafts like attenuated buttresses, and rails with sunk quatrefoil friezes. These are still additions; the frame itself is not much affected by them. Then, however, at Shrewsbury about 1575, patterns are being formed by diagonal struts arranged to form lozenges within lozenges. The dated example is the large house of 1576 at the corner of Frankwell and New Street. Compositionally this is of no interest, but Ireland's
48a Mansion in the High Street, of about the same date, the grandest of all Shropshire black-and-white houses, is a perfectly symmetrical composition of four units, high and towering, and for its effect depending more on the projection and recession of its parts than on embellishments. Embellishments however did come now, apart from the lozenges within lozenges. At the Guildhall in Much Wenlock (1577) the sides of a square panel were given spurs in their middles so as to make up into a cross-
47 like shape. Bishop Percy's House at Bridgnorth (1580) has concave-sided diagonal struts, and soon these were cusped so as to result in pretty, much less structural, pointed quatrefoil or saltire-cross patterns. This is done in Owen's Mansion opposite Ireland's at Shrewsbury (1592). The climax at Shrewsbury is the Gatehouse to the House of the Council of the Welsh Marches, dated 1620. The climax in the field of urban black-and-white
48b in the whole county is however the Feathers Hotel at Ludlow of 1603. The Reader's House at Ludlow is dated 1616, the Bell at Ludford 1614, the Llwyd Mansion at Oswestry 1604. Much of the attractiveness of these houses is unintentional, the happy picturesqueness of irregularly scaled and detailed gables and of porches breaking the line of the frontage or of windows slightly projected on brackets. That is – if we now move from the town houses to the manor houses – what one remembers of Albright
49a Hussey mentioned before, of Old Hall Lee (1594) or Petsey (1634). On the other hand there were also large mansions in which the formality of the E-plan was reflected, with its projecting wings and central porch as the c16 had developed it in stone and brick. Park Hall Whittington (c. 1570) was the largest and most evenly detailed. But that was burnt down in
46b 1919. Pitchford is busier in its details, but equally formal in its main front. It dates from before 1578 and has lozenges within lozenges as its principal motif of decoration.

The chimneystacks are of brick (as they are, e.g., in the Old House at Shrewsbury) of a star-shaped section typical of the

Elizabethan Age. For by now brick had arrived in Shropshire. It was a late arrival, twenty-five years, it seems, after Cardinal Wolsey had chosen it for Hampton Court, and Henry VIII for St James's Palace. The first example is Plaish Hall. This has 43a still the gloriously overdecorated chimneystacks of the Early Tudor age. The windows are straight-headed and transomed and have arched lights. The brickwork is patterned by diapers made of bluish-black vitrified headers. Twisted chimneys and diapered brickwork occur also at Upton Cressett, where part of the house must be decidedly earlier than the recorded date 1580. That part has even its window frames made of brick (as also has Crow-leasowes). The brick diapering of Upton Cressett on the other hand recurs at Belswardine Hall, where nothing else remains, but a date 1542 is recorded. Inside Plaish Hall is a memorable ceiling painted between the beams with Early Renaissance scroll- 51 work. Only a little later – dated 1553 – is the equally memorable fireplace at the Old House, Dogpole, Shrewsbury. This is 52a remarkably sober and classical, with its fluted Ionic colonnettes in the overmantel. The familiar flamboyance and demonstra-tiveness of Elizabethan and Jacobean woodwork came later. The most sumptuous examples are at Stokesay Castle and Brogyntyn (1617). Plasterwork has as a rule sparse individual 52b motifs between the beams (Arlaston House, etc.) or in the geometrical shapes formed by thin interlaced ribs. There are plenty of examples of the latter, and it is interesting to see that the same motifs recur in various places, because the same team of plasterers used the same moulds (Morville, Upton Cres-sett, Wilderhope). The broad decorated bands replacing ribs about 1600 are an exception in Shropshire (Feathers Hotel, 53 Ludlow).

But one should not analyse the interior decoration before the houses. There are plenty of between c. 1570 and the mid C17 in the country, and a few at Shrewsbury. They are now of brick or stone according to choice. But the Shrewsbury merchants still definitely preferred their black-and-white, in spite of Rowley's Mansion of 1618 (brick) and Whitehall of 1578–82 (red sandstone). Whitehall is a country rather than a town house; for it was built in the outer abbey precinct, outside the gates and streets of Shrewsbury. It has a separate gatehouse; and this is not the only Tudor gatehouse in Shropshire. There is one at Langley, one at Upton Cressett, and a specially beautiful one at Madeley Court. This is undated but, in the 43b crispness of its composition and the peculiar shape of its gable,

closely related to Moreton Corbet, and Moreton Corbet has the
44a date 1579. It is by far the most important surviving Elizabethan
house in Shropshire. With the firm articulation given by two
superimposed orders of attached columns with their friezes,
Moreton Corbet belongs to Longleat, the most disciplined
Early Elizabethan. Its significance is not sufficiently appreciated.

45 The most famous Shropshire country house is Condover,
built of stone by the Owens of Shrewsbury in the 1590s. This
belongs to a different group, the group of Hardwick and Barl-
borough, with its close grid of mullioned and transomed
windows and its raised square eminences. It has an arched
loggia at the back, a motif repeated, though we do not quite
know how, at High Ercall. The date here is 1608, the materials a
curious haphazard change from brick to stone. For High Ercall
we happen to know the name of the master mason: *Walter
Hancock*, and it is almost certain that he also built the Market
House at Shrewsbury in 1596 and very likely that he built
Condover.* High Ercall was built for Sir Francis Newport. Of
his older and apparently grander house, at Eyton-on-Severn
(brick; 1607), only one large summer-house remains; so we
cannot say what it was like. Nearly the same applies to Acton
Reynald (1601 and 1625), now mostly Victorian, but clearly a
splendid mansion as it was built. Sir Henry Sydney at Ludlow
Castle about 1580 also renewed with splendour. His ranges are
in ruins however. The finest medium-size houses of the period
are Shipton Hall of *c.* 1587, where the symmetry of the façade
is broken by the four-storeyed porch tower and the porch is
entered from the side. The same happens at Madeley Court

* The evidence is interesting enough to be quoted in full. It is a letter of
November 1595 from Sir Francis Newport to the Bailiffs of Shrewsbury,
and in it he says:

'Whereas I am enformed that you intend to buyld a new market house
of stone in that towne and so go forward with the work next spring, I pray
you let mee comende a Mason of approved skyll and honestye, one Walter
Hancock, unte yo for the doing thereof. . . . I have great cause to make tryall
of workmen . . . and . . . can well write unto you . . . that you cannott
match the man in these parts (with any of that occupacōn) neyther in scyence
and jugement of workmanship, nor in playnes and honestye to deal with
all. . . . I know that if Mr Justic Owen were in the country he would say
as much on Hancock's behalf as I have done. . . .'

Condover was built by Mr Justice Owen. Hancock died in 1599 and is
buried at Much Wenlock. In the parish registers he is praised for his skill
in the art of masonry 'in settinge of plottes for buildinges', but also for
engraving in alabaster, other stone, and plaster. Reference is made to building
by him in England and Wales and to tombs and 'curyous pictures'.

and also at Ludstone, a beautiful Jacobean house with a central 44b
bow-window and shaped gables. Benthall, though often called
1535, must be Later Elizabethan, Wilderhope is late C16, and
that is also the most likely date for the movingly sited house
Frodesley Lodge. All these are of stone. Of brick Whitton Court
and Stanwardine-in-the-Wood, dated 1581, are perhaps the
most noteworthy.

However, this account of secular architecture from the
Reformation to the Civil War must not be closed without
reference to some buildings serving other than domestic pur-
poses. The market houses of Shrewsbury and Much Wenlock
have already been mentioned. At Clun a hospital, i.e. almshouses,
was built in 1618, a handsome composition. And at Shrewsbury
the School, founded by Edward VI in 1552, built premises for 46a
themselves in the 1590s and enlarged them in 1630, so stately
and capacious as no other grammar school possessed in the
country. They are three-storeyed, with long, even, well-com-
posed façades, a large library, a chapel, and plenty of teaching
space. The school also, in 1617, bought themselves a country
subsidiary at Grinshill to be used in times of plague. This also
is a remarkably rationally built plain parallelogram.

CHURCH BUILDING after the Reformation had come more
or less to a standstill. This being so, the fact needs some com-
ment that ten or more churches remain in Shropshire rebuilt
or partly rebuilt or considerably remodelled between the 1560s
and the 1660s. Some of that activity was due of course to damage
suffered in the Civil War, which affected Shropshire more than
many counties, but a remarkable amount was done before the
war. It is all in a style which usually is considered a GOTHIC
SURVIVAL, but may well turn out to be a genuine GOTHIC
REVIVAL, two hundred years before the date as a rule assigned
to the beginning of that movement. The w tower at Sutton
Maddock of 1579 is partly Perp and partly a mid-C16 Tudor,
that is indubitably Survival, but the Dec tracery etc. at Old
St Chad Shrewsbury c. 1571, the chancels of Shifnal after 1591,
and Church Stretton c. 1620–30, and the chancel of Astley
Abbots 1633 can only be understood as a conscious harking
back to a more distant past, i.e. Revival. Dec and Perp forms
appear mixed at Adderley in 1635–7, Lydham 1642, and High
Ercall 1657–62. With High Ercall we have reached the Civil War
again and the repair of damage done. Stokesay church was
largely rebuilt in 1654 and 1664, Condover church in 1662–79,
Benthall church in 1667, and the w tower at Little Wenlock

also in 1667. Even here the style used was still entirely Gothic, and essentially Late Gothic, i.e. Perp, so that we can safely once again speak of survival. The other churches or parts of churches of the later C16 and early C17 need no comment, except for Langley Chapel of 1564 and 1601 with its complete preservation of furnishings. In the timber-framed chapel at Halston also one gets a good idea of the way in which churches were filled with furnishings at that time.

These CHURCH FURNISHINGS are not as a rule of much individual interest in the county. There is much woodwork, easily recognizable. The pulpit at Petton dated 1635 is a specially good example. Dean Cranage counts another thirteen C17 pulpits besides. There are for some reason a number of mid-C17 doors (Shrewsbury Abbey 1640, Cardington 1648, Old St Chad Shrewsbury 1663, St Mary Shrewsbury 1672, etc.), and there are, certainly more interesting and valuable, the mid-C17 timber roofs. They are mostly hammerbeam or even double hammerbeam roofs, a type not native to the county but favoured by the Elizabethans and Jacobeans. Examples are Shifnal after 1591, Astley Abbots 1633, High Ercall c. 1660, Sheriffhales 1661, Bridgnorth 1662, Benthall 1667, Condover c. 1680. So even by 1680 the classical style had not replaced Perp traditions yet.

It is worth following the same development in CHURCH MONUMENTS. Renaissance forms arrived without any emphasis in the Blount monument of 1531 at Kinlet already referred to, 35a the excellent Bromley monument at Wroxeter († 1555), the Talbot monument at Albrighton († 1555), and the Broke monument at Claverley († 1558). The tomb-chest at Wroxeter is divided by candelabra-like colonnettes, in the other two by spiral-fluted colonnettes as they had already been used before the Reformation (at Claverley and Newport). The former work is continued at Moreton Corbet (Corbet monument † 1567) and Shrewsbury Abbey (Onslow monument † 1571), the latter at Stoke-upon-Tern (Corbet monument † 1566). The free-standing tomb-chest in this medieval fashion is still used as late as 1637 in a monument at Ludlow attributed to *Fanelli*, and at Ludford even in 1697. In the Late Elizabethan and Jacobean decades very large monuments were fashionable, but Shropshire was not in the forefront. The most usual types are a couple kneeling and facing one another across a prayer desk (still in *Nicholas Stone*'s monument of 1632 at Acton Burnell), and recumbent effigies on a tomb-chest against a wall and a more or

less deep arch with or without flanking columns and some
achievement on top. This type is represented specially well at
Worfield († 1588) and with more originality at Acton Burnell
(† 1591). In a monument at Condover († 1587) the arch is
deeper and four-centred. After 1600 the effigy is occasionally
given a semi-reclining attitude, cheek resting on hand, and
elbow propped up on the chest-lid (Cardington † 1607, Neen
Sollars † 1624). More ambitious is the six-poster or eight-
poster. The former appears in a very interesting Blount monu-
ment at Kinlet († 1584), where several Gothic motifs are kept
in the architecture and the equally medieval motif of the *gisant*
also survives. Six-posters also at Aston Botterell († 1588) and
Worfield († 1626). At Tong is a free-standing two-tier monu-
ment, the two tiers separated by eight columns. On the corners
of the upper tier rise four large obelisks. The date here is 1632.
Finally there is one curiosity to be recorded, the monument as a
painted triptych: at Burford in 1588, with the signature of the 35b
artist *Melchior Salabuss*. Sculptors' names, with the one excep-
tion of Nicholas Stone at Acton Burnell, are nowhere recorded,
and architects' names, except for Walter Hancock, nowhere
either.

In fact, socially as well as stylistically, there had not been a
conscious break with the past up to the later c17. The arrival
of the Italian fashion in the c16 was a minor event for a pro-
vincial clientele and provincial craftsmen. In the Elizabethan
and Jacobean styles these outlandish elements had soon become
englished, and the result was manifold, sometimes gay and
unruly, sometimes homely and a little stodgy, rarely of real
grandeur (as at Moreton Corbet), and never rational and logical
as the ITALIAN RENAISSANCE had been. The lesson of the
Renaissance had yet to be learned by the provinces. London
and the Court had been taught it by Inigo Jones. By the work
of Webb, his pupil, and of the gentlemen virtuosi Pratt, May,
and Wren, London and the nobility and gentry had accepted
it. How did the CAROLEAN STYLE finally reach Shrop-
shire?

There was first a period of transition, round about 1670–5,
when the upright window with one mullion and one transom
(the cross-window) replaced the variety of windows with more
lights, and first the shaped gable and then the pediment replaced
the straight gable. Examples vary greatly in the mode and degree
of acceptance of these innovations. Preston Brockhurst and
Soulton Hall (1668) still have many-mullioned and transomed

windows and gables, and all that is new is an incorrectly steep open triangular or open segmental pediment over the doorway. Loton Park had originally just such a steep open triangular pediment over the central first-floor window, but apparently a hipped roof and no gables at all – an important change in the general appearance of a house. Bragginton (1675) on the other hand has gables, but a consistent system of cross-windows like a Jones or May house. The best example of the big shaped gable of this period is Longnor (1670), where the doorway has again a steep, i.e. in this case a nearly semicircular, pediment. Shaped gables also at Great Lyth and Stoke Court Greete, and the semi-circular pediment at the (gabled) Almshouses at Berwick in 1672, the so-called Shoemakers' Arbour at Shrewsbury in 1679, and still at Idsall House Shifnal in 1699.

Rossall near Shrewsbury, a house too much altered to be of great help, is dated 1677 and seems the first with the plain hipped roof and quoins and upright windows, and none of the motifs of the past. The house has separate service wings at r. angles, and these have correct classical three-bay pediments too. So here the Wren style (or Pratt style or May style) seems to be accepted. In church architecture the date is still a little earlier, if one accepts 1672 as the date of the church in the grounds of Berwick Hall. The side windows here are of the cross-type. The church at Minsterley, though dated 1689, i.e. seventeen years later, is yet much less correct. But here the solecisms are more in a Baroque than in a native traditional direction. Minsterley had no successors in the county, except that it is the earliest example of large round-arched church windows, and that became the rule in the C18.

The houses of the 1680s in which the new classical style, so comfortable in its sensible simplicity, acclimatized itself in Shropshire are Hampton Hall of 1681–6 and Court of Hill of 1683, the far grander but extremely simple and sensible Shavington of 1685, and Halston Hall of 1690. The first two have the standard quoins and hipped roofs with deep eaves, Halston has quoins and a three-bay pediment, Shavington quoins of even length articulating its seventeen-bay front. A pediment is dispensed with. But inside Shavington possessed originally a hall running up through two storeys with a beautiful arcaded wooden gallery overlooking it on the upper floor at the back. The staircase also is very large and has sturdy twisted balusters. They are a characteristic motif of these years (and help e.g. to date Preston Brockhurst, which would otherwise appear earlier). Sir

Christopher Wren liked them, and in Shropshire they also occur at Aldenham Park, a house dated 1691, but too much altered to be listed in this group otherwise, and at Newport House (the Guildhall) at Shrewsbury which can be dated *c.* 1696.* This is a perfect example of the five-bay two-storey house of its date, as one knows them so well round London and elsewhere. The dormers on the hipped roof with alternating triangular and segmental pediments are also typical. Houses such as this influenced the style of the normal Shrewsbury terrace house of 1700–25 considerably. There are plenty of dated examples. Black-and-white had disappeared in the generation between 1660 and 1700. Late timber-framed houses in town and country are the Star Hotel at Market Drayton (1689) and the school at Chirbury (1675).

The next type of COUNTRY HOUSE made its appearance in the county with Cound by *John Prince*, built in 1704. The 54b innovation is the giant pilaster with richly carved capital used to articulate a brick façade. That was of course no innovation in itself. Giant pilasters had appeared in two houses connected with or designed by Inigo Jones, Lindsay House Lincoln's Inn Fields and Stoke Bruerne Northamptonshire, and at exactly the same time as Cound they were used e.g. at Ven House Somerset and also at Buckingham House London (by Captain Winne, 1705). That house is also in general character and other details comparable with Cound. Other motifs of importance at Cound are angles with quoins of even, not of alternating, size of the stones, an attic storey above the main cornice, and a three-bay pediment over the centre of the façade. The effect of Cound was not instantaneous, but all its new motifs were adopted. Giant pilasters appeared at the Preston Hospital begun in 1716, a remarkably urban and ambitious group, no doubt not influenced by Cound but by work closer to the centre of things. The designer is unknown. One would not look for him locally. The direct effect of Cound is however evident in a group of houses of *c.* 1725–35. Two of them, Davenport (1726) and Kinlet 56b (1727–9), are by a Midland architect of whom we know a certain amount outside Shropshire too, *Francis Smith* of Warwick (1672–1738), who designed Sutton Scarsdale and Melbourne in Derbyshire and acted, with his brother William, as executant

* A slightly earlier type of stair balusters is represented by the splendid 54a staircase of Longnor (1670). The balusters are turned, of substantial girth, and enriched by acanthus leaf – a design inspired by that of such houses as Coleshill, where the date is about 1650–60.

builder for Sir William Wilson, Archer, and Gibbs. Both Archer
55 and Gibbs influenced him. In Shropshire Berwick (1731), Bun-
tingsdale, and Mawley (*c.* 1730) are of brick with generous stone
dressings. They have all got the attic storey above the main
cornice, and all except the first use giant pilasters. Other houses,
one or two perhaps earlier than this group, participate in some
of the same motifs. The N façade of Loton Park looks earliest
and may well be of *c.* 1710. Here also the attic storey is above the
cornice. The angles are stressed by quoins of even length, and
they are continued above the angles by short pilasters. Berwick
also uses the latter of these motifs, and both of them reappear
at Davenport. Quoins of even length side by side with giant
pilasters are used at Hardwick too which was built before 1733.
Hardwick has separate lower service wings at r. angles to the
main block, just like Rossall fifty years before and like the plain
large stone house of Morville, *c.* 1700. At Kinlet the wings are
in line with the main block. At Hardwick they have segment-
headed windows, a motif typical in the county of *c.* 1720–30
(Castle Gate Ludlow 1728, Beaumaris House Newport 1724,
The Square Shrewsbury 1730, also Abbey House Shrewsbury).
At Hawkstone long wings were added later. The body of this
house, built probably in 1722, is more palace-like than the
others, with an attached portico of giant columns. The style is
not local here. The house has a splendid saloon in the Kent taste.
Smith can be splendid too, but he is far more unconventional.
At Davenport the entrance hall as well as the staircase hall are
panelled with wood painted white so as to appear ashlar-
rusticated throughout, a splendid, fascinatingly theatrical effect.
One feels transported on to a stage. The staircase has three slim
balusters of different shapes to each tread. This motif, familiar
in other parts of England, also occurs at Brogyntyn, at Ford
House, and Whitton Hall (1727, 1731). At Mawley there are
56a two alternating types of balusters, and the stair rail is a snake,
the convolution of the body being carried down from top to
bottom and ending at the ground-floor newel-post in a head.
There is more wood carving on the staircase, and there is one
room with inlay work as good as the finest and daintiest to be seen
anywhere in England. Fine inlay work occurs also at Davenport.
The staircase at Kinlet has three twisted balusters per tread, as
have also Hampton Hall, Haughton Hall nr. Shifnal (1718),
Hardwick, and the Abbey House at Shrewsbury. In the grounds
at Hardwick is a beautiful wrought-iron gate. Others at the
Abbey House Shrewsbury, the churchyard at Oswestry (1738),

Preston Hospital, and Henley Hall (from Wirksworth in Derbyshire). The latter two are the grandest, but none in the county can compare with those of Chirk Castle just across the Welsh border. Wrought-iron stair railings, however, which London houses used much at that time, do not appear at all in Shropshire. The only comparable thing is the iron communion rail at Berwick church.

As far as C18 CHURCH FURNISHINGS are concerned, little need be referred to otherwise: the splendid Organ Case at Whitchurch of c. 1715, others at Ludlow and St Mary Shrewsbury, and many sets of simple box-pews with two-decker or three-decker pulpits (e.g. St Martin's), but nothing in the least swagger. CHURCH MONUMENTS also as a rule are modest. Few are more than tablets, even if large tablets, with some figure work and perhaps a crowning obelisk in relief. The leading sculptors make no more than rare appearances in Shropshire: *Rysbrack* at Llanyblodwel 1752 (no figures), *Roubiliac* at Con- 38a dover 1746, *Cheere* at Hodnet 1752, *Bacon* (unsigned) at Tong 1780.

There are plenty of GEORGIAN CHURCHES and slightly pre-Georgian churches in Shropshire, more than in many counties. I have counted about forty completely built between 1710 and 1830, including those whose fenestration has been changed by the Victorians. The majority again are quite humble. More ambitious are the following: Whitchurch by *William Smith*, of 19a 1712–13, a big sturdy building with tall Tuscan columns carrying arches, Jackfield near Broseley 1759, the large brick church of a growing industrial area, now deserted, and then five of between 1790 and 1796. Two of them are by *George Steuart*, the best architect working in the county then: Wellington 1790 and the exquisite St Chad at Shrewsbury 1790–2, equally fine 19b in outline from outside and in the spatial sequence of the three main interiors. Three more are by *Thomas Telford* (1757–1834), the great engineer who had been made surveyor to the county in 1788: Bridgnorth 1792, which is the end of a street vista specially arranged in conjunction with the church, and Madeley 1796 and Malinslee 1805 which are octagonal. Finally St Alkmund Shrewsbury of 1793–5. The architect here may be *John Hiram Haycock*. This is in the new Gothic fashion which had until then appeared in churches only in an occasional purely playful way (one Acton monument at Acton Round, c. 1760, and Coton Chapel, c. 1765, with a Gothick Venetian window). St Alkmund is memorable also in that its windows all had

and some still have a kind of minimum Perp tracery made of CAST IRON.*

The iron industry of Coalbrookdale (Abraham Darby) and 61a Broseley (John Wilkinson) was then just beginning to change the face of this part of the county. The roaring furnaces were seen with admiration and some agreeable horror by travellers. The earliest of all iron bridges was built in 1777–81 to link the two banks of the Severn Gorge. The idea seems to have been Abraham Darby's, whose Coalbrookdale Company cast the parts. Of the early buildings of the company, which still operates, only very little survives, and that disgracefully neglected. The bridge is in one semicircular span, and has in its own terms something of the delicate elegance which we connect with Adam's decoration and Wedgwood's ceramics. At Coalport a similar bridge is dated 1818. *Thomas Telford*'s much more ingeniously designed bridge at Buildwas of 1795–6 has been destroyed. *Telford* also used iron to carry the Ellesmere Canal across the Tern at Longdon in 1794.

For, if the whole period from the late C18 to the mid C19 might be called the Iron Age, as against the Steel Age which was to follow it, its first fifty or sixty years might with just as much justification be given the name of the CANAL AGE. The Railway Age was to succeed, until it, in its turn, was replaced by the Age of the Motor Vehicles on the road and in the air. The first canal in England was built in 1759–61 to connect the young Duke of Bridgwater's coal mine at Worsley with Manchester. It was ten miles long. It was at once lengthened to reach Runcorn and the Mersey. The Grand Trunk Canal followed, begun in 1766. Shropshire comes into the picture with two short private canals of 1782 and 1788, built also to convey coal and in addition iron. The first ran from Donnington Wood to a place on the Newport–Wolverhampton Road, the second from Oakington to Ketley. This was followed by a canal from Donnington Wood to Coalport (1788–92). In 1794, when work on the Ellesmere Canal had begun, *Telford* appeared. The Shropshire canals as they were at the end of the Canal Age are chiefly two: the Ellesmere Canal starting in two branches from Newtown and Llangollen in Wales and leading via Whitchurch and Chester to Ellesmere Port on the Mersey, and the Shropshire Union Canal from Wolverhampton to Ellesmere Port by Market Drayton, with a branch to Shrewsbury. The minor delights of 'canalscape' can-

* Cast-iron tracery also at Adderley 1801 and a renewal in cast iron of a wooden screen in Cleobury North church.

not in this book be registered. The reader must be referred to the text and illustrations of Mr E. de Maré's book (London 1950). As for major building enterprises, the Ellesmere Canal crosses the Vale of Llangollen by a famous aqueduct with iron arches on stone piers, 1,000 ft long, and the valley between Wales and Shropshire at Chirk by another aqueduct. Both are Telford's work. *Telford* was also responsible for the great improvement of the Holyhead Road.

No sooner, however, were the canals and the new roads ready to take all the increased traffic of a growing industrial age than the railways replaced them. The railway is the result of two inventions, the steam locomotive and the rail. It is not usually realized how indispensable the rail was, in spite of the fact that the railway is called a rail-way and in France a *chemin de fer* (cf. *ferrovia*, *Eisenbahn*). Without the iron rail, the locomotive would have been useless. The locomotive is a steam engine. Darby produced cylinders, barrels, etc., for Newcomen's engines in the mid C18, and for Boulton and Watt's Soho Works later, and Wilkinson had the very first steam engine ever delivered outside Soho installed at Broseley. At Broseley he made iron rails. Thus iron and steam and improved means of transport all interacted to create the Industrial Revolution.

Wilkinson was a fanatic about IRON. He made a pulpit of iron for Bradley, Staffs, and insisted on being buried in an iron coffin. The monument which commemorates him at Lindale in Lancashire is a cast-iron obelisk. Cast-iron memorial slabs in the floors of churches instead of slabs of black marble had already been used in the C17. There are such slabs at Onibury dated 1666 and 1673, at Bridgnorth dated 1679 etc., at Leighton dated 36b 1696 etc. They are not the earliest. In Sussex, the home of the iron industry before Darby introduced coke for smelting at Coalbrookdale, they go back further.

But Shropshire was again first in applying iron to architecture proper. Just outside the centre of Shrewsbury, in Spring 61b Gardens, Ditherington, stands the first building ever erected with an iron skeleton or frame, iron columns, iron beams, and even iron window-frames. It is a factory built for Benyon, Bage & Marshall in 1796.

There seems to us – knowing what the C19 had in store – a painful contrast between these forebodings of an industrial age and the insouciant style of architecture, especially DOMESTIC ARCHITECTURE, of the same years. We had left this subject about the year 1740. By then in London Lord Burlington's

renewed Palladian style had won over the livelier and homelier style that had dominated up to 1715 or 1720. Brick was replaced by stone whenever it could be done, and the giant order confined to the portico. Door and window trim lost its exuberance. Palladianism took long to reach Shropshire. Its earliest example is Linley Hall of 1742, and that house made no history. Palladian houses of greater pretensions had to wait until *Steuart* 60a built Attingham in 1783–5. Its giant portico and proportions are what St Chad makes one expect. Giant porticoes followed 60b at Aston Hall by *Mylne* 1780 etc., at Longford Hall by *Bonomi* 1794–7 (in a very weighty style, no longer really '*ancien régime*'), at Brogyntyn 1811 etc., at Apley Castle, at Willey Hall by *Lewis Wyatt* 1813 etc., at Acton Burnell Hall and finally at Onslow Hall 1820, by *Edward Haycock*, son of John Hiram, and the leading local architect. But what is essential about these buildings is really C19 in character.

But before it can be analysed we should quickly recapitulate what there is of later C18 INTERIORS in houses. The interiors 58b & at Attingham are unquestionably the best. Side by side with 59 them *Robert Mylne*'s work of 1766–8 at Halston Hall must find a place here, which is so remarkably Adamish without being influenced by Adam, and the ballroom at the Lion Hotel Shrewsbury of about 1775–80. This kind of job is eminently characteristic of the age. The room no doubt served as an assembly hall for town and county occasions, until a special building was provided in 1840. That building is now called the Music Hall (not meaning by that term what we mean now) but was opened as the Public Rooms. It is designed by *Haycock* in a Grecian style, with an attached giant portico of fluted Ionic columns. *Smirke* had designed the new Shire Hall in the Square four years earlier also Grecian in the details, but less monumental and more utilitarian.

PUBLIC BUILDINGS of the period we are trying to summarize start with the Butter Cross at Ludlow, a handsome gay building of stone by *William Baker*, in the style of the brick and stone houses of *c.* 1730. It was built in 1743–4. There is certainly nothing Palladian about it. Smaller town halls and market houses are at Bishop's Castle *c.* 1765, Broseley 1777, Clun 1780, Ellesmere 1833.* Public buildings is presumably also what one ought to call the fine BRIDGES which now began to replace the narrow bridges of earlier less distance-minded ages. Those of iron have

* And some yet smaller ones undated: Market Drayton, Wem, Whitchurch.

already been mentioned. Of stone the two by *John Gwynne* (who built Magdalen Bridge at Oxford) at Shrewsbury (English Bridge) and Atcham, begun in 1768 and 69. The exquisite Tern Bridge at Atcham is of 1774, the Welsh Bridge at Shrewsbury (by *Carline & Tilley*) of 1791–5.

Finally three more public buildings deserve some notice: the Shrewsbury Gaol of 1787–93 by *John Hiram Haycock*, with the bust of John Howard over the entrance archway, the Royal Salop Infirmary of 1826–30 by *Edward Haycock*, with its monumental and massive Greek Doric portico so incongruously placed behind St Mary's Church, and the former canal terminus, now a railway warehouse, of *c.* 1835, which also makes use of giant Greek Doric columns.

The age which is being treated now is that often summed up in terms of a contrast between classic and romantic. It is indeed convenient to keep to this contrast as one means of arranging what was built, carved, and painted – provided it is always remembered that the contrast is really artificial. Is the revival of the Greek Doric order classic or romantic? Classic without doubt in that it is a copy of Greek precedent, but romantic without any doubt also in that it replaced the other orders because of certain primeval, elemental, or at least grave and earnest qualities which the romantic mind preferred to the smoothness of the Palladians and the elegance of Robert Adam.

The first house in which this new revolutionary conception of classical architecture appears in the county, and an early one for the whole of England, is Longford Hall by *Joseph Bonomi*60b 1794–7, though *Telford*'s Bridgnorth church of 1792 has also 3 more than a touch of it. In both cases the Tuscan order is used to convey a sense of weight and directness. For the Doric order on a monumental scale the county had to wait for *Haycock*'s Onslow Hall (1820) and Infirmary (1826). The latest and one of the finest buildings in that style is Millichope Park of 1840, also 63b by *Haycock*. Here the low entrance below the upper giant portico has very short and stumpy Tuscan columns. The house has also a splendid and original solution of the planning of the interior. Finally MEMORIALS: the so-called Obelisk at Hawkstone, a giant Tuscan column of 1795, and the Lord Hill Column at Shrewsbury, a giant Doric column, of 1816.

The Hawkstone Obelisk forms part of the PICTURESQUE furnishing of the grounds of the house, grounds by nature eminently picturesque. English landscape gardening in its first phase had been gentle to be natural; about 1800, thanks to

Uvedale Price of Foxley and Richard Payne Knight of Downton Castle just across the Herefordshire border, it became awful to be natural. For awe no site could be more suitable than Hawkstone with its sandstone crags, its precipices, and its precariously placed medieval castle, the Red Castle. So Sir Rowland Hill included this red ruin in an ingenious layout with grottos not at all of easy access, tunnels, a hermitage, and so on. An octagonal crenellated gazebo (similar to that built by *Telford* on the top of Shrewsbury Castle in 1790) and the somewhat later obelisk form part of this scheme.

Also part of it is the Citadel, a castellated house with three towers built *c.* 1790 to represent the heraldic castle which appears in the coat of arms of the Hill family. It was not the first medievalizing residence in Shropshire. In fact twenty-five years earlier *Capability Brown* had rebuilt Tong Castle as a Gothic fantasy with a big ogee dome over the centre of the façade. It has unfortunately been pulled down. It was utterly incorrect – an elaborate piece of Rococo wit rather than a reproduction of the past. Castellated houses of 1800 and after tend to be more heavy-handed. The principal example is Apley Park of 1811; we do not know whom by. Others are Sundorne Castle of *c.* 1800 etc., Rowton Castle of *c.* 1809–12 and *c.* 1824–8, and Quatford Castle of 1830. *John Nash*'s Longner of as early as 1803 is, needless to say, lighter, more inventive, and more picturesque in plan.

62 Close by *Nash* had built Cronkhill, probably in 1802, as an Italian villa, with a round tower meant to look baronial and an arcade on two sides meant to look Quattrocento. That mixture was something new; so was the complete asymmetry of the composition. Both helped to establish the type of the Victorian villa. We seem indeed at Cronkhill on the verge of the VICTORIAN AGE. Other symptoms of somewhat later date, familiar from all over the country, are a looser and more Baroque treatment of classical precedent. *C. R. Cockerell* was a national leader in this, and his work is represented in Shropshire by alterations at Oakley Park. But the most splendid example of this

63a loosening of the classical grip is the interior of Willey New Hall by *Lewis Wyatt*, which is of 1812–13 and was complete before 1826, an amazingly early date in comparison with the corresponding changes in London. The great hall and the staircase at Willey are amongst the most specular work done in that vein.

Yet another aspect of the turn to the Victorian style is the freedom to make use of more styles than the classical and

Gothic. That attitude had been introduced in a playful way by the chinoiseries of the mid C18, the moorish Pavilion at Brighton, the cottages ornés of Blaise Castle – before 1820. In our county the first sign is the somewhat heavy neo-Tudor of Oteley of 1826 and Lilleshall Hall (by *Sir Jeffry Wyatville*) of 1829. It was to blossom out into something much more ornate in the Station at Shrewsbury by *Penson*. This was built in its first form, very similar to the present, in 1848.

In CHURCHES the contrast between classic and romantic had been that between St Chad and St Alkmund. It was continued a generation later in the Grecian of St Michael Shrewsbury (1829–30) and St Catherine Whitchurch (1836) and the sober lancet Gothic of St George Shrewsbury (1832) and Ironbridge (1836) and Christ Church Wellington (1838). But the Gothic was to win in ecclesiastical architecture. A large number of small churches was built in the villages of Shropshire between 1837 and 1845. They are all in this minimum lancet style. And corresponding to the admission into houses of Tudor in addition to classical and Gothic there is in these years in church architecture all over England a passing fashion for a Norman Revival. In Shropshire it is represented by Ketley 1838, Grinshill 1839–40, Albrighton 1840–1, and Llanymynech 1845 (*Penson*), where the style turns wondrously crazy and ends up in a mixture of Anglo Norman and the Romanesque of Poitou.

Shropshire is lucky in its STAINED GLASS of these years. The county possesses a first-class piece of what the generation of 1800 regarded as pleasing, the E window of St Alkmund by [31a] *F. Eginton* of Birmingham, and a large number of windows by *David Evans* (born 1793). His glass has the advantage over most [31b] Victorian glass that its colours glow, even if they are strident. But when he did more than individual figures he copied the compositions of famous altar-pieces, Raphael's Transfiguration or Rubens's Deposition, indiscriminately, and that is not what a stained glass window calls for. David Evans died as late as 1861, and his son carried on after him; so here once more we are in full Victorian surroundings.

Now for CHURCH MONUMENTS. No more than a list is needed: one *Flaxman* of 1802 at Badger, some *Westmacott* of 1818 etc. at Burford, several good *Chantreys* at Badger, Berwick, Hodnet, and at St Chad's and the School at Shrewsbury, one exceptionally fine piece by the local sculptor-architect *Thomas Carline* at Prees (1824) and then *Baily* (1843, Hopton Wafers) [38b] and *John Gibson*, the Englishman who lived in Rome (Badger

1848, 1852). His work, even if in the classical tradition, belongs chronologically entirely to the Victorian Age.

A summing up of Victorian Shropshire presents a great difficulty. The county suffered little from wholesale industrialization. Population did not grow excessively. So building was neither extensive nor too depressing. Georgian churches and churches of the earliest years of Queen Victoria are so frequent still because there was less reason and less money to replace them by the bigger buildings which the Victorians demanded. No more than four such churches need mention for the moment: the new Broseley and Dawley parish churches, both of 1845, both in the iron area, and both competent and wealthy. Neo-Perp on the other hand are Holy Trinity at Coalbrookdale of 1851–4, again in the iron area, and Meole Brace of 1867–8 in what was becoming a desirable suburb of Shrewsbury.

32 The apse at Meole Brace has one of the finest series of *William Morris* STAINED GLASS in existence. It dates from *c.* 1869–70, and the firm did more glass in the same church later. Early Morris glass is also at Newport (1872) and Calverhall (*c.* 1875) and later at Whitton. From the eighties *C. E. Kempe* became a serious competitor. His early work is to be seen more frequently in Shropshire than almost anywhere else (Stoke-upon-Tern 1876, Alveley 1882, Baschurch 1886, All Saints Shrewsbury 1886 etc., Wrockwardine 1887 etc., Hope Bowdler 1888, Shrewsbury School 1889 etc., Cound 1891, Tuck Hill 1891–2, Edgmond 1891 etc., Bicton 1892, Cheswardine 1892 etc., Hadnall 1892 etc., and so on). His style is unmistakable, though his familiar signature, the sheaf of corn, does not appear until after 1900. His early work has perhaps more body than the contemporary work of Clayton & Bell or Hardman's, but it lacks the clarity, the sensitive simplification of design, and the purity of colour which made William Morris a pioneer of the C20.

The leading church architects of the High Victorian Age are represented to a varying degree and none of them with work of national importance. *Scott* restored much and all but rebuilt Ellesmere in 1849, *Street* also restored much (Upton Magna 1856, Clun 1877 etc.), all but rebuilt Oswestry in 1872–4, and built a number of small churches (Lyneal 1870) and one bigger

20 early one which shows him at his most original (St George's Oakengates 1861), *Sir Arthur Blomfield* has an early Butterfieldian church in the county (Jackfield 1863) and the mature and dull chapel of Shrewsbury School (1881–2), *Pearson* rebuilt the E end of the abbey church at Shrewsbury in a disciplined

E.E. and vaulted it (1886–7), and *Brooks* vaulted the chancel at
Caynham (1885). Much work was also done by a local archi-
tect *S. Pountney Smith* (1812–83) who was mayor of Shrewsbury
in 1873.*

By then a new generation had appeared on the scene, the
generation of Morris. Its architectural leader was *Richard
Norman Shaw*. His work in Shropshire is significant and reward-
ing. Preen Manor (1870–2) has alas been cut down cruelly, but
the monumental Adcote (1879) remains. The contrast to the 64
High Victorian commonplaces of *Norton* (Ferney Hall) and
Harris (Stokesay Court, Bedstone Court) is instructive. Norman
Shaw also designed Batchcott church, Richards Castle of 1891–2, 21
a truly monumental building too with much originality in the
exterior composition. One of Shaw's followers was *Reginald
Blomfield*, and it is worth pondering whether it was not he who
was responsible in his father's office for the remodelling of the
Shrewsbury Workhouse as Shrewsbury School. The neo-
Georgian trimmings would certainly go better with the younger
than the older man's taste. To Sir Reginald Blomfield's genera-
tion belongs *Sir Aston Webb*, the architect of the Edwardian
Buckingham Palace and Admiralty Arch. In Shropshire he is
seen in his early, less official and classical style, with the remodel-
ling of Burford church (1889 etc.) and the fanciful mansion of
Yeaton Pevery (1890–2). Inside Burford Church *Starkie
Gardner* did some delightful metalwork, and *Bainbridge Reynolds*
did some in Bridgnorth church.

That takes us to about 1900, and there this survey ends. The
first fifty years of the c20 in Shropshire have not yet con-
tributed a single building which would justify an appearance in
this Introduction.

Shropshire has been fortunate in its chief architectural
historian. Dean Cranage's *Shropshire Churches* published in
1901–11 is a complete, detailed, and reliable account of all the
churches in the county and their contents. It runs to more than
1,100 pages. Dean Cranage was a young curate and then vicar
when he began it. Looking back to it now that he is ninety, he
must be proud of its being to this day neither superseded nor in
any essentials found wanting.‡ His synopsis (*An Architectural*

* A footnote at least must be devoted to two mid-c19 eccentrics of the
Welsh fringe: the *Rev. Albany Rossendale Lloyd* of Hengoed and the *Rev.
John Parker* of Llanyblodwel. What they did to their churches and in their
churches is highly bewildering.

‡ Written before he died in 1957.

Account of the Churches of Shropshire) is much more detailed than this Introduction. In addition to Dean Cranage's book the reader may be referred to the Shropshire volume of the *Little Guides* and the very enjoyable Shropshire volume of the *County Books* by Mr E. Vale. For houses of all dates there is of course *Country Life* with its annual index showing all houses ever treated in its volumes. The local antiquarians' journal is the *Transactions of the Shropshire Archaeological Society*, an indispensable source of information. Finally, H. E. Forrest's book on the *Old Houses of Shrewsbury*, 1911, must be used. Nothing need be added to this remarkably short list of 'further reading'.

SHROPSHIRE

*

ABCOTT HOUSE *see* CLUNGUNFORD

ABDON

St Margaret. In a fine high position below Brown Clee. Nave and chancel, and bellcote. One pretty Dec two-light window in the chancel. The chancel arch is four timber posts, two against the walls, two free-standing, thus forming a tripartite entrance. The posts support a tie-beam. King-posts and diagonally placed queen-posts.

On Brown Clee are three iron age hill forts. The largest of the three is Abdon Burf. Now in a sadly ruinous condition, only a stretch of bank and ditch, no less than 400 yards long and with an inturned entrance in the centre, remains to testify to its former greatness. A similar fate has overtaken the second of the camps, Clee Burf, although despite its eroded condition its original circular plan can still be discerned. Overshadowed by both these camps is Nordy Bank, perched on the w shoulder of Brown Clee. It is roughly rectangular in plan and possesses a single bank and ditch. Probably it served as an outpost or look-out station to its more important neighbours.

ACTON BURNELL

Castle. Robert Burnell was chaplain and secretary to Edward I when he was still Prince Edward. He later became Lord Chancellor and Bishop of Bath and Wells. He died in 1293. At Wells he built the sumptuous Hall and Chapel of the Bishop's Palace. In 1284 he obtained licence to crenellate a house at Acton Burnell, the home of his family, and to use timber from the king's forests for its erection. The castle was built between that date and Bishop Burnell's death. It is not really a castle,

but rather what in the C14 or C15 one would call a tower-house, i.e. a fortified and embattled house. It represents a type occasionally to be found in C14 England (Nunney Castle Somerset, Langley Castle Northumberland), but nowhere else as early as at Acton. The type is that of a tall house with four projecting angle towers. The size is 75 by 54 feet. It has in addition on the W side a broad centre projection almost filling the space between the towers. There must have been a similar projection on the E side. The building is of red sandstone. It is not a castle also in that it has no moat, and that its entrances, three single-chamfered doorways, lie on the ground floor (in the SE tower, the NE tower, and the N wall close to the NE tower). In the centres of the N and S sides are broad blocked entrance arches. They were broken in at the time when the castle ruin was used as a barn. This ground floor was an undercroft. The main rooms lay above. The E two-thirds contained Hall and Solar, divided by a wall. The W third had three storeys in all, instead of the low undercroft and tall Hall and Solar. Here no doubt were offices and bedrooms. The windows are small, whereas those of Hall and Solar are tall two-light windows with a transom and with cusped lights and a cusped pointed trefoil in the head. The detail is noticeably more refined than at the other Shropshire house of the C13 which was a fortified house rather than a castle, Stokesay Castle, built indeed a little earlier. In the undercroft the windows are lancets. Only in the SE corner are two two-light windows. They have cusped lights and elongated quatrefoils in their heads. The room behind these windows must have had some importance, but it is not known what it was. Of other rooms something can be recognized or guessed. Curiously enough nothing can be seen of a staircase from the undercroft to the main floor. A spiral staircase ran up from the main floor to the second floor in the SW tower. The Chapel clearly lay in the badly ruined NE tower, see the jamb of the former chancel arch and the jamb of another tall window (to the N). The Kitchen, it is suggested, was in the E projection, see the three straight-headed openings in the Hall and Solar E wall – a familiar feature from later screens passages. But there is on the E face right next to one of these openings an arched recess just like a Piscina. How can that be explained? Also the cross-wall between Hall and Solar seems to cut right through these openings. So they were probably a later insertion. In that case would it not be more probable that the Kitchen was at the W end, as at the Bishop's Palace in

Wells? In any case there is a total absence of large fireplaces. Garderobes with shoots and drains were in the NW tower in the W projection. The house and the towers were embattled. Roofing seems to have been done by two parallel gabled roofs behind the battlements.

BARN. To the E of the Castle stood an extremely long stone building, of which only the two gable ends are upright. The building was 157 ft long and 40 ft wide. It may have been a barn. The side walls were certainly very low and the roof was very high. It has often been suggested that the Statute of Acton Burnell, the result of a visit of Edward I to Bishop Burnell and the holding of a parliament on that occasion, was given from this barn. There is no confirmation; but, if the castle was really only begun when licence to crenellate had been granted, the parliament – the first in English history in which the commons were properly represented – cannot have been held there.

ST MARY. Acton Burnell church lies close to the castle, as if it were its chapel. A comparison between it and a church in a similar position to a castle or fortified house which has disappeared, say Longnor, can show the great difference between a building designed for one of the chief architectural patrons of his day and for a knight of the county. At Acton Burnell everything is up-to-date or fashionable, and everything is a little more ornate. The W front is flanked by buttresses with the closely-set group of set-offs that is familiar from Wells (and Salisbury). The W doorway has a steep arch and a continuous filleted moulding, the window above two pairs of fine concave mouldings – a motif which recurs in other windows at Acton Burnell church. The window is filled by three stepped lancet lights. Corbel-table along the eaves of nave and transepts; for the church has transepts, though no provision for a central tower. A small tower was put up in 1887–9 between the transept and chancel. Original N porch. The outer doorway has a double-chamfered arch which dies into the imposts, the inner doorway again a continuous filleted moulding. Above the outer doorway a niche with at its head a three-dimensional or nodding trefoil, a form familiar from C13 effigies, e.g. at Wells. A small circular quatrefoiled window in a recess E of the porch. Otherwise cusped lancet windows in the nave and also the S transept. Blocked S doorway with hood-mould on head-stops. The S window of the transept has three stepped lancet lights and three stepped, uncusped circles over. This corresponds in

style to the chapter stair at Wells, i.e. work done *c.* 1260–70. The N window of the N transept has the same design. In the 12b (slightly lower) chancel an unusual and successful design of the N and S windows: grouped single lancets with rounded trefoils as their heads. Again the fine concave mouldings. Sumptuous E window of four lights, or rather two separate two-light windows with trefoiled circles set so closely that a larger cinquefoiled circle over both the trefoiled circles creates the impression of one wide and high window. But the whole is nook-shafted (with Purbeck marble shafts) in such a way as to stress the separateness of the two windows. Internally the chancel windows are also shafted in Purbeck. Big piscina with shafts and stiff-leaf capitals. The two basins charmingly corbelled out on small heads. The chancel and transept arches rest on short shafts with moulded or rich stiff-leaf capitals (much renewed), and the shafts on heads or (S transept) stiff-leaf corbels. The arches have complex mouldings and hood-moulds on head-stops. What is the date of the building? It is certainly earlier than the castle. Would *c.* 1260–70 meet the case in all its details? Dean Cranage has made a procedure likely, starting from the N porch and ending with the chancel. The roof of the chancel dates from 1571, that of the nave from 1598. They have collar-beams on arched braces, and in the chancel there are in addition cusped wind-braces.

FURNISHINGS. FONT. Contemporary with the chancel. Octagonal with eight shafts with fillets carrying eight deep rounded-trefoiled arches. – PULPIT. Jacobean. – TILES. The N transept is entirely paved with medieval tiles, some patterned, some not. – MONUMENTS. In the S transept C14 recess with ogee top. No effigy in it any longer. – In the N transept: tomb-chest with crocketed ogee niches. On it brass to Sir Nicholas Burnell † 1382. The 4 ft figure lies under a tall concave-sided gable. – Sir Richard Lee † 1591, an alabaster tomb of uncommonly sumptuous details. Two recumbent effigies, he in rich armour, on a rolled-up mat. Strong projections or pillars l. and r. with much strapwork. Under the arch, small, kneel the children, nine of them, frontally. Top with achievement flanked by two caryatids. A HELM stands on the monument, high up. – Sir Humphrey Lee † 1632. The usual Elizabethan type of monument with two kneeling figures facing one another across a prayer-desk. But the figures are large and exceedingly well carved and presented. The monument is indeed by *Nicholas Stone* who in 1632 was paid £66 19s. 4d.

for it. Row of children below, again represented frontally. – A tablet of 1794 in the chapel is signed by *King* of Bath. It is remarkable how far his clientele extended.

ACTON BURNELL HALL. Exterior shortly after 1811. Seven bays, two storeys, giant portico of four unfluted Ionic columns with a pediment. Giant angle pilasters. To the N two large bow-windows. To the r. additional premises and a plain CHAPEL built in 1846 by *C. Hansom* (GR). The house was gutted by fire in 1914 and its interior is renewed in the Georgian style. In the chapel STAINED GLASS in the taste of *c.* 1300; good work. – Two MONUMENTS, of members of the Smythe family † 1841 and 1853, recumbent effigies. Recesses in the Dec style. – Brasses of two kneeling figures with scrolls very Puginesque.

(GROTTO. Recorded by Barbara Jones. Shell- and tile-lined. The date *c.* 1750 is suggested.)

ROMAN ROADS. Recent excavations have uncovered sections of two Roman roads, originally part of the complicated nexus of roads that linked Wroxeter (Viroconium) with Leintwardine (Bravonium) and Caerleon (Isca). The excavations also revealed a portion of the abutment of a ROMAN BRIDGE lying athwart the line of Watling Street.

ACTON REYNALD 5020

Large Victorian stone mansion incorporating considerable and interesting remains of a C17 house of the Corbets. The E side has front bay-windows oblong in plan and two storeys high. They are crowned by small lunettes with a kind of shell decoration – a Venetian C15 tradition. Three of these bays are said to date from 1601, the fourth was added in 1625. Round the corner to the S is a portico of two pairs of Tuscan columns with elliptical arches. This also is of 1625. The rest is ascribed by Neale to 1800. Late C19 interior alterations by *G. H. Birch*.

ACTON ROUND 6090

CHURCH. Nave and chancel, and timber-framed belfry. Plain timber-framed S porch. The church was altered about 1750, when a family chapel for the Actons (cf. below) was added on the N side, and the S doorway of the chancel was given its characteristic ogee top. – DOOR. With ironwork probably of

the C12 or C13. – MONUMENTS. Richard Acton † 1703.
Hanging monument, demi-figures of husband and wife hold-
ing hands, in a horizontal oval. Signed *Stanton*, and of good
37 sculptural quality. – Sir Whitmore Acton † 1731 and his wife
†1759. Designed by *T. F. Pritchard*,* and made probably *c.*
1760. A remarkably early piece of Gothic Revival in a Rococo
vein. Coupled columns with shaft-rings, Gothic frieze, Rococo
top cresting and urns. Between the columns dark sarcophagus
and inscription below a trefoiled arch.

MANOR HOUSE. Built of brick as a dower house to Aldenham.
The date must be early C18. A very fine, noble, and restrained
design. Seven bays wide, two storeys high with hipped roof
and pedimented three-bay centre. Doorway with segmental
pediment. Several panelled rooms. Staircase with three
twisted balusters to each tread.

4080
ACTON SCOTT

ST MARGARET. Nave and chancel, and thin W tower with
battlements. The masonry medieval, all the details C19.
Added a S porch dated 1722, and N (Stackhouse) chapel of
c. 1820. – MONUMENTS. Brass plate with the kneeling figures
of Thomas Mytton † 1577 and family. – Edward Acton
† 1747; made 1751. Standing wall-monument. Sarcophagus
of dark grey marble with Rococo shield above, flanked by two
noble Tuscan columns of grey marble, with metope frieze and
pediment. Designed by *William Baker* and executed by
William Hiorns (Colvin). – In the chapel Gothic monuments
of 1819 and after.

ACTON HALL. Late C16 gabled brick mansion with mullioned
and transomed windows. Panelling in the Drawing and Justice
Rooms. In the drawing room also an original plaster ceiling.
The panelling in the Library comes from a house at Hatton.

4010
ADCOTE

Built by *Norman Shaw* in 1879. Externally at first not as striking
as some other contemporary Norman Shaw houses. Grey
stone, with Elizabethan straight gables. The best side from
outside is the S, where the steep hall gable with a big buttress
and the hall bay-window make a fine bold picture. The bay is

* According to a letter received from Mr Colvin.

the most remarkable feature. It is glazed to the s and w, with eight and two lights and four transoms. The Hall is reached 64 through a roomy entrance hall or lobby, but otherwise treated with gusto like a hall in a medieval manor house. Wooden screen with screens passage behind, minstrels' gallery over (with panels in thick embossed paper). The bay-window at the traditional dais end has already been mentioned. The hall has a huge fireplace with a hood about 15 ft high and three splendid stone arches to carry the roof, a motif, it is said, derived from Ightham Mote in Kent.

ADDERLEY

6030

St Peter. Church of red sandstone, rebuilt in 1801. The w tower however is older. Its date is 1712–13, and it represents that style (that of Whitchurch parish church) worthily. Big and sturdy with giant Tuscan angle pilasters, a parapet, and bulgily decorated obelisks. Bell-openings with Y-tracery. The nave and chancel and the s chapel have wide pointed windows with minimum three-light Perp tracery, all of cast iron. The s chapel faces the s with a pediment and no window. The n chapel is older, of 1635–7 (Kilmorey Chapel). Doorway with four-centred head and original door. Battlements and pinnacles. – FONT. Big, square, Norman. In the shape of a block capital. Decoration with rosettes, two addossed upright volutes, etc. Inscription on the rim: HIC MALE PRIMUS HOMO FRUITUR CUM CONIUGE POMO. Why should this inscription appear on a font? The inscription is medieval, but later than the font. – SCREEN. Of c. 1637. With slim Tuscan columns, adorned arches, and baluster-like obelisks or finials above the beam. – BENCHES and PULPIT no doubt of 1801. – MONUMENTS. Brass to an abbot or bishop, late C14, the figure c. 4 ft 6 in. long. – Sir Corbet Corbet † 1823, by *John Carline & Son*. – Two Kilmorey tablets (1818, 1824) by *Bacon Jun. & S. Manning*.

ALBERBURY

3010

St Michael. Quite a large church, made impressive by the proximity of the castle walls (an odd flying buttress from the sw corner of the church almost touches them) and by the

powerful N tower and the width of the nave. The tower is of
c. 1300, with clasping buttresses, lancets, cusped lancets, and
cusped Y-tracery. It is finished by a mighty saddle-back roof
but there are squinches visible inside for a stone spire. The
exterior of the rest of the church is damaged by the ugly
chancel of 1845 with its gratuitously Norman E wall. Restora-
tion of the church in 1902 explains the freshness of the other
windows. The finest piece of architecture of the church is the
Loton Chapel, a S chapel of three bays, with an arcade on
piers of quatrefoil section. The demi-shafts have fillets, and
there are spur-shafts between them. The arch has two sunk
chamfers. The E window was very large and wide, but is now
blocked. The S windows have one intersected tracery, the
other a free arrangement of cusped spheric triangles above
strangely arched lights. The W window is a spheric triangle
with fanciful tracery: the spheric triangle is of course convex-
sided; in it is a concave-sided triangle, and the remaining
spaces are filled with three cusped arch-heads pointing in-
ward. The small doorway is finely moulded. The date is
probably c. 1320–30. In the S wall a low recess with cusped
round arch and quarter moulding. The chancel arch also must
be C14, with two chamfers dying into the imposts. The nave
roof is one of the grandest of its kind in Shropshire. Collar-
beams on arched braces forming full semicircles, and five tiers
of wind-braces arranged quatrefoil-wise. – BENCHES. In the
Loton Chapel, substantial, imitation Gothic; of 1840. –
STAINED GLASS. In the chancel, all of 1853 and characteristic
of the date. – S window. An outstanding piece of Art Nouveau
glass, with two kneeling angels, and all the details in the style
of *The Studio*; to Sir Baldwin Leighton † 1897. Designed by
Sir Baldwin's daughter *Mrs Sotherby* who in her youth had
been much influenced by Burne-Jones, a friend of the family.
– MONUMENTS. Two big hanging monuments to Lysters of
Rowton: Sir Richard † 1691 (removed from St Chad's at
Shrewsbury), with two standing genii flanking the inscription.
– Richard Lyster † 1766, by *van der Hagen* (R. Gunnis). Big
inscription, and above obelisk with two putti and an urn; one
putto upright, the other sitting. – In the Loton Chapel two
small brass plates with portraits and Gothic surrounds, quite
original and personal: the Rev. Forester Leighton † 1807 and
his wife, frontal figures in prayer, below heavy ogee canopies.
Made probably c. 1840. – Dame Louisa Leighton † 1842,
kneeling figure in profile.

ALBERBURY CASTLE. An ivy-clad tower to the s of the church and walls from the tower towards the church are all that survives. The castle was one in the chain of defences of the Welsh marches to which Wattlesborough belongs too.

LOTON PARK, *see* p. 175.

ALBERBURY PRIORY, 1 m. NE. Founded for Augustinian Canons in *c*. 1225 but a few years later transferred to Grandmont. What remains is part of a farmhouse. The plan was excavated in 1925 and consisted of nave and straight-ended chancel with the cloister on the s side. The s side of the farmhouse is part of the s side of nave and chancel, with one doorway, originally leading to the cloister. This has one order of shafts with stiff-leaf capitals and a fine triple moulding in the arch. The w side of the house is modern in its s half. But the N half with another original doorway was the w front of the Chapel of St Stephen, a N extension of the church. The chapel is still complete, of three bays, rib-vaulted. The vaults stand on shafts with moulded capitals, the ribs are single-chamfered with a hollow on each side, the transverse arches are a little more complex. The E window has a depressed two-centred arch on nook-shafts with a little nail-head. Bosses, one with the lamb and flag (E), one with a head, one with a man devoured by a winged demon (w). The doorway from the chapel to the church also survives.

ALBRIGHT HUSSEY
¼ m. w of Battlefield

5010

The house consists of a timber-framed and a brick half, the former with a recorded date 1524, the latter with a recorded date 1601 (in the panelling of a room). The timber-framed part is again subdivided, one part with close uprights on the ground floor, the other with diagonal strutting. The first has on the first floor cusped lozenges, the second again diagonal strutting. Porch on the side, round the corner, with ogee struts. There can be no question that the more decorative motifs are not of 1524. It is perfectly easy to replace panels in timber-framed construction, as can be seen to this day. The brick part with its stone dressings and large four-light windows is probably the beginning of a rebuilding intended to sweep away the whole timber house. The gable storey – a curious fact – is ashlar-faced not brick-faced. In the timber part is one room with ceiling beams magnificently boldly moulded. A chapel

which used to stand close to the hall has completely disappeared.

ALBRIGHTON
3½ m. N of Shrewsbury

ST JOHN BAPTIST. 1840–1. Nave and chancel with polygonal apse; bellcote. Red sandstone; in the Norman fashion. Doorway and windows framed with heavy continuous mouldings. The chancel is a little later and was designed by the squire, *Mr Sparrow*. – FONT. Norman, circular, with a bold, nailhead-beaded zigzag and a kind of upright petal motif below. – PULPIT. Plain, Jacobean; with tester. – PLATE. Chalice given in 1790.

ALBRIGHTON
4½ m. SE of Shifnal

Albrighton is rapidly becoming an outer suburb of Wolverhampton. Much new building of detached houses, in addition to quite a number of Victorian villas.

ST MARY MAGDALENE. Red sandstone. Norman w tower, somewhat altered. Broad clasping buttresses, one large nookshafted window, and on the bell-stage circular openings (cf. e.g. Norwich Cathedral). But also C13 lancets and Perp battlements. The tower arch is triple-chamfered. So the alterations are perhaps as late as c. 1300. Dec chancel with splendid five-light E window. The lights are divided in two, one, two with sub-arches. Transom and ogee-heads to the lights below. Large cusped quatrefoil in the head. The other windows reticulated and simpler Dec. Nave and aisles rebuilt in 1853 by *H. J. Stevens* of Derby. – PLATE. Mace of 1664. – MONUMENTS. At the w end of the N aisle a very remarkable C13 tomb-chest. Pointed trefoiled arches on short shafts all along the sides (cf. e.g. the Gray Monument, York Minster). Shields in the spandrels. Lid with a cross in a circle, the space between the arms filled by four more small shields, and the remaining space on the lid by another eight large shields. The British obsession with heraldry started early – long before the Perp displays on tombs. The most likely date is c. 1260–70. – Sir John Talbot † 1555, and wife. Alabaster. Two recumbent effigies. The family frontal against the tomb-chest. Twisted colonnettes as at Claverley and Stoke-on-Tern.

Opposite the churchyard the SHREWSBURY ARMS, timber-framed with brick infillings in various patterns. The HIGH STREET runs towards the E, a wide winding street with old pollarded trees and front lawns on the S side. No houses of special value, but plenty of small Georgian properties.

JUNIOR SCHOOL, Cross Road. By *Jackson & Edmonds*, 1954. Complex group. The two raised parts are Entrance Hall and one part of the classroom block which faces S. Brick, but steel framing for the larger spaces. Extension to SW planned.

ALCASTON 4080
1½ m. SSE of Acton Scott

MANOR HOUSE. Very pretty black-and-white house, originally larger on the r. (NE) side. The last gable on that side now is an imitation. Three original gables, all of different height, width, and decoration. In the porch a tier of balusters instead of studs.

ALDENHAM PARK 6090

The house is built of stone and faces S with a long, low façade of eleven bays. The centre is raised and has typically Early Victorian arched windows. The portal with a pediment on which lie two lions goes with such a date. The sides look Georgian. But round the corner on the W side there is not only a plaque recording that the house was rebuilt in 1691 by Sir Edward Acton, but also architecture clearly of that time. The hipped roof and the eaves are especially characteristic. The windows on the other hand are a puzzle. Some on the W side and more on the N are the horizontal mullioned two-light windows of the earlier C17. There must have been four storeys of them. But the house must also have had upright cross-windows, as traces show clearly towards the former inner courtyard. For the house had a courtyard which was converted into a hall about 1830. The decoration is in the Grecian style. Oblong lantern with Ionic columns. Much honeysuckle ornament. At the same time or a little later Lord Acton, the historian, added a very large library wing to the NE. This is of cross shape. Of elongated cross shape also, with a shallow apse and a shallow segmental vault, the CHAPEL, built to the NE of the house, in 1837. In it MONUMENT to Sir Richard F. Acton † 1837 by *Westmacott Jun*. Seated mourning

woman with a child in front of a door. The front of the chapel seems a conversion. There seems to have been a garden temple here of *c.* 1800, and its front was made into the portico of the chapel. The best interior features are the staircase with strong twisted balusters (i.e. of 1691) and some doorcases on the first floor. In the garden several very fine early C18 wrought-iron gates. Exquisite large ENTRANCE GATE at the S entrance to the avenue which leads straight to the house.

ALKINGTON HALL

5030

Fragment of an Elizabethan mansion, dated 1592 (*Shropshire Magazine* 1952). Red brick with diaper patterns of vitrified headers. The N side with two gables and mullioned and transomed windows. The porch is not original. To the E two gables and a boldly projecting chimneybreast with diagonally placed chimneystacks. To the S a projection with a crow-stepped gable.

ALL STRETTON *see* CHURCH STRETTON

ALVELEY

7080

ST MARY. The village lies on a hill, and the church crowns it. Unfortunately its exterior has been ruthlessly renewed; by *Sir Arthur Blomfield* in 1878–9. Best preserved is the broad W tower which to a considerable height is still visibly Late Norman. The embattled top storey dates from 1779. The Norman tower arch inside is round, with nook-shafts and good mouldings in the arch. The exterior of the tower was refaced later. The N arcade of four bays is a little later. The piers are circular, as are the very flat capitals with leaf motifs, and the abaci. But the arches are pointed. They have one step. Again after a short time followed the S arcade. This must be of the early C13, see the E and W responds which are of three shafts with stiff-leaf capitals. The piers are still circular, but the circular capitals have now a kind of upright crockets all round. Good embattled C15 clerestory and roof. The chancel must once have been a fine piece of E.E. design. But nothing of the surface is genuine. E side with renewed windows: three lancets, shafted inside. The shafts have shaft-rings. N and S windows lancets, also shafted. The chancel arch is in its de-

tails C19, but the present form corresponds to Glynne's description in 1835. The character is early C14. The s chapel was endowed in 1353. Its forms are still Dec. It is also over-restored. Reticulated, straight-headed E window, one three-light s window with flowing tracery. It is not certain that these details are correct. Battlements outside. – REREDOS. Painted on zinc by *Kempe*. – FRONTAL. Embroidered frontal, made as such in the C15. Vertical stripes in two faded colours, cerise and cream (?). In the centre Abraham standing, with souls in his bosom. To the l. and r. cherubs on wheels, and tendrils etc. – STAINED GLASS. In the E window and in the s aisle *Kempe* glass of 1882 and 1903. – MONUMENT. Brass to John Grove † 1616.

BUTTER CROSS, 1 m. NNW. Small Cross on base at the cross roads. In the solid circular head Maltese crosses. The cross probably marks the site of an ancient open-air market.

HAY HOUSE, in the grounds of Severndale, 1 m. WNW. Gabled C17 stone house, derelict at the time of writing. The façade is dated 1697.

POOL HALL, ¾ m. SSE. Red-brick house surrounded by a moat. The back gabled, the front early C18 of five bays with quoins. The porch is two-storeyed, i.e. probably structurally older than its decoration. It has Roman Doric pilasters on the ground floor, an eared window between incorrect pilasters on the first.

APLEY CASTLE

6010

1¼ m. N of Wellington

Remains of a C17 house with some mullioned windows in the stable yard. The present house consists of two parts: the garden (NW) side, built in the 1780s by *Haycock*, and the entrance (SE) side, added in 1856. Both are of brick. The garden façade has seven bays, two and a half storeys, and a portico of four unfluted giant Ionic columns. Round the corner to the SW a bow-window surrounded by one-storey Ionic columns. The entrance side is in a debased style in which Italian, French, and English motifs mix. It is of course much higher, bigger, and fussier than the Georgian side. Central porch tower with a typical steep hipped roof.*

* The house has now been demolished.

APLEY PARK
1 m. w of Stockton

A large three-storeyed mansion in the Gothick style. Built for
Thomas Whitmore. Of Grinshill stone. The house was built in
1811 to the design of an architect who does not seem to be
recorded. s front with a superb view towards the Severn.
Symmetrical façade with a square middle tower or turret
projecting in the centre. Angle turrets as well, and two
porches in the middle of the stretches of wall between.
To the l. pretty Orangery with glazed Tudor arches. There
is now a private swimming-bath behind the Orangery
front. The e front has the main entrance. Large one-storeyed
three-bay porch. Turrets at the ends of the front, a castel-
lated pediment in the middle. To the r. of this symmetrical
composition the apparent e end of a private chapel, with
a very large Gothic window and a castellated gable with
a cross. This is, however, a complete sham. It hides the corner
of a Georgian house which stood on the site before 1811. Its
regular Georgian windows are still all there towards the n,
and some interior features also survive. There was a yet earlier
house here for which licence to crenellate was granted in 1308.
But of that nothing survives. Nor is much left of a succeeding
house which was dismantled in the Civil War. The present
house has a square Entrance Hall and behind it a square,
monumental staircase in the middle of the house. The staircase
has an iron handrail in Gothic forms, starts with one arm,
breaks into two, and goes up from the first to the second floor
in one arm against the back wall of the lower composition.
Glazed octagonal lantern on plaster fan-vaulting. To the s
from here the principal room of the s front, the Library, with
Gothic bookcases and its square bay-window in the tower
projection. To the w of this a passage and then the present
Dining Room, former Chapel, probably altered c. 1860. To
the e of the Library the Drawing Room, in white and gold. All
these main rooms have plaster ceilings with Gothic ribbing.

ARLESTON
1 m. sw of Wellington

ARLESTON HOUSE. An uncommonly handsome black-and-
white house with two parallel gables, the one dated 1614, the

other 1630. The arrangement of the timber is the customary one for more ambitious houses, narrowly placed studs on the ground floor, lozenges within lozenges on the first, concave-sided lozenges cusped into quatrefoils in the gables. (Good if rustic plasterwork in the drawing-room. Pomegranate frieze on the beams, geometrical and heraldic devices in the panels. In an adjoining room also a plaster ceiling.)

ASH

5030

CHRIST CHURCH. 1836, by *George Jenkin* (GR). Nave and chancel. The w tower (with battlements and pinnacles) appears embraced by the nave. Brick. The distinguishing feature of the church is the buttresses with two close set-offs right at the top which separate all the windows and which are placed diagonally l. and r. of the w doorway as if they were supporting the tower. The chancel was added in 1901, and the interior is also no longer in its original state.

ASH HALL. Excellent example of the small early C18 brick house, five bays, two storeys, hipped roof, quoins, the middle bay emphasized by two giant pilasters with well carved Corinthian capitals supporting a pediment. Doorway with segmental pediment on brackets. No entrance hall, just a passage with one room l., one r. Staircase with slender, partly fluted balusters at the end of the passage.

ASHFORD BOWDLER

5070

ST ANDREW. Nave and short chancel with shingled bellcote with broach spire. Norman doorways in the nave, Norman windows in the chancel. – MONUMENT. Jonathan Green † 1792, signed by *William Humphries Stephens* of Worcester. With two joined urns.

ASHFORD HALL. Seven-bay C18 brick house of two and a half storeys, three-bay pediment, hipped roof. Doorway with columns supporting a broken pediment. The house was built, according to Mrs Beesly, in the 1760s. It was then only five bays wide but was enlarged to its present size soon after. Attractive staircase with slender turned balusters, three to a step, and large arched window. Several interior features brought in from Shobdon Court Herefordshire and Wigmore Hall Herefordshire.

ASHFORD CARBONELL

St Mary. Nave and chancel. Weatherboarded belfry with pyramid roof. Norman and Transitional. The Transitional evidence in nave and chancel cannot be overlooked. The N doorway has a hood-mould with dog-tooth. The E side of the church is remarkable with two small round-headed lancets and a large vesica window in the gable above. Small plain Norman chancel arch. The belfry stands inside on a tie-beam with big arched braces. Roof with two tie-beams and two hammerbeams; arched braces up to collar-beams.

(Brook House. Timber-framed house dated 1677 but still entirely pre-classical. MHLG.)

Ashford Bridge. Large elegant main arch and small flood arches leading up to it.

ASTLEY

St Mary. Some old masonry and a blocked late C12 S doorway. Shafts with capitals with upright early stiff-leaf. Arch with castellation, but essentially a C19 church. W tower of 1837, nave and chancel of 1887.

Astley House. A curious attempt at making a three-bay Georgian house look Grecian. Coupled Corinthian giant pilasters on the upper floors, but a doorway with two pairs of Greek Doric columns. Instead of end gables, end pediments, as if the façade were the long side of a temple. Of the wings only one exists. It is of one bay with a pediment and Greek Doric columns *in antis*. It is connected by a screen-wall with the house. Older parts at the back.

ASTLEY ABBOTS

St Calixtus. Norman nave, see the two N windows and the blocked doorway. The chancel was rebuilt in 1633 (date on E gable). The window tracery is entirely Gothic, of the intersected and cusped variety, but the priest's door is round-arched. Specially interesting the roof. This is of hammerbeam type, the stone corbels carved with animals. In 1857 the tower, the S porch, and the nave S wall were rebuilt. – PULPIT. Jacobean, with two tiers of blank arches filled with flowers. – PANELLING. On the chancel walls, entirely in accordance

with the date 1633. – STAINED GLASS. In the E window good fragment of *c.* 1300 made up into one complete figure. – MAIDEN'S GARLAND. Dated 1707. Near the W end . (cf. Minsterley). Wooden hoops with ribbons and two pairs of gloves.

GREAT BINNAL, ½ m. NW. Unpromising exterior, but inside a complete little Hall, with heavily carved beams and a boss, and at the dais end beams coving forward and with painted decoration of the Neuf Preux or Nine Worthies. (On a fireplace the date 1611.)

DUNVALL. Beautiful timber-framed Late Elizabethan house. Symmetrical front with two projecting gabled wings. Only the centre is not entirely symmetrical in so far as the hall window is not centred but allows on the r. space for the small doorway. Mullioned and transomed timber windows. Star-shaped brick chimneystacks. In the timber framing decoration of concave-sided lozenges and also lozenges with an inset concave-sided square.

ASTON BOTTERELL

ST MICHAEL. Nave and chancel in one. In the chancel one small Norman N window and a simple but handsome C13 Priest's Door. The S aisle was added in the mid C13, see the low arcade with short circular piers, circular capitals and abaci, and depressed double-chamfered arches (cf. Cleobury North). The S porch is dated 1639. The W tower was rebuilt in 1884. The tower arch has a late C13 or early C14 moulding. Nave roof with tie-beams and wind-braces. – FONT. Late Norman, circular, with one band of nail-head. – COMMUNION RAIL. Jacobean. – PLATE. Chalice of 1571. – MONUMENTS. Large incised slab to John Botterell † 1479, and wife. – John Botterell † 1588 and wife. Six-poster of rather coarse detail. Recumbent effigies, the children as usual kneeling against the tomb-chest. Cresting of lunettes.

MANOR FARM. The r. half of the house is of stone and incorporates a C13 hall with its doorway still preserved inside. Also one N lancet. In 1576 the house was altered, a ceiling put in, and fine plasterwork applied to the ground-floor and upper-floor rooms. On the ground floor pattern of thin ribs, on the upper floor a vine frieze. The l. half projecting at r. angles may well date from 1576 too. In it a good open timber roof with collar-beams and quatrefoil wind-braces.

ASTON EYRE

CHURCH. Essentially Norman, and containing the best piece of
6b Norman carving in Shropshire, the tympanum over the S
door, clearly work of the Hereford School and considered by
Dr Zarnecki an early work of the master who worked at
Shobdon church. The subject is Christ's Entry into Jerusalem.
Christ is seen riding on the ass, his figure in strict frontality.
To his l. a bearded man with a young ass. His mantle is blown
up so as to fill the tympanum space between him and Christ.
To Christ's right an older bearded man spreading out palm
branches for the ass to step on. The doorway has one order of
shafts with renewed capitals. Also Norman N and S windows.
Transitional chancel arch. The arch is pointed. It has a roll-
moulding and lapping into it the triangular merlons of a
crenellation motif.

HALL FARM. Interesting remains of the C13. The farmhouse
must have grown out of the former gatehouse – see two big
stone arches. The main range was what is now the milking
house. This seems of the C15. Very large entrance arch
(altered?) and two tall windows with double-chamfered
jambs, one to the l. of the big arch at ground-floor level (Hall?),
the other in a projecting range on the first-floor level (Solar?).
Spiral stone staircase. The whole deserves detailed study.

ASTON HALL
3 m. SE of Oswestry

Built in 1780 etc. by *Robert Mylne*. A fine quiet ashlar-faced
house of comfortable, clean proportions, with a flat roof. Two
storeys high. The front is of seven bays with rhythmically
varied accents. At the angles arched niches and blank ovals
over with garlands hanging over them – a classical French
motif, beloved of Gabriel. The centre has a one-storeyed
porch with Doric pilasters, flanked by an attached giant fluted
Ionic column on either side which in its turn is continued by
a fluted Ionic pilaster. The S side has three widely spaced bays
and as punctuation only the motif of the niches with the ovals
over. The ground-floor windows here are tripartite with a
blank segmental arch. Inside a simple entrance hall flanked
to the l. and r. by three-bay rooms with restrained Grecian
stucco friezes. Behind the entrance hall is the spacious Stair-

case, starting in one arm and returning in two. Fine simple iron balustrade. Circular opening with octagonal lantern over.

GATEWAY with two Greek Doric columns and a straight entablature.

CHAPEL. The chapel lies immediately s of the Hall. Built in 1742. Red brick with stone dressings. w tower with angle pilasters and a parapet. Arched and circular windows. The bell-openings have Y-tracery. The windows of nave and chancel have Gibbs surrounds and thin C19 tracery. – FONT. A baluster of rather clumsy shape.

ASTON HALL
1 m. E of Wem

5020

Picturesque timber-framed farmhouse. The first floor has concave-sided lozenges, the gable post-and-pan work – an unusual sequence.

ASTON MUNSLOW
¾ m. SW of Munslow

5080

ASTON HALL. E-shaped early C17 stone house with gables over the three arms of the E. Star-shaped chimneystacks. Staircase with flat cut-out balusters. Handsome brick gate-posts of the walled front garden.

In the village the SWAN INN and several nice cottages, all of timber-framing.

ASTON-ON-CLUN

3080

ASTON HALL. About 1820–30. Five bays wide, with a Greek Doric porch.

In the village the KANGAROO INN, mildly Gothic, and to its l. a ROUND HOUSE of stone.

ATCHAM

5000
InsetA

Atcham offers a fine and varied vista as one arrives from Shrewsbury. The village lies the other side of the Severn Bridge and a little to the w of the Tern Bridge, two excellent Georgian bridges. The church stands just behind a stately C18 inn and with its tower immediately by the Severn. Moreover, the gate screen and the grounds of Attingham are the N backcloth of the vista.

St Eata. A unique dedication. Eata was a companion of St Aidan. Red sandstone. One Norman window in the nave N wall. The rere-arch inside is triangle-headed. The other nave windows Perp. The lower parts of the W tower are C13, and built probably of Roman stones. Broad flat buttresses. Very ambitious W portal, much renewed. Round arch on five orders of shafts, with typical 'water-holding' bases. Shafts and moulded capitals not original. Nor can the oddly coved un-moulded arch be. Yet its outer part seems original. The bell-openings are twin lancets with a shaft between. Above that Perp, with a parapet and a small quatrefoil frieze below. Tall double-chamfered tower arch towards the nave. The chancel is late C13, see the E window with its characteristic three stepped lancet lights under one arch, the uncusped Y-tracery in the N and S windows, and also the priest's doorway. S porch timber-framed with an inscription of 1685. – STAINED GLASS. Good late C15 glass in the E window, brought here in 1811 from Bacton in Herefordshire. Three large figures, grey, yellow, and white, with the kneeling family of Miles ap Harry (Parry) below. He made his will in 1488. Also some C15 and Elizabethan glass in a N window. – MONUMENT. Incised slab to Edward Burton of Longnor Hall † 1524 and wife (from St Chad Shrewsbury).

Severn Bridge. By *John Gwynne* of Shrewsbury, 1769–71. Gwynn was a friend of Dr Johnson and a founder member of the Royal Academy. He also built Magdalen Bridge at Oxford. Hump-bridge of seven arches, immediately S of the new bridge of 1929.

Mytton and Mermaid Hotel. Red brick, Georgian. Seven bays, two and a half storeys. Doorway with pediment on pilasters. In the adjoining stable yard large metal sculpture of the Mermaid by *Ralph Ellis*.

Tern Bridge. Built in 1774, as Mr C. Gotch has discovered, by *Robert Mylne*. An uncommonly beautiful design. One large semicircular arch with head in the keystone and coupled Tuscan columns at the end, strengthened by intermittent square blocking. View to the N straight to Attingham Hall.

5000
Inset A

ATTINGHAM HALL

Now partly an Adult Education College of the County. Built for the first Lord Berwick (Noel Hill) in 1783–5 to the design of

George Steuart, and the grandest house of its time in the county. It incorporates parts of an early C18 house called Tern Hall. Eleven bays wide, two and a half storeys high, ashlar-faced, with a portico of four extremely attenuated pretty Ionic columns carrying a pediment. Colonnades connect the house with low four-bay service wings of one and a half storeys. Alterations by *John Nash* (1807). Uncommonly fine interior. The entrance Hall was originally open to the present Pictures Gallery (which is in the position of Steuart's staircase). It has grey scagliola columns and very delicate stucco-work in the ceiling. The stucco decoration of the Drawing Room is as fine. In the former Dining Room the plasterwork is in the form of three large panels and loose round garlands of corn-ears and vine between and across their frames. Perhaps the most attractive of the rooms are the Octagon and the Round Room in corresponding positions, the latter with slim fluted composite columns against the walls and painted *grottesche*. Domed ceiling. *Nash*'s Picture Gallery has, at its ends, two screens of pairs of dark red columns with gilt capitals and a ceiling with iron beams and a glass and iron coving, a remarkably early structural use of glass. The iron parts were cast by the Coalbrookdale Company. The staircase also is by Nash. It ascends in a circular well, its first flight running straight across. It then divides and curves back to the first-floor landing: reeded dark red walls, pretty glazed dome.

Fine classical LODGE at the Atcham entrance. Gothick LODGE on the W side towards Longner, perhaps by *Nash* (M. Rix). BRIDGE between the house and the Deer Park, 1780 by *William Hayward.** The grounds were laid out by *Humphry Repton,* whose Red Book is kept at the house.

BADGER

7000

ST GILES. 1834, in a poor Gothic style. Nave and chancel and thin W tower. N chapel by *F. Francis* 1886. – STAINED GLASS. E window. This might well be of 1834. In the heads of the lights Netherlandish C16–17 roundels. – MONUMENTS. Mrs Henrietta Browne † 1802, by *Flaxman*. Stele-shaped monument. She stands; a genius appears in a cloud above her. – Isaac Hawkins Browne † 1818. By *Chantrey*. Big seated figure in profile. – Harriet Cheney † 1848, by *John Gibson*. She is

* Information supplied by Mr C. Gotch.

seated; a standing angel holds her arm. – Harriet Pigot † 1852,
also by *Gibson*. Stele-shape; an angel takes her up.

STABLEFORD COTTAGE. Pretty black-and-white work.

(BADGER HALL. The house is demolished. But in the park,
facing a glen, is a classical Temple, probably by one of the
Wyatt family. The road to Albrighton leads through a tunnel,
and above this is the drive to the temple. MHLG.)

6000 BARROW

ST GILES. Nave and chancel, W tower, and C19 N transept.
Anglo-Saxon chancel, as shown by one N window with double
splay and traces of a strip pilaster further W on the same wall;
also the masonry especially on the S side. On that side a Norman
doorway cuts into a window which must therefore be earlier,
but has Norman single splays. Saxon also the chancel arch,
see the characteristic square hood-mould which originally
probably went down accompanying the imposts. These are of
the simplest Norman type. Early Norman nave with remaining
N and S windows and S doorway. To the same building period
belongs what seems the tower arch, but is the W doorway of the
church before it had a tower. Tall and not wide, unmoulded
arch, and tympanum with three tiers of simple geometrical
patterns, mostly lozenges and saltire crosses. The tower is
Norman also and has no specifically Late Norman features.
W doorway and divers windows. Later battlements and pyra-
mid roof. Brick S porch of 1705 with arched doorway and
circular sill windows. – MONUMENT. A monument of cast
iron, dated 1807, in the churchyard. Urn on big square
pedestal.

ALMSHOUSES. Plain, of brick, with mullioned four-light win-
dows. Founded 1621, rebuilt on a different site in 1816.

4020 BASCHURCH

ALL SAINTS. Red sandstone, externally much renewed –
except for the W tower. This is early C13; see the windows
half-way up, and the arch towards the nave, on imposts still
Norman-looking, but with a pointed arch with one full and
one slight chamfer. Later bell-openings and battlements.
Much rebuilding went on in the church in 1790 and again in
1894. Thus only a minimum of features represents what was
there in medieval times. The chancel, e.g., is quite featureless

except for one mysterious half-arch on the s side close to the
w end. This is clearly of the C13. The s arcade also looks all
new, but there probably was an arcade with circular piers,
square abaci, and round single-stepped arches, i.e. an arcade
of the late C12. In the outer aisle wall several recesses, whose
arches have mouldings of late C13 to early C14 type (e.g. rolls
with fillets, and also ball-flower enrichment). There was a s
porch as well, some of which can be recognized outside. –
STAINED GLASS. E window by *Kempe* 1886. – MONUMENT.
William Basnett † 1754, good Rococo monument with an urn
in front of an obelisk.

THE LAURELS. Good timber-framed house with brick in-
fillings, NE of the church. The façade is symmetrical with two
gables.

THE BERTH. An earthwork, presumably of Iron Age date, now
consisting merely of two large mounds linked by a kind of
causeway.

BATCHCOTT (RICHARDS CASTLE) 4070

ALL SAINTS. Built in 1891–2 to the design of *R. Norman Shaw* 21
and perhaps his most successful church exterior. The church
lies against a hill-side and is seen from the E. The building is
faced with small rock-faced stones not at all attractive in them-
selves. The chancel here has a big substructure. In addition a
massive SW tower stands away from the s aisle. The tower has
much bare wall and stumpy battlements. Much bare wall also
in the chancel. The windows sit high up (straight-headed,
reticulated). Moreover at the SE end there is a vestry and above
it at the junction of nave and chancel a turret-like embattled
eminence. The nave windows on the s are like those of the
chancel. On the w side on the other hand Shaw has indulged
in a little archaeological jokery. The nave window is Perp,
the aisle window Dec with ball-flower (cf. Ludlow). On the
N side the nave windows are tall and Dec. The interior is
spacious and light with an arcade of C14 form and three wide
arches. But there is none of the decoration which Shaw must
have visualized when he designed the building. – By him the
ORGAN CASE.

RECTORY. To the N. Georgian, brick, with a Venetian and a
tripartite semicircular window above. The roof alas is altered
and slated.

MOOR PARK. Large brick mansion in the so-called Queen Anne style, eleven bays wide, with giant angle pilasters and shaped gables.

BATTLEFIELD

5010

ST MARY MAGDALENE. Founded by Henry IV as the church of a chantry college to pray for the souls of those slain in the battle of Shrewsbury in 1406. The first reference to the church to be erected is of 1406. The building was ready in 1409. The college was formally established with eight chaplains in 1410. The tower was added later. Money was being collected for it in 1429, but it was not completed until early in the C16, when Adam Grafton was master. The church fell into disrepair in the C18, and was very thoroughly restored by *S. Pountney Smith* in 1861–2. Much of what is most prominent now is by him, notably the openwork parapets and pinnacles outside and the hammerbeam roof inside. The W tower is original, with thin diagonal buttresses with many set-offs. Battlements and pinnacles are again Smith's. In nave and chancel the tracery of the windows is correct and here the most memorable fact is that they have side by side completely Perp and reticulated tracery. Reticulation is a motif characteristic of *c.* 1330–50. Such a late survival ought to make one cautious in dating. Nave and chancel are impressively wide, and there is no structural division between them. – SCULPTURE. Wooden

26b group of the Pietà, oak, *c.* 3 ft 6 in. tall. The composition is more familiar from Germany than from England. The mother's features are beautifully hard and grief-worn. – STAINED GLASS. In the Vestry several figures of French glass, early C16, brought from Normandy. The heads of the three in the E window are badly restored. In four chancel windows typical figures of *c.* 1860–5. – MONUMENT. John Corbet † 1817. Designed by *Archdeacon Owen* (Neale), and made by *John Carline & Son*. Gothic composition of four arches like an Easter Sepulchre. Straight crested top. No figures.

The College lay to the S of the Church; the whole was surrounded by a moat. It stands – except for the Vicarage of *c.* 1862 – on its own still.

BAYSTONHILL

4000

CHRIST CHURCH. Lying by a village green which is now neglected. There are not many village greens in Shropshire so

easily recognized. 1843 by *Edward Haycock*. The chancel was added in 1886. Thin w tower in its upper parts of a masonry different from the rubble of the rest. Lancet windows.

LYTHWOOD HALL, 1 m. w. By *George Steuart*, built *c.* 1782. Red brick, two-storeyed, with far-projecting wings. No features of interest seem to be left. There was originally in the middle a fine detached portico with very attenuated columns and a pediment.

BEARSTONE

7030

BEARSTONE FARM. Elizabethan; with a good black-and-white gable; two overhangs; mostly decorated by diagonal strutting. At the angles of the ground floor twisted shafts.

BECKBURY

7000

ST MILBURGA. Red sandstone. Chancel of *c.* 1300, restored in 1884. E window with intersected cusped tracery, N and S cusped lancets. An outer N recess, arched with straight shanks, must be later. Nave and w tower are Georgian. In the nave this can, however, be seen only at the corner outside. S aisle added in 1856, N aisle in 1879. The tower has quoins, a doorway with alternating rustication, and a pyramid roof. – PULPIT. Stone; Victorian, in imitation of the style of *c.* 1300. With naturalistic leaves as sole decoration. – MONUMENT. Incised slab to Roger Haughton † 1505 and his wife. Children small at the foot of the slab.

BEDSTONE

3070

ST MARY. Nave and chancel, and timber-framed belfry with shingled broach spire. Norman windows (nave S, chancel N) and very plain chancel arch. – STAINED GLASS. N window by *Kempe*, 1899.

MANOR FARM. H-shaped, timber-framed house. The S front stone-faced and dated 1775. Behind it the splendid remains of the former Hall, two huge crucks.

BEDSTONE COURT. By *Thomas Harris* 1884. A large, many-gabled, many-chimneyed neo-black-and-white mansion.

BELSWARDINE HALL

1 m. SE of Cressage

Said to have been built in 1542. Of that date nothing seems to survive except the two big chimneybreasts to the l. and r. of the front door. They are of brick with diapers of blue bricks, one of the earliest cases of the use of brick in the county, if the date 1542 is correct (cf. Plaish). In one room an early C17 plaster ceiling by the same craftsmen as at Wilderhope. Much C19 addition.

BENTHALL

ST BARTHOLOMEW. Built in 1667, after the old church had been burnt in the Civil War. Nave and chancel, and timber-framed belfry with pyramid roof. All nicely white. The chancel alas was gothicized in 1884, and in 1893 some odd additions were made of red brick, ornamented in a C19 way: a W apse and a S doorway, arched, and with an arched upper window reaching into the roof. The roofs of 1667 are interesting, with hammerbeams. W gallery of the same date. – PULPIT and READER'S DESK. Jacobean. – BOX PEWS, RECTOR'S PEW, and SQUIRE'S PEW, probably C18. – MONUMENT. Ralph Brown † 1707, a good tablet with big scrolls and an open segmental pediment.

BENTHALL HALL. The date 1535 is often suggested, but cannot be maintained. Another date in the literature is 1583 (*Brit. Archaeol. Ass.* 1860). That date harmonizes with the appearance of the house. Front with five original gables and below them, without in the least tallying with them, two deep baywindows (five-eighths, not three-eighths) and a square porch. The porch is entered from the side and may be an addition. On its front and entrance side four disks each, arranged so that they may well represent the stigmata, as is the traditional explanation. The Benthalls were Catholics. The bay to the l. of the porch is the hall-bay at the dais end, the other lies to the r. of the porch. Star-shaped chimneystacks. Fine richly-carved C17 staircase to the l. of the hall, running through two upper storeys, with big square baluster-shaped newel-posts and bold finials and flat openwork strapwork panels below the handrail. The treads are hidden behind boards with scrolls and long beasts. Beyond the staircase the drawing room or Parlour. This has elaborate strapwork panels in plaster between the

plastered beams, and an even more elaborate frieze, with animals in roundels and much fine decoration around. Large wooden overmantel. Another big overmantel in another room.

BERRINGTON

ALL SAINTS. Red sandstone. Perp w tower with diagonal buttresses with many set-offs, battlements, and a big w window with Perp tracery. Tall bell-openings with cusped Y-tracery. Double-chamfered tower arch, the capitals of the responds clearly Perp. The nave is of the C13 (an original lancet window in the N wall), and the s arcade was roughly cut into the nave s wall. Double-chamfered arches. In the s wall a single-chamfered recess. The s entrance into the porch must be re-used. It is of the C13. Chancel E window with flowing mid-C14 tracery. The roofs of chancel and nave are ascribed by Dean Cranage to the C14. – FONT. Norman, circular, with seven frontal heads, a beast (lion? lamb?), a cock, and a candle. Certainly not without re-cutting. – SCULPTURE. Two odd demi-figures in the w corners of the nave, high up. – STAINED GLASS. E window by *Evans* of before 1820. – MONUMENTS. Oak effigy of a Knight, cross-legged, late C13 (s aisle). – Mrs Greaves † 1628. Small kneeling figure. – Rebekkah Gillam Williams † 1827. By the younger *Bacon* (signed). Kneeling woman, her arm on a sarcophagus. An obelisk behind.
MANOR HOUSE, to the s. Dated 1658. Symmetrical front. Timber-framed and gabled. Below the middle window two blank arches. Otherwise no decorative enrichments.

BERWICK

CHAPEL. In the grounds of Berwick House. Built in 1672. Of that date the plain cross-windows. The big w tower probably of c. 1731 (the date of the house, *see* below). It has an arched w doorway and three arched w windows one above the other. Parapet with vases. The style is derived from that of the Hawksmoor–Archer generation. s porch with arched entry, the arch fitted with good C18 wrought-iron work. The E end with the transepts and an E gable and the fanciful windows under these date from 1892–4. By *Walker*. He must also have re-modelled much inside. – The WEST GALLERY seems original,

and the BOX PEWS. – The PULPIT also, with its composition of panels, could be of *c.* 1675. – COMMUNION RAIL. Of C18 wrought iron. – MONUMENT. Two Powys daughters who had died young in 1814 and 1818. By *Chantrey*. Relief of two kneeling young figures.

BERWICK HOUSE. Fine SE front of brick with ample stone dressing, built for one of the Powys family in 1731 (rainwater heads). Nine bays, two and a half storeys, the half storey above the main cornice, the centre of five bays and the angles stressed by fluted Corinthian giant pilasters. In the half storey above short pilasters with small panels corresponding to them. The top balustrade with vases and the first-floor balconies are Victorian (*see* below). Doorway with wide complex frame and segmental pediment on fluted Corinthian pilasters; above it the middle window is again flanked by giant pilasters. These have garlands hanging down them. The house clearly belongs to the group of Davenport, Kinlet, Mawley, etc., which is connected with *Smith* of Warwick. Behind the SE front the Entrance Hall survives, wood-panelled with finely carved Corinthian pilasters and two exquisite over-doors. The room above this hall also has panelling and some decoration. The rest of the interior and most of the exterior was converted into an Italianate Victorian by *Stevens* of Birmingham in 1878.

ALMSHOUSES. Also in the grounds of Berwick House. Founded in 1672. Low two-storeyed brick ranges on three sides of a courtyard. The fourth side is closed by a wall with a stone entrance arch. The arch is elliptical, but the whole archway is crowned by a semicircular pediment, a feature typical of *c.* 1675. The chimneystacks of the houses are placed diagonally.

UPPER BERWICK. Good house of *c.* 1700 in the village. Six by four bays, two storeys, red brick with stone quoins and hipped roof. Steep two-bay pediment with circular window.

5000

BETTON STRANGE
2 m. SSE of Shrewsbury

ST MARGARET. Built in 1858, in the lancet style. Nave and chancel, and a bellcote on a middle buttress which is split by a long lancet. The surprising thing about the church is its position inside the 'boundary walk' of Betton Hall. One reaches the church along a path with on the l. and r. just a few yards of planting, to 'conceal the bounds'.

BETTWS-Y-CRWYN

2080

ST MARY. The building essentially of the Victorian restoration (1860). Lancet-style. Good roof of the type of the region. Collar-beams on arched braces, and three tiers of wind-braces arranged into quatrefoils. – SCREEN. A good Late Perp piece, with round arches, mullions running up into their apexes, and small and intricate panel tracery. Frieze of heavy pierced quatrefoils above the dado. – PLATE. Chalice of 1662.

BICTON

4010

OLD CHURCH. Ruins of an C18 brick church, now without any furnishings.

HOLY TRINITY. 1886 by *A. E. Lloyd Oswell*. Nave, chancel, S aisle, big SE tower with higher stair-turret. Geometrical tracery. – STAINED GLASS. E window, a specially good piece of early *Kempe* glass, 1892. The ornament below the figures is bolder and broader than usual, the yellow dominates less in the figures. – In the S aisle also a *Kempe* window (1894).

BILLINGSLEY

7080

ST MARY. Mostly rebuilt in 1875. Nave and chancel, and heavy bellcote with steep hipped saddleback roof. Blocked Norman S doorway; the stove-pipe now pierces the blocking masonry. The doorway has one order of colonnettes. The arch has a thick roll-moulding, and the tympanum is decorated by hatched triangles. Grotesque heads above. Good, solid timber S porch, probably *c.* 1500. Minimum ogee tracery in the side openings between the studs. Large round entrance arch, the gable above pierced by crude foiled shapes. Bargeboarding with quatrefoiled circles. – FONT. Norman, simple, circular. – PULPIT and READER'S DESK. Nice simple Jacobean. – EASTER SEPULCHRE. Probably early C14. The tomb-chest has cusped blank arches. Crocketed gable and, inside it, a five-cusped arch and a pointed trefoil above – all pierced.

BISHOP'S CASTLE

3080

ST JOHN BAPTIST. Low, squat, unbuttressed Norman W tower with later battlements. The rest of the church – quite a spacious

church – with aisles and polygonal apse is by *T. Nicholson*, 1860. – STAINED GLASS. In the apse typical glass of *c.* 1860. – In the N aisle N window of a rather earlier type, *c.* 1850. – In the S aisle one by *Swain & Bourne* of Birmingham (1887), and two better ones of 1863, with good deep colours. – MONU-MENT. Decayed demi-figure of an Elizabethan divine (S transept) from a monument.

In the wall of the vicarage garden, just S of the church, a splendid former DOORWAY of the original church, early C13, with three orders of shafts with stiff-leaf capitals and deeply moulded arch. To its r. the SEDILIA, rather heavy and plain. Across the road, NE of the church, OLD HALL, a handsome black-and-white house. Then N of the church the main street of the little town, first called CHRIST STREET, then High Street. A typical contrast Nos 6, and 8–10, the one three-storeyed, renewed and completely urban, the other two-storeyed, timber-framed, lying a little back, and completely villagey. No. 58 is another good, if not refined, timber-framed house. The HIGH STREET rises quite steeply and in a gentle bend. At its top stands the TOWN HALL, a handsome brick building with stone trim, erected *c.* 1765. The basement with its two circular windows was the lock-up. Above it, facing down the road, one large round-headed window, a Venetian window over, and then a pediment and a cupola.* To the l. of the Town Hall a narrow, cobbled passage, yet steeper, and partly with steps. The so-called HOUSE ON CRUTCHES stands across, with its upper floors on two wooden posts. Pretty black-and-white work above. This passage leads into a street called Market Place. The Old Market Hall of 1775 was pulled down a few years ago. To the l. at the NW end of the town the Castle Hotel and behind it the scanty remains of the CASTLE. The CASTLE HOTEL is dated 1719, stone, seven bays wide, two storeys high, with a pediment-like gable over the three middle bays. Panelling and original staircase.

BISHTON HALL *see* BONINGALE

5070
Inset B

BITTERLEY

ST MARY. Nave and chancel and W tower with timber-framed top and short broach spire. Essentially E.E., see the various

* CORPORATION PLATE. Three Maces, over 3 ft long, the heads hall-marked 1697.

lancet windows, the priest's door with a shouldered lintel, and the tower arch which is remarkably wide and has stiff-leaf capitals and fillets (all this renewed). Restorations 1876 and 1880. – FONT. Norman, tub-shaped, with blank arches and a little foliage above. – PULPIT. Plain Jacobean. – COFFER. Of the C13. Long, closely banded with iron. Some crude leaf scrolls of iron (cf. Cound). – MONUMENTS. Timothy Lucye † 1616. Kneeling figure between two columns. – Littleton Powys (of Hurley Hall) † 1731, with obelisk, but no figure. – Other Powys tablets. – CHURCHYARD CROSS. Bare, fine slender shaft, and remains of the lantern head with Crucifixion.

BITTERLEY COURT. Partly Jacobean, but with a front of c. 1800 which is one-and-a-half storeyed and pedimented.

BONINGALE *8000*

ST CHAD. Nave and chancel and S aisle, weatherboarded belfry with broach spire. Nave and chancel are Norman, see one N window in the nave, and one in the chancel, half hidden by the vestry. S aisle 1861. The roofs of nave and chancel are of very low pitch and panelled. Moulded beams. In the nave, bosses. – PULPIT. Jacobean. – PLATE. Chalice and Paten of 1579.

CHURCH FARM, W of the church. Handsome timber-framed house with two symmetrical gables. Post-and-pan below, concave lozenges in the gables, some with spurs.

BISHTON HALL, ¾ m. SW. Also timber-framed, and of picturesque appearance. Stone barn to the S.

PEPPER HILL, 1 m. SE, *see* p. 226.

BORASTON *6070*

CHURCH. Mostly 1884–7 by *Henry Curzon*. Plain Norman N doorway, blocked, and signs of a Norman S doorway. – FONT. With spiral fluting on part of the bowl; probably c. 1700. The font comes from Buildwas.

BOSCOBEL HOUSE *8000*

With its associations Boscobel House is sure to have its crowds of visitors. Architecturally it is of little interest either externally or internally. Panelling and a little plaster of the early C17 is all there is, unless one considers hiding-holes architecture.

The house was built *c.* 1600 by John Giffard, a Catholic, as a 'place for concealment'.

BOURTON

₅₀₉₀

HOLY TRINITY. Nave and chancel, and weatherboarded belfry with pyramid roof. C19 N aisle. Norman S doorway, quite plain, and over-restored. – PULPIT. Big Jacobean piece with one tier of blank arches at the foot.

BOURTON MANOR, E of the church on the brow of the hill. By *Norman Shaw*.* Two-storeyed, of picturesque irregularity. The façade has one half-timbered gable, the rest of the first floor tile-hung. Older parts are incorporated. Early C19 staircase.

BOURTON HALL FARM. C17 stone house by the main road, with gables and star-shaped brick chimneystacks. (Good staircase. MHLG.)

BRAGGINTON HALL
1 m. N of Wollaston

₃₀₁₀

A stately, though not a large C17 house of red brick (English bond) with red sandstone dressings, at the time of writing shockingly neglected. Three storeys plus gables. The N façade has a centre of five bays and projecting wings of two. The windows are of the cross type. There are gables over the wings as well as the centre. Doorway flanked by very robust, rather corpulent columns. The inscription above gives us the date 1675. At the back are two odd oval windows, and oval windows are a special fashion in England at just that time.

BRAND HALL
½ m. SW of Norton-in-Hales

₆₀₃₀

Of *c.* 1700, though in the pediment the arms of the Styche family appear, which were granted only in 1737. Seven bays, two storeys, red brick and stone quoins and window surrounds. The three-bay pediment on giant pilasters. Lower one-bay wings to the l. and r. In front of the façade and at r. angles to it two archways with pediment and elliptical arches no doubt part of a former walled forecourt arrangement. Entrance Hall with two segmental arches at the end leading to the staircase.

* S. Leighton: *Shropshire Houses*, 1901, and H. E. Forrest: *Old Houses of Wenlock*, 1914.

This has three fairly sturdy turned balusters to each tread and a string covering the tread-ends. Stables to the l. of the façade.

BRIDGNORTH

7090

The hill-town is something of a rarity in England. It presents to the eye a town as a whole as few other situations do. And Bridgnorth is particularly lucky in possessing accents to mark its s and its N ends which can be seen from a far distance. The town lies on the ridge of the sandstone cliff along the w bank of the Severn, and so, whether one approaches it from the hills on the other side of the river, or from the N or s in the valley, the happy surprise will be the same. Nor does it matter in the least that one of the two main accents is a late C18 tower, the other a Victorian in imitation of a medieval one. As accents they could not be better contrasted or better spaced, and one ought to be glad that their medieval predecessors, called 'mean buildings' in 1764, were replaced. The line of houses on the ridge is fairly even, and their gardens are terraced down the cliff, interspersed with cottages. Then there is a line of streets at the foot, and the bridge, and Low Town on the E bank.

Bridgnorth was an important town in the Middle Ages. It 'standeth by clothing' said Leland about 1540. Later it turned, less successfully, to cap-making and hat-making.

ST LEONARD. A large, spreading church of red sandstone with a dominating tower. It is almost entirely Victorian, built in 1860–2. The architect was *Slater*, Carpenter's partner and successor. The church consists of a s tower with diagonal buttresses and a sw stair-turret crowned prominently by a spirelet, nave and chancel, N and s aisle, and an octagonal library to the E of the N aisle. The E end faces the river valley. Of medieval parts there is no more than a little Norman interlace work built into the tower, a few minor and renewed features in the chancel, and the wide and high double-chamfered w arch of the s aisle. The nave roof dates from 1662. It is of heavy hammerbeam construction. – LECTERN. Whole standing figure of an angel with large wings. By *J. Phillips* 1929. – PAINTING. Christ administering the Holy Communion. By *F. A. Smallpiece*, 1898, very conservative. – CROSS and CANDLESTICKS. By *Bainbridge Reynolds* 1898, excellent pieces in the more fluid Arts and Crafts taste. – PLATE. Large

Flagon inscribed 1658.* – MONUMENTS. Several plain cast-iron tombstones taken in from the graveyard (s aisle). The lettering is plain honest Roman. The dates range from 1679 to 1707.

ST MARY MAGDALENE. Begun in 1792 to the design of *Thomas Telford*, the engineer. The church replaces the chapel of Bridgnorth Castle (*see* below). Telford's is a remarkable design, of great gravity inside and out, and apparently done in full awareness of recent developments in France. The w tower
3 (ritually speaking, the tower in fact faces N to take advantage of the vista from East Castle Street; *see* below) stands above a w wall with attached giant Tuscan columns *in antis*. The wall itself has smooth rustication (a decidedly French motif). The columns carry a pediment. The tower is square, with a rusticated base, a tall bell-stage with attached Tuscan columns *in antis*, then a polygonal clock-stage and a lead dome. The entrance hall below the tower is circular. The sides of the church have coupled giant Doric pilasters and tall arched windows. The apse is an addition by *Blomfield*, dating from 1876. The E (i.e. S) end of the church was originally straight. Inside the most impressive feature is the arcade on both sides which consists of giant unfluted Ionic columns carrying a straight entablature. That also was something much propagated in the late C18 from France. Flat ceilings.

NONCONFORMIST CHAPELS. *See* Perambulation.

PUBLIC BUILDINGS. *See* Perambulation.

PERAMBULATION

The walk starts of course at the TOWN HALL. This is placed most successfully in the middle of the long and wide High Street, and as its upper storey rests on open ground-floor arches, the view runs unimpeded through the building along the street. The town hall was built in 1648–52, after much of the town had been burned down in 1646 when the castle was taken. The lower storey was of stone, but is now faced with brick. The upper storey is prettily timbered and has clock belfries to N and s.‡ The N half of the HIGH STREET has the CROWN HOTEL on the l., with an early C19 brick façade with

* Also Chalice and Paten found in the hands of a skeleton at the former Greyfriars (Cranage). Supposed to date from the C13.

‡ PLATE. Two Maces of outstanding design, made in 1676, but remodelled and enlarged in 1754. The upper parts can be removed to form drinking-cups.

three Venetian windows on the second floor. Opposite No. 73, early C18, of two bays, with quoins, projecting a little into the street (as done also at the Crown Hotel). Near the N end, again on the l., Nos 7 and 8, a handsome mid-C18 brick house of five bays. The NORTH GATE was so thoroughly restored in 1910 that it is now all C20. It was a brick structure of 1740. Just outside it on the l. some nice half-timbering. Off the High Street into WHITBURN STREET to look at two more important timber-framed inns, the KING'S HEAD HOTEL on the r., the RAVEN, dated 1646, on the l. The King's Head has three gables and diagonal struts as well as concave lozenges, the Raven is simpler and lower, but has carved brackets below the first-floor window. At the foot of Whitburn Street in POUND STREET the HALF MOON BATTERY, a semi-hexagonal bastion of the former town-walls.

Off the High Street opposite Whitburn Street CHURCH STREET runs up towards St Leonard's church. In Church Street the ALMSHOUSES of 1792, red brick, low, seven wide bays with a pedimented three-bay centre. The windows are pointed, that is intended to prepare for the church. ST LEONARD'S CHURCHYARD surrounds the church in such a way that one is reminded of a small cathedral close. The only notable houses are in the NE corner, Palmer's Hospital, rebuilt in 1889, three sides of a courtyard with stone ground floor and half-timbered upper floor, then the Municipal Offices, early C19, with a remarkably uncouth Ionic porch, and the former GRAMMAR SCHOOL, built in 1629. Three identical houses, brick-faced, each with two gables and a central porch which therefore does not fit the gables. Low three-light mullioned windows. Diagonally set chimneystacks. One of the houses was the school-house, one was for the school-master, one for the Vicar of St Leonard.

Now back to the Town Hall and along the HIGH STREET to the s. The whole of the High Street, with few exceptions, is pleasant to the eye, alternating between C18 brick, C19 brick, and timber-framing. The most notable houses are Nos 27–28, immediately w of the Town Hall, with two orders of clumsy pilasters superimposed (probably c. 1700), then facing one another two fine timber-framed groups, to the w the CASTLE INN, with four little caryatids for the second floor overhang and studs on the second floor in the shape of balusters, and opposite the SWAN HOTEL and its immediate neighbour. Both are mid-C17. No. 50, s of the Swan Hotel, is early C19,

brick, painted. It is six bays wide, with quoins, and an elliptical carriageway on the r. No. 43 opposite with its segmental window-heads and moulded keystones is typical early C18 work. At the s end the High Street narrows effectively, and, facing N, there is on the E side WATERLOO TERRACE with a very curious over-ornate early C18 house. Two bays, both flanked by giant pilasters so that a pair of them is in the middle of the house. Wild keystones on the first and second floors, and in addition the oddest sills to the second-floor windows. They end in down-turned scrolls. Also facing N, across the narrow end of the High Street, the former NEW MARKETS, built in 1855. This is in the grossest Italianate with an angle tower with typical Victorian-Italian roof. The material is yellow brick, blue brick, and red brick. The whole is utterly artless and tasteless, though not over-decorated. The tower tells in the town silhouette, as a minor accent midway between the major ones of the two churches.

Off the s half of the High Street just to the w ST MARY'S STREET. There is here more red brick and black-and-white, all on a minor scale than in the High Street, as was becoming for a side street. On the E side along Waterloo Terrace the top end of Cartway, *see* below. Then, after the narrow s end of the High Street, a changed character.

The Outer Bailey of Bridgnorth Castle (*see* below) was at last in 1786 laid out as part of the town. The New Road (*see* below) is part of this scheme. Its visually most important part is
3 EAST CASTLE STREET. This starts off with a bend, and then runs straight N towards the façade of Telford's church. The siting was done in such a way as to allow the former GOVERNOR'S HOUSE to be preserved as part of the frontage of the new street. The house is very similar to the Grammar School. It was built *c.* 1633. Red brick with stone trim. Three-storeyed porch, three gables, mullioned and transomed windows. At the far end of the garden is a pretty Gothick GAZEBO with a splendid view over the river and the valley. When the town became aware of these scenic possibilities, the CASTLE WALK was built, a promenade along the E walk of the gardens. The other houses in East Castle Street are pleasantly Late Georgian. The whole street is uncommonly undisturbed and unspoilt.

At the N end, to the E of the church are the remains of the CASTLE. Bridgnorth Castle dates back to pre-Conquest times. The castle was rebuilt by Robert de Belesme in 1098–1101, taken

by Henry I in 1102, given by him to Hugh de Mortimer, taken again by Henry II in 1155, and then made royal. Henry II spent much money on the castle and especially the keep from 1168 to 1189. The castle is extremely well fortified by nature, with the Severn on the w side and a deep valley on the N. The Keep is the only remaining part. It is memorable for a degree of leaning (15 degrees) far beyond that of the Leaning Tower of Pisa. The keep is Norman and has its entrance on the first floor, remains of a fireplace in the s wall on the same floor, and remains of a double-splayed window in the w wall on the second. A fragment of the curtain wall extends from the s wall. The Keep is 45 ft square and was 60 to 70 ft high. The church of St Mary Magdalene was inside the castle, and the outer bailey extended as far as the Post Office, where a barbican was built in 1212. The Parliamentarians took and slighted the castle in 1646.

Up the steep drop to the s of the castle the NEW ROAD winds its way into the High Town. It was built in 1792. It is connected with the High Street by WEST CASTLE STREET; here, on the w side, is the BAPTIST CHURCH, Grecian of 1842. The valley is steep enough to make it possible for the New Road to connect with the RAILWAY STATION on the opposite side of the valley by a light iron foot-bridge. The Station is a pretty little symmetrical neo-Jacobean building with three shaped gables.

At the end of the New Road UNDERHILL STREET runs along between the cliff and the Severn towards the bridge. In it two nice houses of c. 1700, one at r. angles to the street (two storeys, three bays, quoins, broad framed windows with bulgy keystones), the other facing the river (three storeys, three bays). But before the bridge can be crossed, one should proceed straight on; for here CARTWAY starts, the only road up from the bridge to High Town before the New Road was built. In Cartway first, facing us as we walk up, BISHOP PERCY'S 47 HOUSE with a date 1580. The house, with its three gables, its picturesquely placed first-floor windows, and the ogee struts as well as concave lozenges, is a first-rate example of black-and-white work. On the first floor plenty of concave-sided lozenges (uncusped). In the gables the decoration differs: much diagonal strutting, but also lozenges. Higher up the BLACK BOY INN, typical of the early C18, and then, after the turn of the direction of Cartway, several CAVES in the sandstone, used as dwellings right into Victorian times.

The BRIDGE was built in 1823. It has six arches and three poly-
gonal main breakers. Across in Bridge Street nothing of im-
portance. At its end MILL STREET turns N, St John's Street
runs on. In Mill Street No. 48, characteristic late C17, with a
straight door-hood on big brackets and broad windows, and
CANN HALL, Jacobean façade on an E-plan with projections
in the re-entrant angles. Door pediments with strapwork,
Victorian bargeboarding. Good staircase. Finally in ST
JOHN'S STREET on the r. the POST OFFICE, c. 1700, narrow
with heavy superimposed pilasters in two orders, and then at r.
angles, turning S, HOSPITAL STREET, where, towards the
river, the house of the GREY FRIARS once stood (founded
before 1244; on the site now a factory). At the far end of
Hospital Street at the corner of Stourbridge Road, a house
with scanty remains of ST JAMES'S PRIORY (no more than
the respond of an arch in a stable and some carving about the
present house).

BRINKYNALT HALL *see* WESTON RHYN

BROADWARD HOUSE *see* CLUNGUNFORD

⁵⁰⁹⁰ BROCKTON
4½ m. SW of Much Wenlock

(There is a CRUCK COTTAGE here. Maurice Little)

²⁰³⁰ BROGYNTYN

A brick house of c. 1730 refaced and much added to in 1811 etc.
The S façade, which is the principal façade, seems now all of
the early C19: nine bays, two storeys, and a balustrade.
Portico of four giant unfluted Ionic columns, with pediment.
Fine big carved scrolls in the pediment. All this corresponds,
however, to the dimensions of the C18 house. The E side is
thirteen bays long as against an original seven. The original
size is easily recognized if one imagines the canted bay-window
placed in the centre. The Entrance Hall is of three bays. At
its end two arches, that on the l. to a corridor of originally
three domed bays, that on the r. to the spacious Staircase which
is still entirely in its C18 form. For every tread, three slim

balusters of different shape – none twisted. Octagonal lantern. In the entrance hall a relic of the former house, an elaborately carved fireplace dated 1617. Gateway and LODGES to the s drive. Arch with two pairs of unfluted Ionic columns. Lower one-bay lodges l. and r.

BROMFIELD

ST MARY. The remaining fragment of a Benedictine Priory church, founded in 1155. The building history is not clear. The present E end is no doubt the Norman chancel arch blocked. It must, according to its style, belong to the foundation building, and is an excellent example of early C12 Norman. Wide and depressed round arch, one order of shafts, capitals with figures, the arch with a big roll-moulding. To the N also a large round arch, single-stepped, on plain imposts. That indicates a cruciform church. The s transept has disappeared completely, but on that side the evidence is confused by the fragment of a Tudor building erected by Charles Foxe, who took over the buildings after the Dissolution. Mullioned and transomed windows. Charles Foxe used the present chancel as part of his house, and it was restored to divine service only in 1658. The s windows are from the time of *C. Hodgson Fowler*'s restoration.* The beautiful recess however, with rich arch mouldings and openwork cusping, is original and of *c.* 1300. The Norman nave of the church is also still visible in part of one round-headed window inside (N side), where the tower now stands, and in a blocked round-headed window at the w end of the s wall. The nave W window is Dec, with (renewed) reticulated tracery. The date of the tower is hard to determine. It stands at the NW end and is at the same time a spacious porch – no doubt for the lay congregation. The inner doorway is E.E. with one order of shafts with stiff-leaf capitals and one order of a filleted continuous moulding. The outer entrance is plainly triple-chamfered. The upper windows are lancets, the bell-openings pairs of lancets. The battlements are probably Perp, but the tower looks *c.* 1300, except for the earlier inner portal. At the same time the N aisle clearly takes it into account, and this is no later than the late C13. Two bays, circular piers, with circular capitals and abaci, triple-chamfered arches. E respond with dog-tooth. Perhaps the N doorway had been completed and then tower and aisle were built

* According to Cranage, but the Shell Guide says *Bodley*.

17 as part of one programme. – PAINTING. The ceiling of the church is painted with robust naivety by *Thomas Francis*, 1672. Angels with scrolls, the Symbol of the Trinity, clouds. A most engaging piece of folk-art. – COMMUNION RAIL. With heavy twisted balusters, *c.* 1700. – STAINED GLASS. In the Vestry Flemish C16 roundels. – In the N aisle all *Kempe* glass of 1890 and 1894, W window by *Kempe* 1895.

42a PRIORY GATE. The eminently picturesque Gatehouse is all that remains of the Priory. Broad stone structure with timber-framed upper storey and gable above the gateway. Narrowly spaced uprights and a few long and strong diagonal struts. Crossley dates the timber work as early as the C14.

BRONCROFT CASTLE
5080
1 m. W of Tugford

A castellated structure of picturesquely asymmetrical appearance with several towers and with hall windows like those at Stokesay. Most of this is mid-C19, but the tower to the r. of the entrance, i.e. the lower of the two main towers, is original C14 work. Leland called Broncroft *c.* 1540 'a very goodly place like a castle'.

BROOK HOUSE *see* ASHFORD CARBONELL

BROSELEY
6000

ALL SAINTS. 1845 by *H. Eginton* (GR). Big church in a town then still prosperous. In a remarkably serious Perp style. Big W tower with pierced battlements, rather Somerset in character. Long nave and clerestory with twice the number of windows as in the aisles. Tall Perp piers inside and three wooden galleries. – STAINED GLASS. Strident window of 1852 in the N aisle; W window by *Kempe*. – CHURCHYARD GATES, of cast iron, early C19.

Broseley in the C18 was the town of the Coalbrookdale coal field, its only urban centre. Long High Street continued towards the church in Church Street, where, near the church, the best houses: BROSELEY HALL, just W of the church, THE LAWNS to the NW, and one or two others. The Lawns is of 1727 (rainwater head), and has a big late C18 bow-window on one side. The staircase inside is original, and very fine. Three slim balusters to each tread, the middle one twisted. Also good

fireplaces, etc. The Lawns was the house of John Wilkinson, one of the most famous iron masters of the later C18. His works were at Broseley, and here in 1776 he had the first steam engine installed. It was the first ever put up by Boulton & Watt outside their own Soho Works at Birmingham. Wilkinson was such an iron enthusiast that he demanded in his will to be buried in an iron coffin. Along Church Street, higher up, Nos 20–22, dated 1663 and still gabled and of Tudor proportions. Then in the HIGH STREET the TOWN HALL, built in 1777. Elliptical arches on the ground floor, three-bay pediment, and lantern rebuilt in 1887.
In QUEEN STREET the METHODIST CHURCH of 1802, red brick, with a pedimented porch and four arched windows along the nave.

BROUGHTON

8090

5½ m. ESE of Bridgnorth

OLD ST MARY. The ruin of the church lies in a field, with a big yew tree and the base of a churchyard cross to its S. What stands, ivy-mantled, is the S and E walls of the chancel, with the single-chamfered priest's doorway.
ST MARY. 1858. – PLATE. Chalice, said to be a pyx of c. 1500. – RUIN of the chancel of the old church. Late Norman. Elongated lancet-like windows in the E wall, later details in the other walls.

BROWN CLEE see ABDON

BUCKNELL

3070

ST MARY. Nave and chancel, and belfry. The nave masonry is largely Norman, but no evidence remains after the restoration of 1870. The chancel seems to have been early C14. – FONT. A remarkable, probably Early Norman, if not Late Saxon, piece, tub-shaped, with very flat carving of strangely irregular interlace. One head to the E.

BUILDWAS

6000
Inset A

HOLY TRINITY. Nave of 1720 and chancel of 1864. The timber-framed belfry with steep pyramid roof is no doubt also

Victorian. The date 1720 is recorded on a cast-iron plate on the s porch. The windows of that date are arched. The Y-tracery is a later insertion. w gallery on two posts. Twisted balusters. – PULPIT. Jacobean.

BUILDWAS ABBEY. The abbey was founded in 1135 by Roger de Clinton, Bishop of Coventry and Lichfield, for monks of the order of Savigny. The order was merged in the Cistercian in 1147. No date is recorded for the beginning of the existing buildings at Buildwas, nor for their completion. Nearly all the details are however Later Norman or Transitional, and a date about 1135 for the beginning of the surviving building seems impossible, though one shortly after 1147 can be justified. The abbey buildings lie in the valley of the Severn, unfortunately cut off from the river by the railway. The site is, in spite of this, peaceful and in harmony with the surrounding landscape, and the architecture is of great simplicity and nobility. Moreover, the church is of a happy, moderate size, spacious but not overwhelming. Total length only c. 180 ft.

The w wall, with broad, flat buttresses, without a doorway, but with three large round-headed windows of equal height is the best introduction to the calm character of Buildwas. The windows have nook-shafts. The capitals seem to have been of 8a the crocket type. Nave of seven bays with closely spaced circular piers, not of any special height. Multi-scalloped square capitals. Single-stepped pointed arches. No gallery or triforium only a plain clerestory. The windows round-headed and again nook-shafted. The capitals again, as far as one can see, crocketed. No vault, flat ceiling. No vault in the aisles either. This happy simplicity is Cistercian, but the details are Anglo-Norman, and not at all Burgundian, as most Cistercian architecture in Continental countries is. The nave was divided by a pulpitum so that the last two bays could form part of the monks' choir. The rest was for the lay brethren. To the s of the s aisle lay a late C14 chapel which did not communicate with the church by any doors. Doors from the n aisle led into the cloister which at Buildwas lies to the n of the church. The more usual arrangement is on the s side.

The nave is followed by the crossing, which originally carried a tower and the two transepts. The crossing arches are two-stepped and pointed. They rest on corbels on the w and e sides so as to leave space for the backs of choir stalls, on composite piers on the n and s sides. Waterleaf capitals show that these parts also cannot be earlier than c. 1160–70.

The arches from the transepts to the aisles are also two-stepped
and pointed. The E end is typically Cistercian: square-ended
vaulted presbytery, flanked by two shorter square-ended also
vaulted chapels on either side. The vaults at Buildwas are
groined in the chapels, ribbed in the presbytery. The arches
into the chapels are two-stepped and pointed. Of the chancel
vaults little can be said. The arch and ribs rested on short
shafts which start high up. A trumpet capital on the l., a
leaf capital on the r. The trumpet variety of the fluted capital
is again a sign of Later Norman date. Three long, lancet-like
E windows, round-arched and freely spaced. Medieval and
especially monastic churches in the Middle Ages were nearly
without exception begun from the E end. The forms here at
Buildwas are decidedly later than those of Fontenay, Rievaulx,
and Fountains, buildings of the Cistercian Order started in the
1130s. The earliest Cistercian rib-vaults in France belong to
the rebuilding of Clairvaux begun after 1153, in England to
Kirkstall begun probably in 1152. That seems to exclude a
date before c. 1160 for Buildwas. Moreover, as has been
pointed out, not a single detail appears earlier, and the re-
versal to the Anglo-Norman in the nave also fits the second
half of the C12 better than the second third. The Sedilia in the
chancel are an early C13 addition, see the moulded capitals
and the dog-tooth decoration.

The E range of the cloister continues the N transept. The
doorway led down into a Crypt below the N transept. This is
groin-vaulted in three bays. The room adjoining the N transept,
usually just a passage, was here a real room, identified as the
Sacristy. It has two vaulted bays. The vault formerly had ribs,
but they have fallen off. All the vaulting that is preserved at
Buildwas is indeed very rough. The Chapter House is entered
in the usual way by a big doorway flanked by two windows.
The doorway had two orders of shafts; the windows were
shafted too. Decorated scalloped capitals. The Chapter House
itself is vaulted in nine bays resting on the walls and four
slender internal piers, two circular and two octagonal, arranged
crosswise: next came the Parlatorium, again of two rib-
vaulted bays. The ribs are of a profile different from those in
the chapter house. Waterleaf capitals here again. N of the
Parlatorium was a room of unusual shape and no known pur-
pose. The Dormitory lay on the first floor of the E range and the
small windows can still be visually reconstructed. Did the
room below belong to the dormitory, or to the Refectory which

filled the N range? It was separated from the refectory by a wall. The room has two circular piers in the line of the E wall of the Parlatorium. The piers have circular multi-scalloped capitals and square abaci. The arches are pointed. How was the room continued?

A little to the NE and now in the garden of a private house are five bays of the arcade of the Infirmary. These are E.E. Pointed arches on short circular piers. Fragments from the Abbot's Lodging which lay SE of the Infirmary are said to be built into the private house referred to.*

The W range of the Cloister finally was, as usual in Cistercian houses, the lay brothers' quarters. Vaulted store room on the ground floor.

BUILDWAS BRIDGE. *Telford*'s Bridge has regrettably been destroyed. It was built in 1795–6 and was Telford's first iron bridge. It represented an important step beyond the Coalbrookdale bridge. It had a span of 130 ft as against the 100 of the earlier, and it used only 173 tons of iron as against 378. The arch was segmental, no longer semicircular.

6030

BUNTINGSDALE
1 m. SW of Market Drayton

55 Built c. 1730, and attributed for good reasons to *Francis Smith* of Warwick. Brick and ample stone dressings. The two main façades W and E not quite identical. Nine bays plus an addition of 1860 in the style of the original. Basement, two principal storeys, and attic storey above the architrave. Giant composite pilasters with excellently carved capitals. On the entrance (E) side they exhibit one odd anomaly. They articulate the angles, bays one and nine and the three-bay centre. But while these and the angle pilasters are fluted, the pilasters between bays one and two and between nine and eight are not. Segment-headed windows, doorway framed, with segmental head and in addition fluted pilasters carrying a broken, open, segmental pediment. Top balustrade. The garden side has the three-bay centre a little projected and crowned with a pediment. The architrave between upper storey and attic storey is here interrupted. S side with a bow-window. The Entrance Hall runs through both storeys. At its end on the upper floor a

* *The Builder*, vol. 79, 1900, pp. 293–4 refers to a row of narrowly placed lancet windows and, SW of this, a room with a blocked doorway 'with early carving on it'.

wooden gallery with a handsome balustrade which, for no special reason, curves up in the middle (cf. staircase rail at Mawley Hall). Doorway behind with open pediment. The staircase lies behind the Hall to the N. It has slim turned balusters and arched openings on the upper floor.

BURFORD

5050

ST MARY. Within 200 yards of the river Teme and the Worcestershire border. Red sandstone, and in character very different from the churches in the villages on the hills to the N. Nave and chancel, W tower, and N vestry (the latter, with a crazy rose window, is of *c.* 1860). The church has Norman masonry in the chancel, C14 work in the nave, a tall Perp tower arch, but will, in spite of that, chiefly be remembered for what *Sir Aston Webb* did to it in 1889 etc., i.e. very early in his career, when he still believed in a free Arts and Crafts Gothic. By him the tower top, and no doubt a good deal of restoration on the embattled N and S sides. Inside by him the rich chancel roof and the Sedilia. Also designed by him (and made by *Starkie Gardner*) the fine CHANDELIERS and other lamps. – LECTERN. Also by *Gardner*, the figure by *Frith* of Chelsea. – SCREEN. Made at Louvain. – REREDOS. 1871 by *Woolbridge*, made by *Powell & Sons*. – FONT. Octagonal, Perp, the stem with shafts and blank arches, the bowl with square panels with leaf motifs. – DOOR (Priest's Doorway). With early iron-work. – MONUMENTS. The church possesses unusually many for this part of Shropshire. The oldest may or may not have been a monument. Cranage suggests that it was an altar and originally stood in a different position. It is in a recess in the S wall of the chancel. The arch looks late C13. Below a front like that of a small tomb-chest, with four cusped pointed blank arches on shafts. In the top two holes (for use as a piscina?). – Brass to Elizabeth de Cornewayle, *c.* 1370. The figure 6 ft long. – Princess Elizabeth, daughter of John of Gaunt, wife of Sir John Cornewayle, † 1426. Recumbent alabaster figure of indifferent quality. Two angels by her pillow. She lies below a coarsely detailed ogee arch (chancel N wall). – Edmund Cornwall † 1508. Recumbent oak figure with two angels by the pillow. Poor quality. – Richard Cornwall † 1568 with father and mother. A most unusual monument.35b It is a painted triptych, 11 ft high, with fluted pilasters and a pediment. On the outer side of the wings panels with the

figures of the Apostles, on the inner sides shields, in the centre three painted standing figures. The monument is signed and dated: *Melchior Salabuss*, 1588. – Two of the usual tablets with kneeling couples facing each other across a prayer desk. Both of 1630. – Lady Caroline Rushout † 1818. By *Sir Richard Westmacott*. She is shown reclining on a couch and raised up by a standing angel. – Two more Rushout tablets by *Westmacott*, † 1822 and † 1827, of identical design, with, as their chief motif, a realistic flower in a medallion. – Also a Rushout monument of 1852 signed by *Charles Geerts* of Louvain.

BURFORD HOUSE. Plain red-brick house six bays wide and two and a half storeys high. 1728 (rainwater head), built for William Bowles, proprietor of the Vauxhall glass works. The doorway with broken pediment of Greek Doric columns must be of *c.* 1825. The later wings have recently been demolished. It is said that in the process remains of the former castle of the Cornwalls were found on the site of the W wings. – GARDEN HOUSE with portico of four slender Tuscan columns. In the pediment a handsome wrought-iron grille.

SWAN HOTEL. On the main road, by the river, at the Tenbury turning. Partly Georgian, with a big bow.

BURWARTON

6080

BURWARTON HALL. 1876–7 by *Salvin* in the Italianate taste. A fine collection of trees in the grounds.*

ST LAWRENCE. The old church was partly demolished and a new one built in 1877. The new church, also by *Salvin*, is in a Dec style, large, of yellow stone, rock-faced, with W tower. It lies away from the road, on a lawn surrounded by a low wall and iron rails. It is reached from the lodge of the house by a rhododendron walk. – FONT. Circular with an odd frieze of blank arches. Could it be a C17 re-cutting and alteration applied to a Norman font?

The ruin of the old church is below to the NE. The E gables of nave and chancel stand, and some of the N and S walls. In the chancel two Norman N windows, in the nave remains of two Norman doorways. Norman chancel arch with single-stepped arch. One order of colonnettes with rude leaf capitals.

* The house has now been partly demolished and the remainder reconditioned.

BURY WALLS CAMP *see* HAWKSTONE

CAER CARADOC *see* CLUN

CALVERHALL

5030

HOLY TRINITY. Two dates appear on the building: 1872 and 1878. The architect was *Eden Nesfield*, and the principal display is round the w front. There are in the village street ALMS-HOUSES, of 1724, a modest range of brick with slightly projecting wings and a centre with a pediment-like gable and two circular windows below. Nesfield knocked off one end and joined his church on to the rest. w front with a nine-light Perp window and to its l. sw tower, big and tall and with a taller stair-turret. The tower contains the porch, accessible from the s. Round the arch of the outer entrance, to the l. and r., a pretty diaper pattern of flowers and leaves and, asymmetrically arranged, a dedicatory inscription on the l., some heraldry on the r. The interior is low and neither particularly impressive nor particularly original. Nave, N aisle, two transepts, and chancel. – STAINED GLASS. Chancel s, a very good piece of *William Morris* and *Burne-Jones*, c. 1875: two female figures in white. – Opposite a three-light window rather in a Crane than a Morris style. Is it by *Powell's*?

CARDESTON

3010

ST MICHAEL. Nave and chancel of 1748 (date on w gable), gothicized in the C19, and a clumsy w tower with octagonal upper storeys added in 1844. There is, however, in the s wall of the chancel a window with a round rere-arch which must be original work of the late C12.

CARDINGTON

5090

ST JAMES. Norman nave, see one s and one N window, and the remains of two s doorways, one much renewed, in the normal position, the other further E and unexplained as to its function. The same anomaly on the N side: of one doorway just an arch, of another the imposts and the tympanum are recognizable.

E.E. w tower with Perp top storey. Chancel windows of
c. 1300, especially the renewed E window of three stepped lancet
lights under one arch. Sharply pointed and well moulded
chancel arch. Handsome timber porch of 1639. In the gable
semicircles on semicircles, the sides open in balusters, the
gate also with balusters. Carved brackets under the moulded
bargeboards. The chancel roof has tie-beams, collar-beams on
arched braces, and one tier of quatrefoiled wind-braces. –
PULPIT. Jacobean. The top panel on each side a crudely
carved merman – an odd conceit for a pulpit. – DOOR. Dated
1648. – MONUMENT. Chief Justice Leighton of Plaish † 1607.
Stiffly reclining on his side. Starved arch behind and under it a
strapwork cartouche. Kneeling family against the tomb-chest.

CAYNHAM

5070
Inset B

ST MARY. Nave and chancel and low w tower with pyramid
roof. Almost rebuilt by *James Brooks* (GR) in 1885. Original
however the remarkable Late Norman chancel arch arrange-
ment with two smaller open arches to the l. and r. of the main
arch. The arches are Transitional in their details (hood-
mould a roll; pointed arches). The s doorway is partly Norman
(scalloped capitals, zigzag arch moulding). The Norman win-
dow on the s side of the nave has also an original head-stone
(with chip-carving; cf. Hope Bagot). Probably Norman w
doorway into the tower. The chancel is vaulted, a rarity in
Victorian churches.

CAYNHAM CAMP. A small and ruinous Iron Age hill fort on
Tinker's Hill.

CAYNTON HOUSE
2 m. NW of Edgmond

7020

Handsome Late Georgian brick house, seven bays wide and two
and a half storeys high with one-and-a-half storey one-bay
wings. Doorway with Ionic pilasters and a segmental fanlight.
End bays on the ground floor with blank segmental arches.

CHAPEL LAWN
3 m. SE of Clun

3070

ST MARY. 1844 by *Edward Haycock*. In the lancet style.

CHARLTON HILL

5000
Inset A

Good typical brick house of *c.* 1660 with gables and dormers. Gabled s porch, the entrance flanked by brick-ornamented baluster pilasters. Also brick friezes. (Staircase with flat cut-out balusters.)

Of CHARLTON CASTLE, 2¼ m. NNE, only the mound remains. The castle received licence to crenellate in 1317.

CHATWALL

5090

CHATWALL HALL. Mid-C17 stone house (the date 1659 in a piece of panelling inside) with mullioned windows and two gables. A Queen Anne doorway in the recently added porch.

CHATWELL FARM. Queen Anne stone house with gables similar to those of the Hall, but symmetrically arranged l. and r. of a recessed centre. In this a doorway with Queen Anne moulding and a pediment over.

CHELMARSH

7080

ST PETER. Except for the Norman N doorway (with scalloped capitals and a thick roll-moulding in the arch) and the red-brick tower of 1720 (date on a bell), a very unified church of the Dec style. Hugh de Mortimer endowed a chantry in it in 1345. That date could mark the end of the busy building time. Nave and chancel, and N aisle (the latter probably the chantry). The E window is of five lights, in design with its cusped intersections and the sexfoiled top circle a replica of the E windows of Kinlet and Stottesdon – a design more of 1300 than of 1345. The w window is of three lights reticulated. The other windows simpler Dec, those of the s side very tall and slender. The arcade is of four bays. The piers are octagonal, a little ballflower in the capitals, two quadrant mouldings in the arch. The priest's door in the chancel has also a (continuous) quadrant moulding. – PULPIT. With Jacobean parts. – SCREEN. Only very little of it is medieval. – PANELLING in the chancel. Mostly done about 1890–1910, in imitation of Jacobean work. – STAINED GLASS. E Window by *Kempe*, 1892. – PLATE. Chalice of 1577. – MONUMENT. Part of a Perp tomb-chest is used as a credence table in the chancel.

CHELMARSH HALL. The house is largely Victorian, but at the back several blocked pre-Reformation doors and windows. They have been attributed to the C13. One doorway has a shouldered lintel. (Inside also several pointed doorways. Remains of the timber roof are still in existence too.)

CHENEY LONGVILLE

4080
Inset B

CASTLE. The remains are extensive but not telling. They prove a moated building with four ranges and an oblong courtyard. Licence to crenellate was granted in 1395. But no crenellations remain. The present living house has a pretty wooden veranda on Tuscan columns towards the courtyard. A few pointed doorways. The remains ought to be studied in detail. One window with original tracery in the E range.

CHERRINGTON MANOR
2 m. ENE of Waters Upton

6020

A very handsome timber-framed manor house, dated 1635, the façade almost but not entirely symmetrical. Gabled centre porch and two gables l. and r., that on the l. being a little wider than that on the r. (see the panels below the gable windows). Ground floor post-and-pan, first floor with diagonal strutting, in the gables concave-sided lozenges. Below the first-floor windows under the gables two blank arches. The porch on the first floor has in addition crosses within lozenges.

CHESTERTON
2 m. NE of Worfield

7090

(FORMER CHAPEL, now cottages. Of the chapel remain a Perp doorway and some windows. Dean Cranage.)

CHESTERTON FARM. Good, quite large early C18 brick house, with its seven bays and three-bay recessed centre, its windows and its hipped roof the exact paradigm from which English architects developed their successful Georgian Revival for wealthy clients between the two wars. The windows still have wooden casement crosses.

CHESWARDINE

7020

ST SWITHIN. Ornate Perp W tower and an exceedingly fine E.E. chapel; the rest is by *J. L. Pearson*, 1888–9, a stately

building of red sandstone, but not specially distinguished. The tower has big diagonal buttresses with many set-offs, battlements and pinnacles. Quatrefoil frieze below the battlements. Another such frieze between the w doorway and the big w window of four lights with entirely unusual panel tracery. L. and r. of the window canopied niches for images. Some carving below the bell-openings, e.g. the Stafford knot and the Talbot dog, suggesting a date between 1467 and 1473. A lion and a dragon on the SE and NE buttresses fairly low down. Tower arch with coarse detail. Now the E.E. chapel. It is to the N of the chancel and has very individual fenestration. To the N groups of three lancet lights of equal height, to the E a group of five stepped lancet lights. Good low-pitched roof with bosses. Something of the arcades between nave and aisles may also be original C13 work. It would at least be surprising to find Pearson give the s arcade round and the N arcade pointed arches. The piers are circular, the arches double-chamfered, the capitals blatantly Victorian. – STAINED GLASS. Much early glass by *Kempe*, namely N aisle w 1892, chancel s 1894, SW 1896, N aisle 1899. – ROYAL ARMS. Richly carved; Georgian. – MONUMENTS. Big foliated coffin-lid; C13 to C14.

CHESWARDINE HALL. Brick, neo-Elizabethan, with steep gables, mullioned and transomed windows, and a tall four-storeyed porch tower with Tuscan porch and square top. Built in 1875.

CHETTON

ST GILES. Nave and chancel, and an unbuttressed w tower added in 1829 by *John Smalman*. The nave was largely rebuilt in 1788, the windows must date from the restoration of 1891–2. The chancel alone is medieval. The doorway and the N and s windows are clearly C13 work. Also of the C13 the s doorway with two orders of shafts, moulded capitals, and roll-mouldings in the arch. The chancel arch has a small quadrant moulding, i.e. any date from the late C13 into the C14. It rests on two large extremely primitive heads, probably of c. 1500.

CHETWYND

ST MICHAEL. 1865–7 by *Benjamin Ferrey*. Large, red sandstone, rock-faced. N tower with tall broach spire. Nave and

chancel, and s aisle. Circular marble piers with lushly carved
capitals.

CHILD'S ERCALL

6020

St Michael. Red sandstone. The chancel is by *Carpenter &
Ingelow*, 1879. They re-used a Late Norman s doorway with
a fat continuous quarter roll below a remarkable hood-
mould on big curled stops. To the c13 belong the two arcades
inside. They are of four bays. The s arcade came first, with
circular piers with typical E. E. moulded capitals. Arches with
two slight chamfers. The w respond of the n arcade is of the
same design. The rest was done to a changed design: octa-
gonal piers, double-chamfered arches. Early c14 s doorway
and windows. The n aisle wall and windows are of 1879.
sw tower Late Perp – see the w window and the arch into the
aisle. Late Perp nave w window. No furnishings of interest.

CHIRBURY

2090

St Michael. An impressive church. Its size is explained by
the fact that it is the nave with its aisle of a former priory
church of Augustinian Canons founded in the late c12 and
moved to Chirbury before 1227. Crossing, transepts, and
chancel have disappeared, or rather the chancel was replaced
by a ridiculous short chancel of blue bricks in 1733, and of the
monastic buildings no more remains above ground than one
base of a compound pier, in a position which only a plan of the
entire site could locate within the whole of an Augustinian
establishment. The central pier of a chapter house seems a
likely suggestion. Octagonal core with slim triple-shafts
against each side. The powerful w tower was added after
nave and aisles were complete. Wide and high nave. Arcades
of five bays with circular piers and circular capitals and
arches with one chamfer and one filleted roll-moulding.
Clerestory without windows. This work looks as if it repre-
sents the original building and is too early in style to justify
any connexion with a consecration date 1290. The restora-
tion in 1871 was responsible for the chancel arch and the
windows in the style of the late c13. Now the tower. This,
according to the outer and inner w doorways which are both
triple-chamfered, seems to have been begun about 1300. The
upper parts and the diagonal buttresses are no doubt Perp.

Arched parapet, battlements, pinnacles and intermediate pinnacles on the centres of the sides. On the first string-course to the W and S decayed figure-sculpture. Finally the nave roof, a late Perp structure with collar-beams on arched braces, and wind-braces in quatrefoil patterns. – FONT. Odd, basically circular shape with four angle knobs. – WOODWORK. The screen and stalls are at Montgomery church in Wales. – REREDOS. In multi-coloured stone mosaic, said to be designed by *Blomfield* (Kelly); made by *Powell's*. – CHANDELIER. Brass, probably C18. – STAINED GLASS. In the S aisle an Annunciation by *Kempe*, 1894, and then a piece of as late as 1932 by Kempe's partner and successor *Tower*, and yet still wholly in the Victorian style. Chancel N and S, by *Powell*, 1890, typical in the lettering and the figures in the style of Walter Crane rather than the Pre-Raphaelites. – PLATE. Chalice and Paten 1595; Chalice *c.* 1680; Paten *c.* 1707.

SCHOOL. To the SE of the church. Built in 1675, yet still entirely in the black-and-white tradition, except that the little three-bay façade is now symmetrical. Central gable and central gabled porch. Brick infilling between the timbers.

HOARE STONES or MARSHPOOL CIRCLE. The Stones are a small but interesting Bronze Age circle, last examined systematically in 1924, which consists of thirty-seven diminutive orthostats buried deep in the gorse and long grass of Stapely Hill.

CHURCH ASTON

7010

ST ANDREW. By *G. E. Street*, 1867. Nave and chancel in one, and N aisle. Lead flèche over the nave, a piquant motif. The arcade has circular piers and circular moulded capitals. Geometrical tracery of *c.* 1300. – STAINED GLASS. One S window by *Morris & Co.*, as late as 1901.

CHURCH PREEN

5090

ST JOHN BAPTIST. The church immediately adjoins the manor house, and the architecture of the S chapel with its battlements is tuned to that of the house. The chapel was added *c.* 1920–5. As for the church, it has nave and chancel in one, and bellcote. It is of the C13, see the lancets on the N side, including the curious 'low-side' lancet with a transom, and the fine E lancets, a group of three of equal height. Narrow and

long interior. The church belonged to a small monastic house, a cell of Wenlock. – PULPIT and READING DESK. Of 1641.

MANOR HOUSE. Originally 1870–2 by *Norman Shaw*, as an extension of an existing house. But all except the ground floor has been demolished (*see Building News*, vol. 21). The broad stone entrance and the big brick wall of the kitchen-garden to the E with gabled buttresses are original.

SCHOOL. At the cross-roads between Church Preen and Hughley. By *Norman Shaw*, 1872. Handsome design, L-shaped. The front gable big and timber-framed. The recessed wing with two transomed windows reaching up into the roof as dormers.

CHURCH PULVERBATCH

4000

ST EDITH. Nave and chancel, and N aisle of 1853. W tower of 1773. Quoins, arched doorway with Gibbs surround (blocked), W window arched with Gibbs surround, circular W window, bell-openings arched with Y-tracery, parapet with urns. – FONT. Big plain octagonal piece; Perp, on heavy moulded foot and stem. – BOX PEWS.

LOWER HOUSE FARM. Brick, five bays, two and a half storeys. Probably Early Georgian, though the date 1757 is on the gate-posts. The back probably C17. The house is seen through a high yew hedge cut out charmingly in arcades. (Good stair-case inside.)

CASTLE PULVERBATCH, ¾ m. SSW. Motte of the former Norman castle.

CHURCH STRETTON

4090

ST LAWRENCE. Large and dignified cruciform church. The nave is Norman, the rest E.E. except for the upper storey of the crossing tower (with battlements and pinnacles) which is Perp, and the W aisles of the transepts which were added between 1867 and 1883. The flat broad buttresses of the nave are unmistakably Norman. In addition there are the N and S doorways. The N doorway has two rolls in the arch (and a Sheila-na-gig above), the S doorway which now leads into the Vestry has one order of shafts. One capital with volutes. Of the E.E. work the most characteristic feature is the tower. The arches inside have responds with much renewed capitals

(the two E capitals of the transepts with heads); the stage above, i.e. the lowest visible outside, has lancets. This is followed by a change from rubble to ashlar, yet there are again lancets here, and the fenestration turns Perp only one stage higher. Apart from windows belonging to the date of the tower, E.E. also the former w doorway of the N transept (now inside the church), the s doorway of the chancel, the N doorway from the chancel to the tower (with a shouldered lintel), and the doorway of the s transept. Dec insertion the reticulated N transept N, s transept S, and nave w windows. The E window on the other hand with its thin and fanciful, seemingly Dec tracery is of a date shortly before 1639, an interesting fact. The robust trussed rafter roof of the nave is attributed by Dean Cranage to the C13. The s transept roof has collar-beams, arched beams, and one tier of wind-braces arranged in quatrefoil patterns. – FONT. Octagonal, Perp, with shields and square flowers. – WOODWORK. Jacobean woodwork inserted behind the altar and behind the font. – STAINED GLASS. In the chancel N and s windows Flemish roundels etc. of the C16 and C17. In the E window glass by *Evans*, before 1837.

ST MICHAEL, ALL STRETTON and ALL SAINTS, LITTLE STRETTON were built in 1902 and 1903 respectively. All Stretton is of stone (by *A. E. Lloyd Oswell*), Little Stretton is timber-framed.

Half-timber is the hallmark of Church Stretton. The place became a resort between 1880 and 1900, and that was the time of the great fashion for neo-half-timbering, especially for gables, above brick storeys below. It is the popular form of the new prettiness which came in with Norman Shaw and his pupils and is not always handled with Shaw's gusto. Two especially good houses of the best period of Church Stretton are Woodcote, just above the cemetery, and Scotsman's Field, on the way up Burway Hill. WOODCOTE is by *Barry Parker* 1895–1903. It has a buff stone ground floor, with windows in pink stone, a roughcast first floor and gables, horizontal windows, and an oriel in the gable facing into the valley. SCOTSMAN'S FIELD is by *Sir Ernest Newton*, 1908, on the E-plan, roughcast with gables and under the two end gables, the *leitmotif* of Newton, shallow, polygonal, metal-faced bay-windows.

The little town is essentially the HIGH STREET. At the main crossing THE HOTEL, 1865 (later additions), debased

Victorian, with its unusual roof and its porch on somewhat Gothic round pillars with round arches. Then to the S the MARKET HOUSE, 1840, in a C17 style with Tuscan columns and arches above. Further S as examples of timber-framing the King's Arms, and THE COTTAGE, originally the Talbot Inn, with vertical studs below, quatrefoil work in the gable, and carved angle brackets. As an example of Georgian work No. 73 may be mentioned.

At LITTLE STRETTON to the S notable timber-framed houses, the MANOR HOUSE (c. 1600, with C18 doorway with pediment), TAN HOUSE (flamboyantly restored and enriched when *Derwent Wood* lived there), and MALT HOUSE with its large vertically weatherboarded barn.

At ALL STRETTON to the N OLD HALL and the OLD MANOR.

7090

CLAVERLEY

ALL SAINTS. A large imposing church of red sandstone on the hill on which lies the village. The church looks much more of a piece from outside than it turns out to be when one starts examining it inside. The interior is surprising by its spatial variety as well as by its spectacular wall-paintings. The visible building history seems to start with an Early Norman aisleless nave whose W wall, W end of the N wall, and E end of the N wall survive. The church was founded by Roger de Montgomery († 1094). A N aisle was built in the first half of the C12. This has strong circular piers with elementary circular capitals and single-stepped round arches (cf. Shrewsbury Abbey). The E arch and respond are different and probably late C13. Then follows the lower portion of the tower. This is not at the W end, but to the S of the E part of the Norman arcade. Its Late Norman date was only realized when in the restoration work of 1902 the former respond of the N arch of the tower was exposed. This was of triple shafts with fillets and a trumpet capital. When in the late Middle Ages the tower was heightened, the arch was filled in. It is not easy to visualize the church as it was c. 1200. It must have been of remarkably ambitious dimensions, with the nave as wide as now, and a S tower, and a N aisle. Whether there was a S aisle as well is not known, but the present S aisle, W of the tower is mid or later C13 work. It is of two bays, with octagonal pier and responds, capitals with heads, upright leaves, and grotesque beasts. The arches are double-chamfered. The

details correspond to the NE aisle respond. The clerestory of two windows per bay is Perp. The W window of the nave has intersected tracery; so have the N aisle windows. That would indicate a date c. 1300. But the whole exterior is terribly renewed. The chancel was rebuilt in the mid C14. It was very long. Its date can be seen by the tracery of the windows. The E window is of five lights with a large spheric quadrangle in the head. The side windows have interesting tracery consisting of a trefoil arrangement of radially placed straight-sided arches filled each with two small arches and a trefoil over. The N chancel chapel is evidently later, but its N windows must be re-used; for they also belong to the stage of the chancel. There is much inventiveness in this work at Claverley. Inside the chancel plain Sedilia with ogee arches. Poor contemporary chancel arch. In its N respond a Perp niche for an image. The rest of the church is C15 to early C16. Nave as well as aisles and the two-storeyed S porch are embattled. The ground floor of the porch was intended to be vaulted. The porch, needless to say, is Perp, as is also the upper part of the tower. This was built shortly after 1494. It has angle buttresses, battlements, and pinnacles, and a pretty frieze of cusped lozenges below the battlements. The NW buttress of the tower stands inside the nave of the church. In it a tall round-arched niche said to be the seat of penitence. The N chancel chapel is separated from the chancel by a Perp two-bay arcade with an octagonal pier, the S chapel by one very large and rude arch. Above it, standing in the chapel, one can see the outline of the former chancel windows. Towards the tower the S chapel has a Perp arch with two head-stops to the hood-mould. Of post-Reformation work the chancel roof deserves special mention. It was put in in 1601 and has a heavy hammerbeam arrangement with arched braces up to collar-beams.

FURNISHINGS. FONT. Norman, of tub shape, with arches on prettily patterned columns. Leaf-work in the spandrels. – PULPIT. Jacobean. – COMMUNION RAIL. Good work in the Arts and Crafts fashion of c. 1912. Designed by F. *Waldo Grey*, brother of the then vicar. – STAINED GLASS. E window by F. *Preedy* 1863 (TK). – PAINTINGS. On the upper N wall 25a of the nave a long strip (c. 50 by 4¾ ft) of c. 1200, illustrating the Battle of the Virtues and the Vices by means of a battle of armed knights on horseback. The series is one of the most important of its date in England. It was discovered in 1902.

Below the main strip separate unconnected subjects in the spandrels: angels, saints, etc.

MONUMENTS. Incised slab to Richard Spicer † 1448 and his wife (N aisle, E end). – In the S chapel Sir Robert Broke † 1558 and his two wives. Alabaster. Many standing children against the walls of the tomb-chest. Twisted colonnettes as separations. – Also in the S chapel two incised plates of Elizabethan couples, one 1577, the other 1599.

The VICARAGE faces with its gable into the churchyard. The Lychgate stands against the Vicarage, and the former Village Cross close by. The Vicarage is an interesting C15 house with its original beamed ceilings and evidence of the original screen. The picturesque end gable towards the churchyard is Elizabethan or Jacobean. It has heavy brackets for the overhang.

A little below the church and vicarage to the S is POWN HALL, another good example of black and white. L-shaped with a kind of low turret in the re-entrant angle.

In the neighbourhood of Claverley the following houses may be mentioned: FARMCOTE HOUSE, 1 m. SW, three-storey Georgian, of red brick, and rather gaunt, except for the gable-end, where above a two-storeyed canted bay-window there is a tripartite window with a fan-arch. KING'S BARN is about ½ m. SW of Farmcote. This is dated 1671 and consists partly of brick, partly of timber-framing. Gables and diagonally placed chimneystacks.

WOUNDALE FARM, 1¼ m. W of Claverley, is timber-framed and has a delightful porch, with open sides on ground floor and first floor and concave lozenge struts in the gable.

HIGH GROSVENOR is about ¼ m. NW of Woundale. Timber-framed, with narrowly placed uprights, overhang on curly brackets, concave lozenges in the N gable.

CLEE BURF *see* ABDON

CLEE ST MARGARET

ST MARGARET. Nave and chancel, and Victorian open belfry with steep pyramid roof. Early Norman chancel with herringbone masonry and one original N window. The chancel arch is no larger than a doorway. Its details are Norman, i.e. the plainest imposts and an unmoulded arch; but the arch is pointed. Hood-mould with (new) head at the top. Nave with

renewed or new lancets. s doorway primitive and could be
Norman. – DOOR. Probably C12 or C13. – PULPIT. Jaco-
bean. – BENCHES. Plain, with moulded tops, probably C17
(cf. Holdgate). – STAINED GLASS. E window 1871 by *Powell &
Sons*. – PLATE. Chalice, probably, *c.* 1550.

CLEETON ST MARY

ST MARY. The church of a small village high up on the Clee
Hills, to the NE of Titterstone Clee. By *T. Nicholson* of Here-
ford, 1878. Of no architectural interest.

CLEOBURY MORTIMER

ST MARY. An uncommonly pure building. Of greenish sand-
stone. W tower, nave and aisles, N chapel at the end of the
aisle, chancel, and a small C15 vestry N of the chancel. The
W tower is C12 to C13, sturdy and strong, the lower storey
Late Norman with a broad depressed arch into the nave.
Two plain shafts and then one outer order of colonnettes
with leaf or scroll capitals. The upper parts of the tower have
consistently pointed windows. Two-light C13 bell-openings.
Later shingled broach-spire (last renewed in 1898) of remark-
ably fine proportions, and with a noticeable twist. Next in
date are the s aisle, the s porch, and the chancel. The s aisle
has lancet windows (renewed on the s side), circular piers
(five bays) with 'water-holding' bases, circular capitals and
abaci, and double-chamfered arches with hood-moulds. The
chancel arch is a splendid piece of early C13 design, with three
orders of shafts, two of them with shaft-rings. Rich stiff-leaf
capitals, also a head. The E window is renewed. It has three
stepped cusped lancet lights under one arch, i.e. a late C13
pattern. To the N one small Dec two-light window. The s
porch and s doorway also are early C13. Again shafts, stiff-
leaf capitals, and heads. Pointed tunnel-vault inside. Now for
the N arcade and N chapel (Chapel of St Nicholas). The
circular piers (also with circular capitals and abaci) are clearly
later than those of the s, but need not be later than 1300. The
W window and the windows of the chapel also are in all their
details (tracery of quatrefoil and sexfoil shapes and sunk – not
yet pierced – spandrels) decidedly late C13 or *c.* 1300 at the

latest. The chapel was founded by Roger Mortimer, and this must refer to Roger I who died in 1330. The roofs of nave and chancel are both C14 and both very fine. The nave has collar-beams, the chancel has not. Both have wind-braces. More decoration in the nave. The roofs are no doubt Perp, yet the nave clerestory looks as if its windows were C13 lancets cut down later to make them square-headed. Restoration of the church 1874 by *Scott*. – STOUP in the porch, with a big, rather flat head, probably C14 (cf. Highley). – STAINED GLASS. N aisle E window 1848 with elongated medallions, naive but not unattractive. – Chancel E window (Piers Ploughman) 1875 by *Powell*, designed by *Burrow*.

SCHOOL. To the E of the churchyard, away from the street, in an elevated position. A handsome stone building of five bays and two storeys with a hipped roof and a lantern. Originally erected in 1740.

The main street runs along the S side of the church rising to its w, with one row of pollarded trees on the side of the higher-lying pavement. The houses are mostly Georgian and in terrace formation. Little half-timbering except some that is Victorian and rather blatant. The best houses are two opposite the church (VICARAGE distinguished by being stone-built, and to its l. plain brick house with quoins, dated 1702), and the MANOR HOUSE near the w end of the street. This is *c.* 1700, brick, of seven bays and two storeys, with hipped roof, a slightly projecting three-bay centre, and a doorway with two fluted Doric pilasters carrying a straight entablature.

CLEOBURY NORTH

6080

ST PETER AND ST PAUL. Short picturesque Norman SW tower with brick top-storey and pyramid roof. Short S aisle and bigger nave and chancel. No original details outside. Inside two-bay arcade with circular piers with circular capitals and abaci and depressed double-chamfered arches (cf. Aston Botterell). The chancel arch of the same design. The Chancel was largely rebuilt in 1890–1. Good roofs of the C16 and C17. – FONT. Octagonal, C13, with dog-tooth band at the foot. – SCREEN. Parclose Screen in the S aisle, with one-light divisions. Some of the renewed parts are of cast iron. – PULPIT. At the top one tier of short blank arches with badly carved caryatids between (cf. Stottesdon). – RAILS. Rails in

front of the chancel stalls and the pulpit, dated 1666, but still Jacobean in type. – PEW. To the N of the pulpit, with high back panelling and pedimented top flanked by volutes. Probably also c. 1666 (cf. Ditton Priors, Holdgate). – STAINED GLASS. E window 1892 by *Mayer & Co.* of Munich and London; of no value. – Chancel N and S, St John and St Peter, by *D. and C. Evans* of Shrewsbury, 1861, naive.

CLIVE
5020

ALL SAINTS. Essentially All Saints looks a Victorian church, owing to its spire – not a Shropshire spire at all – which appears so prominent on the ridge just below Grinshill Hill. The tower of Clive church has an openwork parapet and pinnacles, and the tall recessed stone spire is given two tiers of dormers. Externally nave and chancel also appear all Victorian. But the masonry on the S side of the nave is clearly C12, and the two nave doorways are indeed preserved. S doorway with one order of shafts with early stiff-leaf capitals. In the arch two zigzags, one of them at r. angles to the wall surface. The N doorway is simpler. Wealthy Victorian furnishings. The rebuilding took place in 1885–94 and the designs were by *C. J. Ferguson* of Carlisle.

CLOVERLEY HALL
6030

By *Eden Nesfield* 1864, when he was in partnership with *Norman Shaw*. Red brick, in the Elizabethan style, with mullioned and transomed windows and straight gables. The principal part of the house has been pulled down recently. What remains is the two-storeyed connecting ranges between the house and the stable yard and outbuilding. The dominant feature is the tower of this group, with a steep hipped roof enriched by dormers with far-projecting roofs – a Franco-Flemish rather than an English motif.

CLUN
3080

ST GEORGE. A large church at the S end of the little town, externally characterized by its odd and engaging W tower with a truncated pyramid roof starting only just above the ridge of

the nave roof and continued with a short upright piece of timber and ending in a pyramid roof (cf. Hopesay). The tower below is Norman, but the church possesses older Norman parts. The nave w wall must precede the tower, as is proved by the former w window which now looks into the tower. Equally early perhaps one arch of the N arcade, the one at the E end of the arcade. This is single-stepped. What was it? Evidence of an aisle pulled down after no more than two generations? Or a re-used chancel arch? Or rather an arch into the transept of a cruciform Norman church? The N doorway into the N aisle is no less teasing. It does not seem probable at the time of the aisle arcades. In addition there are the remains of a round-headed doorway in the w wall of the aisle. The tower followed. Doorway of three orders but without inserted shafts. Big w window over. There is nothing Transitional yet in these forms. In the arcades the late C12 is evident. Arcades of four bays to S and N, short, strong circular piers, square multi-scalloped capitals, pointed arches with a zigzag towards the nave. Original clerestory, with windows above the piers, not the arches. The N windows are sparsely placed single lancets, on the w side a pair of long lancets high up. Externally all this, and indeed most of the church, was over-restored by *Street* in 1877. Street also rebuilt the E end, the S aisle wall, and chose exposed timber-framing for the gable of his N porch. The porch below may be C14. It has some part of the staircase to the upper floor plainly and convincingly visible on its E side. On the N side of the chancel an early C14 tomb recess with ball-flower ornament. Splendid nave roof, high up, only partly original Perp work, with collar-beams on arched braces, and three tiers of wind-braces arranged quatrefoilwise. Better preserved the N aisle roof, with the same elements. The arched braces form a complete semicircle here. – Handsome CANOPY over the altar at the E end. – REREDOS. Jacobean, at the E end of the N aisle. – PULPIT. Jacobean with tester.

LYCH-GATE. Fine, solid, timber construction, with four gables. In them openwork cusped concave lozenges. The building was put up as late as 1723 (MHLG).

To the E of the church the VICARAGE, c. 1700, stone, of seven bays and two storeys with hipped roof. Wooden cross-windows.

From the church to the town one has to cross the river Clun by the medieval BRIDGE. Saddleback shape. Five segmental

arches, triangular breakwaters. The main street past the bridge turns E, but to the W the CASTLE must first be visited. It makes a spectacular ruin when seen from the NW. The river protects it on the W and N. Norman Keep standing high up. Plenty of Norman windows preserved. To the SW two semi-circular towers which are of the C13. Nothing else except extensive earthworks remains. These represent three baileys separated by ditches.

The centre of the main street is the COURT HOUSE, built of rubble with ashlar dressings in 1780. The arched ground floor was originally open. Hipped roof, and lantern with cupola.* Of other nice Georgian stone houses an example is the CRESSWELL GUEST HOUSE. LOWER HOUSE a little further E is dated 1682, yet still gabled in the Jacobean tradition. At the E end some way back to the N TRINITY HOSPITAL. The buildings are of 1618, one-storeyed, of stone, round a quadrangle. The architecture towards the quadrangle is extremely simple. The S façade of the hospital however has two end-gables and a fine group of three stepped central dormers. To the r. a projecting wing of 1857 with a veranda on round arches fits in uncommonly well. (Inside the hospital there are some original four-poster beds. In the Dining Hall a long oak table and a two-tier cupboard. MHLG.)

CAER CARADOC or GAER DITCHES. A circular Iron Age hill 1a fort, possessing three lines of defence on the W and two lines of defence on the E. The two entrances are at the E and W.

CLUNBURY

3080

ST SWITHUN. Big nave, chancel, and broad, short W tower with battlements. The wide nave and the chancel are both Norman. The tower is hardly later than the early C13, but must be later than the nave; for the nave W doorway and W window remain. The nave, curiously enough, has in addition a S doorway, altered but also Norman, and had a second S doorway further E of which a jamb survives. Norman windows in nave (N and S) and chancel (N). In the S wall of the nave is a low recess. Dean Cranage convincingly suggested that this may mark the funeral of the man who founded the altar inside the nave, evidence of which is the piscina in the wall

* PLATE. Two Maces, one of c. 1580, the other said to have been given by the Earl of Suffolk in 1622.

inside. Good nave roof of the type of the region, with collar-beams and arched braces and one tier of quatrefoiled wind-braces. – PULPIT. The back of the pulpit which was paid for in 1637 is in the church. – MONUMENTS. Two tablets in the style of 1800 by *Samuel Stead* of Ludlow.

CLUNGUNFORD

3070

ST CUTHBERT. Nave and chancel of the same height, and NW tower. The tower was built in 1895 by *E. Turner* of Leicester. By him also the ambitious timber S porch. The exterior of the church is over-restored. Most of the salient features are of *c.* 1300. Only the N chancel chapel may be a little older, see its small paired lancets on the N side, and the E window, of a curious shape. Steep two-centred arch, three lights; the l. and r. end in steep arches, the middle one simply runs up to the apex of the main arch. The same shape in the nave W window. The nave S windows are tall, of two lights, with spheric triangles in the head. The chancel E window has four lights and in the head a circle with a saltire cross in it, the four compartments cusped into pointed trefoils. The mouldings of the doorways, the chancel arch and the N chapel arch also tally with a date *c.* 1300.

BROADWARD HOUSE. 1½ m. SSW. It looks as if an C18 house had been made romantic in the early C19 or the early Victorian years, by castellation. Castellated outbuilding on the l.

ABCOTT HOUSE. ½ m. W. Good timber-framed parts. Under one gable a room with remarkable plasterwork. Pomegranate trails on the beams, strapwork cartouches in the panels and the broad frieze.

COALBROOKDALE *see* IRONBRIDGE

COALPORT

7000
Inset A

Coalport's fame is connected with porcelain making. John Rose's works started at Jackfield about 1790 and moved to Coalport about 1792. About 1820 the Swansea and the Nantgarw factories were acquired. The firm came to an end only in 1926. Some kilns remain, but the factories serve a different purpose now. John Rose lived at HAY HOUSE FARM, on the hill ½ m. to the NW, a handsome brick house of seven bays with slightly projecting two-bay wings. It may date from *c.* 1720. The

chimney-stacks are made prominent by blank arcading, rather a Vanbrughian effect.

BRIDGE. The bridge across the Severn was built in 1818. It is of cast iron and still detailed with the elegance of the Coalbrookdale Bridge. Semicircular arch. Hump-back roadway. The name and date of the bridge are on semicircular plaques in the middle of the thin parapet.

COCKSHUTT

4020

ST HELEN. Built in 1777, and altered in 1886. Nave and apse, and thin W tower. Brick. The tower has round-arched windows, those in nave and apse are pointed. – STAINED GLASS. The three apse windows have *Kempe* glass of 1896.

WYCHERLEY HALL, 1½ m. SW. Worthwhile timber-framed house with an irregular front, partly square panels, partly post-and-pan, and partly also replaced by brick painted to look black-and-white.

SHADE OAK, 1¾ m. SW. The façade is much prettier now than it originally was, but all the decorative black-and-white is painted on brick. Inside however there is an overmantel dated 1659 and almost exactly like one at Old Hall, Lee.

COLD WESTON
1¼ m. SW of Clee St Margaret

5080
InsetB

ST MARY. A tiny church, completely inaccessible except by walking across fields. Nave and chancel, and bellcote. Plain Norman N doorway, Norman chancel S window. The other windows are renewed lancets. A tie-beam serves to divide chancel from nave.

CONDOVER

4000

ST MARY AND ST ANDREW. A large church not far from the Hall. Of a beautifully creamy pink sandstone. The N transept is Late Norman and has large windows with nook-shafts and waterleaf capitals. The S transept, the nave and W tower are of the rare date 1662–79, the chancel was E.E. but was rebuilt in 1868, when the family chapel to the N was also added. Restoration 1878 (*Fairfax Wade*). The nave is so wide that it clearly replaces a medieval nave and aisles, which was

no doubt followed by a crossing tower. The roof-line still makes one think that there would be aisles. The windows of the 1660s are very low, straight-headed but with a kind of minimum panel tracery. The wall is embattled, and above rises an impressively high roof. The S transept has the engaging peculiarity of a half-timbered gable. The tower looks entirely medieval, and it is hard to believe that it was really completely rebuilt under Charles II. Tall double-chamfered tower arch towards the nave, lancet windows higher up, diagonal buttresses, battlements. Inside the church the nave roof is the dominant feature, hammerbeams, and collarbeams on arched braces – all very wide. – FONT. With carved figures representing the Baptism of Christ, by *Landucci* of Shrewsbury. PLATE. Chalice and Paten presented in 1629; set presented in 1666. – MONUMENTS. A remarkable collection. In the chancel, S wall: probably Thomas Scriven † 1587 and wife. Recumbent alabaster effigies, frontally placed children against the tomb-chest below. Deep four-centred recess, big strapwork achievement. To the r. of this, brought here from St Chad at Shrewsbury, Martha Owen † 1641. Frontal bust in oval recess between columns. Her baby lies in front of her. In the family chapel the chronological order must be broken

39 to pay tribute at once to a figure which does everything in its artist's power not to be overlooked. The artist was *George Frederick Watts*, and the figure is the white, bearded, kneeling statue of Sir Thomas Cholmondeley called Owen † 1864. The style is developed, it seems, from that of Nicholas Stone. Of the same period, by *Reginald Cholmondeley* who had helped Watts in the other monument, the recumbent effigy of Alice Cholmondeley who had died young with her baby. The baby lies by her side, the empty cradle stands at her feet. Now the earlier monuments. Dame Jane Norton † 1640 with her husband and below her brother Sir Roger Owen and her father Judge Owen. Two pairs of figures above one another. Each pair face one another across a prayer-desk, in the usual

38a Elizabethan way. Roger Owen, 1746, by *Roubiliac*. Of a type rather more connected with Rysbrack than with Roubiliac's later and freer conceits. Semi-reclining figure, his wife seated at his feet. No back architecture.

CONDOVER HALL. The grandest Elizabethan house in Shropshire. Built by Thomas Owen, Justice of Common Pleas. He died in 1598, when the house was not quite finished yet. The mason was perhaps *Walter Hancock* (cf. Market House,

Shrewsbury). The interior was so much pulled about in the C19 and again in the early C20 that nothing of interest remains except one stone fireplace in the Hall. This has coupled Ionic columns below and arches above with two standing figures, surprisingly naive if compared with the ease and skill of the elevations. Red sandstone, of the same light creamy colour as the church. Entrance side on the E-plan. The projecting 45 wings have shallow canted bays of seven lights. In the recessed centre three bays of three lights on either side of the porch. The doorway with a wide pediment on columns. The ground-floor windows have two transoms, the upper windows one. Gables over the wings, at the top of the porch bay two obelisks and a strapwork achievement. On the opposite, i.e. W, side again projecting wings, although they project less boldly. The centre between them has on the ground floor an arcade of nine bays which was originally open as at Burghley, Hatfield, etc. (cf. also High Ercall).* As this side lies a little below the level of the entrance side, there is above the arcade a mezzanine storey. This has three-light horizontal windows with pediments. Five gables on this side. The skyline of Condover is further diversified by two square tower-like eminences in the centres of the N and S sides, a motif familiar from such houses as Hardwick.

At the NW entrance to the village a cruck cottage.

CORELEY

6070

ST PETER. Short unbuttressed C13 tower with broad flat NW projection and later shingled broach spire. Arch to the nave on chamfered responds. Nave and chancel brick, of 1757, but with gothicized windows. – PULPIT. Plain, of Jacobean type.

COTON HALL
1½ m. NE of Alveley

7080

A stucco-rendered early C19 house with a four-column porch. Added to it an Early Victorian Italianate part with a tower. Opposite the entrance, on the lawn the ruins of a CHAPEL. Plain oblong with pediments on the W and E walls. The E window a pretty Gothick conceit, Venetian, but with an ogee head on the centre part, say c. 1765.

* Mr C. Gotch suggests that the arcade may be an alteration made by *Robert Mylne* in 1766.

COUND

ST PETER. Mostly C13, N aisle rebuilt in 1841, chancel in 1862. C13 chancel arch with semicircular responds, very simple moulded capitals, and double-chamfered arch. C13 S aisle with plain S doorway (two heavy continuous quarter rolls), plain straight-headed W window, and arcade of four bays, with circular piers and moulded capitals a little more finely detailed than in the chancel arch, and double-chamfered arches. Dec insertions the S arch E window and the tower window, which may be the re-used nave W window. The W tower was added last. It is Perp throughout, broad and short, with big diagonal buttresses, battlements, and eight pinnacles. – FONT. Norman, tub-shaped, with rosettes in beaded medallions, and a foliage strip above. – DOOR. The iron-work of the S door seems original. – PULPIT. Jacobean with back-board. – SCREEN. Now under the tower. Solid with a little blank tracery. – COFFER. Probably of the C13. Long, and iron-bound (cf. Bitterley). – STAINED GLASS. In the S aisle E window a small C14 figure. – The E window a specially good early work of *Kempe*: 1891, with ten three-quarter figures. – SCULPTURE. In the S wall a large head-corbel, probably to carry an image. – MONUMENTS. A number of good large Georgian hanging monuments. The best is to Dr Edward Cressett, Bishop of Llandaff, † 1755. Three putto-heads below, fine Rococo trophies above, with the Bishop's Mitre and crozier. Probably by the same hand as the monument at Wrockwardine. – Sir William Fowler, C18 (chancel W wall, high up). With standing putto in front of a grey obelisk.

54b COUND HALL. Built in 1704 for Edward Cressett by *John Prince* of Shrewsbury. Of red brick with stone dressings. Nine bays by five. Basement, then two storeys of very tall slender windows, and then a half-storey. The W and E façades nearly identical. Very powerful giant Corinthian pilasters with decoration between the flutes in the lower parts and big, richly carved capitals at the angles and at the angles of the three-bay centre which has a pediment only on the E side. The pediment breaks back in its centre. Decorated abaci and fragments of entablature above each pilaster. Rusticated bases. Doorways with broken segmental pediments on pilasters with garlands hanging down them. The short sides of the house have angles with even rustication. The show-piece inside is the staircase, an ingenious alteration attributed to the late C18. The pro-

gramme was to gain the space where the original staircase
had been and fit the new staircase into the entrance hall with-
out depriving this of its spaciousness. The staircase has a
light metal handrail and runs up through both storeys along
three sides of a wide open well. The ingenious thing is that
the back flight does not run along the back wall of the hall,
but leaves space there and 'flies' up independent of the back
wall. It rests on two fluted columns. Thin neo-Elizabethan
plaster decoration on the underside of the stairs and landings.
Glazed lantern above.

COUND LODGE INN, by the railway station. Late C17 brick
with two gables and some ornamental brickwork.

COURT OF HILL
1 m. N of Nash

6070

Fine sturdy brick house dated 1683. Seven bays, two storeys,
hipped roof. Quoins of stone and stone trim of windows and
doorway, probably altered. The windows presumably were of
the cross-type originally. Handsome eaves-coving. Timber
staircase with square open well and heavy balusters; still
occasional Jacobean details. Diagonal board covering the
tread-ends. Fine principal door-case on the first floor.
Panelling and overmantel in the former entrance hall Jaco-
bean or a little later and no doubt brought in. Partly restored.
In one room a remarkable early C19 plaster ceiling, coffered
and with much honeysuckle as well as naturalistic friezes of
oak and vine. – DOVECOTE, octagonal with pretty lead
lantern. – KITCHEN GARDEN. Entrance at the back of a
Georgian pavilion with a front of Tuscan columns and
pediment.

COYNTON HALL see RYTON

CRAVEN ARMS

4080

The junction must have been important before the railways
came, or else the station would not have taken its name from
the INN. This lies – here is the answer – at the very junction
of the Hereford–Shrewsbury road and the road to Central
Wales and Holyhead. The building looks c. 1830. It has three
bays, a sturdy Tuscan porch, and giant Tuscan pilasters,

coupled at the angles. In front an OBELISK of *c.* 20 ft height. Mr Vale has pointed out that the hotel is mentioned in 1825 and that the distances on the obelisk date its erection before the opening of *Telford*'s improved Holyhead road. This was begun in 1811, and the bridge across the Menai Straits was finally opened in 1826.

5000
Inset A

CRESSAGE

CHRIST CHURCH. 1841 by *Haycock* (*see Gentleman's Maga-zine*, 1852). Nave and chancel in one. Thin W tower with battlements and clumsy pinnacles. Lancet windows. Thin timber roof. West Gallery on cast-iron columns. – PULPIT. Jacobean, with a date 1635, perhaps consisting of assembled pieces. – STAINED GLASS. E window with small medallions in the Flemish tradition and copied from engravings after Renaissance and Baroque paintings. Signed by *David Evans*.

CRIFTINS *see* DUDLESTON HEATH

5000
Inset A

CRONKHILL
1 m. SSW of Atcham

[62]The earliest Italianate villa ever built. By *John Nash*, probably the 'Villa in Shropshire' exhibited at the Royal Academy in 1802. Built for the then agent of the Attingham estate. Completely informal design, with a round tower, a lower square tower, and a colonnade with slim columns and round arches connecting the two round a corner – the sort of composition that might be inspired by background archi-tecture in paintings by Claude Lorraine or by villas grown out of fortified houses which on the grand tour one could easily see in Tuscany. Lower outbuilding on the l.

5070
Inset B

CROWLEASOWES
1¾ m. NNW of Henley Hall

A very remarkable brick house, Late Elizabethan or Jacobean. It has certain features not otherwise to be found in the county. Mullioned windows of brick, doorway flanked by rusticated

brick pilasters. In the gables stepped windows of two lights (not three) in their lower part. Below them run friezes of ornamental brickwork. Big chimney with diagonally placed stacks.

CRUCKTON

4010

CHURCH. By *Haycock*, 1840. Nave and chancel, W porch, and bellcote. In the lancet style. W gallery on iron columns.

CULMINGTON

4080
Inset B

ALL SAINTS. Nave and chancel in one, and W tower with stone broach spire, left unfinished and continued with a small funny lead spire. The church is essentially E.E. E side with three stepped lancets, N and S with lancets of odd shape, the arched parts being excessively long and sharply pointed. Tower probably early C14, as also two S windows. In the chancel S wall a handsome early C14 recess with ballflower ornament, the arch on two head-stops. Good robust roof with collar-beams on straight braces, and double-curved windbraces. – SCREEN. Only partially old, one-light divisions, the carved top frieze looks trustworthy. – MONUMENT. Ralph Greaves † 1630, with very primitive Renaissance details; no figures.

TOWER (Flounders' Folly) on Callow Hill, 2½ m. NW, better visible from Hope Dale. Erected in 1838 by Mr Flounders of Ludlow to mark the place where four landowners' boundaries met. Square and embattled with only one merlon to each side; 80 ft high.

CWM HEAD
2 m. NNW of Wistanstow

4080

ST MICHAEL. 1845 by *H. C. Whitling* (GR). Neo-Norman, with apse and starved NE tower.

CYNYNION

2020

CHRIST CHURCH, at Rhyd-y-Croesau. Grey stone. 1838 and 1886. The proportions of the W tower to the nave betray 1838. Most of the rest is the work of *W. H. Spaull* of Oswestry in 1886.

DAVENPORT HOUSE
½ m. SW of Worfield

Built 1726 by *Smith* of Warwick. Little enriched exterior. Red brick, nine bays wide, and in height two storeys, the main cornice, and an attic storey above with vases on top. Quoins of even length. Doorway to the garden with flat slender pilasters and a pediment on brackets. On the entrance side a later C18 porch with two angle pillars and two fluted Ionic columns. Service wings connected with the main block by curved brick walls, l. and r. of the entrance side as well as the garden side. that is four in all. Splendid Entrance Hall, the walls completely wood-panelled, painted white and given smooth ashlar rustication so as to imitate exterior walls. In the same spirit the doorways have heavy Gibbs surrounds, and there are two big niches in the wall facing the entrance. Towards the staircase on the r. big arch between pilasters. Fireplace opposite with astronomical instruments. In the centre of the garden-side and connected with the Entrance Hall by the central doorway, the Saloon, wood-panelled with much fine inlay. The Staircase Hall has the same imitation rusticated walls as the Entrance Hall and large upper windows with sills on brackets, again as if they were facing outside. The effect is curiously theatrical and unreal. The staircase is of wood, finely carved, with three slim balusters to each tread, one fluted, one twisted, one double-twisted in openwork. The most splendid fireplace in the White Drawing Room, with two bearded caryatids. The room above the Entrance Hall has Corinthian pilasters and a fireplace of *c.* 1740 with Rococo ornament as well as a very Roman relief of upright figures in togas.

Large circular brick DOVECOTE with lantern in the gardens.

DAWLEY AND LAWLEY

Dawley is an urban district, but it is not a town. Houses spread over quite a large area, but there is still plenty of open country between them. The land is hilly, and coal-tips are often so old and have been disused so long that grass and even trees have grown on them. Recent council-housing is however now altering this still rural picture.

CHAPEL, S of Malinslee Hall. A Norman chapel in ruins. Nave and chancel W wall with small window in the gable. S and N

walls of the nave with one window each. E wall with two widely spaced windows.

ST JOHN, Lawley. 1865 by *John Ladds*. Red and yellow brick. Tower with steep pyramid roof in the angle between nave and chancel. Apse. Pointed windows. E of the church a C17 house of brick with gables and a mullioned and transomed window.

ST LEONARD, Malinslee, 1¼ m. NNW of Stirchley Church. Built in 1805. The church follows closely the pattern of the parish church at Madeley. Elongated octagon with big, square W tower. Ashlar. Windows in two tiers. The interior is not octagonal. The chancel is oblong and the adjacent triangles are sacristies. N, S, and W galleries with slim columns in two tiers.

ST LUKE, Dawley Parva. 1845 by *R. Griffiths*. Nave and chancel in one, and apse. Pale red brick and yellow brick trim. Two-light Norman windows. Stone belfry with pyramid roof.

HOLY TRINITY, Dawley. At Lawley Magna. 1845 by *H. Eginton* (GR). Large church, in a very competent Perp. Big W tower. Tall slim Perp piers, wide arches, no clerestory. – FONT. A remarkable Norman piece. Tub-shaped. Zigzag decoration at the foot. Above big fluted panels. The only more elaborate carving is the Tree of Life on one side. – PLATE. Paten of 1572.

There are plenty of Nonconformist chapels. None of them is remarkable, but in the aggregate they contribute to the character of the Dawley–Lawley township. Some examples are Methodists Dawley Parva 1837, with arched windows and a truncated gable in the front; Methodists Dawley 1841, classical with pediment; Baptists Dawley 1860, blue brick, with red and yellow brick, arched windows, and a crazy big shaped gable.

DEARNFORD HALL *see* WHITCHURCH

DECKER HALL *see* SHIFNAL

DETTON HALL
1 m. NNW of Neen Savage

6070

Probably early C17. Two ranges, the older to the E, the more recent to the W, projecting at r. angles. The older part is of stone. The additions are timber-framed with brick-nogging.

The w range has a marked overhang on a moulded bressumer. Star-shaped brick chimneystacks. Nice staircase in the angle between the two ranges. Narrow, square, with open well, through two storeys. Flat cut-out panels instead of balusters.

DEUXHILL

7080

RUINS OF OLD CHURCH. To the NW of Hall Farm, across the road to Eudon George, behind a handsome Georgian farmhouse with quoins and hipped roof. Only the fragment of one wall with one cusped window remains.

HALL FARM. Fine timber-framed house, dated 1601. The r. hand gable and that part of the house is later. The older timber-framing is of narrowly spaced uprights below, but on the upper floor diagonal struts and in one gable a concave-sided lozenge.

DIDDLEBURY

5080
Inset B

ST PETER. Late Saxon nave. The N wall entirely of herringbone masonry. The N doorway typically Saxon with big shapeless block-like imposts, and a raised moulding, square in section, framing the doorway and its arch. The N wall also contains one typical Saxon window, small, set high in the wall, and splayed outside as well as inside. Another window in the wall however is Norman. The W tower is intriguing in its architectural evidence. Dean Cranage has good reasons to call its ground-floor masonry Saxon. In that case it must have been a W porch. But what can the purpose of the arch in the W wall have been which is now partly blocked and has the size of a tower arch or chancel arch? Its detail is Norman too, and not Saxon. So is that of the corbel-table above. The doorway set into the blocking and the tower arch are both pointed and seem late C12. The chancel is Norman, see the evidence of the windows. In the C13 a s aisle of five bays was added. Octagonal piers and double-chamfered arches. The S wall is of 1862, the S porch of 1854. In the chancel side walls two early C14 recesses with ballflower decoration. Also a handsome two-light window of the same date. – FONT. Octagonal, Perp. – SCULPTURE. In the N windows of the nave fragments of a Saxon cross, one with interlace, the other with scrolls, birds, and two human demi-figures.

DELBURY HALL. Large brick mansion built shortly after 1752. Very plain from outside. Seven bays and two and a half storeys with two-bay two-storeyed wings. C19 porch. Inside a good staircase with three slender twisted balusters to each tread. Older panelled rooms at the back.

DINTHILL HALL
½ m. SW of Onslow Hall

4010

Dated on rainwater heads 1734. Red brick, six bays wide, two-storeyed, with quoins, a parapet, and still a gabled roof. Doorway with segmental pediment. (Staircase with twisted balusters; some earlier panelling.) Octagonal dovecote with open cupola.

DITCHES see WEM

DITTON PRIORS

6080

ST JOHN BAPTIST. Mostly C13. W tower, nave and chancel and wide S aisle under one roof. The W tower has a weather-boarded broach spire (rebuilt in 1831) of the type usual around Cleobury Mortimer. Round chamfered tower arch. Arcade of four bays with circular piers with circular capitals and abaci. Very slightly pointed double-chamfered arches. The windows, mostly renewed, range from the plain lancet (three stepped single lancets, entirely renewed, at the E end) to a handsome Late Perp form of three lights under a Tudor arch; the mullions run up into the arch and the cusping of the side parts climbs up with the rising tops. Good trussed rafter roof. – SCREEN. Of one-light divisions; partly old. – SEATS. Two 'Jacobean' double-seats, from the old church at Burwarton; one has the surprisingly late date 1714.

DODDINGTON

6070

ST JOHN. Built in 1849, following the pattern of Hopton Wafers nearby. Ashlar outside, wide barn-like interior. Pointed windows. W tower with – oddly enough – arched classical windows below the battlements. This also follows (belatedly) Hopton Wafers.

8000

DONINGTON

St Cuthbert. Early c14 chancel. E window with intersected tracery, the other windows with a spheric triangle in the head. One is of the 'low-side' variety and has a transom. The nave has a roof dated 1635. Double hammerbeams on carved brackets. The whole nave may be of that date, and the elementary Perp windows are also assigned to it by Dean Cranage. c19 w tower with battlements and a quatrefoil frieze below. It is said to represent what was there before (cf. Claverley). N aisle and general restoration by *John Norton*. – STAINED GLASS. Good c14 glass in fragments in a chancel N window. Amongst the figures the Virgin and Christ from a Coronation of the Virgin.

Humphreston Hall, ½ m. NE. Timber-framed.

7010
Inset A

DONNINGTON WOOD
1½ m. N of Oakengates

St Matthew. 1843 by *Sir G. G. Scott*; an early work. Whitish stone with dressings in a stone now much more blackened. Nave, transepts, and chancel; bellcote and steep roofs. Lancet windows with plate tracery.

4000

DORRINGTON

St Edward. 1845 by *E. Haycock*. Quite a stately church, ashlar-built, with a w tower which has a spire behind battlements and pinnacles – the sort of church one expects to find on the fringe of a wealthy landowner's grounds. w gallery inside.

DOWN ROSSALL *see* ROSSALL

5070
Inset B

DOWNTON HALL
1½ m. E of Stanton Lacy

c18 brick house altered *c.* 1830–40. Of that date the Tuscan porch, the fine circular Entrance Hall with Ionic columns, a honeysuckle frieze, and a glazed roof, and especially the top balustrade with heavy lettering.

Lodge. A pretty Gothick folly probably of *c.* 1760. Three bays, stuccoed, ogee arches to the doorway, the first-floor Palladian window, and the gables.

DUDLESTON

3030

ST MARY. The exterior is a puzzle. The masonry is obviously earlier than the C19, everywhere except in the upper, octagonal parts of the W tower which date from 1819. But Dean Cranage quotes a Visitation record of 1799 which speaks of the timber-framed and roughcast church and another record referring to a rebuilding of the aisles in 1819. – PULPIT. Jacobean. – STAINED GLASS. The W window is an interesting example of early C19 glass. – E window 1894 by *Kempe*.

PLAS IOLYN. Handsome ashlar-faced Regency house with a pedimented porch on two pairs of Roman Doric columns. The house is five bays wide; the three middle bays two and a half storeys high, the end bays two only.

DUDLESTON HEATH (CRIFTINS)

3030

ST MATTHEW. 1874 by *W. G. MacCarthy* (GR). Red brick, nave and chancel, and bellcote over their junction. The brick is exposed inside. – STAINED GLASS. E windows by *Kempe* 1893, and l. and r. 1907.

DUDMASTON HALL
¾ m. NW of Quatt

7080

Called 'lately rebuilt' in 1730. A nine-bay house of red brick with a recessed five-bay centre. Stone quoins and stone-framed windows. The attic appearance altered early in the C19 with Grecian motifs. Large entrance hall with panelled walls. Later Georgian staircase with dainty iron rail.

DUNVALL *see* ASTLEY ABBOTS

EARDINGTON

7090

EARDINGTON HOUSE. Late Georgian, cement-rendered. Three bays wide, two and a half storeys high, with giant pilasters near the angles. Porch with Tuscan columns.

GRANGE FARM. Red brick, five bays wide, two and a half storeys high. Quoins. Three-bay centre with quoins and pediment. Simple pedimented doorway.

HAY FARM. One part is C17, of stone, with gable and mullioned and transomed windows.

EARDISTON

3020

CHAPEL. Built as a private Chapel of Pradoe in 1860 by *Rhode Hawkins*. Nave and chancel and thin square N tower with pyramid roof. Lancet windows and windows with Geometrical tracery.

EASTHOPE

5090

ST PETER. Nave and chancel, and timber-framed belfry with pyramid roof. The church was burnt out in 1923 and restored after the fire. Of before the fire the rather lovable Elizabethan windows in the nave and the windows of *c.* 1300 in the chancel. In the re-furnished interior a pretty touch is the substructure of the belfry in the form of a timber-framed gable with plaster

30b infilling. – HOURGLASS. On an iron arm; replica of the original one which was dated 1662.

MANOR HOUSE. Of *c.* 1600 with one plaster ceiling of a design similar to Wilderhope and with the same motto.

COTTAGE. Opposite the Manor House. Built on crucks.

EATON CONSTANTINE

5000
Inset A

ST MARY. 1841. Nave and chancel and bellcote. – FONT. Circular, Norman. Some decoration at the foot of the bowl. – BOX PEWS.

BAXTER'S HOUSE. Timber-framed, with brick-nogging. The house of Richard Baxter, the Puritan theologian.

EATON MASCOTT

5000
Inset A

Dated 1734. Brick. Recessed centre and slightly projecting wings. Above the centre bay a broken pediment on scrolls and in it and below it a tripartite semicircular window. Venetian windows l. and r. of the doorway. At the back an odd little brick building of 1686, with ornamental blank arcading in brick. The arches are triangular.

EATON-UNDER-HAYWOOD

4090

ST EDITH. Nave and chancel in one, and SE tower. Norman nave, see the two windows on the N and the one on the S side.

C13 chancel and tower, see the three fine small separate lancets in the E wall, the priest's door, and all the details of the tower. The most interesting are the bell-openings, big, of two round-arched lights with a dividing shaft below one large round arch. Plain pointed arch from the tower into the nave. Perp battlements. C13 also the nave N doorway. One nave N window is of *c.* 1300 (intersected tracery). Nave roof with tie-beams and collar-beams on arched braces. The chancel roof is lower and richer, almost flat and with plenty of bosses. The tympanum between chancel and nave roofs is pointed with arms. – PULPIT and READING DESK. Jacobean. In the pulpit Late Perp panels with Flamboyant tracery re-used. The tester of the pulpit is dated 1670. – PANELLING and COMMUNION RAIL in the chancel Jacobean. – STAINED GLASS. The W window typical of *c.* 1860. – MONUMENT. In the chancel N wall, in a recess below a canopy with ballflower decoration, effigy of oak. Civilian; early C14.

NEW HALL, ¾ m. SW. In the farmhouse, in a room on the first floor, PAINTING of a deer-hunt, mid-C16. The figure of the bearded hunter about 4 ft tall.

EDGMOND

7010

ST PETER. Broad Perp W tower with a big four-light window, and battlements and pinnacles. Frieze of quatrefoils below the battlements. Embattled S aisle and S porch; both Perp. Higher Dec chancel with steep-pitched roof, see the reticulated E window. Perp N and S arcades of four bays with tall slender octagonal piers. On the N side, as Dean Cranage has shown, the piers are partly C13 work re-used (bases, abaci). – FONT. Early Norman, tub-shaped, with unsystematic loose interlace and geometrical motifs. – REREDOS, with figure carving, stone, designed by *Bodley & Garner*, 1889. – STAINED GLASS. Chancel S, 1873 by *Powell*, very Pre-Raphaelite, and not well preserved. – Chancel E and N *Kempe*; 1891, 1896. – MONUMENT. Brass to Francis Yonge † 1533, two figures, he in a shroud, she in her normal clothes. The figures are 2 ft 6 in. long.

OLD RECTORY (Provost's House), just W of the church. A large house with an C18 garden front. But towards the entrance C14 masonry survives and much of a C14 porch. The moulding is unmistakable. Even rarer is the survival inside of the three doors from the former screens passage to the kitchen,

buttery, and pantry, three arches with double sunk quadrant-mouldings, clearly early C14. Georgian alterations at the back, carried out, according to Mr C. Gotch, by *R. Mylne*.

EDGMOND HALL, opposite the Old Rectory, is Late Georgian, of three bays and two and a half storeys, with one-bay one-and-a-half-storey wings and a pedimented doorway.

EDGTON

3080

ST MICHAEL. Nave and chancel and bellcote. Mostly rebuilt in 1895–6. C13 windows, including that in the W front above the single-chamfered doorway. – BENCHES. Partly of 1631.

EDSTASTON

5030

ST MARY. Nave and chancel, and C19 bellcote. Nave and chancel are Late Norman and have their complete corbel-table of trefoiled arches. Three Norman doorways. That on the S side, leading into the nave, is surprisingly sumptuous, with three orders of shafts plus demi-shafts in the jambs. Leaf capitals. The arches have a variety of zigzag and crenellation motifs. The hood-mould, starting from head-stops, shares these motifs. A head also at the apex of the hood-mould. The N doorway is simpler; one order of shafts and a second replaced by tiny corbels; hood-mould; arch with leaf scroll and yet another geometrical motif. In the chancel on the S side the third doorway, also with one order (capitals with in-turned upward leaves) and the same geometrical motif in the arch as in the N door. Also in the chancel, on the N side, a small Norman window. On the same side, in the nave, a very renewed Norman window with outer nook-shafts and a decorated arch. Inside the church much remains of two Norman string-courses, one at the level of the sills, the other at that of the springing of the window arches. In the nave N wall a large Norman recess. The church about 1200 must have been impressive in composition and details. Early C14 alteration the chancel E window (of five lights, intersected, but with a spheric triangle in the head) and a S window. Other windows are Perp. Restoration under *G. H. Birch* 1882–3. Good nave roof with tie-beams, kingposts, and two tiers of curved wind-braces. – PULPIT. Simple Jacobean. – DOORS. The S as well as N door seem original with their ironwork. The S door is sumptuous enough to match the doorway. – STAINED GLASS. In a nave S window C15 fragments, including part of one bearded figure.

10a

ELLESMERE

ST MARY. The church lies above the street with a good view over the mere from the E end. From outside the church looks at first all Victorian, except for the crossing tower, a smooth Victorian, with the whitish stone in rather small neat blocks, the Geometrical tracery, and the slated roof. All this is the work of *Sir George Gilbert Scott* who rebuilt most of nave and aisles in 1849. But the crossing tower is clearly E.E. in its lower part and Perp in its top part with pairs of two-light bell-openings, battlements, a quatrefoil frieze below them, and eight pinnacles. Inside, the arches on which the tower rests are all Scott's in their surface except the E side of the E arch which shows stiff-leaf capitals and an arch with one chamfer and one filleted roll. The other capitals are also of the stiff-leaf kind, but all C19 carving. The exterior of the transepts, chancel, and chancel chapels is also ruthlessly scraped. Yet the N transept contains a bit of original evidence as old as the tower, the small N doorway with one order of shafts, and an arch with three roll-mouldings. Dean Cranage thought that the one piece of medieval work in the nave is even older, the E respond of the N arcade, semicircular with a very plain capital and abacus. The S chancel chapel is of the early C14, as is proved by the two W arches into the chancel with their piers of a rather squashed quatrefoil section with fillets. The E arch is the sign of a Perp lengthening. It is panelled. At the time of this lengthening the chapel received its roof, one of the finest in Shropshire, of very low pitch, with moulded and carved beams, moulded rafters, bosses and quatrefoiled panels in all the spaces between beams and rafters. The N chapel is entirely Perp, and distinctly late, according to the triangle-headed windows. The arcade to the chancel has octagonal piers and double-chamfered arches dying into the piers and walls. Perp also the Sedilia in the chancel, arrived at by taking the mullions of the S window down to the seat. The black marble columns, needless to say, are Victorian. More restoration took place after Scott's death in 1881, 1889, and 1900.

FONT. Octagonal, Perp, with small square panels filled with representations of the Instruments of Christ's Passion. – SCREEN. W screen in the S chapel, Perp, with one-light divisions. The tracery is cusped ogee arches under semicircular arches. – PAINTINGS. Christ crucified; attributed to *Zurbaran*. – Christ and his parents returning from the Temple; probably

by a Central Italian Late Mannerist. – STAINED GLASS. In
the s transept (c. 1845) and s aisle glass by *Wailes*. – E window
by *Heaton, Butler & Bayne*, c. 1888; s chapel E window by
Burlison & Grylls, c. 1872; in the N transept glass by *O'Con-
nor*, c. 1853. – MONUMENTS. Effigy of a short-legged Knight
of c. 1300. Frontal figure, head on a pillow. N chapel W wall. –
Francis Kynaston of Oteley † 1581 and wife. Alabaster. Re-
cumbent effigies on a tomb chest. Far-projecting piers of the
tomb-chest. On these knelt the children. Their figures are
sadly mutilated. Contemporary HELM above the monument.

THE TOWN. The centre of the town is the TOWN HALL. It was
built in 1833. It is three bays wide, ashlar-faced and had
originally an open ground floor. This is arched; there are
Grecian upper windows and a colossal pediment which pro-
jects extremely far. In front of the Town Hall, Cross Street
extends narrowing tunnel-wise. To the NE runs the High
Street. Off on the r., in BIRCH ROW the WHITE HART, a
pretty timber-framed house with much diagonal strutting on
the upper floor. Then Watergate Street and at its end on the
l. in TALBOT STREET again a timber-framed house worth a
look. On the r. CHURCH STREET which leads to the church
past a number of Georgian brick houses. Back to the Town
Hall and now to the SW, along SCOTLAND STREET. The
SAVINGS BANK was founded in 1830 and is typical in its
architecture of the 1840s and of its function. Banks liked the
Italianate Renaissance style introduced by Barry. Nos 15–19
are early C18, six bays wide with wooden casements in the
windows. No. 31 is timber-framed and has the first floor all
with ogee-shaped struts. Off on the r. in VICTORIA STREET
is FULLWOOD HOUSE, a characteristic piece of c. 1830–40,
three bays, two and a half storeys, with heavy Tuscan porch
and the one and a half storeys above it connected by a big
blank rusticated arch. Further out in Scotland Street more
detached Georgian houses. The typical pattern, as indeed in
Church Street, is three bays with a one-bay pediment.

OTELEY, *see* p. 226.

THE LYTH, 1¼ m. SE. Built in 1819. With a pretty trellis veranda
of iron.

ELLESMERE COLLEGE, 1 m. SW. Built originally in 1879–83
by *Carpenter & Ingelow*. Two open quadrangles forming the
shape of a letter H. To the original plan belongs the cross-bar
running N–S, the s continuation of this (Big School etc.), and
the s wings running W as well as E. The chapel was added at

the N end of the E quadrangle. It was begun by *Sir Aston Webb*'s firm in 1932. It is not yet complete. The Science Wing (s range of w quadrangle) is by *Stanley Hamp* 1938–9. Red brick with stone dressings throughout, in varying modes and degrees of Early Tudor.

ELSYCH
1 m. SW of Diddlebury

4080
Inset B

A very irregular stone house, probably of Elizabethan date. It may belong to two dates or have been originally two houses, one small with the handsome timber-topped turret, the other on a more symmetrical plan with two broad gabled projections. Mullioned windows, in the gables of three lights, stepped. Diagonally placed chimneystacks.

EUDON GEORGE
1 m. NW of Glazeley

6080

Two good timber-framed houses, NORTH EUDON and EUDON GRANGE.

EWDNESS *see* WORFIELD

EYTON-ON-SEVERN

5000
Inset A

Of the mansion built by Sir Francis Newport in 1607 only a delightful SUMMER HOUSE and a barn (now converted into cottages) remain. The summer house is on the wall of the former garden. The present farmhouse incorporates its opposite number. The summer house is octagonal with a higher octagonal turret. The drawing room of the farmhouse is also octagonal. The summer house is of brick with stone dressings, a round-headed doorway, and cross-windows and mullioned and transomed windows. On the roof is a balustrade of vertically symmetrical, widely spaced stone balusters. The turret has an ogee cap. Lord Herbert of Chirbury, the philosopher, was born at Eyton.

EYTON-UPON-THE-WEALD-MOORS

6010

ST CATHERINE. Red brick. Nave, chancel, and w tower 1743, the polygonal apse added in the same style – a gratifying

exception – in 1850. Arched windows and quoins. The tower has a parapet and a pyramid roof. – WOODWORK. W gallery, benches, pulpit, panelling contemporary with the church. – STAINED GLASS. C15–16 fragments in a N window. – The E window of c. 1855–60 has one big female figure in a terrible Renaissance surround à la Holbein, and in blatant colours.

FARLOW

6080

ST GILES. 1858 by *R. Griffiths* (GR). Nave and lower chancel, and bellcote. E.E. style. The only ancient fragment is the S doorway with zigzag on the intrados and extrados of the arch. – PLATE. Chalice of 1577, in bad condition (according to Dean Cranage).

FARMCOTE HOUSE *see* CLAVERLEY

FAULS

5030

IMMANUEL. 1856 by *Benjamin Ferrey*. Nave and chancel, N transept. Belfry over the junction, set diamond-wise and with a high, droopily overhanging shingled spire. Lancet windows and plate tracery.

FELHAMPTON COURT
1½ m. SSW of Acton Scott

4080

Early Georgian brick house of five bays and two and a half storeys. The centre of three bays has a preposterously steep big pediment, really a gable. In it a tall arched window. Below this a semicircular window, and below that a Venetian one. Handsome staircase.

FERNEY HALL
1½ m. SW of Onibury

4070
Inset B

By *John Norton*, built after a fire in 1856.* In an intolerable neo-Jacobean. It makes the neighbouring Stokesay Court appear chaste by comparison. Symmetrical front, but on the E a tower with ogee cap and an open top storey with diamond-rusticated pillars. Also a Jacobean gate-lodge.

* Or by *S. Pountney Smith*?

FITZ

ST PETER AND ST PAUL. Nave and chancel, and W tower. Brick with stone dressings and quoins. Built in 1722 and restored in 1878. Arcade windows with apparently original Y-tracery. The tower has a parapet and stubby pinnacles. The chancel was remodelled in 1905 by *Sir Aston Webb*, also in a round-arch fashion, but more ornately. The plain apse e.g. with its three windows has been replaced by a big broad Venetian window. – STAINED GLASS. E window by *Tower*, 1915, in a Holbein Renaissance style. – PLATE. Beaker dated 1565 but probably remodelled from a C14 Pyx. – Paten of 1695; Chalice of 1819.

MYTTON HALL. Three-bay Late Georgian front, stuccoed, with a porch on two pairs of unfluted Ionic columns. Long extension to the r., at an angle.

FLOUNDERS' FOLLY *see* CULMINGTON

FORD

ST MICHAEL. Nicely placed on a little hill between the Mansion House and Ford House. Nave and chancel in one, and bellcote. E.E. evidence the one S lancet in a deep reveal, the S doorway, and the priest's doorway. Restoration 1875. Good nave roof with the wind-braces arranged so as to produce the effect of cusped circles rather than of quatrefoils. One hammerbeam truss. – REREDOS. Made up partly of Jacobean bits and partly of interesting carvings by some Antwerp Mannerist of *c.* 1530, four larger figures and a smaller Madonna and Child. – SCREEN. Perp, extremely simple. – CHURCHYARD GATES. Early C19 cast iron, in heavy Gothic forms.

MANSION HOUSE. Dated 1779. Seven-bay façade of two storeys. Adamish doorway with demi-columns and pediment; three-bay main pediment with Louis XVI garlands. Jacobean remains inside.

FORD HOUSE. Early C18. Of five bays and two storeys, with quoins. Tuscan porch on the entrance side, on the garden side doorway with Tuscan pilasters against a rusticated background and with a pediment. Handsome staircase inside with slender balusters, three to the tread, one fluted, one turned, and one spiral (cf. Whitton Hall).

FRANKTON

ST ANDREW. 1858 by *Haycock*. Nave and chancel and SW
tower with broach spire. Rock-faced. The only distinguishing
feature is the heavily gabled parapets of the outer staircase
leading up to the tower porch.

FRODESLEY

ST MARK. 1809 with a N aisle of 1859. Nice white square belfry
with low-pitched pyramid roof. Arched W doorway and win-
dows. BOX PEWS and nice PULPIT. – FONT. Slender baluster,
now replaced by a most barbaric Norman font of tub shape.

FRODESLEY LODGE, 1 m. S, all on its own, against the bracken
of the hillside and with a wide view to the N. Plain, gaunt,
grey Elizabethan house of stone with a short Georgian
addition. Mullioned windows – no transomed windows – and
a roughly semicircular stair tower rising above the gables of
the house.

GAER DITCHES *see* CLUN

GLAZELEY

ST BARTHOLOMEW. 1875 by *Blomfield*. Nave, chancel, bellcote.
Decorated style, rock-faced; of no interest. – FONT. Plain
tub-shaped Norman font in the churchyard. – STAINED
GLASS. E window, signed by *Kempe*, commemorating a death
in 1887. – MONUMENT. Brass to Thomas Wylde † 1599, and
wife. The figures 28 in. long.

GOBOWEN

ALL SAINTS. By *Freeman & Ogilvy*. Nave and chancel 1928;
nave extended 1934; tower added 1945. In a neo-Perp style.
SECONDARY MODERN SCHOOL. *See* St Martin's, p. 239.

GOLDING
1 m. NE of Acton Burnell

Red-brick manor house with a front with recessed centre and
two gables on the short wings. The same pattern at the flat
back. Quoins, square chimneystacks. Staircase with turned
balusters. Octagonal brick dovecote.

GREAT BINNAL *see* ASTLEY ABBOTS

GREAT BOLAS
6020

CHURCH. The chancel, in its masonry still medieval-looking, is said to date from the second half of the C17. The nave was rebuilt in 1726–9 and a w tower added. Both are of brick. Quoins and arched windows. The tower has a parapet with vases instead of pinnacles. Nave and tower were designed by one *John Willdigg*. – WOODWORK. The ends of the chancel seats no doubt C17. The rest, w gallery, pulpit with back panelling and tester, panelling and communion rail, is C18.

GREAT HANWOOD
4000

ST THOMAS. 1856. Red brick. Nave and chancel, with polygonal apse and weatherboarded belfry. – FONT. Circular, Norman, fluted on the underside. – STAINED GLASS in the apse. Ornamental except for one figure of St Peter. By *David & Charles Evans* (TK). In their characteristic strident colours.

GREAT LYTH
2 m. NW of Stapleton
4000

Mid-C17 house of red brick, deserted at the time of writing. An interesting small house with recessed centre of three bays and projecting wings of two. Cross-windows, shaped gables over the wings, a dormer of oddly parabolic shape over the centre. Doorway with semicircular pediment. Brick courses on narrowly set corbels.

GREAT NESS
3010

ST ANDREW. Nave and chancel, and w tower. Nave and tower of red sandstone, the chancel a pinkish buff. The tower is E.E., see some windows. The upper parts look post-Reformation. The nave is E.E. too, as is clear from the s doorway with its steep arch and its mouldings, and also from the blocked single-chamfered N doorway. The evidence is however made more complicated by some arches inside in the s wall which are apparently of the same date. Yet one of them contains the

lower s doorway. These arches have the size and proportions of arcade arches, but there is no evidence otherwise of a former s arcade. Besides, the doorway does not look later. Dean Cranage's suggestion is that an aisle was projected, but the plan given up during construction. The chancel is Dec of the early C14 at the latest, according to the mouldings of the string-courses, the window surrounds, and the continuous triple chamfer of the chancel arch. But the E window has reticulated tracery, which means a date between *c.* 1325 and the mid C14 or later. So the window might well have been renewed shortly after erection. Good nave roof with collar-beams on arched braces, two tiers of wind-braces, and cusped, diagonally set queen-posts. – PEWS. 1775. With nice plain rounded ends.

Some Georgian brick houses in the village, especially GREAT NESS HOUSE with its side porch of two pairs of slender Greek Doric columns and its coach-house.

GREAT OXENBOLD
5090
2 m. E of Shipton

A house of the Priors of Wenlock. The C13 chapel survives, with three blocked lancet windows on the N side and a larger E window. (To the w of the chapel the hall with C16 features. M. E. Wood.)

GREETE
5070

ST JAMES. Nave and chancel, and bellcote. The Norman s doorway was extensively renewed in 1856. E.E. lancets in nave and chancel. In the nave on the N side also a Late Perp window with wooden tracery.

STOKE. To an older house (see E side) a new w front with projecting wings and a new s front were added, it is said, in 1702. They have shaped gables. Walled garden to the s.

GRINSHILL
5020

ALL SAINTS. 1839–40, by *J. Carline Jun.* (GR). This neo-Norman church, in a local red sandstone looking as smooth and red as brick, does not seem to fit the lovely village at all. Nave and chancel in one. Nook-shafted side windows. Thin w tower with corbelled-out parapet, like an Italian municipal tower.

Immediately E of the church HIGHER HOUSE, early C18, three bays wide, red brick with stone quoins, also to stress the middle bay. This has in addition a steep pediment. S of the church the MANOR HOUSE, Cotswoldian-looking in its grey stone. The date 1624 on a stone in the garden wall. Three bays, the outer ones with four-light mullioned and transomed windows and steep gables, the middle one altered and with a smaller gable.

Further E the ELEPHANT AND CASTLE HOTEL, similar to Higher House, but of five bays and with segment-headed windows, Early Georgian no doubt. The carved brackets of the doorway in the later wing could be part of the original doorway. This has now an early C19 Tuscan porch. Yet further E STONE GRANGE, a house built by or bought by Shrewsbury School in 1617 as a country retreat in times of plague. Grey stone. Plain oblong shape with only end gables. Two doorways. The porches are C19, but the two doorways may originally have marked a division between master and pupils. The upper windows on the entrance side have a rhythm of 3–2–3–2–3 lights, on the S side they are all of three lights. Mullions as well as transoms. The even run of windows seems a reminiscence of the Shrewsbury building of the school.

HABBERLEY

3000

ST MARY. Nave and chancel in one, and bellcote. The church looks entirely Victorian, though the masonry is medieval, and two very plain Norman doorways survive.

HABBERLEY HALL. Timber-framed house with a date 1593, vertical studs below, diagonal braces above. Tall chimney-stacks on a star plan.

HADLEY
1¼ m. ENE of Wellington

6010
Inset A

HOLY TRINITY. 1856, by *Owen* of Southsea. Red and yellow brick. Stone lancet windows, also plate tracery. NW turret.

MANOR HOUSE FARM, ⅓ m. WSW. Gabled timber-framed house; mostly narrowly spaced uprights, but below the main first-floor window lozenges with a diamond in the centre.

5020

HADNALL

St Mary Magdalene. Plain Norman s doorway. Late Norman n doorway with keeled arch-moulding and hood-mould. The s porch seems to be partly medieval in its timbers. The initials refer to the late C17; cf. the date 1699 on the nave roof. But most of the church is recent: the w tower of c. 1830–40, the rest of 1874 and 1903. – Stained Glass. Much early glass by *Kempe*: e window with Christ and many angels 1888, n and s windows in the nave 1892 and 1897. – Monument. First Viscount Hill † 1842, by *Thomas Carline*. A rather naive piece with a mourning grenadier and a mourning tenant. A lion couchant between them.

4080
Inset B

HALFORD

Church. Above the Onny. Nave and chancel, and bellcote. The chancel of 1887, the nave restored in 1848. Norman s doorway, small, with plain imposts, and a hood-mould of a chain of crocus-blossom forms (cf. St Mary Shrewsbury). One lancet window w of the doorway.

5030

HALSTON

Halston Hall. Built in 1690. Nine-bay brick front of two storeys, with quoins and quoins also to single out the five-bay centre. This has a pediment with a circular window. The pediment has heavy square brackets. Parapet with balls at the corners, gabled (not hipped) roof. At the gable ends groups of long square chimneys standing above a blank arch which carries the flues. This is an addition by *Mylne* (see below). Closed-in porch with alternately rusticated pilasters and open segmental pediment. The doorway looks original, the porch may be later. The semicircular walls to the l. and r. are an addition of 1850. The s (i.e. garden) side has a more complex rhythm with two-bay projecting wings and a slightly projecting three-bay centre. Good staircase inside, brought in from a house in Herefordshire. (Of even greater interest the Saloon. This is work of *Robert Mylne* datable 1766–8. The room has shallow apses at both ends and a fine door surround. The style is entirely that universally known as Robert Adam's. Yet Robert Mylne is using it here independently and

seems in some degree ahead of Adam. The date of the Saloon as well as this interpretation come from the researches of Mr C. Gotch.)

CHAPEL. Facing the garden side the Chapel, surrounded by yew trees. This is one of the two timber-framed ecclesiastical buildings of Shropshire, although its W tower is of brick. The tower has pointed windows and a pyramid roof and is no doubt Georgian. As for the timber-work, the framing is exclusively of the post-and-pan type. Two tiers of posts separated by big moulded beams. Three-light windows above these beams. Lower chancel with low depressed two-centred gable. The three-light window below has a shallow segmental head. The interior has tie-beams on short braces with bold figure-carving in the spandrels, including a fox, a bear (?), a horse, and two big bearded faces – one wearing a mitre, i.e. a bishop. The roof is ceiled. W Gallery on the first tie-beam. The front of the gallery has motifs of mixed odd balusters and Perp tracery. The tracery panels are said to come from the rood screen of Whittington church. What is the date of all this? The timber structure might be C15 or C16. The bishop in the spandrel seems to make any date after 1558 impossible and after 1536 unlikely. The W gallery looks Jacobean with re-used early C16 parts. The furnishings and fittings are preserved with exceptional completeness. But their date is again puzzling. Panelled walls, the panelling looking decidedly Elizabethan and not C17. Two big square PEWS below the W gallery. The BOX PEWS face each other college-chapel-wise. Two-decker PULPIT on the N side and opposite in the SE corner of the nave CHRISTENING PEW with baluster FONT and seats arranged around it. COMMUNION RAIL between the Christening Pew and the Reading Pew. REREDOS with open pediment. PAINTINGS of Moses and Aaron l. and r., and in addition the Ten Commandments, the Lord's Prayer, and the Creed. Finally a handsome brass CHANDELIER, painted ROYAL ARMS on the W gallery, a HELM and SHIRT (with armorial bearings) suspended above the Christening Pew, and a number of HATCHMENTS. The pulpit is dated 1725. The reredos, communion rail, and chandelier fit that date. The pews however look earlier, and so undoubtedly does the W gallery. The same has already been said of the panelling. So Halston Chapel ought to be regarded as a pre-Reformation building fitted up in the first half of the C17 and re-fitted again c. 1725.

3000

HAMPTON HALL
1½ m. NW of Worthen

In a splendid position looking towards the Stiperstones. Although the house looks simple and all of a piece, its architectural history is not quite simple. Red brick; clearly of different dates. The w wing has a large 1686 on its façade, and in the cellars is a date-stone 1681, probably the foundation stone. The cellars of the w wing are of stone, and a brick facing of the plinth visible outside indicates the thicker walls of an older house which they did not want unnecessarily to continue in 1686. The wings of the 1686 house are complete, but the centre is altered. As it is now, the wings are of two storeys with sash-windows and hipped roof, the centre is higher and has slenderer windows. The fronts of the wings are two bays wide, the centre seven. Big stone porch in the middle, arched and with an open curly pediment. The porch carries the date 1749. Above the ground-floor windows follow to the l. and r. of the porch two circular windows on either side, a typical late C17 feature (cf. e.g. Hampton Court), and then the upper floor with its slender windows. Top parapet with vases. Complicated adjustments of floor heights were necessary inside to fit this elevation. The convincing suggestion is that the house of 1686 had a centre with hipped roof, broader windows, and the circular windows. Also in 1749 no doubt the curious bow was added on the E side of the E wing. It has a curved pedimented doorway and a handsome curved Venetian window over. As for the interior, the oddest thing is that behind the porch the hall still lies in the medieval position, i.e. to the side of the porch, as if there had been a screens passage behind the porch. The staircase with three slender twisted balusters to each tread may belong to 1749, not to 1681–6.

3030

HARDWICK
1½ m. W of Ellesmere

John Kynaston inherited the family estates in 1693. He died in 1733. He built on virgin ground 'a compleat house' at Hardwick, the house which we now see, though with a number of regrettable alterations concerning the interior even more than the exterior. The house is of brick and faces s with a beautiful view over undulating lawns. It has a seven-bay front of three

storeys and is connected by semicircular walls with five-bay one-and-a-half-storey service wings, projecting at r. angles. These wings would be entirely in the style of *c.* 1700, with their quoins, hipped roof, and dormer windows with steep alternating pediments, if it were not for the segment-headed windows. But such windows in Shropshire do not seem to have appeared before *c.* 1720, and the house is not in other ways metropolitan. It is decidedly similar to such buildings as *Francis Smith*'s Mawley Hall, Buntingsdale, and Kinlet – i.e. all houses of *c.* 1720–30. It has angle quoins of even rustication and the three middle bays flanked by sturdy Corinthian pilasters with finely carved capitals. They carry a rather clumsy segmental pediment with a shield surrounded by leaves and ribbons. This centre of three bays is ashlar-faced, the rest is brick with stone dressings. The main windows have brick aprons. The doorway is flanked by Corinthian columns. The window above it has garlands and ears, again well carved. The doorway unfortunately has lost its hood or entablature. Originally an outer staircase led up to it, and basement windows were visible. Later a terrace was built in front of the whole house. As regards the interior, the finest room is the staircase which runs up, square with an open well, through two storeys. It has a handrail curving up at the newel-posts, three twisted balusters to each tread, and carved tread-ends.

To the w of the house a pair of excellent GATES: The gate-piers have Corinthian pilasters on three sides and carry eagles. The gates are of wrought iron.

HARDWICK *see* NORBURY

HARDWICK GRANGE
½ m. N of Hadnall

5020

The mansion, Gothic, by *Harrison*, has been pulled down. Towards the s end of the grounds the WATERLOO WIND-MILL remains, a replica built by Viscount Hill in memory of his military exploits.

HARLEY

5000
Inset A

ST MARY. 1846 by *S. P. Smith*. The w tower however is medieval, C13 below, Perp above. – STAINED GLASS. By

Evans of Shrewsbury with small medallions after famous paintings (cf. Cressage). – PLATE. Paten of *c.* 1480; silvergilt. In the centre the head of Christ. – BRASS. Knight and Lady of *c.* 1480, 26 in. figures. The children small below.

HARNAGE
1 m. SE of Cound

HARNAGE GRANGE, 2 m. SSE. The large house is a successor of a Queen Anne mansion pulled down *c.* 1878. It consists of various originally independent parts. The W parts represent what had been the grange, with pre-Reformation masonry. At the E end Jacobean brick with two fine big crow-stepped gables at r. angles to one another and chimneystacks of star section.

HARNAGE HOUSE, ½ m. SE. Brick house of the later C17, with two symmetrical straight gables and stone quoins, ornamental brick bands, and windows with wooden mullion-and-transom crosses. The staircase still has a string hiding the tread-ends. The balusters also still look Jacobean, and there is more decorative carving to the staircase, of Jacobean character too.

HATTON GRANGE
1 m. NNE of Ryton

Built in 1748. Red brick, two and a half storeys high. The principal front has two canted bay-windows and a doorway in the middle with a broken pediment on attached Tuscan columns. Three-bay pediment with garlands. To the l. the entrance side with a late Tuscan porch. This side is connected by a curved wall with an office wing, the end of which towards the entrance porch has a Venetian window. Staircase with slim twisted balusters. Some original plasterwork. Fine grounds with a long serpentine lake.

HAUGHMOND ABBEY

Haughmond Abbey was founded about 1135 by William Fitz Alan for Augustinian Canons. Nothing now visible belongs to the first building. A more ambitious rebuilding must have taken place later in the C. 12. Of this there is plenty of evidence.

As one approaches the site, one finds oneself in a curious quandary. The approach is through an archway in what

must have been a garden wall. The arch is Elizabethan or Jacobean, round-headed with two volutes on the top. Opposite is the S front of a very stately mansion – that is the impression. There are four tall two-light windows of C14 design, and there is a large canted bay-window with cusped arched lights, unmistakably late C15 or early C16 (cusped, two-centred heads of the individual lights). It is hard to reconcile this façade with what one knows about the planning of monasteries, and the plan of Haughmond is indeed highly unusual. To understand it one ought to make a new start, this time at the far end of the buildings, that is along the N side of the site.

It is here that the church was situated. The Great Gate lay yet further N – we do not know where exactly. The church has to be reconstructed visually from no more than foundation walls laid out in the ground. It was an aisleless C12 building with a crossing, transepts, a straight chancel, and two chapels to the E of either transept, of stepped length, and also straight-ended, i.e. the plan which the French call *en échelon*, and we the plan with staggered apses – only that the apses here, no doubt on the strength of Cistercian precedent, are cast off and replaced by straight walls. Early in the C14 a N aisle was added. The piers had major projections of a flattened sort and thin shafts in the diagonals. No decorative features survive, except for the doorway into the CLOISTER close to the W end of the church towards the S. This has to the N one order of very tall slim shafts with shaft-rings, and small decorated Late Norman capitals. The arch has a hoodmould with a small chain of lozenges. The S or cloister side is much more ornate, not so much in the two orders of shafts as in the arch. The motifs are geometrical and take the third dimension so much into consideration as to make a late C12 date certain. The hood-mould here has deeply undercut foliage. An odd insertion was made in the C14. The angles between the shafts were cut into figures over 4 ft tall. They stand under nodding ogee arches.

The cloister walks exist no longer; though the extent of the cloister can at once be seen. Rooms round the cloister were arranged in the usual monastic way. The W range was pulled down in the C16, at the same time that the W end of the church was shortened. What remains of the W range is the very impressive E wall, completely bare from outside, but with one small doorway close to the church front with one order of

shafts towards the cloister, and some minor later alterations, including an Elizabethan fireplace. The crenellation also seems C16. Towards the cloister the wall which remains has an uncommonly monumental Lavatorium, two tall blank single-stepped arches again on remarkably tall slim shafts with shaft-rings.

The E walk starts from the S transept end as usual with the Slype, and this is followed, again as usual, by the CHAPTER HOUSE. The façade of the chapter house is magnificent, three arches of which the outer two contain smaller twin windows, the middle one the doorway. Shafts between the arches and three orders of shafts to each side of the separating shafts as well. Foliage capitals; the arches differentiated between window bays and door bay – simply stepped in the side bays, with a half-roll and a quarter hollow in the door bay. Decorated hood-moulds. The early C14 again felt the need for a more human kind of decoration and set the spaces between the shafts out with figures, much smaller than in the church portal. Inside, the chapter house shows something of the C16 conversion of the abbey into a mansion. There is a ceiling with splendidly moulded beams, and the C12 E wall is cut off and replaced by a two-storeyed bay-window with mullioned openings. The bay-window is canted and has buttresses at the angles.* The abbey premises after the Dissolution were sold to Sir Rowland Hill who in the 1550s was Lord Mayor of London. Through his sister they came to the Baker family, who were responsible for the domestic alterations.

The S range contained the REFECTORY. It was above an undercroft, but in the case of Haughmond, owing to the fall of the land to the S, this was a real cellar. It was subdivided longitudinally by a row of pillars. Of the windows of the Refectory two to the S survive, still round-headed. The W wall had small blank arcading – pointed not round-headed – with capitals decorated by upright leaves, and above this, no doubt for better lighting, a large, six-light window was opened out in the C15 or early C16. The capitals of the nook-shafts are replaced by a band of small tracery motifs.

Haughmond lies with its E end against Haughmond Hill.‡ The solid rock is so close that some of the walls have their

* In the Chapter House a museum of architectural fragments has been assembled, including a fine, if mutilated C13 figure of the seated Virgin and Child.

‡ Two small CAMP SITES traceable on the W side of the hill may have been Roman look-out posts over the road to Chester (Deva).

8b

lower courses hewn out of the rock. This situation is the reason why the remaining buildings do not, as was customary, extend to the E, but to the S. Here the cloister is followed by a second cloister of somewhat irregular shape, known as the INFIRMARY CLOISTER. Its E range was the DORMITORY with an undercroft again subdivided longitudinally. The upper parts do not remain. An irregular projection to the E is not explained. The W range housed the KITCHENS. They are expressed unmistakably by the three large chimney-breasts which stand to a considerable height. The middle one is of the C14, the other two were added in the C15 or later.

The S side of the cloister is occupied by the large and monumental INFIRMARY, the building whose tall two-light windows with a transom greeted us as we arrived. The tracery of the windows is most unusual, two lights with one arch on their apexes touching the apex of the window, and a small finial of the mullion reaching up into this apex arch. There are in this S wall of the Infirmary also two small doorways. The W wall has a pair of small doorways and above a very large window between two turrets. The fireplace is a C16 insertion. The hall is not at all like other monastic infirmaries, and, to complicate matters yet further, there is no indication of the plan of the Chapel, which as a rule is placed E of the Infirmary Hall.

There, however, there was already a late C12 range. This projects yet further S, though at an angle, and is supposed to have contained the Abbot's Lodgings. The C15 or C16 bay-window noticed at the beginning of this description marks its S end. To the E of the Abbot's Lodging the walls of yet another building are exposed, a long range running diagonally from the S end of the Dormitory to the E end of the Abbot's Lodgings. This contained the REREDORTER (or Latrines). The drain all along its length is obvious.

HAUGHTON HALL *see* SHIFNAL

HAWKSTONE

Hawkstone is not as well known as it ought to be – neither the remarkable house (now a College of the Order of the Redemptionists) nor the even more remarkable park.

The house is clearly of two periods, a tall, compact core, and two wings on the W front, curious additions on the E side, and

more extensive additions on the N. But what are the dates of the two periods? The first must be c. 1720 (1722, MHLG). The house was built for Sir Richard Hill. The wings were added by his nephew Sir Rowland Hill (see T. Rodenhurst's Description). Stylistic evidence indeed points to c. 1750 for them and no later date. Red brick with stone dressings. w front of nine bays and two and a half storeys, the half-storey being above the main cornice. Quoined end bays. Three-bay centre rendered, with four attached giant Corinthian columns, an elaborate frieze, an attic, and a pediment. Outer steps with sphinxes l. and r. This centre (with or without the giant order?) is the house of c. 1720. Curved one-and-a-half-storey wings connect it with the five-bay wings of two storeys which have bowed ends. The E front is similar but more restless, and with more small interference of the second period. The centre here has three arched windows with small blocked square windows above. There are some splendid rooms inside the house,* especially four: the Saloon (now Refectory) in the middle of the E side, the Staircase, the Ballroom behind the s screen wall, and the so-called former Chapel in the s wing. The Saloon is in a noble Venetian style. Big fireplace with an overmantel with female termini caryatids, a large picture of the siege of Namur opposite (with Marlborough and Hill). Very rich doorcase, very rich frieze. The Ballroom is much less restrained. It belongs to the exuberant neo-Rococo of the C19. The staircase has twisted balusters. The so-called chapel has again a fine fireplace. It was the library originally, and the chapel was below. However, the room was converted into a chapel about 1860 and the apse decorated with much alabaster. The two square fluted pillars in front of the apse belong of course to the former library.

In front of the E front to the l. a CONSERVATORY with Tuscan pilasters and glass panels, probably c. 1820. Higher up a domed ROTUNDA, of before 1784. It was one of two, but the other, further E yet, at the far end of the so-called Temple Walk, has collapsed recently. Altogether the romantic features of the park are in decay and in danger of disappearing altogether.

The Redemptionists in 1934 built a CHURCH just behind the s wing, in a kind of Romanesque style (architect G. B. Cox of Birmingham).

* All comprised in the Enclosure of the Fathers Redemptionists.

THE PARK. The grounds of Hawkstone are exceptionally happily situated for any improver who wanted his picturesqueness not gentle but rough, i.e. for the Later Georgian rather than the Mid Georgian ideals of landscape. The ridge of sandstone cliffs, falling precipitously away SW and S of the house and being guarded by sudden isolated crags, could not be more dramatic. Moreover, when the improvements began, there was already a genuine ruined castle there, perched on its rock as no painter could have invented it more improbably. This is the Red Castle to which reference will be made presently. The improvers at Hawkstone were Sir Rowland Hill († 1783) and Sir Richard Hill who succeeded him. We have descriptions of the whole large and felicitous scheme as it originally was, including walks of over ten miles, rocks compared with the ruins of Palmyra, the wax effigy of the ancestor of a neighbour in the grotto, a hermitage complete with a hermit 'generally found in a sitting posture' with an hourglass, a skull, a book, and spectacles on his table, a vineyard laid out like a fortification with turrets, walls, and bastions, an Elysian Hill, an Awful Precipice, a menagerie, a Gothic greenhouse the situation of which 'would require the united efforts of Salvator Rosa, Claude, and Poussin to do it the smallest degree of justice', a 'tame and docile' Stately Lion and so on. All these features dated from before 1784. After that date others were added, including 'A Scene in Switzerland', 'A Scene in Otaheite', and the obelisk.

The OBELISK was erected in 1795. It is really a Tuscan column, 112 ft high, with a look-out at the top (with circular windows) and originally a statue of Sir Rowland Hill, Lord Mayor of London in 1555, on the top. The obelisk is best reached from the W of the house, turning S along a ride to the ridge. E of the obelisk, also on the ridge, is a SUMMER HOUSE of red sandstone with pointed windows and battlements (similar to Laura's Tower of 1790 at Shrewsbury) and yet further E a grey circular tower which is original medieval work.

If one now follows the drive from the house to the W and then the S towards Weston the road descends and passes through a tunnel (made in 1853–4) and then comes out into the open. To the immediate r. there is the almost vertical GROTTO HILL. It is arduous to ascend it from here; a gentler ascent is again from the NE.

The splendid shell grotto has lost its shells, corals, ore,

minerals, and stained glass. It has, the *Description* tells us, nothing 'of that petitesse by which grottoes are usually rendered like artificial Baby-Houses'. A gaunt pointed arch still stands on the edge looking down s and across to the RED CASTLE. This was a real castle begun in 1228, and ruinous already in Leland's time. It stood on two cliffs with a deep glen between. It had various towers, especially two on the two cliffs at the s end of the site and a much taller one towards the NW corner. This is close to the wall known as Giant's Wall. The tower was still over 100 ft tall fifty years ago. Now there is only a fragment left.

As one continues towards Weston, one should now turn N past the hotel (*see* Weston, p. 312) to the WINDMILL, a real windmill (without sails) at the w end of the long HAWK LAKE, made about 1790. Opposite stood a cottage in the Dutch style. A colossal statue of Neptune has also disappeared.

Turning s from the Hotel one passes THE CITADEL, a picturesque residence of *c.* 1790, built as a dower house. Symmetrical front with three circular towers connected by walls with two canted bay-windows. Higher stair-turret of the middle tower. From here one gets a good view of the red summer house on the cliff.

(NORTH LODGE. Towards Hodnet. A pair of square classical lodges. MHLG.)

BURY WALLS CAMP. The twenty-acre enclosure on the crown of the plateau may indicate that an Iron Age hill fort of a somewhat rough-and-ready type once existed here. There was nothing about the enclosure, as revealed by excavation, to suggest that it was Romano-British in origin, while Camden's assertion that it was the site of a Romano-British township is clearly wide of the mark.

HAY HOUSE *see* ALVELEY

HAY HOUSE FARM *see* COALPORT

HAYES

2020

½ m. w of Oswestry

A very curious Elizabethan stone house – inasmuch as it is cruciform in plan. Basement with mullioned windows, two

storeys all with cross-windows or windows of three lights with mullions and transoms, and straight gables. The one canted bay-window may be a later alteration.

HEATH

HEATH CHAPEL. The perfect example of a small Norman church, now lying quite on its own in a field. Nave and chancel; no bellcote. Broad flat buttresses. Small windows, three in the w gable, one each in the middle buttress of the w and the E side. S doorway with two orders of shafts. Decayed, originally ornamented capitals. Zigzag in the outer arch moulding, and zigzag in the hood-mould. Chancel arch with two orders of shafts with scalloped capitals. Double stepped arch. Tie-beam roof. – FONT. Norman, tub-shaped, with just a frieze of incised arches below the top. – PULPIT, READER'S DESK, SQUIRE'S PEW, BOX PEWS, all probably c17. Another pew, in the chancel, made up of old, including Perp, parts. – COMMUNION RAIL. Jacobean. – DOOR. The ironwork could be c12 or c13. – WALL PAINTING. Traces of a scene (said to be St George and the Dragon) on the nave S wall.

HENGOED

ST BARNABAS. Built 1849–53 to the design of the *Rev. Albany Rossendale Lloyd*, who also paid much of the cost. E.E. with lancet windows and a thin bell-turret with steep pyramid roof and thin obelisk pinnacles. Inside a roof with thin timbers and thin iron tie-rods. – STAINED GLASS. In the N transept a window designed by the designer of the church, with a rising sun above plants. The inscription ought to be read.

HENLEY HALL

A large red-brick house with a complicated history and not much of aesthetic appeal in its exterior. Elizabethan or Jacobean work is said to be incorporated, and a star-shaped chimneystack and plain gables tell of it, as does one large panelled room with an elaborate plaster ceiling, the motifs being strapwork cartouches and not ribs or broad bands. However, it is not certain whether the plasterwork is not a piece of skilful Victorian imitation. Then the early c18 (a date

1725 scratched on a window-pane) altered the centre part of seven bays. The fine staircase with its slim balusters, three to each tread, belongs to the next set of alterations. Their date no doubt coincides with the addition of the three-bay wings to the l. and r. The date 1772 is recorded on rainwater heads. Finally much was done in 1875 and more in 1907.

Stables to the E of the S front Georgian, with centre archway and cupola.

PARK HOUSE to the S of the S front, a plain square summer house. Entrance Gates to the N, splendid Early Georgian wrought iron from Wirksworth, Derbyshire.

HENLEY FARM, just N of the main road. Partly post-and-pan timbering, partly stone with mullioned windows.

HIGH ERCALL

ST MICHAEL. Dean Cranage makes much of the rebuilding after the Civil War – the church was called demolished in 1646 – but the architectural evidence is all in favour of an almost complete survival of the medieval church. Perp W tower with angle buttresses, battlements, a quatrefoil frieze below, and no pinnacles. Nave and aisles and chancel with N chapel. The nave is divided from the aisles by fine Transitional arcades of three bays with circular piers and square capitals (cf. Shrewsbury). The capitals are shallow and have volutes and leaves, also, on the third pier of the N side, two heads and two rams' heads – very much renewed. The W responds and the first pier on the N side are not circular but square with semicircular projections. The arches are steeply pointed and double-chamfered. One would expect round arches instead. The chancel arch is of the same date and details. The tower arch is triple-chamfered with one semicircular respond on each side and again capitals of c. 1190–1200. Chancel E window reticulated. Other windows Perp with unusually straight panel tracery (this could be C17 copying) or straight-headed. The N chapel is of two bays with an octagonal pier and double-chamfered arches, Dec rather than Perp. The roofs of chancel, nave and N chapel have all double hammerbeam and are typical post-Reformation work, in this case no doubt after the Civil War. The church seems to have been re-opened in 1662. – SCULPTURE. A small Early Norman tympanum with a fan or palm motif above two symmetrical leaf volutes (the whole perhaps a tree of life) and surrounded by a frieze

of rosettes re-set in the N wall of the nave. – STAINED GLASS.
E window 1897 by *Heaton, Butler & Bayne*. – MONUMENT.
Cross-legged Knight under the E arch between chapel and
chancel, *c.* 1320 and perhaps the founder of the chapel.

HIGH ERCALL HALL. Built for Sir Francis Newport in 1608
by *Walter Hancock* (of Market Hall Shrewsbury and perhaps
Condover). The house as it is to-day consists of two wings
arranged L-wise. The main entrance can no longer be
recognized, and the interior altogether does not tell much.
N front with three gables and two narrow recessed bits
between them. Even four-light mullioned windows. The
ground floor of red sandstone, the upper floor and the gables
brick with blue diaper patterns. To the S, E, and W both
storeys are stone and only the gables brick. Windows without
and with transoms. The most curious thing about the house
is, however, an arcade of four arches on round piers now on
its own, on the lawn between the house and the church. This
must have been originally an open loggia such as exists still at
Condover, and was probably part of a range of buildings form-
ing one composition with the remaining two ranges. According
to Mrs Stackhouse Acton's book of 1868 the house had an
inner courtyard. The moat and drawbridge which formerly
surrounded and defended the house exist no longer.

ALMSHOUSES. Founded in 1694. One-storeyed, of brick, three
sides of a courtyard, very plain.

HIGH GROSVENOR *see* CLAVERLEY

HIGHLEY

7080

ST MARY. Norman nave and chancel, see the remaining N
windows. The doorways, however, are later; the best that on
the N side now leading into the vestry. Perp W tower with
battlements and pinnacles. The responds of the tower arch
are polygonal and concave-sided (cf. the arcade at Quatt).
Good, nearly flat nave roof with carved bosses. – DOOR.
Ironwork probably of the C12 or C13. – CROSS in the church-
yard. The base uncommonly elaborate. Heads at the corners
(cf. the head on the stoup at Cleobury Mortimer). Rope-
moulding at the top of the base, and in the E side a grossly
crocketed niche. The shaft is also preserved.

CHURCH HOUSE overlooking the churchyard, prettily timber-framed.

Highley is a colliery village of brick houses. To its N at WOOD-HILL a housing estate of typical between-the-wars council design and layout. The colliery has one of the well-designed PITHEAD BATHS, provided by the former Miners' Welfare Committee. Designed by *J. H. Bourne* and opened in 1950.

HINSTOCK

6020

ST OSWALD. Nave and chancel and W tower. S aisle added in the 1850s to match the nave, making the church look two-naved. The original nave of 1719–20. Arched windows. The tower looks *c.* 1800, but Dean Cranage assigns it to the C17. Its windows are pointed. – Big W ORGAN. – WOODWORK of *c.* 1800, i.e. pulpit and benches.

HINTON HALL *see* WHITCHURCH

HOARE STONES *see* CHIRBURY

HODNET

6020

ST LUKE. A strange building in an uncommonly fine position. As one enters it at present, it consists of a wide low nave and chancel and a very wide S aisle. Originally, however, the aisle was the church, and the present nave was an added exceedingly wide N aisle. The situation is yet more confused by the fact that the W tower faces the former aisle, i.e. the present nave. This tower is octagonal from the bottom to the top – a thing unique in Shropshire. Almost as unusual is the E end of three parallel gables. Red sandstone. Most of the details are due to C19 restoration; especially that of 1846 which made the E windows Dec. The third E gable and E window belong to the Heber chapel erected in 1870. The tower is original and Dec – see e.g. the bell-openings. Battlemented top. Of the arcade between the two naves (to call them that) the two E bays have an original C14 octagonal pier and original double-chamfered arches. – FONT. Octagonal and probably C17, an interesting case of Norman Revival, as one meets them occasionally. Norman foliage motifs and Norman-looking lions and rosettes. But the cock and the eagle cannot possibly be Norman, nor is the placing of the motifs in the

panels convincing. – STAINED GLASS. E window of 1846; whom by? – S aisle E by *David Evans*; four large figures.* – MONUMENTS. Richard Hill, † 1726 (S aisle W wall). Big obelisk and two vases; no figures. – Henrietta Vernon † 1752 (N wall). An exquisite Rococo piece. Wreathed urn on a pedestal against an obelisk; two wreathed urns l. and r. In the 'predella' three cherubs' heads. Attributed to *Sir Henry Cheere*. – Sir Richard Hill † 1808 (S aisle S). Urn in front of an obelisk. Signed by *John Carline*. – John Hill † 1814 (N wall). Mourning woman, seated on the ground by a sarcophagus, with a standing child. By *Carline* (Gunnis). – In the Heber Chapel Bishop Heber † 1826. By *Chantrey*. Portrait head in profile on a draped cube of marble. – Blanche Emily Heber † 1870. By *Reginald Cholmondeley* of Condover. Recumbent effigy on a sarcophagus.

HODNET HALL. Built in place of the seat of the Vernons in 1870. Large regular neo-Elizabethan mansion by *Salvin.* N front on the familiar E-plan. Gibbs windows and mullioned and transomed windows.

HOME FARM. Fine timber-framed Barn dated 1619. The framing is in square panels, the upper parts are weather-boarded behind the frame, the lower parts have later brick-infilling.

RECTORY. Off the Market Drayton road in the former grounds of the Hall. Built by Bishop Heber while he was rector of Hodnet. Modest Tudor with symmetrical façade. Castellated porch flanked by two gables.

The village of Hodnet is very attractive as it develops towards its centre, just SE of the church. Here the three gables of the church look down on several well-placed black-and-white houses. The scene needs no detailed description. The houses seem arranged so as to afford the best views wherever one comes from. The most picturesque black-and-white house lies on its own, THE COTTAGE, to the N of the church.

The MOUND of the former Hodnet Castle is in the grounds of the Hall to the SW of the church.

HOLDGATE

HOLY TRINITY. Nave and chancel, and short, broad W tower. Norman nave, see the W window now looking into the

* PLATE. A pre-Reformation Chalice and Paten was found in the burial of a priest in the old chancel (Cranage).

tower. The s doorway is uncommonly rich, with two orders
of shafts with a scalloped and an ornamented capital. The
arch has an inner moulding of widely spaced beak-heads, a
middle moulding of a kind of frieze of arches, an outer
moulding of zigzag, and a hood-mould of V-shapes on the l.
half, pellets on the r. C13 chancel and w tower, see several
windows, and the old ground-floor window from the tower
into the nave. But what is the date of the doorway to its l.?
In the nave s wall an E. E. recess. In the chancel s wall outside
a sheila-na-gig (cf. Tugford). – FONT. Circular bowl with
bold, deeply rounded carving of a dragon, interlace, foliage,
and medallions. One with dragons. – MISERICORDS. One with
dragons. – PEW. The high back of two seats with detached columns as at
Cleobury North. Pew as well as Misericords were probably
imported from some other church. – BENCHES. Plain, with
moulded tops; Perp or later?

CASTLE. Of the castle remains one semicircular tower at the
back of the present farmhouse. Fine ashlar masonry probably
of the late C13 or early C14.

3000
HOPE
3 m. sw of Minsterley

HOLY TRINITY. A delightfully placed church, in the Hope
Valley, below the road, reached by a little white bridge across
the stream and embedded in a variety of conifers, as if the
whole were part of the setting of a country gentleman's land-
scaped grounds. Nave and chancel in one, and bellcote. Lancet-
style. By *Edward Haycock* of Shrewsbury, 1843.

Up the Hope Valley, as one travels s, one comes across a number
of deserted LEAD MINES with their tips, dark grey and whitish,
and the occasional square tapering chimney and ruin of an
engine house.

5070
HOPE BAGOT

ST JOHN BAPTIST. Nave and chancel, and small w tower with
pyramid roof. Nave and chancel from the N are entirely
unaltered Norman. The Norman chancel window has a
decorated head-stone. s doorway and chancel arch very similar
and both clearly of the same date as nave and chancel. Plain
imposts, much chip-carving of saltire crosses. Clumsy
roughly semicircular orders of shafts. Single-step arch.

22

Inconclusive evidence for the date of the tower. The arch is small and of a raw pointed shape.

HOPE BOWDLER

4090

ST ANDREW. 1863 by *S. Pountney Smith* (GR). – STAINED GLASS. E window Early Victorian. – Much by *Kempe*: chancel N 1888 (St Andrew; specially good) and 1896; nave N 1896. – PLATE. Chalice of 1571.

HOPESAY

3080

ST MARY. Nave and chancel, and broad low W tower, irregularly buttressed, with a roof like that of the tower at Clun: truncated pyramid, a low upright storey and a smaller pyramid roof. Nave and chancel of *c.* 1200 or thereabouts. Small lancet window in the nave, but S doorway still with round arch on shafts with decorated scalloped capitals. Larger lancet windows in the chancel. One of them is carried down inside to form Sedilia. Single-chamfered priest's doorway. Chancel arch double-chamfered, but on semicircular responds. The nave roof rests on a wallplate very charmingly decorated with blank arcading like the dado of a screen. Collar-beams on arched braces. Three tiers of wind-braces in quatrefoil patterns. – CHANCEL STALLS. Partly Jacobean. – PLATE. Paten of 1571.

14a

HOPTON CANGEFORD

5080
Inset B

CHURCH. Fine view towards Clee Hill. 1766. Red brick with arched windows and doorway in the W tower. Circular bell-openings, pyramid roof. Nave and chancel with polygonal apse. – Original PULPIT, READER'S DESK, VICAR'S PEW, and SQUIRE'S PEW.

HOPTON CASTLE

3070

ST MARY. 1871 by *Nicholson* (GR).
CASTLE. Norman Keep still standing high. The doorway to the N (staircase to its l.) and the principal windows are of C14 forms.

HOPTON WAFERS

St Michael. Ashlar-built in 1827. w tower, nave and chancel. The w tower must have had classical arched windows (cf. Doddington), but they have alas been normanized. Those of nave and chancel on the other hand have been made Gothic. – ROYAL ARMS. Of Queen Victoria. Handsomely carved. – MONUMENT. Thomas Botfield † 1843 by *E. H. Baily*. Large relief. He lies propped up by pillows, and points out with a telling gesture the rays of heaven to his kneeling disconsolate wife.

Hopton Manor. Late C18 brick house. Attached to its back row of cottages, facing the s side of the churchyard.

Hopton Court. Big five-bay house of three storeys. The s side has a veranda along the ground floor with coupled unfluted Ionic columns. Built as an addition to a farmhouse in 1776 by Thomas Botfield. Enlarged and embellished by the veranda about 1812. The architect then is said to have been *John Nash*. The grounds, it is also said, were laid out by *Repton* (Murray).

HORDLEY

St Mary. Norman nave and chancel, and much later belfry with timber-framing and brick-nogging. Pyramid roof. In the N wall a blocked doorway with a fat continuous quarter moulding. – STAINED GLASS. The E window of *c.* 1887 looks as if it were by *Powell*'s. The style but not the colouring clearly influenced by the Pre-Raphaelites.

HUGHLEY

St John Baptist. Nave and chancel in one, timber-framed belfry with brick infilling and pyramid roof. The nave N wall of the C13, see the lancet windows and the doorway between. The s doorway in the same style. The chancel however and most of the windows Dec. In the chancel to the r. of the altar a bracket for an image resting on a large head of a lady, also a Pillar Piscina (Perp rather than Dec?). The nave roof is of the trussed rafter type. It was boarded up by *Norman Shaw*, who had clients in the neighbourhood in the early seventies. –
28 PULPIT. Jacobean. – SCREEN. Perhaps the finest in the

county, though not of course of the lavishness of Devon or Somerset screens. Broad one-light divisions. The dado in its upper part most delicately pierced. One tier of charming tracery in Dec and Perp forms, then one tier of unpierced quatrefoils, then one of pierced quatrefoils and a dainty cresting. The tracery above again very dainty and varied in the designs. Coving with lierne-vaults forming crosses; frieze and cresting. – STAINED GLASS. Glass of the C14 in the chancel E and N windows, canopies and also parts of small figures.

OLD HALL. Timber-framed house of c. 1600. In the gable decoration with concave-sided lozenges.

HUMPHRESTON HALL see DONINGTON

IGHTFIELD

5030

ST JOHN BAPTIST. A Perp church. W tower with diagonal buttresses, battlements, a quatrefoil frieze below them, and tall pinnacles. W doorway and three-light W window. Nave of three bays with N aisle, chancel of two bays, S porch – all embattled and with pinnacles. The chancel seems largely rebuilt (restoration 1865), but with an odd original priest's door, with ogee mouldings. In the S wall of the nave a three-light window with equally odd tracery. The arcade has short octagonal piers, plain capitals, and double-chamfered arches. The tower arch is also simple and rather coarse. – BRASS. Dame Margery Calverley, end of C15. The figure is 3 ft 6 in. long, but there is a triple canopy with a figure of St John the Baptist at the top bringing the total length to 7 ft 3 in. – CHURCHYARD CROSS. The base has quatrefoils, and at the angles are the remains of decayed figures.

IRONBRIDGE

6000

Before man made industrial use of coal and iron, Ironbridge and Coalbrookdale were the dramatically narrow gorge of the Severn and the valley of a brook coming in from the north. The present names Ironbridge and Coalbrookdale indicate what made this part of England the centre of English industry

in the C18. The smelting of iron had depended on wood
fuel until then, and so the combination of iron ore and forest
country was what mattered. Sussex was the centre at that
time. But timber grew scarcer, and the use for smelting
was wasteful. So the industry could not expand until coal
could be used instead of wood. The use of coal for domestic
heating goes back to the Middle Ages. But for the purposes of
the iron industry coal became important only when Abraham
Darby had discovered that coke could be used for smelting.
The date is not quite certain, but *c.* 1713 seems the most prob-
able. The next inventions came fifty years later: a technique
to make cast iron malleable, and then Henry Cort's improve-
ments of the puddling process. Abraham Darby was the foun-
der of the Coalbrookdale Company (1708). The company still
exists, and at the N end of the premises one can see the re-
mains of the earliest furnace, behind a big warehouse of 1843,
with a handsome square lantern on an openwork splayed cast-
iron undercarriage. The area with the early furnace is (at the
time of writing) shockingly sordid. A little money could put it
right and create a monument to early English industry, much
as it has, e.g., been done on the Witwatersrand with the earliest
gold-mining apparatus.

Surrounding this oldest part of the works some respectable C18
brick houses, both higher up beyond the railway bridge and
immediately E and NE. The street then winds down to the
Severn. High up on the l. first the Italianate red brick
METHODIST CHURCH (1886), then, picturesquely placed,
the church of HOLY TRINITY, built in 1850–4 with money
given by the then Abraham Darby. The architects were
Reeves & Voysey. The street in the valley is not in the least
urban. Wooded hills l. and r. and in front, and a straggling
accompaniment by council houses, older cottages, and even a
former farmhouse, timber-framed, and with the date 1642.

Then the Severn and Ironbridge are reached, at a place where
the opposite bank of the river is so steep that there is no road,
only the railway, the track partly built up on arches. On the
l. the RAILWAY BRIDGE, or Albert Edward Bridge, of cast
iron, designed by *John Fowler*, a single span of 200 ft built in
1859. On the r. as one walks towards the bridge, the former
WHARF of the Coalbrookdale Iron Company, mid-Victorian,
of red and yellow brick, and crazily provided with two
castellated turrets and a castellated apse between. In front of
the apse originally was the basin for the barges.

Ironbridge is called after the IRON BRIDGE, the earliest 61a
bridge of cold blast iron. It was designed by *Abraham Darby**
and cast in 1778 by his Coalbrookdale Company. To-day's
traffic conditions have reduced it to a footbridge. The roadway
rises from both sides and the arch below is semicircular. Two
concentric arches with a filigree of connecting members. In
the spandrels a circle and an ogee-arched panel, a little
awkwardly placed side by side. The railing is like a thin
fence, and the charm as well as the admirable boldness
of the bridge is indeed its light and lacy thinness. Two
subsidiary arches on the S bank.

At the N bridgehead the one attempt of this conurbation, as is
the fashionable term, to appear a town: a market square, with
a hotel on the l., and the former MARKET HOUSE facing the
bridge, two red-brick buildings of *c.* 1800, both of five bays.
The Market House has five segmental arches on the ground
floor, originally open, and blank arches above with tripartite
windows; pediment over the middle bay. More than 100
steps above, very picturesquely, lies the church. ST LUKE was
designed by *Thomas Smith* of Madeley (GR) and built in 1836.
Pale brick with lancet windows in pairs and an embattled w
tower. Very similar to Christ Church Wellington. Inside three
galleries and STAINED GLASS in the E window, doubtless by
Evans.

Further E as well as at the W end the town soon ceases, and after
a mixture of miners' cottages and bedraggled fields the open
country is quickly reached again.

ISLE 4010

The house is not on an isle, but the loop of the Severn on which
it lies is such that at its head there is less than a quarter mile of
land. The house is assigned to the late C17, but there is little
to go by. It is an undistinguished-looking large red-brick
block. The staircase has slim turned balusters, probably Early
Georgian. Close by an older black-and-white house with a
walled garden, and in one of the corners a tall brick Summer
House with quoins and a pyramid roof. It looks late C17.

* The attribution of the design to the Shrewsbury architect *Thomas
Farnolls Pritchard* is not justified. The designs he submitted in 1775 were for
a bridge of stone, brick and timber (*see* the Minute Books at the Shrewsbury
Public Library, and A. Raistrick: *Dynasty of Iron Founders*, 1953).

JACKFIELD

The houses stretch along the river Severn, interrupted by Victorian factories. Messrs CRAVEN DUNHILL's is in a restrainedly Gothic style, of brick, with faience tympana (date unknown). Messrs MAW, specially famous for their tiles about the middle of the C19, also have their factory at Jackfield. This was built in 1883. Coalport is the adjoining town. The Victorian church is in the centre of Jackfield, but the Georgian church stands on the hill, quite on its own. A little above the street which runs parallel with the river are some larger houses, e.g. THE CALCOTTS, dated 1695, red brick, three bays wide, W of Dunhill's, and THE TUCKIES, of about the same date, also brick, with recessed centre and projecting wings, seven bays wide. This is behind Maw's.

ST MARY. 1863 by *Blomfield*, i.e. an early work of his, when he was still strongly under the influence of Butterfield. Small church, but intended to look rich by the use of pale red, strong red, yellow and blue bricks, and stone dressings. Windows with Geometrical tracery. S porch with red terracotta columns, and an odd turret in the angle between nave and chancel. Octagonal, with short columns at the bell-stage and a conical roof. Wide polygonal apse.

OLD ST MARY. Built in 1759 by *Francis Turner Blyth*. The large church of a prosperous industrial neighbourhood. Now deserted and gutted, and even the gravestones upset and overgrown. Red brick. Big W tower with twin bell-openings, and a parapet raised at the corners. Nave of five bays, chancel of one. Windows with Gibbs surrounds. Venetian E window. A square chimney, like that of a small factory, in the angle between chancel and nave – a surprising adjunct.

KEMBERTON

ST JOHN BAPTIST. 1882 by *J. Farmer* (GR). The W tower of 1908. – PLATE. Chalice and Paten of 1520.

KEMBERTON COLLIERY, 1¼ m. NW. Pithead Baths, 1940–1 by *J. H. Bourne*.

KEMPTON
4 m. ENE of Clun

(On the Walcot Estate, according to the *Shropshire Magazine*, vol. 7, a CRUCK COTTAGE.)

KENLEY
2 m. SE of Acton Burnell

ST JOHN BAPTIST. Nave and chancel in one, and W tower. The tower is so low that its pyramid roof starts below the ridge of the nave roof. Round-arched single-chamfered S doorway. Round-arched blocked N doorway. Two-light Dec E window. Pointed doorway to the tower. The rest of the windows are, it seems, early C19. Fine chancel roof with collar-beams on arched braces, and above the collar-beams strutting forming quatrefoils. – PULPIT with tester and READER'S DESK. Jacobean.

Archibald Alison was rector of Kenley, and here wrote his *Essays on the Nature and Principles of Taste* (1790).

KETLEY
1 m. WSW of Oakengates

ST MARY, RED LAKE. 1838. Nave and chancel, transepts and W tower. Dark grey stone, in the lancet style, rather similar to Samuel Smith's church of 1813 at Wrockwardine Wood. The lancets have hood-moulds. The only surprise is that the tower has a Norman W doorway and a bell-stage with low pyramid roof of a general *Rundbogenstil* which may be meant as Norman or as Early Italian.

KING'S BARN *see* CLAVERLEY

KINGSNORDELEY
1 m. N of Coton Hall

(T-shaped house, partly of the C17, partly later. On the W side a date 1715.)

KINLET

ST JOHN BAPTIST. Quite a large church, lying in the grounds of Kinlet Hall, though some distance from the house. The former village has disappeared. Several minor fragments tell of the Norman church, notably a part of the tympanum of the S doorway; also a plain window in the chancel S wall and the head of one in the chancel N wall. To this Norman church a

N aisle was added late in the C12. Three bays, the piers circular, the bases typically Late Norman (with spurs), the capitals rudely altered (when?), the arches round, single-stepped and single-chamfered. The s arcade, s doorway, and s porch followed in the first half of the C13. The workshop must have been the same which worked at Cleobury Mortimer. The arcade is very similar to that of the N side, with its circular piers and arches. The s doorway has stiff-leaf capitals and an arch with fillets. The outer porch doorway is more elaborate, a fine piece, with three orders of colonnettes, again stiff-leaf capitals, and again arches with fillets. E.E. also the broad W tower, except for the Perp top with battlements and pinnacles. The tower arch is very spacious and handsome. The semi-circular responds have capitals with stiff-leaf and heads. The early C14 is as important at Kinlet as the early C13. The chancel was rebuilt and both transepts added. All this must be of c. 1310–20. Chancel arch with three orders. Moulded capitals and fillets. Transept arches on five-shafted responds. The chancel E window is a splendid piece of five lights, intersected and cusped, but the top intersections replaced by a sexfoiled circle (cf. Stottesdon and Chelmarsh). The form is more like 1300 than like 1310. The N and s windows typically two-light Dec. N transept N and s transept s have straightforward three-light intersected and cusped windows. In the s transept s wall a small door (with ballflower decoration) with a small window to its l. The Perp style (apart from the tower top) contributed a charming clerestory (well restored by *Oldrid Scott*, 1892). It is timber-framed with a pair of two-light windows for each bay.

FURNISHINGS. SCULPTURE. Good alabaster figure of the Trinity, fitting a central recess in the E window of the s transept. – STAINED GLASS. E window, 1814 by *Sir John Betton* or probably his assistant *David Evans*; with mid-C14 parts. – MONUMENTS. Alabaster effigy of a Lady, early C15, probably Isobel, daughter of Sir John Cornwall and wife of Sir W. Lychefield. Recumbent figure with angels at her pillow. – Sir Humphry Blount † 1477 and wife. Two recumbent effigies on a tomb-chest with mourners under ogee-headed arches. The monument stood originally in the arch between chancel and s transept. – Sir John Blount † 1531 and wife. Alabaster. Recumbent effigies on a tomb-chest. The mourners and a fine shield with supporters in broad panels divided by shapeless colonnettes. The arches replaced by typical Early

34b

Renaissance scrolls. – Sir George Blount and his wife who died in 1584. In the N transept. Alabaster. Six-poster. The principal figures kneeling frontally, i.e. facing S, towards the chancel. The tomb-chest open towards the front with trefoiled arches. They expose a gisant or cadaver behind. The trefoiled arches seem an odd medievalism. More so are the arches in front of the figures which consist each of two pointed arches with a pendant between. The ceiling above the figures has blank Perp tracery. All this points to conscious archaism rather than survival.

In the churchyard a remarkably large base of a CROSS. It is square with four gables. Beneath these kneeling recesses of differing depth. That on the E side is deepest: 1 ft.

KINLET HALL. Built in 1727–9 by *Francis Smith* of Warwick. Red brick with stone dressings. The main house is a block of seven by seven bays. On the entrance side this is continued by walls with much stone trim, and then four-bay wings, one and a half storeys high. Behind the walls are the offices etc. The main block is two and a half storeys high, flush on the entrance (E) side, with a recessed three-bay centre on the garden (W) side. This side has rusticated giant pilasters at the angles. The doorway has pilasters with alternating rustication and a pediment. The doorway on the entrance side has Roman Doric columns and a pediment. The windows are framed and have ears. The half-storey is above the main cornice. Entrance Hall with a screen of Roman Doric columns at the back. Behind the Entrance Hall, i.e. in the centre of the garden façade, a fine panelled room. To its N the spacious staircase. Three daintily twisted balusters to each tread. Further N the large former Library, tripartite, the parts divided by piers and columns of dark-blue marble. The date of this room is said to be 1827.

KINNERLEY

ST MARY. Red sandstone. Perp W tower and Georgian nave and chancel with apse. The Georgian work dates from 1773–4. The design for it is by *Thomas Farnolls Pritchard* who in 1769 was paid for drawing the plan of the church (Gunnis). W tower, not high, with diagonal buttresses and battlements, nave, chancel and apse with big round-headed and elaborately framed windows. S porch and alteration of tower windows and

chancel arch 1887–90. – STAINED GLASS. In the apse 1932 by *Tower*, yet completely Victorian inasmuch as it is in imitation of Holbein's most exuberant architectural fantasies.

KINNERSLEY

6010

ST CHAD. Nave and chancel, and W tower. In addition a double bellcote over the W end of the chancel. The W tower was built in 1722–3 (arched doorway, parapet with obelisks). So the bellcote belongs probably to the church as it was before then. In the nave only the walls are medieval, the windows being of the Victorian restoration. But the chancel is medieval, and according to the windows *c.* 1320–30. The chancel arch also belongs to that period: double-chamfered on short polygonal shafts set on corbels.

KNOCKIN

3020

ST MARY. Late Norman nave and N aisle and chancel, but heavily restored and improved in 1847. The church was established between 1182 and 1195. The chancel has its S doorway with one order of shafts, a tympanum on a segment-arched lintel, and a zigzag frieze in the intrados of the arch. The aisle arcade is of four bays with circular piers, circular waterleaf capitals, polygonal abaci, single-chamfered arches, and chamfered hood-moulds. The aisle itself has been demolished. The architect of 1847 decided to go on Norman in chancel and N aisle, but gave paired lancet windows to the S side of the nave and the S transept W porch and yellow brick bellcote.

To the E of the church the MOUND of the former Castle. Leland says that in his time already 'Knoking Castel' was 'a ruinous thing'.

TOP FARM, at the W end of the village. With an extremely pretty gable, probably somewhat restored. Close uprights on the ground floor; on the first floor cusped lozenges in three tiers, in the gable in two tiers. Carved bressumers. The lozenges are so heavily cusped that the white areas inside appear like very elongated pointed quatrefoils.

KNOWBURY

5070

ST PAUL. Built in 1839, and altered in 1885. – REREDOS. In the style of the German Primitives. – FONT. The font looks like

a large Norman capital turned upside down; with two decorated scallops on each side. Fluted bowl with a leaf-frieze. Of what date can it be? – STAINED GLASS. E window by *Mayer* of Munich, 1886.

LANGLEY

1 m. SSE of Acton Burnell

5000

CHAPEL. The date 1564 outside the building is recorded in the Lloyd manuscript. The date 1601 on a roof beam. Nave and chancel in one. Ashlar-faced and weather-boarded belfry with pyramid roof. Small lancet windows and an E window of three lights with only the side lights given their own pointed arches – i.e. a late C13 form. Roof in the chancel of the trussed rafter type, in the nave with two tie-beams and three collar-beams on arched braces. – Perfect furnishings of the early C17. PULPIT, square, with two back walls and a square tester, as if it were a square room with two walls removed. – MOVABLE PULPIT. – BENCHES with drop-shaped poppy-heads. – PEWS, very complete; with a musicians' pew at the back.

GATEHOUSE. The only remaining part of Langley Hall, the mansion of the Lee family. To the NE timber-framed with much diagonal strutting, to the SW stone, with two gables not placed in line with the double-chamfered archway or the windows. These are mullioned, and one has a transom as well. Embattled wall to the NW. At a short distance to the SW long weatherboarded barn.

LARDEN HALL

1½ m. N of Shipton

5090

Partly timber-framed, partly of stone. The gabled stone parts with mullioned and transomed windows are dated 1607, but much restored. The timber part cannot be much earlier in its rich decoration with lozenges within lozenges formed by diagonal struts. (Inside, panelling and a mantelpiece made up of carving formerly over the front door.)

LAWLEY *see* DAWLEY

LEA CASTLE
1½ m. E of Bishop's Castle

One tall fragment of the Keep remains attached to a victorianized house. The details are not Norman but C14 and later.

LEA HALL *see* PRESTON GUBBALS

LEATON

HOLY TRINITY. 1859 by *S. Pountney Smith*. A façade as crazy as any of this High Victorian phase. Steep gable with a bell-cote set diagonally on a diagonally projecting buttress which stands on a flying buttress. In 1872 the NW tower and N aisle were added, far more reasonable and sober work. The tower is tall and has a tall crocketed spire. The details however are fanciful here too, e.g. the aisle piers which are circular with four fillets.

N of the Church at the corner of the road to the station a brick HOUSE dated 1683. It has diagonally placed chimneystacks and a string-course ornamented with rectangularly projecting brick brackets.

LEE OLD HALL
1½ m. S of Ellesmere

The house makes an ideally lively and varied picture. On the strength of the square panels Forrest attributed the S portion to the mid C16. The main part of the house is dated 1594 and has chiefly diagonal strutting. Inside is a fireplace dated 1657 but still Jacobean in its motifs (cf. Shade Oak).

LEEBOTWOOD

ST MARY. Nave and chancel in one, and narrow, oblong W tower. This is probably Georgian, the church medieval. Blocked single-chamfered S doorway, i.e. C13. Good roof. – STAINED GLASS. E window, *c.* 1854, probably by *Evans*. – MONUMENTS. Sir Uvedale Corbett † 1701. Handsome hanging monument with two columns, and an open segmental gable with two small reclining figures. – Also other Corbett tablets. The Corbetts were the family of Longnor Hall.

LEE BROCKHURST

St Peter. Late Norman nave – see the s doorway with one order of shafts with scalloped, decorated capitals, and zigzag in the arch, both the extrados and the intrados. Also two Norman windows, very small. Chancel and bellcote of 1884.

LEIGHTON

St Mary. Nave and chancel of brick, begun in 1714 partially with medieval masonry. Arched windows, large arched w window. Later weatherboarded belfry with pyramid roof. Coved white ceiling. w gallery with turned balusters. – font. Urn on a stone pillar. – monuments. Effigy of a cross-legged Knight, a member of the Leighton family, probably late c13. – Tomb-chest with incised slab to William Leighton † 1520 and his wife. – Thomas Kynnersley † 1843, large hanging monument with over-big pedestal and draped urn. By *J. Evan Thomas*. – Several more large tablets. – In the nave floor cast-iron slab to William Brown, 1696. – In the churchyard cast-iron monument of 1828, with urn on a big pedestal.

Leighton Hall. Brick mansion of 1778 with stone dressings, and two canted bay-windows. Much added to. The stables are on the other side of the church which stands in the grounds of the hall. The stables are also of red brick and have the usual lantern above the archway into the yard.

LILLESHALL

The village, the Hall, and the Abbey ruins are all unconnected with each other.

St Michael. Short Perp w tower with battlements and small pinnacles. Nave and chancel, and n aisle. The nave is Late Norman, see the s doorway, with two orders of shafts provided with shaft-rings, and complex arches with some normal and some three-dimensional zigzag meeting at a keeled roll. In addition a second Norman doorway on the same side, probably re-set. The capitals of the shafts have a kind of waterleaf decoration, and the arches again three-dimensional zigzag. The chancel is E.E., see the w lancet and the s doorway, and was lengthened early in the c14, see the E window with its subdivided reticulation. At the same time the aisle was added, see

the window details. Arcade of five bays on very short octagonal piers with the plainest capitals and bases. – FONT. Norman, tub-shaped, with short blank arches filled by simple decorative motifs, and some fluting or hatching above and below. – STAINED GLASS. In the chancel E window, probably by *Evans*. – MONUMENT. Large standing wall-monument, of a period not otherwise well represented in the county. Sir Richard Leveson † 1661 and his wife † 1674. Two reclining figures, he above and behind her. He is in his robes, she in a shroud. Large columns l. and r., putti standing outside them. Steep semicircular pediment and on the sides volute-like plain curves leading up to it.

The village lies immediately E and just below a rocky hill which screens it from the main road. On it the OBELISK, erected to commemorate George Greville, Duke of Sutherland, † 1833. The obelisk is 70 ft high.

LILLESHALL HALL. Built in 1829 for the same Duke of Sutherland by *Sir Jeffry Wyatville*. In large grounds and extending its impact to the S and N by means of long avenues. The house is not excessive in size. It replaces a preceding Leveson house. It is in the Tudor style, of fine whitish stone, with mullioned and transomed windows, and straight gables with finials. Porch tower of four storeys. Formal gardens below to the w.

LILLESHALL ABBEY, ½ m. SE of the village. The impressive ruins of an abbey founded c. 1148 by two brothers de Belmeis for Arroasian canons from Dorchester, Oxfordshire. The building is Late Norman to E.E. and makes an exquisite picture as one approaches it from the w. The w front of the church stands fairly high up, and through this monumental gateway, to call it what it appears today, one sees all along its 228 ft length and through the ruinous E window into the trees beyond. Plan with aisleless nave, crossing, two transepts, two square-ended chapels E of either, and a longer square-ended chancel, i.e. entirely the Cistercian plan of e.g. Buildwas. The chancel is wholly Norman, with tall round-arched windows, in two tiers where it projects and with flat shafts high up on corbels with scalloped capitals. They carried a vault (*see* the Buck engraving). The only later alterations are an E.E. recess in the S wall, round-headed on short shafts, and the E window which must once have been of five lights and in the Late Geometrical style. Very little remains to reconstruct its tracery. Norman also the crossing of which no architectural details are visible. Of the N transept little remains. The chapels off the s

transept, however, are there and show that they were groin-vaulted (or rib-vaulted). The transept itself was in two bays, with a large triple wall-shaft dividing it. At the w end of the nave a large unmoulded arch into what seems a chapel. More traces of building outside the N wall. The arch is on triple responds. Above it inexplicably sumptuous E.E. window, shafted inside with four orders. Opposite the doorway into the cloister. Cross-walls through the nave for rood-screens as well as pulpitum. At the w end a square bay is singled out by triple wall-shafts. The capitals are of the trumpet variety here, i.e. Transitional rather than Norman. The nave was vaulted, and the vaults rested on thin shafts starting high up. They look decidedly later than the rest. The w front also is at least in its upper parts E.E. The w portal is a fine, generously broad piece with three orders of piers with very defaced capitals. The capitals seem to have been early stiff-leaf however. Finely moulded arch – still round. Hood-mould of the richest filigree of stiff-leaf. The façade was tripartite with the side parts slightly projecting. Above to the l. some blank arcading with pointed trefoiled arches, i.e. no earlier than the mid C13. Similar arcading just recognizable in the centre part.

Now the conventual remains. The doorway from the nave 10b into the cloister has two orders of decorated shafts, spiral and a kind of vertical crenellation motif with triangular merlons. The responds between the shafts also decorated. Zigzag in the arch and the tympanum which rests on a segmental lintel. The same unusual design also in other doorways. The E range has not the normal arrangement of rooms. It is Norman, divided by flat buttresses. The first room may have originally belonged to the transept; for it opened to the E in an arch as large as those of the transept chapels. Then follows the Slype with a doorway with one order of shafts and a tympanum on segmental lintel. Inside, vault in two ribbed bays. The ribs are of different mouldings. After that the former Chapter House. A window to the w can still be recognized, but the room is open to the skies. The dormitory lay (as customary) above the E range. The w window *in situ* belonged to an adjoining room. In the s range (again as customary) was the Refectory. There were other rooms as well, proved by cross-walls and the fenestration to the w. Two doorways from the cloister, both again with segmental lintels. Large round-headed s windows. Below an odd small recess with a surround with Late-Norman-looking decoration and a quatrefoil opening to the outside. What was

it? The w part of the s range and the w range are devoid of architectural features.*

LINLEY

St Leonard. Standing on its own, in the trees, up a drive from the Hall. A fairly complete Norman church of nave and chancel, and w tower. The w tower is heavy and has some remarkable details round the bell-openings. They are of twin arches, set in recessed fields. Corbel-table below the top. Tiled recent pyramid roof. Inside the tower on the ground floor the chamber has its three Norman windows and its surprisingly substantial arch towards the nave. Big semicircular responds with capitals with volutes and beaded ornamental bands. Single-stepped arch. Nave with s doorway with the plainest imposts and a tympanum decorated with incised bands of zigzag. Blocked n doorway – curiously enough not in line with the s doorway – with an even more primitive tympanum: a 'green man', i.e. a demon with legs wide apart and stylized foliage sprays issuing from his mouth. Chancel arch again on the simplest imposts. The arch is completely unmoulded. Original n and s chancel windows. The e windows, according to Cranage, are c19. – Font. Norman, tub-shaped, with medallions framed by beading and filled with rosettes etc. Some of the medallions are connected by a face from which issue the bands round the medallions.

LINLEY HALL
1 m. n of More

1742 by *Henry Joynes* of London, surveyor of Kensington Palace. A very handsome Palladian stone house of moderate size. The s façade is only five bays wide. The l. and r. bays project a little and are crowned by pediments. Their windows on the principal floor have pediments too. The door between them to which a staircase leads up has an Ionic porch with a pulvinated frieze and pediment. This main floor is in fact the first. The entrance to the house is on the e side and the main floor is reached by an elegant staircase with late c18 iron railing. The doorway here has a Gibbs surround, and the stair-

* I am most grateful to Mr S.E. Rigold of the Ministry of Works for having looked through my account of Lilleshall and suggested alterations and additions.

case window above it is of the Venetian type. Tripartite semi-circular window above this. The ground-floor rooms are vaulted and represented in accordance with this character outside by rustication. Fine mid-c18 decoration in the Saloon, the principal room on the first floor. The fireplace did not originally belong to the house. Another good room to the w of the Saloon. The main room on the w front has a bow-window and some charming mid-c19 wallpaper.

Stone-built stable-block to the E with a two-storeyed s façade of nine bays with cupolas. Again a central doorway with Gibbs surround.

LITTLE BRAMPTON
½ m. NNW of Clunbury

3080

SIGN POST. Stone pillar with metal bands. The three directions are indicated by iron sheets, with the names of the places cut out. The lettering looks certainly more recent than the date of the erection of the post, which is 1800.

LITTLE DRAYTON see MARKET DRAYTON

LITTLE NESS

4010

CHURCH. Red sandstone. Nave and chancel in one. Bellcote. Norman s doorway with one order of shafts with many-scalloped capitals. Arch with four zigzags in the intrados. Remains of a Norman N window visible from inside. All much renewed. – FONT. Norman, circular, with a cable-moulding at the foot of the bowl. – PAINTINGS. German early c16 Triptych, in early c19 English frames. The pieces certainly ought to be better known. – CHANDELIERS. Two Georgian brass chandeliers. – PLATE. Chalice and Paten of 1565.

LITTLE STRETTON see CHURCH STRETTON

LITTLE WENLOCK

6000
Inset A

ST LAWRENCE. To a small church of nave and chancel, a w tower was added in 1667, and a new nave and chancel in 1865, converting the old church into an aisle and side chapel. The tower looks Perp with its battlements. The new nave is of

brick. In the new chancel a doorway into the old, clearly of
C18 form, i.e. a priest's doorway into the old before the new
existed. – FONT. Oval stone urn.

OLD HALL. Fragment of an Elizabethan mansion with mullioned
and transomed windows and gables, but inside predominantly
Early Georgian. Good staircase with fine twisted balusters.
Some signed heraldic STAINED GLASS by *W. Collins*, 1820.

LLANFORDA

2020

1½ m. SSW of Brogyntyn

Llanforda Hall was built in 1780. Only the stately STABLES
survive, now farm buildings. Square red brick front with
central archway. The angle bays raised and crowned by pyra-
mid roofs in the William Kent tradition. The ground-floor
windows here have pediments.

LLANVAIR WATERDINE

2070

ST MARY. 1854 by *T. Nicholson* (GR). – COMMUNION RAIL.
Made up of parts of the former screen. Boldly carved with
foliage, grapes, men and women, and also plenty of beasts –
deer, pig, rabbits, dogs, etc.

LLANYBLODWEL

2020

ST MICHAEL. Designed by the vicar, the *Rev. John Parker*,
c. 1847–50. The design is certainly absurd, but it impresses as
a demonstration of staunch individualism. Everything is in-
correct here, and little is beautiful. But the church cannot be
denied character, though that is admittedly a dim term of
praise. Octagonal W steeple, nearly detached from the church
and crowned by a stone spire of slightly swelling outline. N and
S walls with plenty of dormer-windows. Arches with a curly
cusping without period authority. Medieval are only the follow-
ing features of interest: the simple, tall and narrow Norman S
doorway, the Perp N aisle arcade of three bays, with simple
short octagonal piers, and the two Perp E windows. John
Parker vaulted his S porch with some wild wooden timber
ribs, including flying ribs, and built an equally wild West
Gallery. – FONT. Octagonal, with simple geometrical orna-
ment, probably *c.* 1660. – SCREEN. Much restored, but

essentially Perp, with one-bay divisions. – MONUMENTS. Sir John Bridgman, by *J. M. Rysbrack*, signed and dated 1752. Very large tablet, with long inscription in two columns (to use the printer's terminology), big volutes to the l. and r., a Rococo cartouche below, and a big urn flanked by volutes at the top. – Two tablets of 1719 and 1746 by *Thomas White* of Worcester (signed 'of Salop').

VICARAGE and SCHOOL. One group, only too obviously to *John Parker*'s design. The school has a steep gable into which a thin turret cuts viciously.

BRIDGE and HORSE SHOE INN. An extremely attractive and remote picture. The inn is timber-framed and probably of the C16, the bridge, narrow, of stone, with three arches, is of 1710.

BLODWELL HALL. In the garden an attractive stone-faced Summer House; early C18. Rusticated; arched entrance with pilasters with sunk panels and an open-mouthed face as a keystone. Pediment with shield and garlands.

GLANYRAFON. By *Neville Conder*, 1954. One of the few examples of good contemporary domestic architecture in the county. A graceful design making much use of screen walls for plants. Handsome oval conservatory. Living room, dining room, study, and conservatory are all spatially linked.

LLANYMYNECH

2020

On the Welsh border and below the steep cliffs of Llanymynech Hill, with an open view to the s across the Vyrnwy valley.

ST AGATHA. 1845 by *Penson*. A crazy demonstration of the neo-Norman fashion. The details are all Anglo-Norman, but the whole was no doubt inspired by Poitou. Grey stone with yellow stone and yellow brick trim. NW tower with porch under. Big angle buttresses and pyramid roof. Elaborate compositions of windows and arcading on the W and E ends. The windows all shafted, in an elephantine manner. – STAINED GLASS. E window with the monogram of *Wailes* and a date 1855.

LLANYMYNECH HILL. The higher slopes of the hill are honeycombed with the shafts and passages of the mines which were sunk to extract lead, copper, and zinc in Roman times. From this area too was probably derived the vast quantity of lime necessary for the construction of Viroconium. It may be possible, in fact, to identify Llanymynech with the Roman township of Mediolanum.

LONGDEN

St Ruthin. The few remains of a date earlier than the C19 are
as follows: the s doorway, probably of the C17, the roof which
also could be of that century, and the polygonal apse which,
although it now is a Victorian brick appendix to a stone church,
is at least a memorial to a polygonal apse which was there in the
late C18. – FONT. Baluster-shape, C18. – PULPIT. C18.

LONGDEN MANOR has recently been pulled down.

At the s entrance to the village an octagonal Victorian brick
GAZEBO.

LONGDON-UPON-TERN

St Bartholomew. Red brick, built in 1742. Further re-
modelled in the C19.

LONGDON HALL. The impressive, tall, and somewhat gaunt
fragment of a large Tudor mansion. Brick and stone dressings,
mullioned and transomed windows in two storeys, and gables
with mullioned windows. Also two big chimneybreasts with
star-shaped stacks.

AQUEDUCT. At Longdon in 1794 *Telford* carried the Shropshire
Union Canal over the river Tern by means of a bridge of iron
which is a trough square in section – the earliest cast-iron
aqueduct to be built.

LONGFORD
1½ m. sw of Newport

St Mary. Built in 1802–6. Red stone, nave and polygonal apse
and small w tower, all embattled. Wide lancet windows.

To the s of St Mary lies the OLD CHURCH of which only the
chancel is preserved. It is E.E. Its only interest is the large
monument inside. – MONUMENT. Thomas Talbot † 1686 and
wife † 1706. Standing wall-monument with large twisted
columns flanking an inscription plate. Two standing putti l.
and r. Segmental pediment. Original iron rails round.

LONGFORD HALL. By *J. Bonomi* 1794–7. A very personal
design, quite different from the normal run of the nineties,
that is the Adam–Holland–Wyatt style, and just as different
6ob from Soane. Square stone block, seven by four bays, two

storeys high, with continuous giant pilasters and a consciously heavy, Etruscan porte-cochère of four big Tuscan columns with pediment. Behind this frontispiece the entrance is a tripartite doorway with two Tuscan demi-columns and a tripartite semicircular window over. The doorway leads into a small Entrance Hall with a Grecian frieze and a small pedimented door-case with Tuscan columns through which the central Staircase Hall is reached. The staircase has a bronze railing. High above an oval lantern on elongated fan-like fluted spandrels.

LONGFORD
2 m. W of Market Drayton

6030

LONGFORD OLD HALL. Timber-framed house with a symmetrical front. Two gables and a dormer between. Widely spaced posts and little wooden decoration, but the chimney on the l. with the most elaborate diaper ornament in brick, in height two and a half diapers, and again two and a half smaller diapers. In width a half – three – and again a half.

LONGNER HALL
1½ m. NW of Atcham

5010
Inset A

By *John Nash*. The old house was taken down in 1803, and the new one replaces it. It is in a Tudor style, completely free in its grouping of elements. The entrance side has a porch taller than the rest and to its r. the large decidedly ecclesiastical-looking window of the staircase. To the r. of this side the Stables with a tall clock turret. Its upper storey is open and octagonal. The main fronts of the house face s and w. They are connected by a glazed colonnade with four-centred arches which runs round the corner. The *pièce de résistance* of the interior is the staircase hall. The stairs start in one flight and return in two. The church window (which has STAINED GLASS by *David Evans* – three large figures, one being Edward Burton who was buried here in 1558) is on the landing. The corridor and the low part of the staircase hall have fan-vaults, and above a pendant on the first-floor landing a semicircular balcony is ingeniously fitted in. A Gothic ceiling also in the main drawing room. *Humphry Repton* landscaped the grounds in 1803–4.

LONGNOR

4000

CHURCH. No more than a small chapel close to the original site of the hall and not far from the present hall, but a perfect example of E.E. architecture of *c.* 1260–70. Nave and chancel in one, and a late timber belfry. In the N and S wall single lancets, thin hood-mould carried on as a horizontal string-course. E window of three stepped lights with three uncusped circles. Such circles are typical of *c.* 1270. – BOX PEWS, dated 1723. – Also PULPIT and READER'S DESK, and SQUIRE'S and VICAR'S PEWS.

LONGNOR HALL. Built by Sir Richard Corbett in 1670. Plain quoined oblong with hipped roof, in the tradition of Coleshill. Red brick with stone dressings. Seven bays, two storeys, with, on the entrance side, a big shaped gable in the centre. This, the shaped heads of the dormers, and a few odd gothicisms must be C19 alterations. Over the doorway a segmental almost semicircular pediment, typical of a date about 1670. The pediment is on somewhat corpulent unfluted Ionic columns. The doorway to the garden has a segmental pediment and equally corpulent fluted pilasters. Entrance 54a Hall with wood panelling and doorcases with open pediments, triangular as well as scrolly double-curves. The Drawing Room with carving and door-surrounds characteristic of 1670. Splendid staircase with elaborate inlay work, even applied to the treads. Heavily moulded balusters with leaf decoration. Diagonal board covering the tread-ends. This is carved with laurel. The staircase is very similar to that at Powis Castle over the Welsh border and does not seem to fit into the space available at Longnor.

MOAT HOUSE. An interesting black-and-white house. Externally all post-and-pan. Inside there are remains of the former open roof of the hall, the embattled wallplate and arched braces on head corbels.

LOPPINGTON

4020

ST MICHAEL. Nave and chancel Dec, see e.g. the reticulated E window and the N doorway. W tower and S aisle Perp. The tower has diagonal buttresses and battlements, the S aisle a three-bay arcade with octagonal piers and broad three-light windows with four-centred arches. Plenty of head-stops, in one case two heads to one stop. Timber S porch, dated 1658.

Good nave and aisle roofs with collar-beams, plain braces, and ogee-curved wind-braces. Probably C17.

LOPPINGTON HALL. Tall, rather bare early C18 brick house of five bays and two and a half storeys. Parapet curving up at the ends. Doorway on Tuscan pilasters. A square SUMMER HOUSE on the garden wall.

THE NOOK. Pretty timber-framed house close to church and Hall.

At the S entrance to the village a CRUCK COTTAGE.

LOTON PARK
3010

The house has two different façades, that to the S Jacobean-looking, the opposite one to the N clearly Queen Anne. In addition there is a large SE wing attached at an angle, which was added in the 1870s. All these parts are of brick. To turn S is an odd thing for a Jacobean house to do, and there are indeed illustrations in existence at Loton Park showing that this side in 1792 had no gables and no porch, but a hipped roof and the doorcase and upper window as they still appear behind and above the porch. The doorcase has Ionic pilasters with rather bulgy volutes, and the steep pediment above the first-floor window carried by two Corinthian columns is most character-istic of a date c. 1670. So that was the house whose size some thirty or forty years later was more than doubled. The gables and some E and W additions, and also the porch, were, again according to illustrations at the house, added in 1838. The N front is of eleven bays and two and a half storeys. The half-storey is above the main cornice. Angles with evenly rusticated quoins. Above the cornice short pilasters instead with sunk panels. Parapet, partially with balustrade. Straight aprons below the first-floor windows. Doorway originally reached by open steps; it has a segmental pediment on pilasters. Saloon with panelling, penetrated by pilasters. Good fireplace. In two symmetrically placed rooms on the N side Jacobean-looking panelling. Does that indicate that the house of c. 1670 was H-shaped, not E-shaped?

LOUGHTON
6080

CHURCH. Nave, chancel, and bellcote. The church is dated 1622. Two-light windows, the lights with segmental arches. The chancel arch may incorporate some Norman bits; the

s doorway certainly incorporates C14 bits. – FONT with thick
baluster stem. – PULPIT and READING DESK. All C17, but
probably later than 1622.

LOWE HALL *see* WEM

LOWER SPOAD FARM *see* NEWCASTLE

4070
Inset B

LUDFORD

A village of great charm, leafy below Whitcliffe and connected
with Ludlow by the fine medieval BRIDGE (for which *see*
Ludlow, p.188).

ST GILES. Nave and chancel and short W tower. In addition
the Fox Chapel on the N side, with its mullioned and tran-
somed N window. The whole almost touching Ludford
House. The nave is Norman, as can be seen in the W window
now looking into the tower. The plain pointed doorway is
later. The chancel dates from *c.* 1300, including the double-
chamfered chancel arch. The Fox Chapel was established
c. 1555. – MONUMENTS in the chapel. William Fox † 1554 and
wife, brasses, the main figures 2 ft tall, separate groups of
small kneeling children below. – Edward Fox, *c.* 1610,
erected before his death. Like an altar, with the lid (which has
chamfered corners) supported by shapeless columns. –
Dorothy Charlton † 1658. Hanging monument with good
frontal bust in oval niche between the columns. – Sir Job
Charlton † 1697. Exceedingly conservative, with recumbent
effigy on a tomb-chest with Ionic pilasters. Back with semi-
circular top flanked by two vases.
ST GILES HOSPITAL. To the NE of the church. Founded
after 1216. Plain stone range of one storey.
OLD BELL. Partly timber-framed house of 1614, to the NE of
St Giles Hospital. The decoration comprises lozenges within
lozenges and cusped concave lozenges. At the bottom of the
garden by the river Teme the MILL, of stone with timber
gables, facing the Ludlow mill in Temeside across the river.
LUDFORD HOUSE. A picturesque group just S of the church.
The main range of the house is that immediately facing the
church. Here was the original principal entrance and the

Hall. The big chimneybreast of the hall fireplace is the main accent of this front. The ground floor of this and the adjoining garden (E) side is of stone, the upper floor timber-framed. The timber work on the N side indicates a Late Elizabethan or Jacobean date. The W range, towards the road, is entirely of stone and accentuated by four big sheer chimneybreasts and stacks. They correspond to the kitchen and offices. The house is now approached from that side through an archway and a spacious service courtyard. The details of the building history of Ludford House are by no means clear. The E front was remodelled in the C18 (for the doorway cf. one in Broad Street Ludlow). The main staircase belongs to the same campaign.

LUDLOW ARMS HOTEL. On Whitcliffe, ½ m. N. C17 timber-framing. The principal object of interest is the FIVES COURT, to the NW, a brick wall, about 35 ft high. Stone back with buttresses.

LUDLOW

ST LAURENCE. The largest parish church in Shropshire, 203 ft long and with a crossing tower 135 ft tall. Light pink sandstone externally much renewed, so that portions of the church look rather too smooth. Restorations by *Sir G. G. Scott* (1839–60) and *Sir A. Blomfield* (1889–91), the latter concerned with the S chapel and the tower. Nave and aisles, transept, chancel, and chancel chapels, and a long low N vestry. Ludlow church was never collegiate, but it possessed in the end about twenty chantry chapels and, therefore, must have had a large staff of priests.

The church to the eye belongs so prominently to the C15 that one tends to overlook what important earlier work there is. No important remaining work however is of before 1300. The only yet earlier details are a flat buttress just E of the porch, another at the S chancel chapel, and a round-headed recess inside the same chapel. These may well be connected in date with a document referring to alterations and enlargements in 1199. There are also some late C12 capitals and other fragments kept in the S chancel chapel. So the church about 1200 must already have possessed nave and chancel, S chapel, and S aisle. The contribution of the C13 appears minor in the picture of the church as it is now, though it includes the fine S doorway with one order of slim shafts and a finely moulded

arch. The inner order of the arch runs down the jambs in a continuous moulding. That looks late C13, as does also the cusped lancet window in an odd asymmetrical position in the chancel E wall (giving on to a small room behind the reredos), and the pointed trefoiled piscina in the S chancel chapel.

Of the Dec style much more remains, notably the N aisle, Herefordshire in style. W window of four lights with much ball-flower, and in the tracery head a circle containing a cinquefoil made of an unbroken wavy line. Ball-flower inside the window as well. The design is repeated in the six two-light windows on the N side. It is known from remains of heraldic glass that this aisle was built by Theobald de Verdon about 1316. Somewhat later the S doorway received its hexagonal porch, a typical conception of the Dec style. There is only one other hexagonal porch in England, at St Mary Redcliffe in Bristol, and there it can be dated about 1320–30. It fits entirely into the picture of Bristol work at that moment. At Ludlow the tracery of the porch has no ogees at all and looks rather like *c.* 1300–20. The porch is rib-vaulted inside, with ridge-ribs and a big boss. Is the date of all this indeed before Bristol? If not, i.e. if it is as late as *c.* 1330, then it would form part of more extensive alterations. The N transept with its four-light N and its three-light E and W windows is evidently Dec (though it was heightened later). The S transept has all reticulated tracery, i.e. must also be Dec. The E window of the S chancel chapel is again reticulated (much renewed) and so are the two westernmost windows of the S aisle.

But in spite of so much C14 work the character of the church is wholly Perp. To that style belong, as far as the exterior is concerned, the composition of W doorway with very tall nave W window of seven lights (the centre part into the foot of which the doorway reaches up still has reticulated tracery; so this may be late C14 work), the N chancel chapel, the vestry stretching out low along it, the chancel, the S chapel S windows, and the S aisle W and some S windows. The chancel windows are so tall that they have two transoms. The crossing tower is the final self-assertion of the C15 parish church. It is of a height to dominate the town from nearly everywhere, and to serve as a beacon for miles around. Very tall four-light windows with depressed arches and depressed Y-tracery. The motif is repeated on the bell-stage, even taller and with a transom, but mostly blank, as there are only small

14b

bell-openings. Blank-arcaded battlements, polygonal angle turrets carrying pinnacles.

Regarding the interior, the impression of the church is even more completely late medieval. Very tall nave with wide aisles. Tall Early Perp arcade with piers of a usual moulding (four shafts and four wide waves between; capitals only to the four shafts), later clerestory and low-pitched rich timber roof with tie-beams and many carved bosses. Heightening of the transepts. Chancel and heightened transepts of the glasshouse character which the C15 wanted. The walls inside the chancel below the windows have blank panelling. Four-part Sedilia. One wide arch to either of the chancel chapels. The roof is of the same type as in the nave, but even more enriched by carved bosses. Very tall crossing with piers of complex mouldings with shafts and waves between.

The following dates for the Perp work are known. The chancel stalls were made in 1447; so the chancel was complete then. The tower was built with contributions of the gilds of carpenters, smiths, butchers, bakers, tailors, dyers, and cordwainers. Dates of contributions are recorded for 1453 and 1470. In the parapet of the clerestory two names of burgesses are recorded who were bailiffs of the town in 1462, 1471, and 1479.

FURNISHINGS. As the church contains so much, a topographical arrangement is called for.*

CHANCEL. – REREDOS. Stone, Victorian, but with some ornamental bits and perhaps even some small figures which may be original. – STALLS. Made in 1447. The upper part Victorian, but the seats original and provided with an interesting and entertaining set of MISERICORDS. Amongst subjects the following may be mentioned. N: Falcon and Fetterlock, referring to Richard Duke of York, Lord of Ludlow; Fox in Bishop's robes preaching to the geese; Prince of Wales's feathers; Antelope chained, the badge of Henry VI; Mermaid; an ale-wife carried off by a demon. s: January (a man warming himself by the fire, and two killed pigs to the r.); Wrestlers; Ostler; Scholar. The poppy-heads on the s side have not only foliage but also a Pietà, souls held in a napkin by two angels, the Good Shepherd, St Peter, a bishop. – ROOD SCREEN. Of veranda type, two bays deep,

* PLATE. Two Almsdishes 1590 and 1660; two Flagons 1637; two large Patens 1709; two Chalices and Patens Elizabethan, but 1774. A Chalice and Paten 'older'.

with coving and cresting and pendants in the entrance vault. –
STAINED GLASS. Original, though much restored about 1828
by *Evans* of Shrewsbury. The W window has twenty-seven
small scenes from the life of St Laurence. The other windows
seem now almost completely of *c.* 1860. They have large
figures. – MONUMENTS. Sir Robert Townshend † 1581 and
wife. Two recumbent effigies. Tomb-chest with fluted Ionic
columns and in each panel between the columns two statuettes
under a round arch separated by a pilaster (N wall). – Edmund
Walter † 1592 and wife. Alabaster. Two recumbent effigies.
Tomb-chest with kneeling figures. Shallow back arch with
strapwork cartouche; ribbonwork in the spandrels. Columns
l. and r. and top achievement (S wall). Contemporary iron
railings with two iron flags. – Edward Waties † 1635, erected
by him 'in memoriall of himself', the usual type with two
kneeling figures facing each other across a prayer-desk. –
Ambrosia Sydney (daughter of Sir Henry Sydney) 1580.
Tomb-chest with a back wall with rather disjointed Renais-
sance motifs. – Theophilus Salway † 1760. Classical frame
like that of a window with pediment. Inside it a badly done
seated putto on a Rococo pedestal, and books, a skull and
bones, etc.

NORTH CHAPEL (Chapel of St John, the chapel of the
Palmers' i.e. Pilgrims' Guild). ALTAR CANOPY. Of wood, C15,
of a type typical of North Wales. – COMMUNION RAIL.
Elegant C18 work. – PANELLING. Of linenfold type, on the N
wall. – SCREEN. Tall, with coving and two-light divisions
with close panel tracery. – STAINED GLASS. E window, *c.* 1460,
story of Edward the Confessor and the Palmers (cf. West-
minster Abbey, Reredos). N windows, Annunciation, St
Christopher, Apostles. All rather coarse large figures, whereas
the E window has smaller scenes and more important canopy
work. – MONUMENT. Sir John Bridgeman † 1637 and wife.
Black and white marble. Attributed to *Fanelli* on the strength
of his work at Gloucester. Two recumbent effigies on a big
tomb-chest. Low back wall with a rich, well carved garland.

SOUTH CHAPEL (Lady Chapel). SCREEN. With one four-
light division on either side of the entrance. The central
mullion runs up into the apex. Coving and handsomely
decorated cresting. – STAINED GLASS. E window, with Tree
of Jesse, C14, but so much restored by *Hardman & Co.* in
1891 that it seems entirely of that date.

TRANSEPTS. SCREENS. To the N as well as the S transept;

simple. – ORGAN CASE. Handsome work of 1764 with Rococo ornament. – STAINED GLASS. Fragments of the C14 and C15 in the S transept E window. – MONUMENT. Dame Mary Eure † 1612 and her husband † 1616. Alabaster. Stiffly semi-reclining on her side.

NAVE AND AISLES. STAINED GLASS. Nave W window, 1860 by *Willement*, with kneeling Kings and large standing figures of Knights. – N aisle W window, also *c.* 1860. – N aisle, two easternmost windows, quite interesting work of 1886 and 1888, by *Hardman*. – MONUMENTS. Two identical, now empty recesses in the N wall of the N aisle. Tomb-chest with three very cusped quatrefoils, canopies, separated and flanked by ogee-headed niches.

ST JOHN, Gravel Hill. 1881 by *Blomfield*.

ST PETER (R.C.), Henley Road. 1936 by *G. Rinvolucci* (GR). In the Byzantine style, grey stone, with trefoiled E end and central dome.

CASTLE. Ludlow Castle was built about 1085 by Roger de Montgomery Earl of Shrewsbury or Roger de Lacy. In Early Tudor times it was specially favoured. Arthur Prince of Wales, elder son of Henry VII, died at Ludlow. In the late C15 the castle became the seat of the Lords President of Wales and their Court of the Marches. The castle enjoys an admirable position. The cliff falls steeply to the Teme on the W and the Corve on the N. That made it safe in the Middle Ages and makes its ruins picturesque now, especially as they appear from Whitcliffe on the Ludford side of the Teme. To the S and E there was originally a deep ditch. The castle is approximately a square, consisting of the Outer Bailey and, in the NW corner with a roughly semicircular S and E wall, the Inner Bailey. The wall of the Outer Bailey is late C12, except for the semicircular Mortimer's Tower on the W side which was added in the C13. The late C12 wall is specially well preserved on the E side. Here is the Outer Gatehouse which was deeper originally in the direction of the bailey. It had originally a pointed vault. To its S an Elizabethan range leans against the curtain wall. On the S side of the Outer Bailey is another range, detached from the wall. The E part of this was the Chapel of St Peter, first mentioned at the time of Roger de Mortimer in 1328. It has one remaining window with Y-tracery. The E continuation of the chapel is Elizabethan.

The Inner Bailey has much of its early C12 walls and several

early C12 towers. The view of the Inner from the Outer Bailey behind its deep moat is spectacular. It is dominated by the early C12 Gatehouse-Keep. This type of keep is relatively rare, but other examples exist, e.g. Newark Notts., Richmond Yorks., and Rougemont Castle Exeter. This high, four-square building has a few Norman windows left. Inside, the ground floor which was the gateway has fragments left of its former blank wall-arcading with colonnettes and primitive capitals. It had no doubt originally a tunnel-vault. The present pointed tunnel-vault is later. Above this ground floor the present first and second floors were originally one. On the first floor the principal room is flanked by smaller apartments to the E and W, both vaulted. The keep was originally deeper in its northerly direction than it is now. Its N end was cut off in the C15 and a new cross-wall built. Before that time, however, in the C14, or perhaps even the late C12, it had been found unsafe to combine the function of gatehouse and of keep. So the keep was blocked to the S. In the C14 a new entrance was made to the E of the keep. The same happened at about the same time at Dunstanburgh in Northumberland. Inside the C14 entrance is an elaborately decorated C15 doorway leading to the C15 staircase of the shortened keep. To the E of the C14 entrance lies the building erected in 1581 by Sir Henry Sidney, President of the Council of the Marches. One of the Elizabethan gables is above the C14 entrance. Mullioned and transomed windows. Polygonal stair-turret towards the Inner Bailey. In the SW corner of the Inner Bailey is an early C12 tower, inside converted in the C14 into a large room. The castle well is N of this tower and E of another early C12 tower. From this tower an early C13 wall runs due E and then turns S towards the S wall of the Inner Bailey just E of the Keep. Leaning against the N side of this wall was the square kitchen-building projecting irregularly into the court. It dates from the early C14.

7b Equally irregular is the position of the CHAPEL. This has the utterly uncommon distinction of a circular nave. No convincing reason for the choice has yet been put forward. The chancel is pulled down, but its outline with its polygonal apse are marked in the ground. The chapel is crenellated. Its date must be about 1140; W doorway with two orders of shafts. Ornamented scallop capitals, much zigzag in the arches. One W, one N, and one S window, nook-shafted. Inside blank arcading with zigzag. Above corbels (three with heads, one

like a C13 moulded capital), according to St John Hope re-cased for an Elizabethan upper floor. Chancel arch of three orders of shafts to the w. The same motifs as in the doorway, and in addition much chip-carving especially in the innermost intrados.

Finally the N or HALL RANGE, even in its ruined state giving a vivid idea of the splendour in which life could be lived in a castle as early as the early C14. The hall itself lay between two tower blocks to the l. and r. It is recognizable by the two tall two-light windows with transom and cusped Y-tracery. The doorway is at the l. end of the facade, the fireplace between the two windows. Fine continuous moulding of the doorway. As one enters, one sees that the Hall had a basement below (unvaulted) and another floor above. One also sees several doors on the l. These led off the former screens passage and must have connected with the offices. A wooden gallery probably linked them with the detached kitchen building. A spiral staircase from the N end of the screens passage led up to a large living room, perhaps the Solar. This has windows of two lights like those of the hall and a large fireplace. The block is attached at its NW corner to the early C12 NW tower of the castle. A curious feature of this is on the first floor a 3 ft-wide passage with tunnel-vault all round its three outer sides. The hall has on its N side three of the same tall windows as to the S, and in the NE corner is the small doorway to the upper storey. In this hall Milton's *Comus* was first performed in 1634.

To the E of the hall stands another tower block. This must have contained the most important living rooms of the C14. There are two, one above the other, the lower standing on a ground-floor room of the same size. Both upper rooms have good fireplaces. The better of the two has a big projecting hood and two brackets l. and r., with foliage and a head. Windows of different dates. N of the Solar the garderobes in a projecting oblong tower. More Elizabethan re-management E of Parlour and Solar, including a spiral staircase and a brick chimney with star-shaped stacks.

PUBLIC BUILDINGS *see* Perambulation.

PERAMBULATION

Ludlow is a town which grew in the shadow of a castle soon to be one of the strongest of the Welsh Marches, and of a church

which by the end of the C12 had almost the extent of the present
2a church. The town lies on a hill, and in the late Middle Ages the
view of the two accents of the church with its arrogantly high
tower and the castle still standing to full height in all its parts
must have been overwhelming as travellers arrived from the s or
the N. The two accents demonstrate the sources of Ludlow's
prosperity, the castle, later seat of the Council of the Marches of
Wales, and the church, built almost entirely by the burgesses of
a town wealthy by its cloth trade and other trades. Stokesay
Castle, it must be remembered, was built by the son of a Ludlow
clothier.

Ludlow is a planned town. In its s half the pattern is at once
discovered, a grid of streets, the important ones running down
the hill to the s, the connecting lanes running E–W. The grid
started from the High Street line from the castle to the Bull
Ring, a line obscured in the late Middle Ages by island building
which converted the wide street into a number of narrow
parallel lanes. The plan seems to belong to the early C12. The
walls round the town were begun in 1233. They run along a
clearly discernible line on the s side, with Broadgate still
standing, then turn N at the foot of Dinham (former Dinham
Gate), run along the N side of the old town from the castle past
the churchyard to the N and the Bull Ring (former Corve Gate),
and then along the E side behind Bull Ring and Old Street.
They are now best visible at the foot of Old Street.

Aesthetically speaking it was a blessing that the old High
Street was filled in by later medieval building. The town, as one
wanders through it, has now a narrow and a spacious part, a part
where the eye looks unimpeded along wide streets or from houses
over extensive back gardens, or from the churchyard immediately
into open countryside, and another part with lanes and arches
and close backyards. Both are needed in a town, and may
Ludlow never decide to pull down its tortuous centre to please
the gentleman motorist or the charabanc tourist. Gordon Cullen
has illustrated this warning better than my words could.

The hub of the town is the BUTTER CROSS, a curiously out-of-
date name for *William Baker*'s effort (of 1743–4) of a classical
town hall for Ludlow. His architecture is not polished, but it
has an attractive robustness. Stone, three bays wide, with a
low portion of four Tuscan columns and a pediment in front
of the middle bay. Semicircular window above. Top balus-
trade, clock turret with volutes l. and r. of the clock, and
cupola. The ground floor is open, and the views down Broad

Street into the open as well as to the N against the close frontages in Church Street are equally effective.

To the N is indeed the first direction to explore. There is the CHURCHYARD with, E of the church, the READER'S HOUSE, an extremely picturesque piece of Ludlow black-and-white. The stone ground floor is partly of the C13 or C14 and belonged to the Church House. Pretty porch with two overhangs dated 1616. Open sides on the ground floor, with balusters. The motifs of the decorative timbers are found again and again in other houses, especially lozenges within lozenges, made of diagonal strutting, and concave-sided lozenges in the gables. On the W side of the church is COLLEGE STREET. At its N end the RECTORY with a C15 stone ground floor and roughcast timbers above, then, at the back of the hospital, the quadrangle of the PALMERS' GILD, with C18 windows. The stone parts of the Rectory may be older parts of the gild premises. Yet further S HOSYER'S ALMSHOUSES, founded 1486 and rebuilt 1758, red brick, two-storeyed, with two projecting wings. Seven-bay centre with three-bay pediment containing a Rococo cartouche.

Back S to the Butter Cross and now to the E along KING STREET. There is little here except the splendid overhang of the timber-framed house at the beginning which belongs to Broad Street, and one Victorian abomination. The area immediately E of King Street is hard to describe. It is all BULL RING, but does not seem one street or square, because it is trumpet-shaped, has two islands, and turns N at its E end. The best buildings on the W–E stretch are on the S side, No. 45 and the adjoining OLD BULL TAVERN. Here another black-and-white motif is first met which Ludlow liked, concave-sided lozenges cusped or spiked. The Old Bull consists of a two-storeyed and a three-storeyed gabled part. Nos 50 and 51 on its island site was originally the Tolsey and had an open ground floor and an outer staircase. Central part on the ground floor and radiating beams. As soon as the Bull Ring has turned N, there is on the r. side that prodigy of timber-framed houses, the FEATHERS HOTEL of 1603. Here 48b everything of motifs that was available has been lavished on the façade. In addition, on the first floor along most of the façade runs a balcony with flat openwork balusters. Lozenge pattern on the first floor, cusped concave lozenges on the second. Three bay-windows and three gables, but the l. bay and gable projecting further than the others. Asymmetry surely

was applied here for an artistic reason and not either for a utilitarian, or just by chance. Inside, panelling, a rich plaster
53 ceiling with broad bands decorated with vine scrolls, framing panels of vine, rose, oak, and thistle scrolls. Also two elaborate fireplaces. Opposite the Midland Bank of 1905 as a warning how not to imitate black and white. The National Provincial Bank a little lower down, on the other hand, is a tactful imitation. On its l. the BULL HOTEL with a discreet early C19 front, but a charming two-storeyed timber back-range in the courtyard. Ludlow was a town of coaching inns.

Bull Ring is continued N in the wider CORVE STREET. As in all the outer main streets of Ludlow, stately Georgian brick dominates over timber, e.g. No. 9 of six bays with two identical doorways side by side and Nos 14–15 of five bays and three storeys. However, the speciality of Corve Street is that lower down again timber-framed property survives. The first house to be noted in Corve Street is STONE HOUSE on the r., a surprisingly urban three-storey house with a front of c. 1840. Three bays with giant pilasters starting at first-floor level. Opposite this the GATEWAY to the former Carmelite house of Ludlow, founded in 1350. Then on the same side FOXE'S ALMSHOUSES, low two-storeyed stone front of 1593, with four entrances, heavily restored. Nos 103–104 opposite are quite ornate timber-framing with the usual Ludlow motifs. After that, and after the turn of the main Shrewsbury Road, Nos 46–50 black-and-white, No. 50 with a gable, behind No. 58 the OLD CHAPEL, a small plain rectangular brick building with a segment-headed E window. Probably early C18. Even as far out as No. 69 there is still a three-storeyed timber-framed house. At the end of Corve Street is the CORVE BRIDGE, probably late C18, ashlar, with three semicircular arches.

Back now to the Bull Ring and due E, down TOWER STREET, where on the l. the former GAOL, built in 1764, with a gable like a steep pediment. Doorway on the ground floor, just two windows on the first, oval niche in the gable. Then through Upper Galdeford and Gravel Hill to LIVESEY ROAD. (Here ST JULIAN'S WELL with a crude stone cover of pediment shape. MHLG.)

Back again to the Bull Ring and S down OLD STREET. It starts in the narrow tangle of the Bull Ring and then at once widens to a generous size. Its course is a gentle curve down the hill. In Old Street No. 14, the TOWN PREACHER'S HOUSE of

c. 1611 with two gables, two canted bays and the usual lozenges within lozenges, and cusped concave lozenges above. Lower down the CONGREGATIONAL CHAPEL of 1830, brick, lying back from the road, and then LANE'S CHARITY, again timber-framed and gabled. Inside an ornamented plaster ceiling. No. 69 at the s end seems to be part of a tower on the town walls. These were built from 1233 through the C13. To the r. in ST JOHN'S ROAD, opposite No. 20, remains of another wall-tower.

Back once more to the Bull Ring and the Butter Cross and now straight to the s and down BROAD STREET, one of the most memorable streets in England. It is wide with pavements raised by a cobbled incline. The houses start on the r. with an urban rounded corner, probably *c.* 1840, and on the l. with an improbably lucky survival of timber-framed houses on 'piazzas' (Nos 1–13). The first at the corner of King Street has two bold overhangs with most effective dragon-beams.* No. 2 has two gables with finials; C19 bargeboards. Nos 3 to 7 all have narrowly placed upright posts only. Nos 3–4 have far-projecting oriels. The ANGEL HOTEL also has bold oriels, but they are bow-shaped and of the C18. Opposite more modest Georgian properties, then a painful jog with the METHODIST CHURCH, Italianate of 1878, and another with the pretentious imitation-Tudor of Lloyds Bank again on the l. Lower down No. 49, C18, four bays, two and a half storeys, brick with rusticated angle pilasters and a parapet with vases, and No. 51, of five bays, with a remarkably ambitious wooden porch of *c.* 1750–60 almost identical with that on the e front of Ludford House. No. 53 is again early C17 black-and-white. On the other side No. 27 is a stone house with an Early Georgian front and a castellated gazebo in the garden. Pretty Gothick first-floor window in the gazebo. At the s end of Broad Street bigger and more spacious Georgian brick houses, e.g. No. 39 with all Venetian windows, Nos 38 and 37 with nice doorcases, and so on to BROAD GATE, a C13 gate with two semicircular towers and, built over it so as to close the vista down Broad Street most effectively, a plain but castellated C18 house. Castellated low-pitch gable over the gateway. Broad Street is continued in LOWER BROAD STREET which, coming up from the Bridge, one finds equally successfully closed by the gate with its narrow passage rousing curiosity, and in this case, the Wheatsheaf Inn on the r. of the gate,

* There is a king-post roof inside (information given by Mr S. E. Rigold)

exhibiting a Gothick ogee-headed window. Little of note in Lower Broad Street till the bridge is reached. Before looking at it, a few things ought to be noted in the side streets which connect Broad Street with Old Street to the E and Mill Street (cf. below) to the W. They are Brand Lane and Bell Lane, and crossing Bell Lane RAVEN LANE which runs parallel with Broad Street and Mill Street, but is narrow and subsidiary. In it, however, one good black-and-white house, Nos 14–15. As for BRAND LANE, it ought perhaps to be said that even there quite ambitious Georgian houses were built, such as Brand House, and Garth House, one of seven the other of five bays.

LUDFORD BRIDGE is of the C15, ashlar, of three arches with triangular breakers. At the corner of Lower Broad Street and TEMESIDE, facing the bridge, is the surviving fragment of ST JOHN'S HOSPITAL, a tall pointed arch belonging to the chapel. To its r. some lower black-and-white work. Also in Temeside the OLD MILL, disused, with an overhang of 5 ft over the river.

The last perambulation from the Butter Cross starts to the W. This is where originally the broad High Street ran straight to the Castle. Now there are four streets or lanes instead, the main one being still called HIGH STREET. In it little of note, except for No. 1a, a good four-storeyed timber house, and No. 2, also timber-framed. Market Street is a back lane S of the High Street, Harp Lane a back lane N of it, but CHURCH STREET, equally narrow, has more to offer. It starts behind the Butter Cross, crosses under a brick arch, and passes the ROSE AND CROWN INN with its timber-framed courtyard and then QUALITY SQUARE which is another courtyard, but older and now with not very telling stone buildings.

All these streets abut on to Ludlow's bad luck, the MARKET HALL of 1887 by *Harry A. Cheers* of Twickenham. There is nothing that could be said in favour of its fiery brick or useless Elizabethan detail. To its N and S and then its W Castle Street and Castle Square go on to the Castle. On the N side No. 14 CASTLE SQUARE, lying back behind a front garden, has rainwater heads with the date 1728. Five bays, two and a half storeys, segment-headed windows, quoins, broad doorcase with fluted Doric pilasters and a segmental pediment. Then the GIRLS' HIGH SCHOOL with a pretty staircase and an octagonal gazebo in the garden, looking down to the Teme. Opposite two buildings of note, the Picture House and

Castle Lodge. They flank the entrance to Mill Street. The
PICTURE HOUSE was built as the Public Rooms, Museum,
and Court House in 1840. Handsome five-bay front to both
Castle Street and Mill Street, with giant pilasters. Behind, in
Mill Street, the lower front of the Museum. (In it neo-
Egyptian cases for exhibits. MHLG.) CASTLE LODGE has a
C14 stone ground floor and overhanging C16 timberwork
above.

In MILL STREET Nos 56 and 55 are typical examples of early
C18 brick architecture with segment-headed windows. Then
the GUILDHALL of the Palmers' Gild, built in the C15 and
given its exceedingly pretty Gothick doorcase in 1768 (triple
shafts with shaft-rings, frieze with quatrefoils – all a classical
conception turned Gothic). The hall inside the Guildhall has
its original C15 roof with cusped slanting queen-posts. Brick
coach-house with cupola to the l. Lower down the GRAMMAR
SCHOOL, partly a C14 hall. Doorway with depressed two-
centred arch, ogee-headed cusped windows. Original roof
with tie-beams and a second tier of tie-beams added probably
when the school heightened the hall to house a dormitory.
This seems to have been done about 1600. The school moved
to the site in 1553. In Side Lane another formerly private
hall, Barnaby House, now partly the school gymnasium. This
may date from c. 1400. The hall here has a good roof too, with
cusped wind-braces. In a room on the first floor Early
Renaissance wall decoration of c. 1580. Another range faces s.
This has a lancet window on the N side and a doorway with a
shouldered lintel on the s side. Turn here; by Camp Lane the
foot of Dinham can be reached.

DINHAM BRIDGE is of 1823, four arches long. In DINHAM
the most interesting building is the isolated fragment of the
former CHAPEL OF ST THOMAS OF CANTERBURY. Stone
with arches on the ground floor of late C12 detail and windows
on the first floor, made up picturesquely in the C18 or C19.
Large W arch and large N arch, both blocked. Inside vaulted
with single-chamfered ribs. Opposite two spacious brick
houses, Dinham Lodge, brick, of five bays and two and a half
storeys, with a nice doorcase, and Dinham House of nine bays,
plainer. Then Dinham turns and becomes the s and sw foil to
the castle walls. Promenade of trees between the walls and
the street. Of the houses the following deserve a word: Nos
14 and 13 timber-framed, No. 11 C18 with a doorcase with
Gibbs surround, Nos 2–4 timber-framed and decorated with

the usual lozenges within lozenges and cusped concave lozenges, and finally – a parting shot – No. 1, a High Victorian shocker, of multi-coloured brick with a timber-framed gable too tall to be in scale – and at the very corner of Castle Square.

LUDSTONE HALL

8090

A Jacobean house of great charm, built by John Whitmore.
44b Brick with stone dressings. The entrance side has a recessed centre with a semicircular bay in its middle coming out nearly as far as the broad side wings. Large broad shaped gables over these as well as the centre. The windows are mullioned and transomed, and those in the gables have the two middle lights considerably raised and connected with the outer lights by volutes. The middle one of these three windows leads on to a balustraded balcony which forms the top of the bow-window. The house is surrounded by a moat and has a beautifully kept garden. Entry to the house is by a doorway which leads from the inner side into the l. wing. The hall was originally lit from both sides. Its ceiling is not original, nor is the wooden screen, though this seems to consist largely of Jacobean materials. The overmantel, however, with its big strapwork cartouche is similar to others in the house and probably unaltered. In a smaller room is an overmantel with the story of Joseph and Potiphar's wife and caryatids l. and r., all done rather rustically. An interesting motif is the three big bosses of opaque glass in the overmantel of the chamber above the hall. They form the centre of a strapwork cartouche. The adjoining room has a frieze of plaster also with such glass bosses. Good panelling in the Drawing Room, with decorated pilasters. Staircase with flat cut-out tapering balusters.

1090 LUTWYCHE HALL (WENLOCK EDGE SCHOOL)
¾ m. sw of Easthope

Brick mansion of 1587. Originally on the E-plan. But the space between the wings was filled in by a mid-c18 hall with fine plaster decoration. The hall was then given Victorian Jacobean trim of a nature to outdo the old Elizabethan work. The window details also were altered. The Victorian work is by *S. Pountney Smith.* Nice mid-c18 staircase with three fine twisted balusters to each tread.

LYDBURY NORTH

St Michael. Quite a large church, of nave and chancel, two long transepts, known as the Plowden (N) and Walcot (S) chapels, and a very heavily propped w tower. Norman evidence one window in the N, one in the S side of the nave, three windows in the chancel N and one in the chancel S side. Here also a Norman doorway, oddly ambitious for a priest's door. One order of shafts, the capitals decayed but probably with rather late upright leaves. In the arch zigzag in the intrados. That also is a sign of late date, say c. 1175–80. The larger size of the chancel windows as against the nave windows would tally with such a date and indicate that the present chancel was built later than the nave. Then came the tower. This is early C13 to the corbel-table, with pairs of lancets as bell-openings. Later battlements. Good pointed tower arch towards the nave. Single-chamfered, but the capitals of the responds still multi-scalloped with a little decoration. The N transept has windows of c. 1300 or a little later, but a Norman arch to the nave. So the Norman church seems to have been cruciform. The windows of the S transept are all C19. The upper room above this transept used to be the schoolroom. Handsome timber S porch probably of Late Perp date. Four-centred arch with leaf in the spandrels and a castellated beam. Wavy barge-boarding. Rebuilt in 1901 in connexion with the thorough restoration carried out by *J. T. Micklethwaite*. His unaided work is the S transept arch. Nave roof with collar-beams on arched braces, one tier of wind-braces arranged in quatrefoil patterns. – PULPIT. Dated 1624. – SCREENS. The rood-screen is much restored. Wide one-light divisions with fine curved tracery heads. The upper part of the dado is pierced in pretty little pointed quatrefoils. – The screen to the N chapel is a sturdy utilitarian piece, probably c. 1500 or later. – BENCHES. Jacobean box-pews, much restored and added to. – PAINTING. As a tympanum above the rood-screen painted Creed and Commandments, dated 1615, and still written in black-letter. – CANDLESTICKS. Two very rare wooden, baluster-shaped candlesticks of c. 1640. They were set up instead of images on existing brackets l. and r. of the altar.

Red House. Tall brick house with two projecting wings. Late C17 probably. Gables over the wings. The present fenestration Georgian. Attached to the house is an octagonal COCKPIT with pyramid roof.

LYDHAM

HOLY TRINITY. Nave and chancel in one, and bellcote. C13, restored in 1642 and largely rebuilt in 1885. Four windows in the S wall are of 1642. They are entirely Gothic in style, their details vacillating between Dec and Perp. C13 trussed rafter roof in the chancel, roof with collar-beams on arched braces and one tier of quatrefoil wind-braces in the nave. – PULPIT. Plain Jacobean.

LYNEAL

ST JOHN EVANGELIST. 1870 by *Street*. An avenue leads to the church, which is placed beautifully with a W view towards a tree-lined mere. Biscuit-coloured stone with a few red bands. Nave and chancel, and bellcote at their junction. Geometrical window tracery. The interior is dignified and peaceful, with the beautiful stone exposed and a simple trussed rafter roof. Low stone screen and pulpit as one composition, as Street liked it. – The PULPIT is circular and the walls are of pierced pointed quatrefoils set in lozenges. – The REREDOS no doubt is also *Street*'s. Triptych with a carved Crucifixion in the middle, and side panels of tiles showing corn and vine in vases.

LYTHWOOD HALL *see* BAYSTONHILL

MADELEY

ST MICHAEL. 1796 by *Thomas Telford*, the engineer. Ashlar-built. Octagonal with a square W tower. The tower has an arched entrance, an arched window over, then a pediment, and then the square free-standing upper stages. Parapet. The body of the church has two tiers of windows. The projecting chancel is an unfortunate addition of 1910. Its Venetian E window however represents an original E window of the chancel-less church. The interior is not octagonal. The vestries cut off two triangles, so that the nave is oblong and followed by a narrower chancel. Three galleries with columns in two tiers, Tuscan below, attenuated Adamish above. – MONUMENTS. Of the great monument to the Brooke family of Madeley Hall only four large kneeling figures remain. They kneel frontally

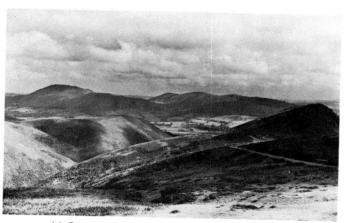

(a) *Scenery:* Caer Caradoc and Hope Bowdler Hill

(b) *Scenery:* The Stiperstones. Old Lead Mine near Shelve

(b) *Townscape*: Grope Lane, Shrewsbury

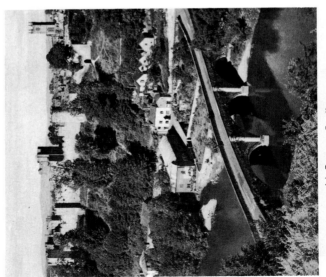

(a) *Scenery*: Ludlow

2

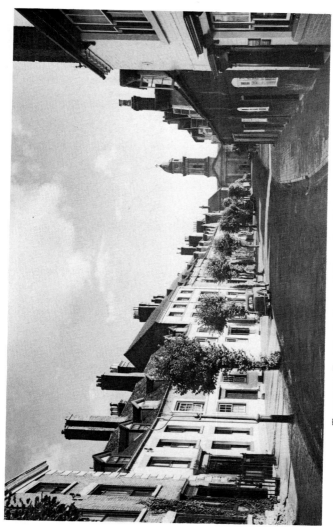

Townscape: East Castle Street, Bridgnorth, with St Mary Magdalene

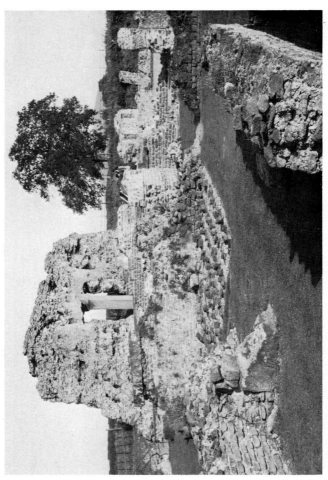

Roman: Wroxeter

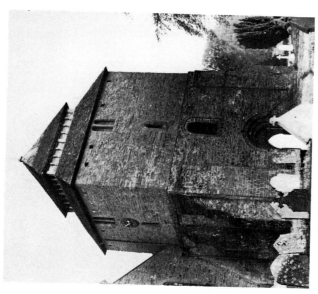

(a) *Early Norman*: Shrewsbury Abbey, the arch between north aisle and transept, *c.* 1100

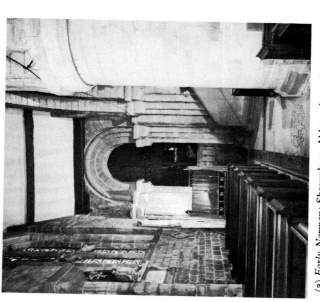

(b) *Early Norman*: Clun, west tower

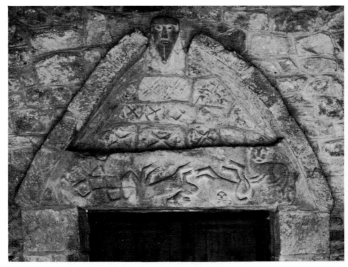

(a) *Norman:* Stottesdon, the tympanum

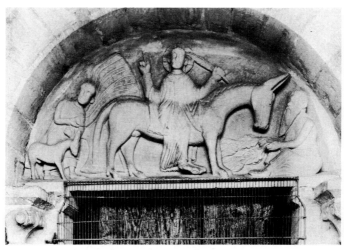

(b) *Norman:* Aston Eyre, the tympanum

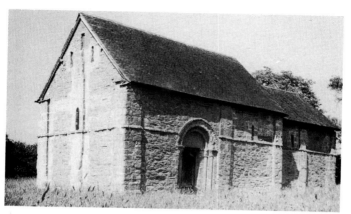

(a) *Norman:* Heath Chapel

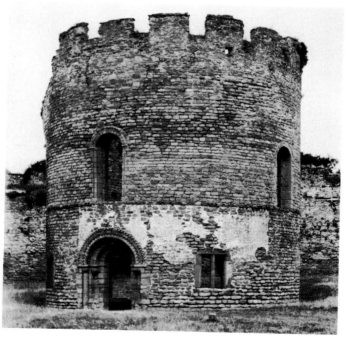

(b) *Norman:* Ludlow Castle, the chapel

7

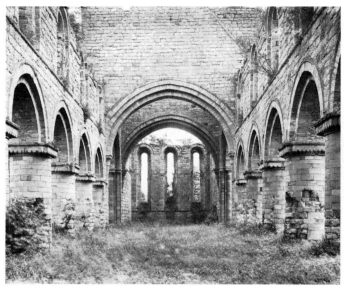

(a) *Norman:* Buildwas, the nave, view towards the chancel, after 1147

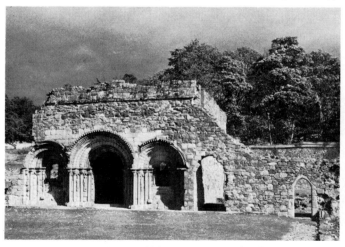

(b) *Norman:* Haughmond Abbey, entrance to the chapter house, late twelfth century

8

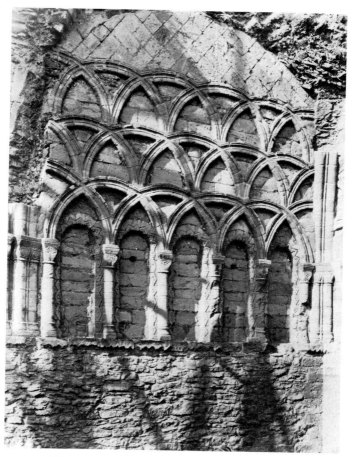

Norman: Much Wenlock Priory, the chapter house

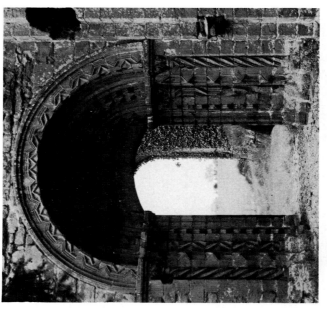

(a) *Norman*: Edstaston, the south doorway

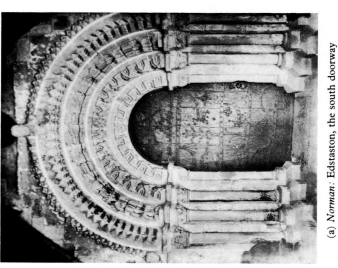

(b) *Norman*: Lilleshall Priory, the south doorway

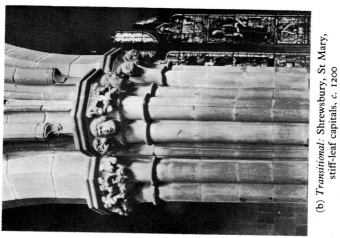

(b) *Transitional*: Shrewsbury, St Mary, stiff-leaf capitals, *c.* 1200

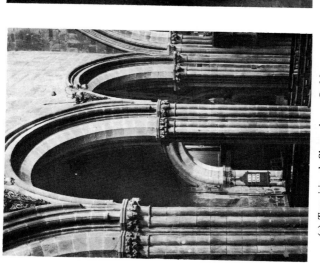

(a) *Transitional*: Shrewsbury, St Mary, *c.* 1200

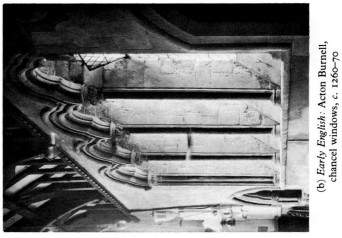

(b) *Early English*: Acton Burnell, chancel windows, c. 1260–70

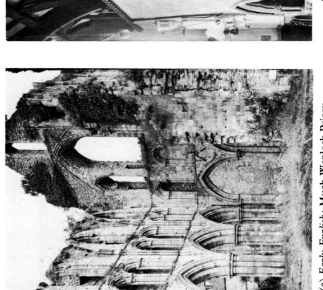

(a) *Early English*: Much Wenlock Priory, the transept, early thirteenth century

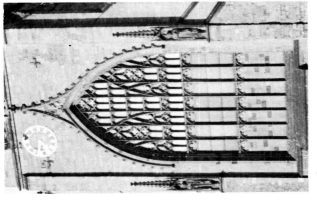

(b) *Perpendicular*: Shrewsbury Abbey, west window

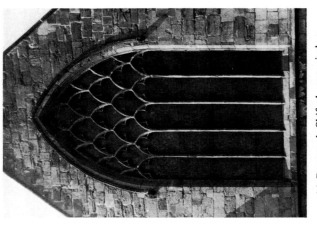

(a) *Decorated*: Shifnal, east window, *c.* 1300–10

13

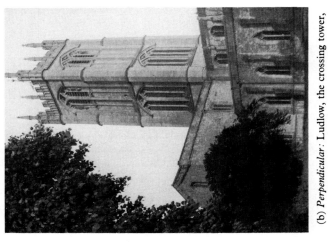

(b) *Perpendicular*: Ludlow, the crossing tower,
c. 1453–79

(a) *Perpendicular*: Hopesay,
the open timber roof

14

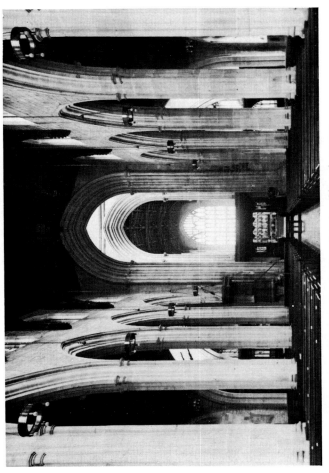

Perpendicular: Ludlow, interior, fifteenth century

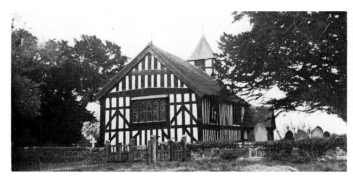

(a) *Perpendicular:* Melverley

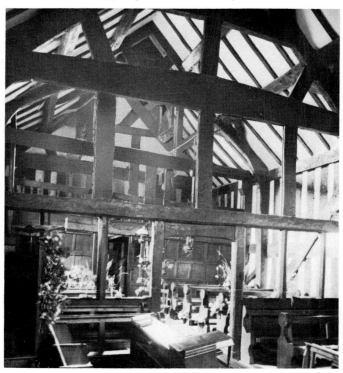

(b) *Perpendicular:* Melverley

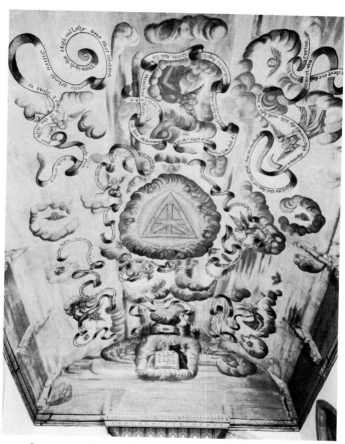

Seventeenth-Century Churches: Bromfield, the ceiling, 1672.
Copyright Country Life

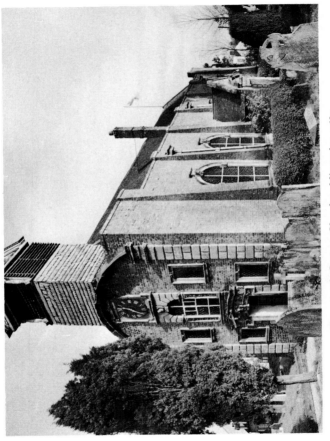

Seventeenth-Century Churches: Minsterley, 1689

18

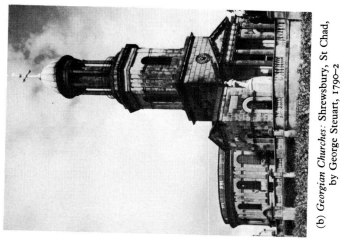

(b) *Georgian Churches*: Shrewsbury, St Chad, by George Steuart, 1790–2

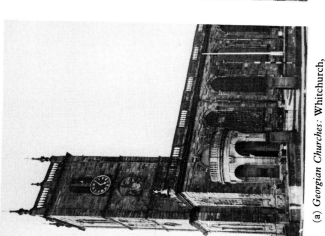

(a) *Georgian Churches*: Whitchurch, 1712–13

Victorian Churches: Oakengates, by G. E. Street, 1855

Victorian Churches: Batchcott (Richards Castle), by R. Norman Shaw, 1891–2

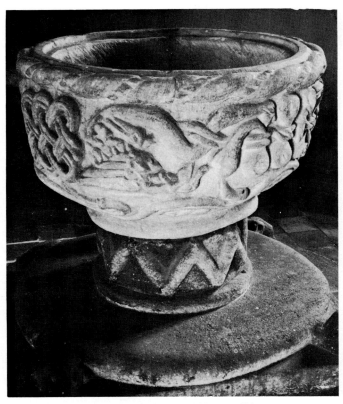

Church Furnishings: Holdgate, font, twelfth century

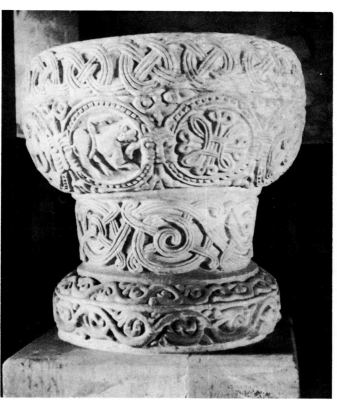

Church Furnishings: Stottesdon, font, *c.* 1160

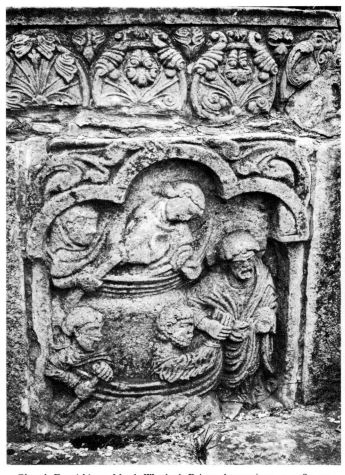

Church Furnishings: Much Wenlock Priory, lavatorium, *c.* 1180–90

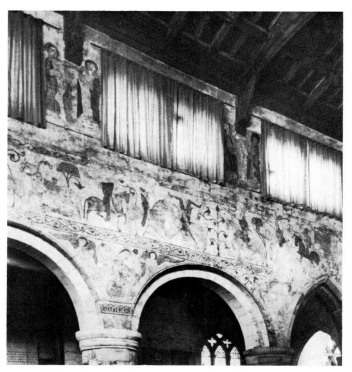

(a) *Church Furnishings:* Claverley, wall paintings, *c.* 1200

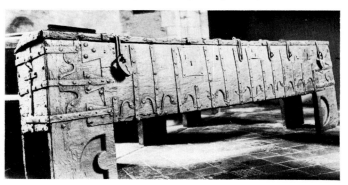

(b) *Church Furnishings:* Bitterley, chest, thirteenth century

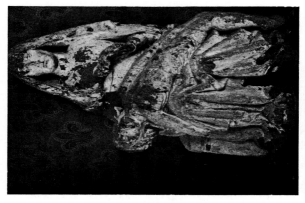

(a) Shrewsbury Abbey,
the refectory pulpit, early fourteenth
century. *Copyright Country Life*

(b) Battlefield, Pietà,
fifteenth century

Church Furnishings: Ludlow, misericord, c. 1447

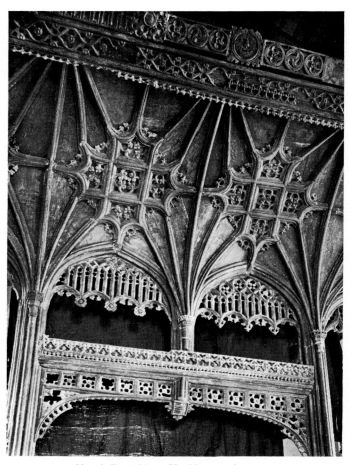

Church Furnishings: Hughley, rood screen,
fifteenth or early sixteenth century

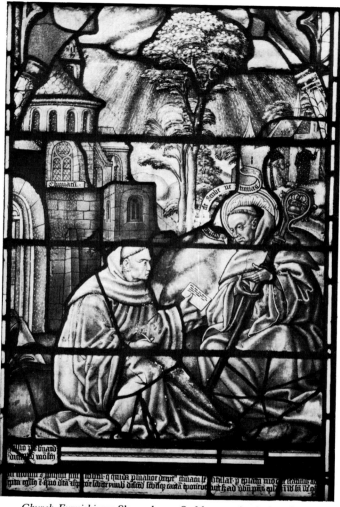

Church Furnishings: Shrewsbury, St Mary, stained glass from Altenberg near Cologne, early sixteenth century

(b) *Church Furnishings*: Easthope, hour glass, copy of the original of 1662

(a) *Church Furnishings*:
Tong, cup and cover, *c.* 1540–50.
Copyright Country Life

30

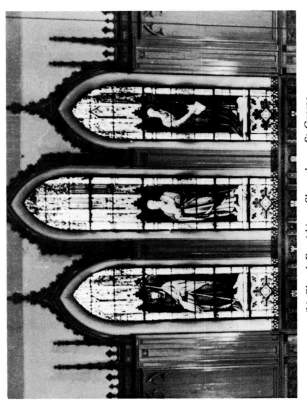
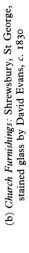

(b) *Church Furnishings*: Shrewsbury, St George, stained glass by David Evans, c. 1830

(a) *Church Furnishings*: Shrewsbury, St Alkmund, stained glass by Francis Eginton, 1795

31

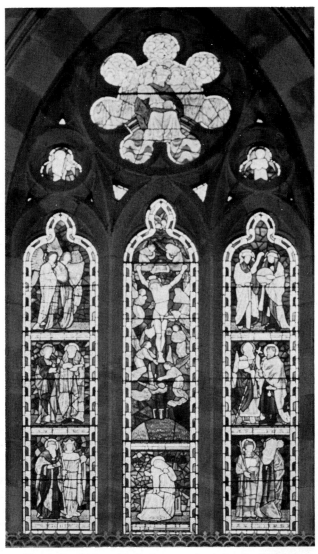

Church Furnishings: Meole Brace, stained glass by William Morris and Edward Burne-Jones, *c.* 1870

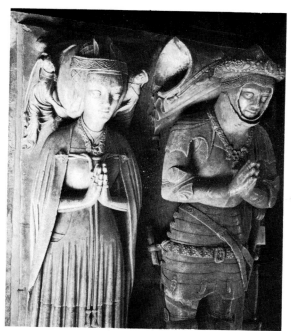

(a) *Church Monuments:* Tong, Sir Richard Vernon, †1451

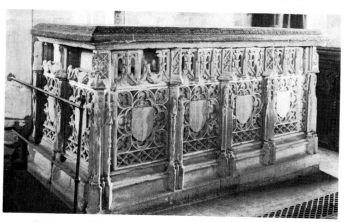

(b) *Church Monuments:* Tong, Sir William Vernon, †1467

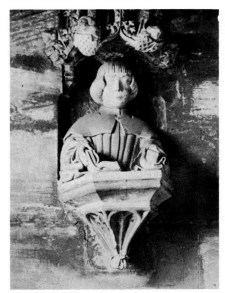

(a) *Church monuments:* Tong, Arthur Vernon, †1517(?)

(b) *Church Monuments:* Kinlet, Sir John Blount, †1531

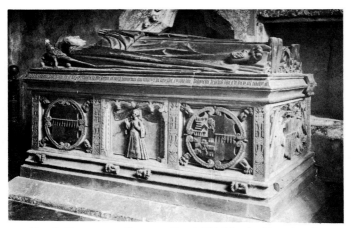

(a) *Church Monuments:* Wroxeter, Lord Chief Justice Bromley, †1555

(b) *Church Monuments:* Burford, Richard Cornwall, †1568.
Painted by Melchior Salabuss. *Copyright Country Life*

35

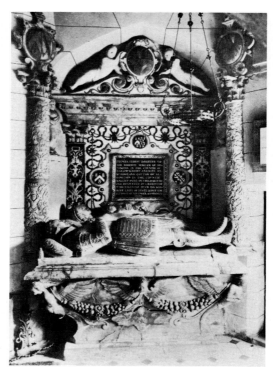

(a) *Church Monuments:* Norton-in-Hales, Sir Rowland Cotton and Lady Cotton who died in 1606

(b) *Church Monuments:* Leighton, cast-iron ledger stone of 1696

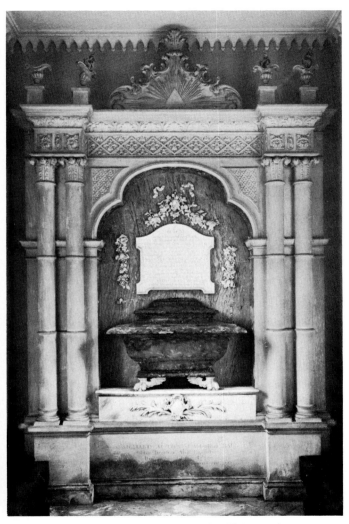

Church Monuments: Acton Round, Sir Whitmore Acton,
c. 1760 to a design by T. F. Pritchard

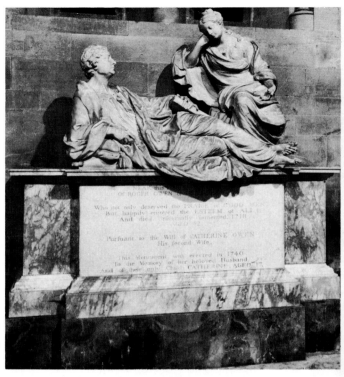

(a) *Church Monuments:* Condover, Roger Owen,
1746 by J. F. Roubiliac

(b) *Church Monuments:* Prees, Sir John Hill, †1824,
by Thomas Carline

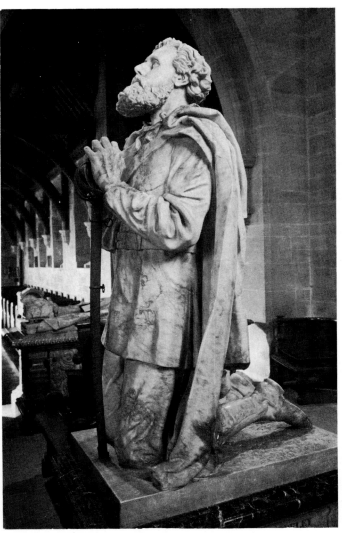

Church Monuments: Condover, Sir Thomas Cholmondeley, †1864,
by G. F. Watts

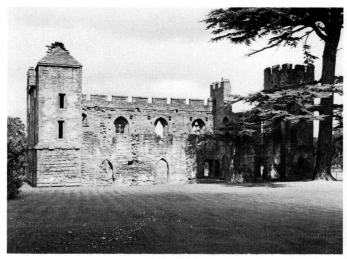

(a) *Medieval Secular Buildings:* Acton Burnell, begun in 1284

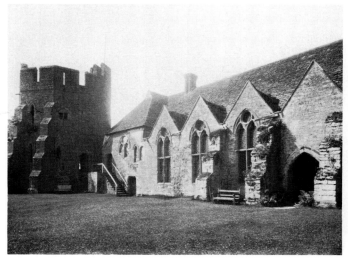

(b) *Medieval Secular Buildings:* Stokesay Castle, *c.* 1280,
the tower on the left begun in 1291

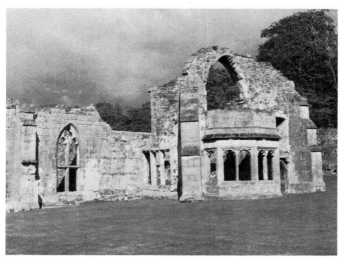

(a) *Medieval Secular Buildings:* Haughmond Abbey, the Infirmary and the Abbot's Lodgings, fourteenth century and *c.* 1500

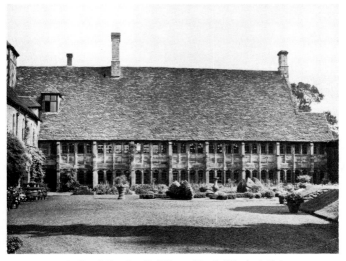

(b) *Medieval Secular Buildings:* Much Wenlock Priory, the Prior's Lodge, *c.* 1500. *Copyright Country Life*

41

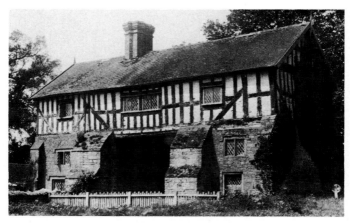

(a) *Medieval Secular Buildings:* Bromfield Priory, the Gatehouse, perhaps fourteenth century

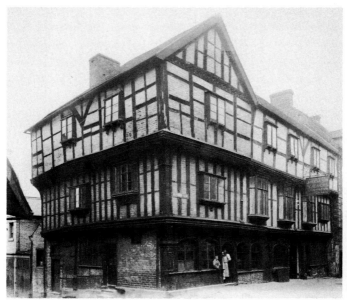

(b) *Medieval Secular Buildings:* Shrewsbury, the Abbot's House, Butcher Row, probably early sixteenth century

42

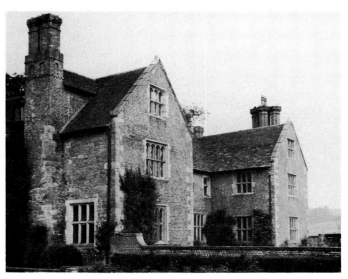

(a) *The Age of Henry VIII*: Plaish Hall, *c.* 1540

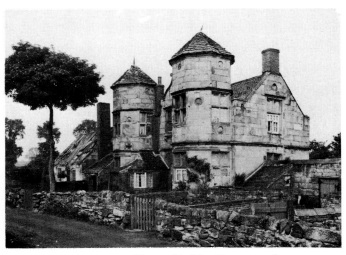

(b) *Elizabethan Houses*: Madeley Court, *c.* 1560.
Copyright Country Life

43

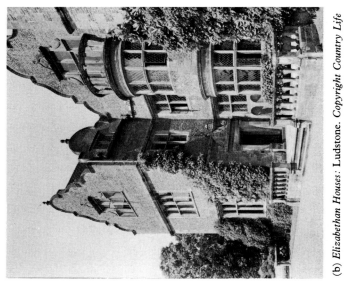

(a) *Elizabethan Houses:* Moreton Corbet, *c.* 1575–80

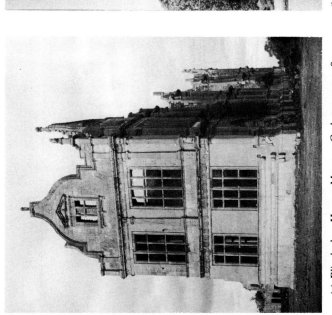

(b) *Elizabethan Houses:* Ludstone. *Copyright Country Life*

44

Elizabethan Houses: Condover, *c.* 1598

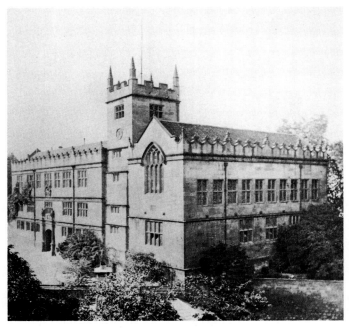

(a) *Elizabethan and after:* Shrewsbury School, the original buildings, 1590s on the left, 1627–30 on the right

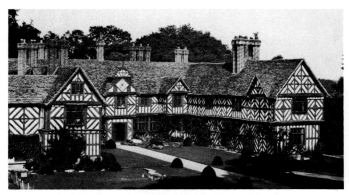

(b) *Timber-framed building, Elizabethan and Jacobean:* Pitchford, *c.* 1560–70

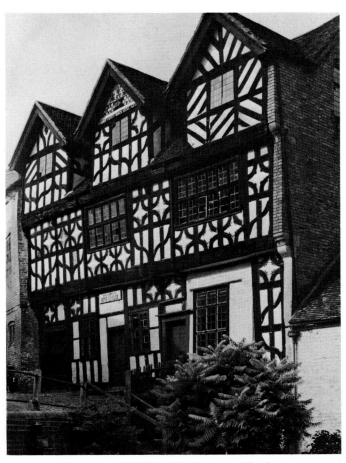

Timber-framed building, Elizabethan and Jacobean:
Bridgnorth, Bishop Percy's House, 1580

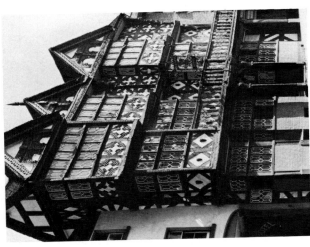

(b) *Timber-framed building, Elizabethan and Jacobean*: Ludlow, The Feathers, 1603

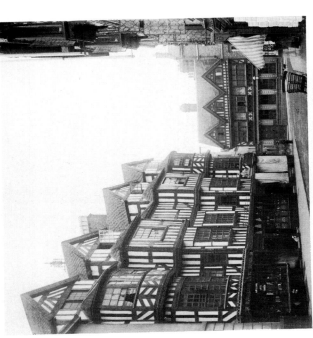

(a) *Timber-framed building, Elizabethan and Jacobean*: Shrewsbury, Ireland's Mansion, 1575

48

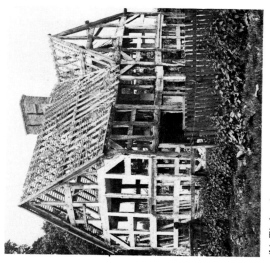
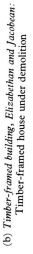

(a) *Timber-framed building, Elizabethan and Jacobean:*
Lee Old Hall, 1594

(b) *Timber-framed building, Elizabethan and Jacobean:*
Timber-framed house under demolition

49

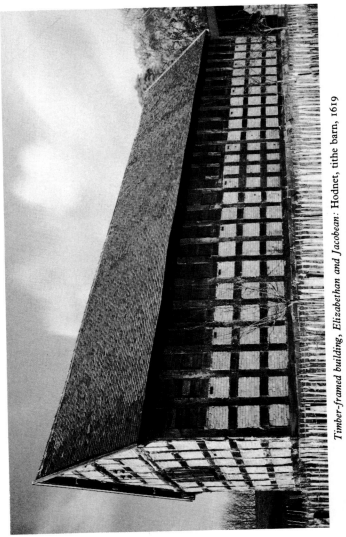

Timber-framed building, Elizabethan and Jacobean: Hodnet, tithe barn, 1619

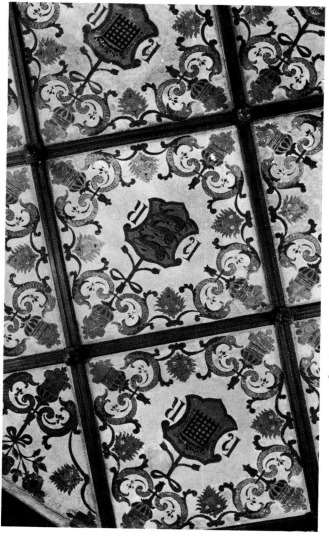

Interiors, Sixteenth Century: Plaish Hall, c. 1540

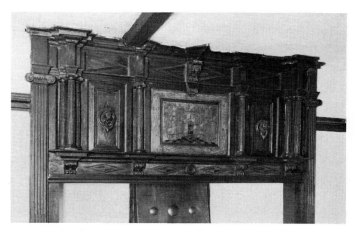

(a) *Interiors, Sixteenth Century:* Shrewsbury, Old House, Dogpole, 1553

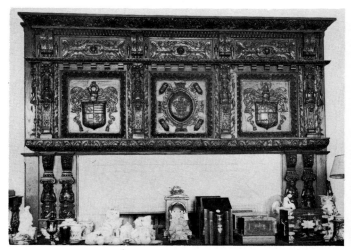

(b) *Interiors, Jacobean:* Brogyntyn, 1617

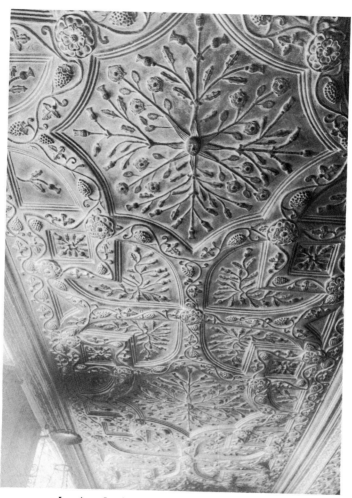

Interiors, Jacobean: Ludlow, The Feathers, 1603

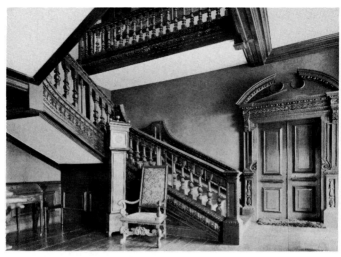

(a) *Interiors, Stuart:* Longnor, *c.* 1670. *Copyright Country Life*

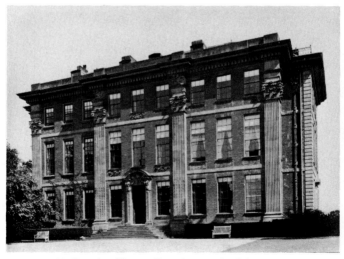

(b) *Georgian Houses:* Cound, 1704, by John Prince.
Copyright Country Life

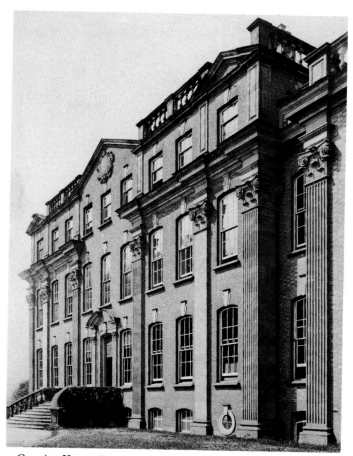

Georgian Houses: Buntingsdale, *c.* 1730, perhaps by Francis Smith.
Copyright Country Life

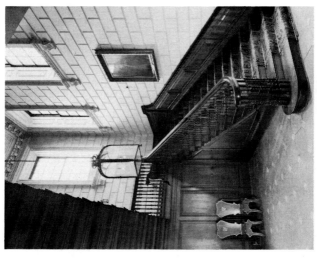

(a) *Georgian Houses*: Mawley Hall, *c.* 1730, probably by Francis Smith. *Copyright Country Life*

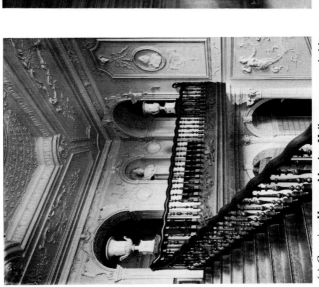

(b) *Georgian Houses*: Davenport, 1726, by Francis Smith. *Copyright Country Life*

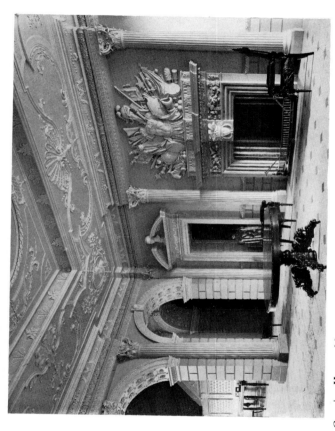

Georgian Houses: Mawley Hall, *c.* 1730, probably by Francis Smith. *Copyright Country Life*

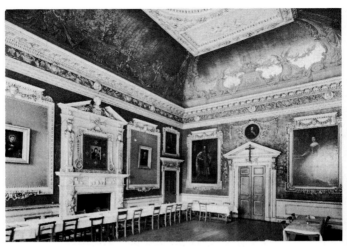

(a) *Georgian Houses:* Hawkstone Hall, *c.* 1720

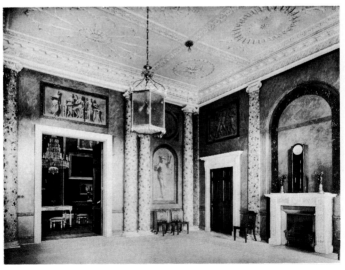

(b) *Georgian Houses:* Attingham, 1783–5, by George Steuart.
Copyright Country Life

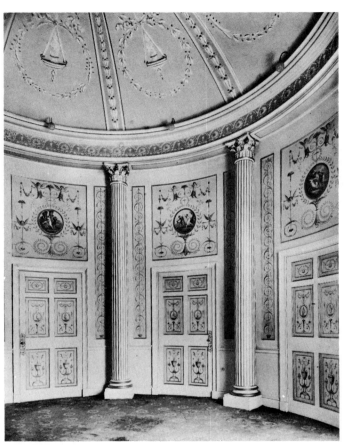

Georgian Houses: Attingham, 1783–5, by George Steuart.
Copyright Country Life

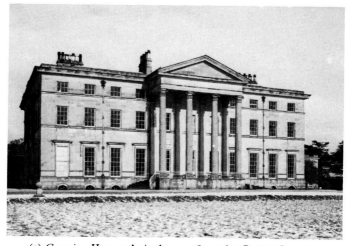

(a) *Georgian Houses:* Attingham, 1783–5, by George Steuart.
Copyright Country Life

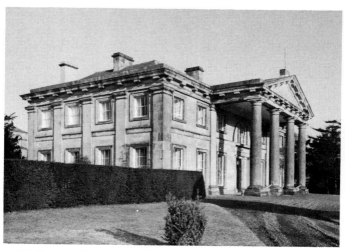

(b) *Georgian Houses:* Longford Hall, 1794–7, by Joseph Bonomi

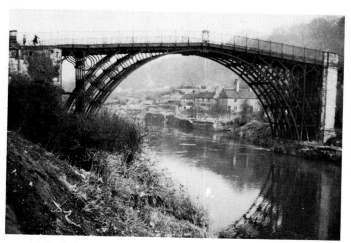

(a) *Early Iron Architecture:* Iron Bridge, Coalbrookdale, 1777

(b) *Early Iron Architecture:* Shrewsbury, factory in Spring Gardens, 1796

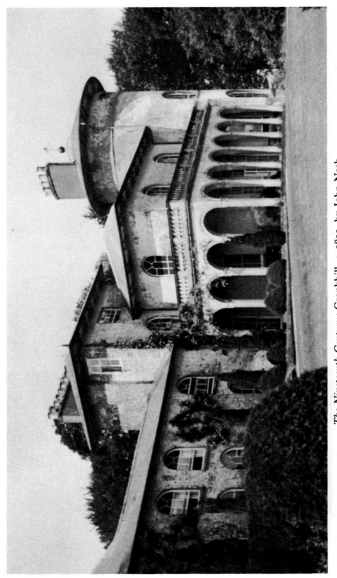

The Nineteenth Century: Cronkhill, *c.* 1802, by John Nash

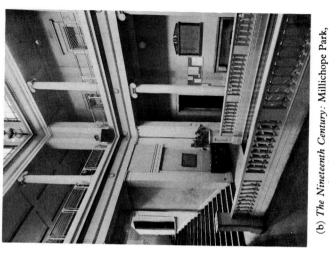

(a) *The Nineteenth Century: Willey Hall, 1812–15, by Lewis Wyatt. Copyright Country Life*

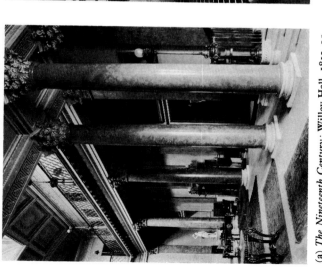

(b) *The Nineteenth Century: Millichope Park, 1840, by Edward Haycock*

63

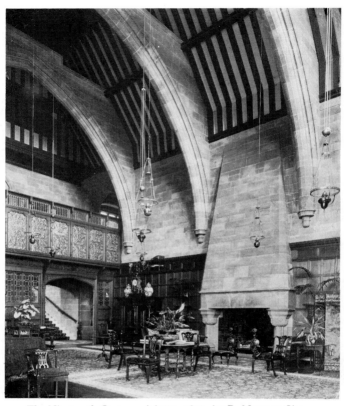

The Nineteenth Century: Adcote, 1879, by R. Norman Shaw.
Copyright Country Life

and piquantly in the windows of the upper tier towards NE and SE. – In the churchyard several early C19 tombs of cast iron, notably those of two iron-masters: William Baldwin † 1822. Big pedestal with four columns in the corners, and small sarcophagus above. – R. R. Anstice † 1853. Four attached Tuscan columns carrying a pediment. Arched inscription tablets between the columns (NE corner).

Immediately NW of the church OLD HALL, a fine house of c. 1700, brick, with quoins, a parapet, and a hipped roof. Shell-hood over the door. Immediately to the W of the church the NATIONAL SCHOOL, light brick, three bays wide, in the Tudor style; 1841. CHURCH STREET runs on from here to the NW. On the l. UPPER HOUSE, gabled and much modernized. Some original mullioned windows. (Jacobean staircase. MHLG.) Next to it the former barns, etc., of Upper House, timber-framed, with brick infillings. They include a later C17 part that afterwards served as the Market House. Good timberwork inside. Opposite another brick house of c. 1700 (five bays, two storeys, hipped roof) with a gazebo or summer house above the street.

The centre of modern Madeley is the ANSTICE MEMORIAL INSTITUTE, red brick and stone, with large arched upper windows, in the Italianate taste. By *John Johnson* of London, 1869.

In Court Street the WESLEYAN CHAPEL, 1841, light brick, with giant pilasters and pediment. Court Street is named after Madeley Court, the house to which it leads.

MADELEY COURT, ½ m. N. The mangled remains of a mansion which must once have been architecturally of high value. Before the Dissolution Madeley Court was a grange of the priors of Wenlock. Bought by Sir Rupert Brooke, Speaker in the House of Commons, 1553, and built probably in the early years of Queen Elizabeth I. From 1709 to his death inhabited by the first Abraham Darby. The gatehouse is complete, even 43b if converted into cottages. It is a fine design with two spacious polygonal towers l. and r. and a round-arched gateway in the middle. The window above this is of three lights with mullions and transom. The windows in the towers are of the cross-type. Simple shaped gable in the middle; pyramid roofs on the towers. Many medallions or plaques. The porch of the house itself is not in line with the gatehouse, and the relation of house and gatehouse is altogether not easily grasped. The house in its present fragmentary form is L-shaped, the hall-

range facing the gatehouse, and a wing projecting towards it immediately to the r. of the porch. The porch has its entrance on the side, not in the front (cf. Shipton, Benthall, Ludstone). It is crowned by a strapwork achievement and seems a Jacobean addition. The interior of the hall is destroyed. Big chimneybreast at the back and to its r., at basement height, an unmistakable C13 doorway. The windows of the Elizabethan house are mullioned and transomed. Big gable over what must have been the parlour (to the l. of the Hall). Smaller gables or dormers above the hall and in the projecting wing. In the former garden to the W the remains of a large astronomical toy, a square block of 4 ft, with holes for a large number of dials, and a hemisphere on top. The whole stood originally on pillars 15 ft tall.

MALINSLEE see DAWLEY

6030

MARKET DRAYTON

St Mary. The W tower acts as a *Stadtkrone*. It dominates the picture of Market Drayton from afar, especially from the S. It is evidently of the C14, yet it has a W doorway which is Late Norman. Two orders of (former) shafts, the imposts decorated with lozenges bent around the edges. The tower itself has angle buttresses with many set-offs, a W window with Dec tracery, bell-openings with Dec tracery, battlements and pinnacles. There are squinches visible inside for a stone spire. The rest of the church is externally so restored (1884 by *Carpenter & Sugden*) that it looks all Victorian. The windows anyway are new; for in 1786 repairs started including sixteen new windows. Nave and aisles, chancel and two chapels. Eight-bay clerestory all C19. Nave arcades of four bays, octagonal piers and double-chamfered arches mostly C19, but the first pier on the N side has a very fine C13 capital with fifteen heads. The chancel chapels are of two bays. Their double-chamfered arches look old, as does the chancel arch. This has a C14 sunk quadrant moulding. The C14 tower arch has the same. – STAINED GLASS. Much by *Kempe*, namely E 1895, S aisle 1901 and 1903, N aisle 1904. – The W window with good large pale figures by *Shrigley & Hunt*. – ROOD SCREEN. By *Kempe*. – MONUMENTS. Sir J. J. Markham † 1778. Signed by *Joseph Wilton*. Large seated woman with an anchor by an urn. – Fine view to the S from the churchyard,

and placed close to the s wall of the churchyard a monument of 1846 under a four-column canopy.

CHRIST CHURCH, Little Drayton. 1847 by *S. Pountney Smith & J. Smith* (GR).

PERAMBULATION

The centre of Market Drayton is the HIGH STREET, really rather like a market place. From here the main streets fan out. The church appears only in odd glimpses. It is not on any of the main streets, and, as it is at the same time the one accent on the skyline, there is a fine competition of accents here. Not much of note in the High Street: the CORBET ARMS HOTEL, Late Georgian, of three widely spaced three-light bays, with a porch, and the TRUSTEE SAVINGS BANK of two bays with Venetian windows on the first floor. From the High Street to the n two nearly parallel streets. At the corner of QUEEN STREET the CROWN HOTEL, timber-framed. The other street, Cheshire Street, leads at once to a widening, where the BUTTER MARKET stands, a market hall of 1824 with Tuscan columns and a pediment to the n. It stands against the background of a timber-framed house.

To the s the continuation of the High Street is Great Helen Street. This goes down the hill rapidly and, in turning, one sees suddenly from one point the church towering on a cliff above the former Grammar School. This can be reached up some steps. The GRAMMAR SCHOOL was founded in 1558. The present brick buildings, one-storeyed schoolroom and two-storeyed house, betray nothing of a c16 origin, but inside the schoolroom is the stone bust of the founder, Sir Rowland Hill, Lord Mayor of London, in a niche with an elliptical arch, and this, though not of good quality, is clearly mid-c16, based on the Quattrocento type of frontal bust made fashionable in England by Torrigiani. The inscription below reads: ROLANDUS HYLL MILES. Along the n side of the churchyard runs CHURCH STREET. Here, a little further w the former Congregational Chapel, dated 1778. Red brick, three bays, with high roof.

Back into GREAT HALES STREET with some detached Georgian houses. RYLAND HOUSE must be Early Georgian, though its windows were at some time, probably *c.* 1850, given a typical Early Victorian shape. This pattern of outer detached Georgian houses repeats along the main w and e streets.

To the W from the High Street runs SHROPSHIRE STREET. This has at its beginning the best display of black-and-white at Market Drayton, the National Provincial Bank and Sandbrook's Vaults. The latter is dated 1653. Not an inkling yet of classical design. Two storeys and gables, the Bank with a big corner gable, Sandbrook's with two dormers. Both houses have oversailing upper storeys, and both have carved bressumers. Both have lozenges on the first floor and cusped concave-sided lozenges in the gables. Further out the RED HOUSE, the most ambitious Georgian house in the town. Seven bays, with a three-bay pediment and brick quoins. More Georgian houses, e.g., of three bays, No. 39 and opposite No. 30. Then No. 41 which lies back a little. It must be early C18 at the latest, as it has a large semicircular gable instead of a pediment. Yet more Georgian houses: No. 40 of five bays, and its former stables and coach-house, then one of seven bays, ruined in its ground floor, and finally the former Workhouse, gaunt enough looking, and inscribed with a date 1839.

In STAFFORD STREET to the E the pattern is the same. The start is the STAR HOTEL, dated 1669 and timber-framed. The composition is symmetrical. Two gables and a projecting gabled porch. The gables have the usual cusped concave lozenges, but in the porch gable is a kind of cross pattern instead. The end is such Georgian houses as THE GROVE with its stables and coach-house.

MARRINGTON HALL
¾ m. SE of Chirbury

2090

Built in 1595, and one of the dozen best-known timber-framed houses in this part of the county. Yet a great deal appears C19–20 work.

MARSHE MANOR
1¼ m. NW of Westbury

3010

Uncommonly attractive, small, timber-framed manor house, dated 1604. Large l. front gable with concave-sided lozenges, smaller r. end gable with lozenges within lozenges.

MARSHPOOL CIRCLE see CHIRBURY

MAWLEY HALL

6070

Built *c.* 1730 for Sir Edward Blount. Red brick with ample stone dressings. Unfortunately the sandstone used has weathered so badly that details are often no longer recognizable. Nine bays by seven, two storeys high, and in addition a third or attic storey above the main cornice. Giant Tuscan pilasters at the angles and the angles of the three-bay centre continued above the cornice by short pilasters and sunk panels. Three-bay pediment on top; rather steep. Doorway with demi-columns and segmental pediment. The window above has decoration to the l. and r., it seems of trophies. The exterior of the house is thus restrained and not intent on making a show. The interior on the other hand is splendid, designed with much imagination and originality and executed obviously without regard to cost. It is consequently the finest of its date in Shropshire. Entrance Hall white, with attached composite columns (the 57 capitals have odd inturned volutes), a magnificent overmantel with military emblems and trophies (for the instruments carved in the top part of the fireplace itself cf. Davenport House), elegant plaster ceiling, and three rusticated arches opening at the back towards the staircase. The staircase is large with a square open well and walls again decorated 56a lavishly with plasterwork. Busts and medallions of Roman emperors are here the principal motif. In the centre of the ceiling Jupiter and his eagle. The balustrade has balusters of two different shapes and a handrail representing a snake. It serpentines or undulates up and down all the way and ends at the lower newelpost with a snake's head. Against the string, carvings of emblems of fishing, shooting, etc. below, of architecture, sculpture, painting, and music on the upper landing. The most astonishing feat of craftsmanship is the sw room, to the l. of the staircase hall. Here inlay or *tarsia* is used with the utmost finesse, all up the walls and even in the top cornice. There are also good fire-places in several rooms. A specially fine room is on the first floor, with very odd and wilful doorheads and in two pilaster capitals kissing amorini. The dining room and the back room to the r. of the staircase were re-decorated in the later C18, in the Adam style. Attached to the house at the NW end is a largish private chapel with a segmental plaster vault.

The architect of Mawley Hall is not documentarily known,

but certain features of the outside and the peculiar inventions of internal design make it very likely that *Francis Smith* of Warwick, the architect of Kinlet Hall and Davenport House, also designed Mawley.

MEESON
6020

1 m. NE of Waters Upton

MEESON HALL. Dated 1640. Red sandstone with three straight gables. In the Dining Room an elaborate wooden fireplace, typical of its date in its inadequately blended details.

MELVERLEY
3010

16a ST PETER. One of the two timber-framed churches in the county (the other is Halston). Placed right above the river Vyrnwy, in its wide meadows. Nave and chancel in one, and timber belfry with broached roof. Built probably in the C15 or early C16 (first recorded mention 1557) and much restored in 1878. The pretty E window dates from the restoration. So do all other windows, though the mullioned and transomed S window may represent an Elizabethan or Jacobean insertion. The timber-framing is nearly exclusively post-and-pan. But at the E end there are some diagonal struts. Simply braced
16b timber porch. Inside tie-beams, collar-beams, and cusped wind-braces. Near the W end there is another tie-beam at half the height of the walls, and this supports the WEST GALLERY. This may date from 1588 – see an inscription now placed near the entrance on the r. near the foot of the screen. – ROOD SCREEN. Just the plainest dado and then posts up to the tie-beam. Middle entrance only very slightly arched. The whole of the interior timbering is robust and rustic, more like a barn than a church.

MEOLE BRACE
4010

HOLY TRINITY. 1867–8 by *E. Haycock Jun.* A surprisingly ambitious church for what was at the time still a village near Shrewsbury. Big, red, rock-faced, with big square NW tower. Wide nave, circular arcade piers with leaf capitals. Wide polygonal apse. Geometrical tracery. But the reason why this church must rank with the most important of its date in the

county is its STAINED GLASS – nearly all by *Morris & Co.*, and that in the apse among the best ever designed by *William* 32 *Morris* and *Burne-Jones*. It was executed in *c.* 1869–70. Three large windows. In the middle Crucifixion with an exquisite figure of the seated Virgin below, and Christ surrounded by angels in the tracery head. The lights to the l. and r. of the Crucifixion have Apostles, Holy Kings, Martyrs. Scenes from the Old Testament in the l. apse window, from the New Testament in the r. The total effect is rich, yet clear, the colours are not too strong or glaring. The aisle windows are later Morris work, except one in the s aisle (with Hope, Noah, and Simeon). This also seems to be *c.* 1870, and the colour scheme has more brown and yellow than the work of the 1890s and the years after Morris's death, when features and gestures tend to be more sentimental and the colouring has more dark blue and ruby. In the E window of the s aisle is *Kempe* glass of 1894, and although in most Victorian churches early Kempe glass stands out, Kempe is here – in this comparison with Morris in 1870 – exposed as yet another Victorian without any real understanding of what colouring for stained glass and designing for stained glass really means.

MIDDLETON
2 m. NW of Ludlow

5070
Inset B

CHURCH. Nave and chancel, and bellcote. Norman, see the remaining windows on N and S. Much renewed in 1851. – PULPIT. Plain Elizabethan. – SCREEN. Some old work used to re-create a complete rood-screen with loft on coving. – STAINED GLASS. W window with Crucifixion, must be early C 19. – E window, apparently by *Kempe*.

MIDDLETON-IN-CHIRBURY

2090

HOLY TRINITY. 1843 by *Edward Haycock* (Colvin). Nave, transepts, and chancel with polygonal apse; w porch and w bellcote. In the lancet style. The transepts are two bays wide, with a circular pier separating them from the 'crossing'. – STAINED GLASS. E window by *Kempe & Tower*, 1915.

MIDDLETON SCRIVEN

6080

ST JOHN BAPTIST. 1843–8. Nave, chancel, and bellcote. In the E.E. style. Pretty bargeboarding on the s porch (cf. the original porch at Billingsley). – FONT. Circular, in a very

elaborate imitation Norman, with figure scenes; a gift of Archdeacon Hobhouse.

MILLICHOPE

5080

MILLICHOPE PARK. The house is approached by an avenue, partly deeply cut into the sandstone, partly flanked by old yew-trees. The house itself is of high architectural value, full of character and original ideas. It was designed by *Edward Haycock* of Shrewsbury and built for the Rev. Robert Norgrave Pemberton. The façade has a portico of fluted Ionic giant columns on the first-floor level, continued in terraces on the l. and r. The entrance lies at ground-floor level (which for the rest of the house is basement level) below the portico and has two excessively short and stubby Tuscan columns *in antis*, the sort of columns which Ledoux enjoyed. But the house is fifty years younger than Ledoux's time. It is dated above the entrance in fine Egyptian letters MDCCCXL. One enters a low Hall with a heavy Grecian fireplace, and then the staircase leads up in one straight flight between solid walls so as to come out in the middle of a lofty central Hall, at ground-floor level. The hall is surrounded by wooden Ionic columns on two storeys. Glazed lantern above with swans attached to the posts. The staircase to the second floor starts as a continuation of the magnificent lower flight and then divides. The principal front-room behind the portico has a segmentally vaulted ceiling of some composition material. In a room to the r. the fireplace is placed immediately below a window and at night a mirror can be pulled down so as to convert the window into a niche. In front of and below the house a lake, and by its side a pretty ROTUNDA with Ionic columns. This is older than the house. It is dated 1770.

63b

UPPER MILLICHOPE FARM. That rare survival, an early C14 stone house. The type is that of the tower house. Entrance on the ground floor. The arch has ball-flower decoration. Spiral staircase in the angle to the r. of the entrance. Two slender two-light windows on the upper floor, where the Hall was. They have elegant shafts and seats in the reveals inside. The top of the house is later: timber-framed with brick infilling.

MILSON

6070

ST GEORGE. Small Norman church of nave and chancel with a squat C13 W tower. Norman windows on the S as well as the

N side, Late Norman S doorway with one order of colonnettes, the capitals with trumpet-shaped scallops (r.) and waterleaf (l.). In the tower on the W side a long slit-like lancet. Shingled top stage and pyramid roof. The arch towards the nave is pointed and rests on single-chamfered imposts. Good timber-framed S porch, probably of the C14. It has rubble walls on the sides below, and four studs above. Gable with tie-beams on big arched braces, and plain wavy bargeboards. Inside the church a simple tie-beam roof in the nave. The most curious feature of the interior is a large lintel high up replacing a chancel arch. The chancel E window is C19. – PULPIT. Elizabethan with square ornamented panels in two tiers.

MINDTOWN

ST JOHN BAPTIST. In a splendid position on a slight eminence below Longmynd, with the bare hills to its E and (nowadays) the elegant shapes of gliders overhead. Nave and chancel and small belfry. Roughcast. No architectural features of interest. – FONT. The bowl has on each side one large scallop and half a scallop l. and r. This is in all probability C12. The stem may be of the C14. – COMMUNION RAIL. With bulbous posts and heavy balusters; C17. – WEST GALLERY. Remains of a Jacobean pew.

MINSTERLEY

HOLY TRINITY. Built in 1689 (date on former rainwater heads; see the Williams MS.). This is a rare date for a church in the county, and the church is indeed both interesting and attractive in its naive handling of the new semi-classical, semi-Baroque motifs. Red brick. Nave and chancel in one, and W tower with timber top. The sides have buttresses of excessive batter and large arched windows with cherubs' heads in the keystones. The E window is longer, but of the same kind, except that Y-tracery is used – the tracery so favoured a hundred years later. The W tower has the oddest façade. Rusticated giant pilasters with segmental pediment. Inside this frame W portal with bold segmental arch and a segmental frieze above decorated with skulls and bones. Arched window above this flanked by pilasters down which hang garlands. Above this the clock in a square, eared frame. The top, above the segmental pediment, is weather-boarded

with short bulgy columns at the four angles of the low bell-stage and four pediments on top. N porch with eared doorway. – The WEST and SOUTH DOORS are original. – Altogether there is excellent original woodwork in the church, especially the COMMUNION RAIL, which is the only piece that is not rustic. – PULPIT with big polygonal tester and ogee dome. – PANELLING at the E end, with segmental pediments to the l. and r. of the E window. – WEST GALLERY with big balusters. – FONT. On a short, heavy octagonal baluster. – PLATE. Set of 1691. – MAIDENS' GARLANDS (cf. Astley Abbots). A number of between 1726 and 1794 hanging above the W gallery. They were made for the funerals of young girls and placed upon the coffin. They consist of a wooden frame with paper flowers, ribbons, and pairs of gloves.

MINSTERLEY HALL. Much restored large timber-framed house to the N of the church. Some decoration with lozenges within lozenges and concave lozenges in two of the gables. (Panelling in two rooms, and carved overmantel with the Thynne arms.) The Thynne family had moved down from Caus Castle, when this was dismantled. They built the church as well.

4090
MINTON
2½ m. SW of Church Stretton

(Arrangement of cottages with gardens and small-holdings around the village green. One of them has cruck construction. The arrangement is the typical Saxon one which can here be studied well. There is also a large Saxon mound near the manor house. MHLG.)

6090
MONKHOPTON

ST PETER. Nave and chancel, and thin W tower of 1835. Norman nave, see what little remains of the S doorway, and Norman chancel, see the N and S windows internally. It is curious that the S window was given such a sumptuous surround with two zigzags and between them a chain of elongated, beaded links. The priest's doorway is probably early C13, as its shape is too odd for the restorer of 1835 to have invented it. Trefoiled head and round hood-mould of dog-tooth over.

MONTFORD

4010

St Chad. Red sandstone. Nave and chancel, and w tower, all of 1737–8 by *William Cooper* of Shrewsbury (Colvin). Restoration in 1884, to which the window tracery probably belongs. Arched windows, heavily framed with pilasters, broad arches and keystones. Wide E window. Embattled w tower. Plain early C19 w gallery on iron columns.

Bridge. Fine red sandstone bridge of three segmental arches. By *Thomas Telford* as part of the works for the new Holyhead road.

Preston Montford Hall. Very handsome early C18 house. Five bays, two storeys, red brick with quoins and hipped roof. The tripartite doorway with pediment is a late C18 addition.

MOOR PARK *see* BATCHCOTT

MORDA *see* OSWESTRY, p. 225

MORE

3090

St Peter. Church of 1845, w tower medieval, with the pretty 'double-pyramid' top as at Clun and Hopesay. The work of 1845 is in the lancet style. N chapel (More Chapel) C17, but later lengthened. w gallery on cast-iron shafts. – Some Jacobean WOODWORK. – In the More Chapel MONUMENT to Harriott Mary More † 1851, by *Field* of London. Still in the style of 1830. Standing woman, leaning on a pedestal with an urn. On the pedestal the inscription: 'I know that my Redeemer liveth.' In the floor in front of the monument coat of arms of engraved brass.

The church is prettily surrounded by black-and-white houses. To the w a cottage, to the E CHURCH FARM with two rather wildly and irregularly decorated gables, and to the N at some distance MANOR FARM, a handsome group with the low weatherboarded farm buildings on the l.

MORETON CORBET

5020

St Bartholomew. Norman chancel (see one N window). Ambitious s aisle of *c.* 1330–40. Large E window of four lights with flowing tracery applied with moderation. Remarkable w

window in the form of a large spheric triangle with a pointed trefoil motif and more motifs as tracery (cf. Alberbury). Three-bay arcade inside with piers consisting of four broad shafts with fillets and four thin shafts in the diagonals. The arches have two sunk chamfers. Much alteration in the C18. The w tower, begun in the 1530s (will of 1539), was completed only in 1769. The s chapel (or Squire's Pew) was built *c.* 1778. The tower has a parapet and pinnacles with C18 details, but a Perp w window. In the nave also remains of an C18 window and windows looking early C19 (Y-tracery). – PULPIT. Jacobean. – READER'S DESK. With Jacobean panels. – RAIL of the family pew; C18. – STAINED GLASS. E window by *Sir Ninian Comper* 1905. – The REREDOS with the two unhappy small figures of the Annunciation freestanding against the glass is also by *Comper*. – MONUMENTS. Sir Robert Corbet † 1513 and wife. Two recumbent effigies on a tall tomb-chest. Small and dainty figures below crocketed ogee arches against the tomb-chest. – Sir Richard Corbet † 1567 and wife. Two recumbent effigies on a tall tomb-chest. The panels of the chest divided by candelabra-like colonnettes. Shields carried by the Elephant and Castle of the Corbets. The central panel contains a babe in swaddling clothes with a rose bush and a lily growing out of it, and a panel below with a squirrel in foliage. – Richard Corbet † 1691. Frontal bust in a recess between fluted pilasters. The pilasters carry an open segmental pediment with a shield, but the recess has a pointed head – a remarkably early case of the re-use of a Gothic motif. – Charlotte Corbet † 1774. Putto by an urn in front of an obelisk. – Four young Corbet sons, erected 1770. Remarkably elegant, in different-coloured marbles. No figures; no signature. – In the churchyard: Vincent Corbet who died aged 13. Seated bronze figure of a naked boy. By *I. H. M. Furse*, 1904.

44a MORETON CORBET CASTLE. The last word has certainly not been said about this magnificent ruin.* A roughly triangular enclosure with a splendid Elizabethan range along the s side, a Keep of *c.* 1200 to the N of it (with a fine fireplace on the first floor the polygonal shafts of which carry tall capitals with upright leaves), and a Gatehouse at the NE apex which has a pointed archway. The gatehouse was altered in 1579 (see the N

* Mr George Chettle's account of it, written for the Ministry of Works, has not yet been published. I am most grateful to him for discussing his results with me.

window and a plaque). The Elizabethan range has the date 1579 at the SW corner and the cypher E.R. 21 (i.e. again 1579) at the SE corner. The range was built by Sir Andrew Corbet († 1579) and his sons. Sir Andrew had however built a half-range and a staircase along the E wall of the enclosure a little before. Of this little survives, though old drawings tell of its four-transomed bay-window. Of the range with the date 1579 much stands upright. Architecturally it was amongst the most impressive and consistent designs in the country. It ought to rank with Kirby Hall. S front of two tall storeys, the upper taller than the lower. Both have three- to five-light windows with two transoms. The façade is articulated throughout in the French way by attached Tuscan columns (with an ornamented metope frieze) below, by slim fluted Ionic columns above, an exceptional thing in England, though one familiar from Longleat. Tall slim ogee-shaped gables with pedimented windows of three lights. There is also a rhythm of flat wall and slightly projecting bays. To the S – i.e. out of what had been the Inner Bailey of the Castle – only two small insignificant doorways. Of the ruined interior the main remaining feature is a large fireplace with strapwork decoration. The N wall of the range is known only from old illustrations. It had a central transomed seven-light window with a segmental pediment flanked by two four-light windows with normal pediments and also the steep ogee-shaped gables, but curiously enough no orders of pilasters.

MORETON HALL see WESTON RHYN

MORETON SAY

6030

ST MARGARET. The church appears all Georgian, brick, with arched windows in two tiers, and brick quoins, and a W tower with low parapet and obelisks. But, inside, the W doorway into the nave clearly dates from *c.* 1200. Round arch, one order of (former) shafts with early stiff-leaf capitals, a keeled roll in the moulding of the arch. So the brick exterior is the re-facing or re-modelling of a medieval church. The tower was built in 1769, the nave altered to fit it 1788. – Excellent WEST GALLERY with a big staircase with typical Jacobean balusters. The gallery is dated 1634. – STAINED GLASS. E window 1900, evidently by *Kempe*. – MONUMENTS. Jane Vernon and her two husbands, 1623. Recumbent effigies, she between her

husbands. The figures rise slightly from front to back. Back architecture with two columns and a shallow arch between; top achievement between two obelisks; indifferent quality. – Three Vernon Sisters, small kneeling figures; put up in 1642, and signed (?) T. PVE. – Several tablets to members of the Clive and Corser families.

MORVILLE

A beautiful picture from the road: a field in the foreground with the church at its back and on the r. side the Hall with its service wings facing towards the church.

ST GREGORY. Nave and aisles, chancel, and W tower. The church is mostly Norman, i.e. Norman nave, Norman chancel, Norman tower, and Late Norman or Transitional aisles. The nave came before the tower, as is proved by its surviving W window in the former gable and by the absence of a proper tower arch. This nave and probably the chancel belong to a church which was consecrated in 1118. Then in 1138 the church became part of a Benedictine Priory, and further developments may be connected with this fact. The tower cannot be much later than the nave. It also has Norman windows. Its top however is late, perhaps post-medieval. The S doorway leads into the S aisle; it is much re-done but may be the re-used original S doorway of 1118. The chancel arch also may well be as early as that. It has one order of shafts. One capital has a scroll with a grape, the other a human figure. The arch has much billet. The aisles are somewhat later. The original angles of the nave can still be seen outside. The arcades of three bays date the aisles to the late C12. Square piers with four keeled shafts. Capitals with upright leaves. One on the S side has scallops instead (carved later?), one on the N side is left uncarved. The arches are pointed. The clerestory windows belong to the C19. – FONT. Norman, tub-shaped, with flat carvings in medallions connected by wide-mouthed faces. – DOOR. The ironwork of the S door is partly of the C12. – STAINED GLASS. In a chancel window small figure of Christ crucified; early C14.

MORVILLE HALL. Elizabethan house converted almost entirely in the C18 (*William Baker* of the Ludlow Butter Cross worked at Morville in 1748–9. So did *W. Hiorns* of Warwick). Grey stone, with two projecting wings towards the E. The narrow staircases in the projections in the re-entrant angles are an

Elizabethan survival. Another is a plaster ceiling in the Kitchen. This is so similar to Upton Cressett and Wilderhope that it must be by the same team of craftsmen. The most extraordinary feature of the exterior is, however, the two giant pilasters and two giant Tuscan columns attached to the fronts of the two wings. They carry balls. In West & Calvert's *Picturesque Views* (1831) they are absent, but the parapet has balls. Lower service ranges of four bays with cupolas are connected with the house by curved walls.

MUCH WENLOCK

6000

Much Wenlock is now a little town, with, at its back, a picturesque medieval dwelling-house in ornamental grounds, towered over by the ruins of a priory. In the Middle Ages it was, of course, a priory with a little town nestling on its w fringe.

WENLOCK PRIORY. The priory was founded as a nunnery about 680. Its abbess was St Milburga. Excavations have shown the plan of an early building, small with an apse encased in straight walls, which may well be that of the late C7. The nunnery was destroyed by the Danes about 874. A re-foundation took place about 1050. The new founder was Leofric, Earl of Mercia, the friend of Edward the Confessor. We know nothing of what that recorded fact implied, but shortly after the Conquest it is reported that Earl Roger de Montmorency had made the church into an abbey. Earl Roger was the mightiest follower of the Conqueror in the county, and he was a benefactor of Cluny, to which monastery he had given the money for building a large refectory. So he asked for monks for his priory – for it was a priory, not an abbey – to be sent from Cluny, and they came from one of the leading Cluniac houses, La Charité-sur-Loire. But the La Charité whence they came was not yet the church which we know now, nor can we see anything today of Roger's Wenlock. From excavations the E end of the church can be made out. It followed the example of Cluny II, since the infinitely larger and grander Cluny III was not started until *c.* 1080. The chancel of Cluny II had an apse and slightly shorter, also apsed, chapels to the l. and r., and this was repeated at Wenlock. Excavations have also given information on the Norman nave, which was curiously narrow in proportion to its length. But the present building is entirely E.E. with certain Late Norman monastic

parts. The ruins stand high up in three separate fragments. Gilpin, as the *Shell Guide* has quoted, objected from his point of view, that of the picturesque traveller, to this separateness. He writes: 'The ruins offend from being too much detached; . . . if they had been connected with each other by fragments of old walls, and connected with the ground by a few heaps of rubbish, and a little adorned with wood, we should have considered them in a higher style, and looked on them as picturesque.' Picturesque and architectural interests often conflict. Cases must be treated on their own merit. A building of little antiquarian merit can make the finest ruin; in the case of a building of high antiquarian importance, the historian must have it his way. For the layman a training of aesthetic sensibilities and of a historical sense is equally desirable.

A considerable fragment remains of the W front, clearly E.E. It proves the existence of a W portal of five orders, and to the r. of it much bare wall and only a small window. Higher up above this a taller two-light window with a circle. The central W window was large, perhaps a group of three stepped lancets, and flanked by several tiers of small blank arcading. The nave was eight bays long. Transepts with E aisles or chapels, no doubt a crossing tower, and a chancel of seven bays with a projecting straight-ended Lady Chapel. The total length was just under 350 ft. Of the E end only foundations survive. It was probably the earliest part to be built. Attached to its S side was a heptagonal chapel. We are however fairly completely informed on the transepts and nave. Of the N transept the W wall stands, of the S transept the S, W, and E walls, with the adjoining monastic buildings. The E wall had an arcade of three bays to the E aisle. Piers with four major and four minor shafts, all keeled. Arches with a quarter-moulding and a hollow. Tall triforium of paired lancets with nook-shafts. Vaulting shafts rising from thin long corbels in the spandrels between the arches. The shafts are tripartite. Clerestory with wall passage. Single lancet openings to the inside and the outside. The S wall has two blank arches at arcade level, with an elongated quatrefoil in the spandrel, then a tier of three blank lancets, nook-shafted, then a large window, three stepped lancets, the middle one being remarkably wide, and finally a lancet in the gable, lighting the roof space. In the W wall a lavatorium of three blank arches with blank drop-shapes in the spandrels and basins on corbels.

Attached to the W side of the N transept was a chapel with a crypt.

The shape of the big crossing-piers can no longer be made out, but the nave piers again clearly had four major and four minor shafts. The major shafts however were not keeled but had fillets. We can assume that the elevation was like that of the transept E walls, but there was one curious exception. The three W bays on the S side, instead of the triforium, had a vaulted upper chamber. That led to an anomaly in the elevation. The piers were made very short and squat, and their arches were made depressed two-centred. They were all enclosed in higher arches including those of the upper chamber – the system of Glastonbury and Oxford. Only above this follows the triforium, again of paired lancets, and the clerestory. This has paired instead of single lancets. The corbels for the vaulting shafts are shorter than in the transepts. The three bays are vaulted on the ground floor with quadripartite vaults, an indication probably of what the aisle vaults were like. Of the high vaults we know nothing.* But the upper chamber referred to has a longitudinal ridge-rib. There are no accurate dates available for the building of the church. Style and comparison with other buildings makes c. 1200–40 likely.

The CLOISTER affords evidence of an earlier building campaign, say about 1150–80. Immediately adjoining the S transept S wall is the CHAPTER HOUSE. It is an oblong chamber, and its E wall does not line up with that of the present transept. So the Norman transept was probably less wide. It was also shorter in all probability; for the usual thing was a slype between transept and chapter house. The chapter house has an entrance by three wide arches. Their shafts are badly preserved; the arches are decorated with various geometrical motifs, including zigzag in the intrados, i.e. at r. angles to the main surface, a typical later C12 motif. The N and S walls have a plain dado ending in a zigzag frieze and then 9 intersected arches on shafts with decorated capitals, and at the apexes of the arches a second tier, and on that a third. The system is very similar to that of the chapter house of Bristol Cathedral, a former Augustinian priory. The chapter house was vaulted in three bays and the vaults stood on triple shafts, again with decorated capitals. The ribs have a rather ancient profile: a spur between two rolls. To the N of the

* A note of c. 1500 refers to the vault above the High Altar.

chapter-house entrance are three recesses in the w wall of the
s transept. They were made at the time of the rebuilding of
the church and served as a book store. Above the vault of this
a gangway connects a staircase in the sw angle of the transept
with the Dormitory which lay on the upper floor to the s of
the chapter house. To the e of its n end, half adjoining the
chapter house, lay the INFIRMARY.

This, with its lancet windows, now forms part of a private
house. The house also includes the former chapel of the
infirmary and to the s of that, giving the house an L-shape,
the PRIOR'S LODGE. This is one of the finest examples of
domestic architecture in England about the year 1500. To
41b the w it is faced by a two-storeyed gallery, replacing no
doubt an earlier cloister walk. The gallery forms a continuous
grid of windows, very much as in a building of the c20.
Buttresses between every pair of two-light windows. Four-
centred arches. Very big stone-slated roof. The whole
impresses one as stately and yet entirely domestic. The
windows to the e and n are odd. Again ground floor and upper
floor are taken into one system by allowing the upper mullions
to descend down the wall and link up with the lower. But the
upper arches are straight-sided, and so are those of the
individual lights of the two-light windows. Is all this genuine
or a c17 adaptation, after the building had passed to the
Lawley family? The interior arrangements were as follows.
On the ground floor at the n end the chapel with the altar in
the e bay-window, then to the s a narrow room, then a large
one connected with the kitchen which was at the s end. Above
the chapel the prior's private oratory, and then the hall.
Spiral staircase at the n end of the cloister or gallery and in the
hall down to the kitchens. The hall has an open timber roof
with cusped wind-braces. In the window recesses, instead of
the usual seats, are table-tops on short pillars. The staircase
between hall and kitchen has two parallel runs above one
another, round the same newel-post, and within the same
circular well.* In another room a c13 marble LECTERN,
excavated on the priory site. It has three inverted leopards'
heads with foliage scrolls sprouting out of them.

Of the other sides of the Cloister no more can be seen than
walls of the REFECTORY against the s walk, with the springers

* It is the arrangement made famous by the grand central staircase of
Chambord, and also used, as Mr John Gloag kindly tells me, in the sw turret
at Tamworth church, Staffordshire.

of a vault, and in the w wall two round-headed recesses. The refectory was not at r. angles to the other cloister walks. In the cloister close to the s walk was a LAVATORIUM, of which only the substructure remains. It had a big well in the middle and outer arcades of columns in pairs one behind the other. The juicy foliage is typical of c. 1180–90. So is the remarkably good SCULPTURE. One panel with two standing figures under arches, and one with Christ on the Lake. There were no doubt many more, and it is much to be regretted that they have disappeared; for they are of outstandingly good quality, especially the figure of Christ with strong rounded features, the head bent tenderly, and the mantle draped with deep rounded folds. The character of the folds as well of hair and beard is practically the same as that of the foliage.

The w range is represented now only by odd walls. Further w, some distance away, a square, featureless tower, connected probably with the outer courtyard of the priory.

Parish services were not held in the priory church but in a separate parish church, close by to the sw.

HOLY TRINITY. Wide Norman nave and wide Norman chancel, and added to this a Transitional w tower. The Norman chancel is visible only in one half-uncovered upper s window with a nook-shaft and a moulding with a hollow and a demi-roll, and in the much restored chancel arch. This has two orders of shafts with block capitals and roll-mouldings in the arch. Small window on the E side above. In the nave also no more is at first visible than one N window from outside and parts of a s window from inside. But the w wall, though covered by the tower, survives remarkably completely and can be reconstructed visually if one climbs up in the tower. Large w portal with two orders of shafts with block capitals, roll-mouldings in the arch, and an inner zigzag band. Large w window above with big nook-shaft to the inside and two orders of nook-shafts to the outside. Simple small window above that, in the former gable. To the inside elaborate decoration with blank arcading in three tiers, two of five arches each, and one of two. Much zigzag ornament.

The tower has broad flat Norman buttresses, pointed arches to the N and s, no doubt originally open and used as a passage, and round-arched twin bell-openings of the originally Saxon type, much renewed. Perp battlements. To the s of the tower the corner of the Norman nave is still clearly visible outside.

The C13 added and altered various things. Two-storeyed S porch, C13 below, with big double-chamfered outer doorway. Fine inner doorway with one order of shafts. Moulded capitals and finely moulded arch. S aisle of five bays with circular piers with circular capitals and double-chamfered arches.

Dec windows in various places. Interesting the tracery of the easternmost window of the S aisle, three lights, with arches upon arches. The westernmost chancel window on the N side is reticulated. C14 also the S chancel chapel, connected with the chancel and the aisle by double-chamfered arches of continuous moulding. In the S wall of the chapel below a window two shields in blank panels, perhaps connected with a former monument. In the chancel deep, vaulted Sedilia with concave-sided gables, two of them cut off by the Perp window above. Perp E window of five lights with big crocketed outer ogee gable and niches inside l. and r. for images. The Perp S window seems to have been altered in the C17. C18 brick parapet on the nave N wall.

FONT. 1874, with tiles set into stone. – PULPIT. Jacobean, with the oddly inappropriate decoration by panels with two-tailed mermen. – DOOR. With ironwork probably of the C12 or C13. – SCULPTURE. Two heads in the chancel S wall, no doubt former head-stops of hood-moulds. – MONUMENT. Brass plate to Richard Ridley † 1592, and family; kneeling figures.

PERAMBULATION

A perambulation might profitably start at the W end, where some spacious Georgian brick houses mark the C18 and early C19 end of the town: the GASKELL ARMS HOTEL with two widely spaced bay-windows, No. 40 High Street, taller and also with two bay-windows, and No. 2 Bourton Road, a red brick villa. Then half-timbering starts at once, with No. 41 High Street. In the HIGH STREET most houses are at first cottages of two storeys; the street seems no more than a village street. Notable No. 48 and ASHFIELD HOUSE, a picturesque house with a pre-Reformation stone ground floor and timber-framing, mostly close uprights, but diagonals in the gable. A little further on on the other side BARCLAYS BANK, again timber-framed. Then the street gets narrower and more townish. On the l. Nos 55–56 with three gables, three bay-windows, and some very picturesque timber ornament, a kind of cross of spurs with a diamond as its centre. Also two

balconies between the bays, one with turned, the other with twisted balusters. The CORN MARKET and AGRICULTURAL LIBRARY of 1852 does not hurt, and soon Barrow Street and the Guildhall are reached.

The GUILDHALL is a building of great charm. Its lower part is said to be medieval, but the wooden parts date from 1577. Arched braces from the ground-floor posts support the over-hanging bressumer of the upper storey. Two gables and a third at a slight angle above the passage through to the church-yard. Three-light windows, one with a transom. In the gables again the ornate motif of a cross of spurs. The back much rebuilt. The principal room has a roof with tie-beams and queen-posts. Jacobean panelling. Now first down BARROW STREET. At the angle of the churchyard CHURCH HOUSE, timber-framed, then some Georgian brick houses. Down ST MARY'S LANE, at the end, facing down the street, No. 5, a Gothick bijou with a stepped sham-Jacobean gable.

Back to the Guildhall and down WILMORE STREET. Facing the church tower some C18 brick houses and then the STORK HOTEL, Early Victorian, of three widely spaced bays. Finally at the corner of BULL RING Nos 7–9, a picturesque cottagey corner, stone and timber-framing. Down Bull Ring one passes the square Priory tower and reaches the entrance to the priory ruins. Further on in SHEINTON STREET Nos 55–57, timber-framed, but incorporating two arches of c. 1300 in its E wall, then Nos 51–54, a set of almshouses with ogee-headed windows, and then, just in front of the railway arch, the MANOR HOUSE, L-shaped and with a timber-framed gable. Good late C17 staircase.

MUNSLOW

5080

ST MICHAEL. Nave and chancel, and W tower. The tower is Norman with a Perp top-part and an C18 parapet. The tower arch is broad, with plain imposts and a slightly decorated hood-mould, resting on two head stops. The chancel is E.E., see the one slit-like lancet which now gives on to the vestry. In the nave on the S side late C13 or early C14 windows. Then several interesting early C14 windows in the chancel N, and especially the N aisle. Their tracery consists of arches on the apexes of others (cf. Wells Lady Chapel, c. 1300). The fact that the N aisle is in its arcade (three wide

bays, octagonal piers, double-chamfered arches) Perp need not contradict the date. The N windows of the nave may well have been re-used (cf. Claverley). It is a pity that the inner walls of the church have been stripped of whitewash or plaster. Perp vestry, Perp S porch. The latter is exceptionally handsome, timber-framed, with open sides in two-light round-headed arches with Y-tracery. – FONT. Octagonal, Perp, with blank arches on the stem, and quatrefoils with flowers on the bowl. – SOUTH DOOR. With ironwork probably of the C13. – BENCH ENDS. Some are original. They are carved with simple geometrical patterns. – CHEST. With traceried front. – STAINED GLASS. In one S window C15 to early C16 fragments, two seated Virgins, a kneeling family, etc. In other windows glass of the early C19 of various types, the three Apostles in the W window entirely of that date, the N windows in imitation of the C15 and with occasional original bits. – CURIOSUM. A large brick from the Great Wall of China, brought to Munslow in 1884. – PLATE. Flagon of 1689. – MONUMENTS. Quaint slate plate commemorating William Churchman † 1602, with heart, recumbent figure bundled up in a shroud above, hourglass and scroll below. – Two large hanging monuments by *Carline* of Shrewsbury, one in the Grecian (Rev. R. Powell † 1845), the other in the Gothic taste (Thomas Pemberton † 1832).

RECTORY. Three-bay two-and-a-half-storey stone house. Late Georgian with a porch on two pairs of Ionic columns.

BEAMBRIDGE SMITHY. A C19 folly by the roadside. Gothic style, castellated, with two blank three-light windows under round arches on the ground floor and a circular window in the raised segmental centre.

HUNGERFORD FARM. Good late C18 stone house. Two and a half storeys high. The centre has a Venetian window on the first floor, a tripartite semicircular one above, and a pediment-like gable.

MYDDLE

4020

ST PETER. W tower with diagonal buttresses and battlements, but no pinnacles. The bell-openings have plain Y-tracery. The interesting thing about this Perp-looking tower is that it dates from *c.* 1634. The church was rebuilt in 1744, see the cornice of the nave. The rest was thoroughly gothicized in 1837–58 and 1877. – STAINED GLASS. The E window commemorates someone who died in 1847, and might well be of

c. 1850. – MONUMENTS. Brass to Arthur Chambers † 1564 and wife, s of the altar. – Robert Atcherley † 1758 and other members of the family to 1773. Tablet of wood in imitation of stone.

CASTLE. Built by Lord Lestrange of Knockin. Licence to crenellate 1307. All that remains is a slender circular stair-turret, probably abutting on the hall. The castle was already 'veri ruinus' in Leland's time.

NASH
6070

ST JOHN BAPTIST. Early C14. First mentioned in 1330. Consists of nave and chancel in one, and thin w tower with weatherboarded broach spire. In addition a N aisle of *c.* 1865 with lush foliage in the capitals of the arcade. The roof is a continuation of the nave roof, with a different pitch. The w window of the aisle however is original early C14 work and so must be re-used. Most other windows are renewed, but also represent the style of *c.* 1300. Low archway from the nave into the w tower, single-stepped, pointed, no capitals or other articulation. – SCREEN. Carved at Louvain, probably also *c.* 1865.

NASH COURT. Red-brick house of five bays and two and a half storeys, with parapet. Porch of four attached columns, central window above with a pediment. At the back stables with clock cupola. The suggested date of the house is *c.* 1760.

COURT OF HILL, see p. 115.

NEEN SAVAGE
6070

ST MARY. Norman, of nave and chancel, and w tower. A blocked Norman doorway on the N side, a very renewed priest's door on the s side. (Restoration 1882.) The w tower had its top with battlements renewed after a fire in 1825. Before the fire there was a timber spire. The s porch is timber-framed with diagonal struts between the posts on the w side and a gable with foiled circles. The roof inside runs uninterrupted through nave and chancel. It is of the trussed rafter type, but also has five heavy tie-beams. – SCREEN. Much renewed. But some of the tracery is original, and the pretty bands of foliage of the top cornice. The tracery is of two lights with a pendant instead of a mullion. The forms are all ogee,

the most likely date *temp*. Henry VIII. – STAINED GLASS.
In the E lancets, with tiers of small figures above each other.
They might well be of *c*. 1825–30.

NEEN SOLLARS

6070

ALL SAINTS. Essentially late C13 or early C14 (first mentioned
in 1287). Red sandstone. A cruciform church with crossing
tower. The tower carries a shingled broach spire with dormer-
windows at the foot. They are of one light cusped, and may
well represent what was built contemporary with the church –
cf. the cusped lancet windows in transept and nave. But a
tapestry map of 1747 shows the tower without a spire. The
crossing rests inside on single-chamfered responds. The
arches are double-chamfered. The chancel was rebuilt in
1859, but tactfully. Trussed rafter roofs. – MONUMENT.
Humfrey Conyngesby † 1624. Standing wall-monument of
alabaster. The effigy semi-reclining in armour, head propped
up by the hand. Shallow arch behind with two good figures
in spandrels. Two smaller standing figures l. and r. of the top
achievement.

NEENTON

6080

ALL SAINTS. 1871 by *Sir Arthur Blomfield*. Of no interest.
Nave, chancel, and bellcote. The style is that of *c*. 1300. –
FONT. Circular, plain. – CHEST. A richly decorated piece of
the C15, with lozenges, quatrefoils, and Flamboyant tracery. –
STAINED GLASS. The E window of *c*. 1920 probably by
Morris & Co.

NETLEY HALL
1 m. NNW of Longnor

4000

Built in 1854–8 by *E. Haycock*. The centre of the house is a
large glazed hall with Tuscan pilasters and a screen of two
Tuscan columns behind which – grand as in a London club –
a staircase goes up, starting in one flight and returning to the
first floor in two. The hall is decidedly restrained for its date.
Equally restrained the outside, a deliberately conservative,
that is classical, job. Porch of two pairs of Tuscan columns in
front of the stone-faced centre bay of the five-bay red brick
house with rusticated quoins. Balustrade on top.

NEWCASTLE

ST JOHN EVANGELIST. 1848 by *Haycock* (GR). In the lancet style. – STAINED GLASS. E window no doubt by *Evans* and no doubt *c.* 1848.

LOWER SPOAD FARM. In the farmhouse an interesting over-mantel carved with a hunting-scene. There is nothing but animals, and they are arranged in a way more reminiscent of Norman lintels or tympana than of the time to which the carving probably belongs, namely the Elizabethan Age. In the middle affronted a doe and a stag. L. and r. two hounds one above the other. L. and r. of these three hounds again on top of each other.

NEW HALL *see* EATON-UNDER-HAYWOOD

NEWPORT

ST NICHOLAS. A large town-church, which looks its best from a distance as one approaches from the N. Red sandstone; lawn and some trees to the N. W tower, nave and aisles, and clere-story, mostly Perp and some Dec. All embattled. On coming nearer one discovers that most of what one sees is rebuilt – the work of *John Norton*. Chancel 1866, nave and S aisle 1883–5, N aisle 1890–1.* C14 W tower. Broad, not high, with angle buttresses, battlements, and a higher stair-turret with pyramid roof. A stone spire was projected (see the squinches inside). Correctly renewed W window. Tower arch tall and plain, triple-chamfered. Rebuilt arcades of five bays with tall slim octagonal piers and double-chamfered arches. Original nave roof of low pitch with carved bosses. In the N aisle two double-chamfered recesses. They were originally in the E wall of the aisle. S chancel chapel of two bays with heavier octagonal pier and double-chamfered arches. – SCULPTURE. Small relief of a figure with arms raised. In a spandrel of the N arcade. What date can it be? – STAINED GLASS. Chancel S, a window by *Morris & Co.*, 1872, and very good. Two *Burne-Jones* figures above, two small oblong scenes below, the Mount of Olives especially fine. – S chapel E and S by *Kempe*, 1906. – MONUMENTS. Alabaster tomb-chest of *c.* 1520 with two recumbent effigies. Against the chest wall small figures

* The N porch dates from 1904.

under cusped segmental arches. In the middle two angels with a shield. Twisted colonnettes at the angles. Not good sculpturally. – Elizabeth Blakemore † 1828. With a large seated mourning angel. Gothic surround. No signature.

ST PETER AND ST PAUL (R.C.), Salter's Lane. 1832 by *Potter* of Lichfield. Brick and stone dressings. W wall with large circular window with Dec tracery. Interior of no architectural interest.

CONGREGATIONAL CHURCH, Wellington Road. 1817. Classical front with giant pilasters and pediment. The entrance in a recess the whole height of the front.

THE TOWN. From the point of view of townscape there is nothing better in North Shropshire than Newport. The town is really one long High Street, winding its way gently to the church and downhill to the canal. The point about the street is that the church lies on an island site in the middle and that SE of it the island site is built over by normal small properties. Thus, while one gets the full view of the church coming from the N, one sees only a widening blocked by houses when one comes from the SE. To the l. and r. of these houses the street seems to divide. The High Street runs on on the l., the street on the r. is called St Mary Street. Past the church they unite again. This piece of visual planning is more important than the individual houses. Of such the following may be mentioned. To the NW of the church immediately on the l. ADAMS' GRAMMAR SCHOOL. A combined composition with two small separate blocks nearer the street which are almshouses. The group was built in 1657, but much rebuilt in 1821. Brick. Recessed five-bay centre and two three-bay wings. Hipped roofs. The centre filled in by a lower ashlar-faced frontispiece with five arches separated by awkwardly tall bases for the pilasters of the upper storey. Lantern behind. A little further NW BEAUMARIS HOUSE, a wealthy house with the date 1724 on. Brick, five bays, two and a half storeys, segment-headed windows, giant angle pilasters; doorway with Tuscan pilasters and a pediment. Opposite IVY DENE, a detached Late Georgian house with a porch of two pairs of Ionic columns lying a little back. E of the church in ST MARY STREET the ROYAL VICTORIA HOTEL, ashlar-faced, probably of c. 1830. Two and half storeys, five bays, Tuscan porch *in antis*, giant Tuscan pilasters above, coupled below the three-bay pediment. SE of the church less of interest. At the widest point where the island site inter-

venes, to the NE the TOWN HALL, 1859–60 by *J. Cobb*, debased Italianate with a semicircular centre scroll on top with carved garlands and the clock. Opposite No. 53, which is hard to date with its odd two short Tuscan columns below and odder short Ionic columns above carrying a semicircular arch. The style of the motif is more mid-C17 than mid-C19. Further SE some timber-framed houses, especially the OLD GUILDHALL, dated 1615, a symmetrical front with two slightly projecting gabled wings. Towards the Station the style of the street changes from Georgian and before to Early Victorian.

HARPER ADAMS COLLEGE, 1½ m. NW. 1900–1. Free neo-Elizabethan, of hard red brick, E-plan with central lantern. By *H. Teather* of Cardiff and Shrewsbury.

NEWTOWN

KING CHARLES CHURCH. 1869 by *E. Haycock Jun.* Lancet style. Inside a SCREEN of wrought iron.

NORBURY

ALL SAINTS. Nave and chancel of 1880 and 1892 (by *Henry Curzon*), and W tower probably of the C14 or earlier. The tower arch looks C14. The tower has a strong batter. C19 broach-spire.

HARDWICK, 1¼ m. S. Timber-framed house with pretty porch. Open below with arched braces for the upper floors. Concave-sided lozenges on the first floor, diagonal strutting in the gable. The projecting wing on the l. of the porch is of the more straightforward post-and-pan type.

NORDY BANK *see* ABDON

NORTHWOOD HALL *see* WEM

NORTON

The SCHOOL is a Victorian oddity, looking with its tower like a church. In the little green in front of the church the STOCKS and WHIPPING POST are preserved.

NORTON-IN-HALES

ST CHAD. Perp W tower, the rest mostly of 1864–72. The Norman W doorway in the tower is apparently entirely Victorian, a curious idea, perhaps optimistically based on some original fragments found. The chancel is E.E.; but only the S doorway reveals that. The aisle arcades may be based on medieval fragments, but are essentially of 1864. Finally the tower. It has diagonal buttresses, battlements, and pinnacles. Bell-openings with cusped Y-tracery. W window of the same design. The architect of 1864–72 added an octagonal baptistery at the W end and an octagonal vestry N of the chancel. Is the castellated archway N of the church of the same date? – WOODWORK. Parts of a Jacobean bedstead in the chancel. – MONUMENT. Sir Rowland Cotton and his wife who died in childbed in 1606. The monument is of alabaster. As it is now displayed in the porch, it is clearly not in its original state. It must have had a back wall with pilasters corresponding to the two columns in front, and a ceiling over. Recumbent effigies, she with her breasts bared and her infant naked in her arms. The columns are most ornately decorated with close arabesque. The figures lie on a splendid, generously shaped sarcophagus with harpies at the angles and thick garlands.

36a

OAKENGATES

The centre of an Urban District, but too straggling to appear a town anywhere.

HOLY TRINITY. 1855 by *Harrison*, supervised by *Ewan Christian*.

ST GEORGE'S, Oakengates, see p. 239.

OAKLEY PARK

An early C18 house immediately above the river Teme, altered and added to about 1800 and again, most successfully, by *C. R. Cockerell* in 1820 etc. The house is of brick, and on the W, i.e. the entrance side, the early C18 appears behind Cockerell's one-storeyed screen with two symmetrical porches of heavy Tuscan columns *in antis*. The columns have the small bands of Doric fluting at top and foot which were taken over from the Olympiaeum at Syracuse and the so-called

Temple of Hephaestus at Girgenti. The s side again is C18, but Cockerell added a flat one-storeyed attached portico of pilasters and a heavy balcony above. Towards the N unchanged Georgian work with two Venetian windows one above the other and a pediment. Beautiful oval Entrance Hall by *Cockerell* with his characteristic diagonal coffering, and then large Staircase Hall with glazed circular dome and on the side facing the entrance on the upper floor a screen of two Egypto-Grecian columns and a piece of the frieze of Bassae over. Cockerell had been one of those who discovered the frieze in 1811, although he was not present at its final excavation in 1812.

OFFA'S DYKE

Sections of this mighty earthwork, of which no less than 81 miles of ditch and bank are still visible in Wales and the Marches, pass through North-West Shropshire and South Shropshire. In the North West, it descends through the Vale of Llangollen and passes 2 miles w of Chirk, 2 miles w of Oswestry, and through Llanymynech. In South Shropshire, it runs through Nutwood, Mainstone, and 2 miles w of Clun. For further observations about this extraordinary and grandiose engineering achievement, which was evidently designed to serve as a dynastic boundary rather than as a military edifice, see the Introduction, p. 16.

OLD MARTON
3 m. E of Ellesmere

3030

OLD MARTON OLD HALL. Timber-framed farmhouse, mostly narrowly spaced uprights. The porch originally had open sides with slim balusters.

ONIBURY

4070
Inset B

ST MICHAEL. Roughcast nave and chancel and short unbuttressed embattled w tower. Norman chancel arch. Depressed arch on plain imposts with a little decoration of pellet and zigzag. The other datable details E.E. At the E end three closely set stepped lancets, inside under one arch. Perp timber porch. Solid heavy tie-beam roof in the nave. – WEST GALLERY and some ironwork by *Detmar Blow* from the time of his

restoration (1902). – PULPIT. Perp?* – MONUMENTS. Dorothy Pytt † 1657, in a gargantuan Renaissance surround (cf. Ruyton). – Two cast-iron slabs with shields and inscriptions (instead of black marble). They are dated 1666 and 1673 and are to the l. and r. of the altar.

4010

ONSLOW HALL
3¼ m. w of Shrewsbury

Neo-Greek mansion of 1820 by *Haycock*. Built of Grinshill stone. Seven bays wide. Giant Greek Doric portico and pediment. To the l. an added block with giant pilasters and a lantern. Greek Doric lodges on the main road.‡

6010
Inset A

ORLETON
1 m. w of Wellington

ORLETON HALL. Stucco-rendered Late Georgian house of two and a half storeys. The main front is nine bays wide and has a three-bay pediment. Behind the house to the N a moat with a stone bridge over and a GATEHOUSE. This is timber-framed and was erected in 1588, but altered later. It has features of different dates, an oval window, a Gothick dormer, and a lantern, the outline of which looks Georgian. There were indeed extensive remodellings in 1766. On the garden wall a GAZEBO with a low ogee roof and oddly shaped windows, called mid-C19 by the MHLG.

2020

OSWESTRY

ST OSWALD. A large church facing Church Street with three parallel gables, but a church in which the Victorian contribution dominates. The big and strong tower at the SW end is in its lower part of the C13, in its upper parts with balustrade and eight pinnacles of the late C17 (probably 1692), after the church had suffered badly in the Civil War. At the W end of the nave close to the tower and now internally hidden by an aisle pier is an original lancet window, also of the C13. The chancel E window has reticulated tracery copied in 1861, it is

* Cranage says that the pulpit 'does not belong to any of the pure Gothic periods'.

‡ The house has meanwhile been demolished.

said, from the Dec original. The N aisle windows are also supposed to be correct reproductions. They are Late Perp and may date from the late C17. All the rest is by *G. E. Street*, 1872–4, and not one of Street's masterpieces. Irregular and confusing plan of nave with wide N aisle, double s aisle into which the tower cuts, s transept, and chancel with N and E chapels. The oddest feature is that the aisle arcades at their E end have two octagonal piers set very close to one another. – FONT. Dated 1662, and typical of the fonts made in large quantities all over England in those years. Octagonal, that is in the Perp tradition, and with flat carving. Three sides only are carved, with the date, a double eagle, and a rosette. Nice fluted COVER. – REREDOS. By *Street* 1880. – PLATE. Cup and Cover silver-gilt 1575; Cup with openwork and tall Cover, silver-gilt, made in London 1619–20; Cup and Paten given in 1635; Flagon given in 1707. – MONUMENT. Hugh Yale † 1616, and wife. Standing wall-monument with two big kneeling figures facing one another. Columns and big coarse strapwork achievement between obelisks. From the old church. – CHURCHYARD GATES. The timber-framed lychgate in Welsh Walls is dated 1631 and formed the entrance to the Grammar School. – The fine wrought-iron gates and gatepiers towards Church Street date from 1738. They were made by the *Davies Brothers*.

HOLY TRINITY, Salop Road. 1836–7 by *R. K. Penson*. Wide nave and chancel with apse. Grey stone, lancet windows. The only remarkable fact is the rib-vaulting of the apse, very heavy in the details and the dog-tooth ornament. This also dates from 1836–7. In 1894 *Eustace Frere* made alterations and additions (GR). They include the NW tower with its fanciful timber spire with four spirelets and the Vestry w of it.

NONCONFORMIST CHAPELS, see Perambulation.

PUBLIC BUILDINGS, see Perambulation.

PERAMBULATION

There is not much that has to be recorded. Starting by the church, one starts with the best houses: Nos 1–3 CHURCH TERRACE immediately w of the churchyard, timber-framed, of *c.* 1600 and originally part of the Grammar School.*

* In 1776 the GRAMMAR SCHOOL moved away to its present position. The earliest building on the new site is the Late Georgian Headmaster's House. The chapel dates from 1863.

LAUREL COTTAGE, also just w of the churchyard, is a cottage with Gothick windows with diamond glazing. Then in UPPER BROOK STREET which runs s of the church Nos 16–22 just opposite the lychgate, and Nos 26–28. Nos 16–22 is Late Georgian, a handsome seven-bay brick front with an alternation of wide segment-headed and narrow round-headed windows. Below the latter pairs of doorways under one pediment. On the first floor all windows have fan ornament in the window heads, on the ground floor only the wide ones. Nos 26–28 is simpler, early C18, with segment-headed narrowly set windows. Then into CHURCH STREET to the most ambitious houses, the WYNNSTAY HOTEL opposite the church, and Bellan House to the N of the church. The hotel is a Late Georgian building with a deep porch of two pairs of Tuscan columns and has inside a handsome ballroom.* BELLAN HOUSE has two big canted bay-windows and pediments above them, and a porch with two Ionic columns in front of four demi-columns. The gatepiers to the r. of the house carry shapely Adamish urns. Church Street itself is not successful as a street; for there are two big breaks – a car park and a public park. The OLD VAULTS has a good Early Victorian shop front, Nos 4–6 framed and eared windows. The house is probably mid-Georgian. Brick, five bays wide. Finally at the main street junction of the town the MIDLAND BANK of 1890 by *Grayson & Ould*, red brick, Tudor, Waterhouse style.

At this same junction, with the front into CROSS STREET stands the LLWYD MANSION, dated 1604. It is timber-framed with three slightly projecting first-floor windows and an oversailing second storey. Opposite the NATIONAL PROVINCIAL BANK of 1905–6 (by *Shayler & Ridge*), an attractive design with fancifully shaped gables and an angle turret. The building stands at the entrance to BAILEY STREET, where No. 29 is timber-framed and derives its prettiness from the Gothic carvings of bressumers and bargeboards which are probably early C19. At the head of Bailey Street is BAILEY HEAD, with the two main public buildings.

MUNICIPAL BUILDINGS, 1893 by *H. A. Cheers* of Twickenham, stone, quite picturesque, in what one might call a free

* It is referred to as built by Sir Watkin Williams Wynn in the diary of the English and Welsh trip undertaken by the Dublin architect Francis Johnston in 1796. (Information received from Mr Neill Montgomery.)

version of the Loire style,* and the POWIS MARKET, i.e. the Corn Exchange and Cheese and Butter Market, built in 1869 in a curiously restrained posthumous Georgian style, also stone, nine bays, with quoins and segment-headed windows. Above the centre a big shaped gable.

Just behind Bailey Head steep Mound of the former CASTLE. The keep was of the shell type and seems to have been built in the C12. Only some bits of masonry are there as a reminder of it. The position of the bailey is recorded in Bailey Street. Next to the Castle is CHRIST CHURCH CONGREGATIONAL CHURCH, 1871 by *W. H. Spaull*, a local architect. The church is very much a church, with its SW broach spire. Down ARTHUR STREET the MINISTRY OF PENSIONS etc., a former Nonconformist Chapel, big, of brick, with arched windows in the front and a Greek Doric doorway *in antis*. The building dates from 1830. Arthur Street ends in Willow Street. But WILLOW STREET ought to be followed from its start, in the centre of the town, at the corner of Bailey Street. In it the CENTRAL CAFÉ, an early C18 house of three bays with quoins and a one-bay pediment and pronounced modillion frieze, lying back a little from the street, and Nos 64–70, more or less a copy of the terrace in Welsh Walls described above.

SECONDARY MODERN SCHOOL, Pool Road. By *Richard Sheppard & Partners* in collaboration with the County Architect. Begun in 1956. One of the best recent buildings in the county. Long and low, one- to three-storeyed. Light steel construction. Brick, glass and slate facings.

MORDA HOSPITAL, 1¼ m. S at Morda. Regular composition with pedimented centre and pedimented projecting wings. Red brick. Built in 1791–2.

WESTON MILL, just E of this. A tall former mill building, four storeys high and only four bays wide. Stone with segmental brick arches above the windows, and pediment-like end gables. A lower wing at the W end.

OLD OSWESTRY (YR HÊN DDINAS). A superb Iron Age hill fort, described by Sir Cyril Fox as 'the outstanding work of Early Iron Age type on the Marches of Wales'. It covers forty acres, and underwent many vicissitudes between its

* Oswestry possesses the following Municipal PLATE: two Maces of 1617 or 1677, a Cup of 1616, two Ewers of 1739 and 1740, a Race Cup of 1777, four Drinking Cups of 1791, four Candlesticks of 1795, a Scotch Mull of 1822.

first beginnings about 250 B.C. and its final abandonment after the Claudian conquest. Originally it consisted of two huge earthen banks, but at a later stage a third bank was added, and finally the whole structure was enclosed by an enormous double rampart. The entrances were on the W and the NE.

OTELEY
½ m. E of Ellesmere

4030

Neo-Elizabethan stone mansion of 1826–30, with additions of 1842. Straight gables and an archway as part of the N front, approached by a drive and heavy walls l. and r. Outer walls with some sort of bastions. The house was built for Charles Kynaston Mainwaring and lies splendidly above the mere.

PEPLOW

6020

CHAPEL OF THE EPIPHANY. 1879. The architect was *Norman Shaw*.* Timber and brick-nogging and a very tall roof, starting very low down. Fanciful open timber bellcote over the junction of nave and chancel. An excellent, lively design.

PEPLOW HALL. Built in 1725 and considerably enlarged later. The original house was seven bays by six bays and two storeys high with a big parapet, and no special decorative enrichments except for the curly tops of the first-floor windows of the three middle bays. To the E the centre is recessed and the sides project somewhat. Original staircase, not *in situ*, with slim balusters, three to a step, one turned, and two with different spirals. Excellent GATES of wrought iron at the W entrance to the garden. C18; by *Jones* of Wrexham.

PEPPER HILL
I m. SE of Boningale

8000

(Old house perched on the sandstone cliff. Stone walls below, brick above. A barn nearby. The ornamental FOUNTAIN HEAD has been removed to Pattishull, Staffordshire.)

PETSEY see STOKE-UPON-TERN

* Information kindly given me by the Rev. N. V. G. Griffiths, Rector of Hodnet.

PETTON

4020

CHURCH. Built in 1727 and restored and altered in 1870 and 1896. Nave and chancel in one, and bellcote with steep pyramid roof. Brick, with three arched windows on the long sides. – Interesting WOODWORK. – BOX PEWS no doubt of 1727. – PULPIT. A splendid Jacobean piece with tester; dated 1635. The handrail next to it has twisted balusters with foliage near their feet. That again looks 1727. – The WEST GALLERY rests on two columns brought from the Council House at Shrewsbury. They are all covered with oval, oblong, and diamond shapes. – REREDOS. Made up of all kinds of C17 parts. – SCULPTURE. A Dutch panel of the Resurrection of Christ (Christ opsta). – IRONWORK. Elaborate ironwork of the later C19. – PLATE. Chalice and Paten of 1572.

PETTON PARK. 1892. Large neo-Elizabethan brick mansion with straight gables and an asymmetrically placed square turret.

CASTLE. The mound of the medieval castle is close to the church.

PITCHFORD

5000
Inset A

ST MICHAEL. Nave and chancel, and weatherboarded belfry with pyramid roof. Norman evidence one blocked window in the N wall of the nave and herringbone masonry below it, and unmoulded round-headed doorway on the N side of the chancel. More E.E. evidence: nave N doorway with fine continuous mouldings and lancet windows. The E gable with its classical details dates from 1719. – PULPIT. Jacobean, with tester. – Also Jacobean the READING DESK and some BENCHES. – ORGAN. Gothick, probably early C19. – MONUMENTS. John de Pitchford † 1285 (?). Oaken effigy, 7 ft long, of a Knight, slender figure, cross-legged. Well preserved. – Four excellently drawn incised alabaster slabs of couples of the Pitchford family. They date from 1529, 1534, 1578, and 1587, and make an enlightening study of the history of costume.

PITCHFORD HALL. The most splendid piece of black-and-white building in Shropshire. Large and well-planned house, built by Adam Otley, a woollen merchant of Shrewsbury, c. 1560–70 (and anyway before 1578, when he died). The present garden side is the original entrance side. E-plan, but with 46b

square projections in the re-entrant angles between wings and centre. The timber-framing makes plentiful use of diagonal struts, forming the familiar lozenges within lozenges. No higher flights of fancy, no concave cusped lozenges, and quatrefoils only in the porch. In fact, what is by far the most attractive quality about Pitchford is the combination of considerable size with an undeniable homeliness. The only further decoration is a shaped gable with volutes below at the top of the porch – and this may well be a later alteration. Two overhangs, the upper with carved bressumers. The far-projecting wings are simpler, and from an early painting inside the house it looks as if they had originally been only half their present length. C19 wing to the w, in line with the present entrance side (the N side). This also has a porch in the middle. To its l. and r. big chimneybreasts, brick on stone bases. The chimneystacks of Pitchford are one of its most enchanting features. They are all star-shaped. The Hall lies to the r., as one enters the house from the N side. There was no doubt originally a screen. In the SE wing the Drawing Room with thin-ribbed geometrical plaster patterns between the deep beams. Then the Library, an C18 room, but with a fireplace dated 1626.

Opposite the s front up the hill the enchanting folly of a timber-framed SUMMER HOUSE in the branches of a tree. It has the prettiest Gothick decoration, according to its style hardly later than the 1760s.

PLAISH HALL
2 m. NNW of Longville

5090

Essentially a work of the later years of Henry VIII, and the most important of its date in Shropshire. Built by Sir William Leighton. He evidently found a house on the spot, and the most likely explanation of the surviving evidence is that the present entrance, i.e. sw, side was the front of an older stone house of which nothing remains except one window of three lights probably of the C15: straight-headed, with pointed cusped lights. The new house has its façade turned to the SE. It has projecting wings, and as they are carried on at the back, an H-shape results. The house is of red brick, at that moment the fashionable material, with diapers in vitrified blue brick and stone dressings, including big quoins; straight gables. Plaish is the earliest use of brick in the county. The windows

are of three or four lights, transomed, straight-headed, and with pointed, uncusped lights (cf. e.g. such houses as Barrington and Poundisford in Somerset). The entrance to the Henry VIII house is in the recessed centre of the SE front, at the l. end. The Hall windows follow, that at the dais end being an Elizabethan replacement. The whole projecting r. wing has yet later, probably Jacobean, windows. Above the hall chimney three excellent stacks of moulded brick, with zigzag, diaper, and diamond patterns (cf. e.g. Hampton Court). On other sides of the house stone is used (or kept) for the walls, and brick only for the gables. The chimneybreasts also are of stone. The l. stack on the SW front is a later C17 replacement. Additions on the NW. Inside, the Hall was subdivided horizontally within living memory. Some parts of the hammerbeams of the sturdy roof are re-used in the staircase built behind the Hall. The original stairs were narrow newel staircases, one at the dais end of the Hall (stone entry), one at the screens-passage end, and another of which more is preserved in the projecting NW wing. The most interesting room is the one with its ceiling 51 divided into panels by thin ribs with miniature pendants. The panels are painted with H.R., emblems, and typically Early Renaissance scrolls. The walls have Elizabethan panelling painted to imitate relief and with small floral etc. motifs, sparsely applied. Excellent fireplace surround with Elizabethan blank arches and real tarsia or inlay. In another room a plaster frieze and one curious motif with the word IESU in a heart surrounded by strapwork. The same moulds were used at Wilderhope.

PLAS IOLYN see DUDLESTON

PLOWDEN HALL 3080
2 m. E of Lydbury North

Timber-framed house, mostly Elizabethan, that is the time of the great lawyer Edmund Plowden. The house still belongs to the same family. The timber-work is mainly of the post-and-pan variety. Much panelling and a good Jacobean overmantel with inlay. One small staircase with flat balusters, another with C18 balusters. In the chapel BRASS to H. Plowden † 1557 and wife; 2 ft figures; from Bishop's Castle church. C18 stable range of stone to the NE.

PONTESBURY

3000

ST GEORGE. The large church of a small town, not a village.
The chancel is of the late C13, red sandstone, and of fine
proportions. Large E window with intersecting tracery, inter-
rupted with a naughtiness typical of *c.* 1300 by a pointed
quatrefoil (cf. Kinlet etc.). Tall windows with Y-tracery to the
N and S. The chancel arch tall and wide with two bold quadrant
mouldings. The rest of the church, nave and aisles and big
SW tower, 1829 by *John Turner* (GR). Buff ashlar. Lancets in
pairs. The evidence inside the church points to a medieval
date for the arcades. They are of red not of buff stone, and the
piers used are so short that they stand on tall bases (useful also,
on the other hand, for box-pews). The piers are quatrefoil in
section with fillets, and the arches are like the chancel arch. It
is known that the church before 1829 had aisles and was lower.
– FONT. Norman, square. On the underside scalloped. –
REREDOS. With three scenes in marble figures, against a back-
ground of a mosaic of stones of various colours. Designed by
G. E. Street (Kelly). – MONUMENTS. An unusual number of
tablets; remarkably good sculpturally that to Thomas Davies
† 1674, merchant in London, with two small standing figures,
and a sailing-ship in the 'predella'. – In the churchyard a
monument of 1843, with an urn on a big pedestal – of cast iron.
To the E of the church the DEANERY, early C18, brick, with
quoins; five bays, two and a half storeys.
The OLD RECTORY (Nos 1–4) is of cruck construction – see
the gable end. The infilling between the timbers is of brick.
In bad condition at the time of writing.

POOL HALL *see* ALVELEY

3010

POYNTON
1¼ m. W of High Ercall

CHAPEL. Of a medieval chapel the W wall remains as part of the
outbuildings of a farm – right on the main road. Three-light
Perp window of odd design.

3030

PREES

ST CHAD. Red sandstone. W tower of 1758, with battlements and
pointed bell-openings with Y-tracery. Nave and aisle and N

chancel chapel c14. The arcade of four plus two bays with short octagonal piers, plain capitals, and double-chamfered arches. The tower cuts into the w arches. Late Perp N porch with stepped gable and finely moulded entrance. The chancel was rebuilt in 1864, when the whole church was severely restored. The vesica-shaped w window is of 1857. – STAINED GLASS. In the easternmost N window fragments of the early c15. – MONUMENT. Sir John Hill † 1824. Signed by *Thomas* 38b *Carline* of Shrewsbury. With a fine, quite uncommon funeral procession of small figures in a style much influenced by the Elgin marbles.

PREES HALL. A remarkable Georgian house, opposite the church. Brick. Seven-bay centre, the middle three bays recessed but the three-bay pediment kept flush with the un-recessed parts. So the doorway and the three middle windows on the upper floor lie back behind and below the pediment. One-bay wings, with pyramid roofs, connected with the house' by one-bay links.

PRESTON BROCKHURST 5020

Handsomely placed, overlooking, across its walled garden, a proper village green lined with black-and-white cottages, some original, some c19. Grey stone mansion of the later c17, quite sizeable, though only three bays wide. Three gables, the outer ones belonging to the slightly projecting sides, the middle one rising above a square porch projection. This has an altered doorway, and above the first floor a balcony. Three-light mullioned and transomed windows. Square chimneystacks. As for the interior, the best feature is the staircase. It has sturdy twisted balusters, and newel posts consisting of a square of four such balusters and repeated in the panelling of the dado along the wall. This can hardly be earlier than 1690.

PRESTON GUBBALS 4010

ST MARTIN. 1866 by *S. Pountney Smith*. The s wall of the aisle was kept, with a plain round-headed priest's doorway and a Perp window. – STAINED GLASS. E window 1880, signed by *Ward & Hughes*. – MONUMENT. A very interesting early c14 slab with a sunk panel, rounded below, provided with a crocketed ogee gable above, and containing the bust of a man

with a foliated cross on his breast. The arms of the cross are of equal length.

LEA HALL, ¾ m. N, on the main road. Elizabethan brick house, dated 1584 on a fireplace inside. This fireplace is uncommonly noble, the overmantel articulated by pairs of fluted Ionic pilasters. The house has two gables and slightly projecting wings on the E side. Only a few of the original mullioned and transomed windows remain.

6010 PRESTON-UPON-THE-WEALD-MOORS

ST LAURENCE. Red brick. 1739, with a W tower and arched windows. The tower ends in a parapet. In 1853 a chancel with lancets was added. Inside the WOODWORK is mostly original: panelling, benches, etc.

HOSPITAL. Founded by the will of Lady Catherine Herbert in 1716. The buildings were complete about 1725. They form a most spectacular example of Georgian almshouse architecture. Red brick with stone dressings. The main buildings face S and form three sides of a quadrangle. This composition is continued to the S by a short avenue of trees and ends in two narrowly placed gate lodges. Even the lodges have giant Tuscan pilasters and very tall windows. As the lodges are two-storeyed, their ceilings cut through them. The main building is separated from the avenue by fine wrought-iron gates. Its centre is the Hall, slightly higher than the rest and crowned by a lantern with a clock. The lantern is square, and arched and pedimented to all four sides. The Hall has giant pilasters, and two large arched windows with Gibbs surrounds and a surprisingly grand doorway with a Gibbs surround and a pediment over. Inside it, there is contemporary panelling. In the middle of the long sides two fireplaces with large arched niches over. The niches, at the time of writing, were filled with glass cases of stuffed birds on top of each other. To the l. and r. of the Hall two bays to the corners. They are two-storeyed, both storeys being again remarkably high. The projecting wings are twelve bays long and of the same height. The first three bays are not different from the S front, but after that the ground floor is opened in 'piazzas' with elliptical arches (again with the Gibbs motif). The ends of the wings have giant angle pilasters. They are continued outward by short curved wings of three bays and two-bay outer pavilions. These again have angle pilasters. The

whole is both grand and sober, inspired perhaps by the Chelsea Hospital, not by palaces or by normal almshouses.

PRIORSLEE
1 m. SE of Oakengates

ST PETER. 1836 by *Robert Ebbles* (Colvin) or by *F. Halley* (GR). Brick, with lancet windows and a thin W tower.

PRIORSLEE HALL. Good early C18 house. Façade of seven bays, with projecting two-bay wings. Red brick and stone quoins etc. Hipped roof. Doorway with open segmental pediment on brackets. The façade is much damaged by C19 dormers.

PULVERBATCH *see* CHURCH PULVERBATCH

QUATFORD

ST MARY MAGDALENE. In a picturesque position on a sandstone cliff. Norman chancel of tufa with one N window and the original chancel arch, very wide and monumental, but in its details very worn. It has three orders of shafts and an arch with big rolls. The tower arch also is Norman; so the Norman church had a W tower too. The arch mouldings here are finer and probably later. The chancel received new windows in the C14. The E window with reticulated tracery. One S window is of the low-side variety. Nave and tower were rebuilt in 1714 by *Henry Pagett* and *William Higgins*. The tower is of a very straightforward Gothic with battlements and pinnacles, survival rather than revival. In 1857 *R. Griffiths* added a S aisle and S porch. – FONT. Circular and probably Norman, though the carving must be later, and could be as late as the C17. – SCREEN. Fragments on the pews. – PLATE. Chalice and Paten 1572.

WATCH TOWER, N of the church, on a crag. A small embattled folly of red brick.

QUATFORD CASTLE. 1830. Built by *John Smalman*, a builder, for himself. Picturesquely sited, with heavy sham-fortifications, machicolations, and battlements, and divers outbuildings.

QUATT

ST ANDREW. The church on its eminence at first appears Georgian. Red-brick tower, with circular bell-openings and

bell finials, red-brick nave and N aisle walls with arched windows. All this dates from 1763. But the chancel, N chancel chapel, and the N arcade inside are medieval, and of widely differing periods. The visible building history starts with the chancel. The priest's doorway has a round arch with late C12 moulding. Traces of a blocked round-headed window also on the chancel S side. The N chapel is Dec, with an E window of original design, intersected, but with a dagger above a circle in the top of each light. The N arcade is puzzling. The piers appear Perp – octagonal with concave sides (cf. e.g. Chipping Campden, Northleach, Kidderminster). But the arches have two quadrant-mouldings, usually a sign of the early C14 (cf. Chelmarsh). The arch from the chancel to the chapel is almost as puzzling. For it is round and yet without doubt of the date of the chapel. – FONT. Circular, Norman, with a cable-moulding at the foot of the bowl. – SCREEN. Remains of the Perp screen at the W end of the chancel chapel. – PULPIT and READER'S DESK. Dated 1629. – PLATE. Large Chalice and Paten inscribed 1773. – MONUMENTS. Francis Wolryche † 1614 and wife. Recumbent effigies, she with a baby by her side. Kneeling children against the tomb-chest. No superstructure. – Sir Thomas Wolryche † 1668 and Sir Francis Wolryche † 1689, both big tomb-chests with black marble tops and no figures. – Mary Wolryche † 1678, with semi-reclining figure holding a lute in her hand. Reredos background with twisted columns and open segmental pediment containing a vase. Mrs Esdaile suggested London work, but the carving is poor.

DOWER HOUSE. Early C18 brick house, now of nine bays and two storeys with hipped roof, but said originally to have had five bays. The pleasant motif of the two doorways in bays three and seven would then be the result of an addition. The back doorway was transferred to the front. The windows are narrowly placed. The doorways are flanked by fluted Ionic columns with rustic capitals. Between these an equally rustic motif, something like an open scrolly pediment with its arms turned up almost vertically. The windows above are flanked by flat ornamental carving, again so rustic that it seems a kind of strapwork.

RATLINGHOPE

4090

ST MARGARET. In a side valley of the upper East Onny, below Longmynd. Nave and chancel in one; weatherboarded belfry

with pyramid roof. Nothing of the architectural detail is likely
to be medieval. The SOUTH DOOR is dated 1625, and Dean
Cranage suggests that the good tie-beam roof might also be
of the C17. On the other hand a rebuilding of the church is
recorded for *c.* 1788, and the wrought-iron COMMUNION
RAIL and the PANELLING of the chancel could just be as late
as that, although both look rather mid-Georgian.

REASIDE MANOR FARM
1 m. S of Cleobury Mortimer

6070

Early C17 manor house of stone, perhaps with older masonry.
Divers gables. Gabled porch at the l. end of the W front, as if
the building had originally continued further to the N. To the
S of the porch the dining room (Hall) with big fireplace. To
the S of this, corresponding to the porch, the staircase, pro-
jecting, also gabled, and then the parlour, again with gable.
Fine brick chimneystacks of star-shape. The staircase is not
spacious but handsome, of the square type with open well. It
runs through three storeys. Square tapering balusters and open-
work finials. In the large lounge (parlour) at the S end of the
house and running through from W to E big fireplace with
plasterwork overmantel and panelling. Also plaster frieze and
plaster ceiling. The motifs are mainly elaborate strapwork. All
windows are altered.

RENNERLEY *see* SHELVE

RHYD-Y-CROESAU *see* CYNYNION

RICHARDS CASTLE *see* BATCHCOTT

RODINGTON

5010

ST GEORGE. 1851, with a corbelled-out belfry and a polygonal
apse.
The canal here is carried above the river. One of the canal
bridges is a drawbridge like those in Holland and France, e.g.
that near Arles painted by van Gogh.

ROSSALL
1¼ m. E of Bicton

4010

Dated 1677. The house itself has been much pulled about. The
entrance side does not tell much now. The garden side is of

five bays and two storeys with a hipped roof and vertical
pilaster-strips at the angles and between the windows. Pretty,
no doubt later, bay-window of five sides of an octagon. The
ground floor is treated as an open porch with Tuscan columns.
To the l. and r. of the entrance side, at r. angles, two separate
service buildings, much better preserved. They are of five bays,
the three-bay centre two storeys high with a pediment. The
outer bays are only one and a half storeys high. Quoins, and a
doorway with a surround of alternating rustication. The house
also had such a doorway. It is not in its original place now, and
above it is the date 1677. The house was built for Edward
Gosnell, a London merchant who had moved to Shropshire
and became Mayor of Shrewsbury in 1682. Hence its remark-
able up-to-dateness for 1677.

6020

ROWTON

CHAPEL. Nave and short chancel, with a weeny bell-turret. This
and the chancel date from 1881. The nave has medieval
masonry. From this it can be seen that it had originally none
of the excessive width which makes one feel a little uncomfort-
able now.

3010

ROWTON CASTLE
2¼ m. wsw of Ford

The castle seems, as seen from the w, entirely the early C19
dream castle, castellated with a big round tower. In fact it is
on the site of a medieval castle, razed to the ground by Llewel-
lyn in 1482. It is said in books that the big round tower is only a
little later, but it is in fact also C19. What on the other hand did
exist before the romantic revivers started was a Queen Anne
house of red brick, the least promising thing for them. There
is plenty of panelling left and plenty of brickwork. This
house was then added to at two periods, between 1809 and
1812 by *George Wyatt*★ and *c.* 1824–8. In 1824 Col. Henry
Lyster had married Lady Charlotte Ashley-Cooper. The date
1828 is on the outbuildings to the w of the round tower. There
is a drawing at the house in which the round tower is only
dotted in as a future addition.

★ Mr Colvin kindly tells me that these two dates are those of work for
Rowton Castle exhibited by Wyatt at the Royal Academy before and after
execution.

RUCKLEY GRANGE

1 m. SW of Tong

By *Sir Ernest George & Yates*, 1904. Neo-Elizabethan, with an E-shaped entrance side, treated not strictly symmetrically. Stone, with mullioned and transomed windows. On the side a two-bay-deep oblong projection on an arcaded ground floor.

RUSHBURY

ST PETER. Nave and chancel, and W tower. Fine chancel of *c.* 1200. Three separate stepped lancets in the E wall, inside with slim nook-shafts with waterleaf capitals. Above a circular window in the gable. To the N and S single lancets. Priest's doorway now opening into the vestry. In the nave much renewed pairs of lancets. S doorway with slender shafts with waterleaf capitals. N doorway blocked. What remains appears Norman, and there is indeed herringbone masonry in the N wall. Tower with a W lancet and pairs of lancets as bell-openings. Later battlements. Very wide arch towards the nave. Fine roofs. In the nave tie-beams, collar-beams on arched braces and wind-braces forming at the junction of principals and purlins cusped lozenges. No chancel arch. The chancel has a hammerbeam roof, with collar-beams and arched braces and wind-braces forming quatrefoil patterns.

SCHOOL. Brick, of 1821.

BRIDGE. Small one-arched packhorse bridge without parapets. The roadway is *c.* 6 ft across.

RUSHBURY MANOR. Handsome timber-framed house. Symmetrical front. All upright or horizontal timbers. At the S end a massive stone chimneystack. In the N half newel staircase.

STANWAY MANOR, 1 m. SE. The *Shell Guide* states that farm buildings here were built by *James Brooks*.

RUYTON-OF-THE-ELEVEN-TOWNS*

ST JOHN BAPTIST. Above the road and probably originally in the castle precinct – see below. Red sandstone. Norman nave and chancel, Dec N aisle, Perp W tower. The nave has its Norman S doorway with no decoration. Tympanum on a segment-arched lintel. Chancel S doorway almost identical in

* So called because in the C12 eleven townships were united in the one manor.

design. Two Norman chancel s, two N windows. The s door-
way is connected to the windows by its hood-mould. Chancel
E window *c.* 1300: three lights of the same height and two
spheric triangles side by side above them. N aisle E window
with reticulated tracery; the other N aisle windows also Dec.
The arcade of four bays has clumsy octagonal piers, with plain
capitals. Single-chamfered arches; the hood-moulds are a roll
with a fillet. In the E respond a Perp niche for an image. An
odd anomaly is the narrow arch at the w end of the arcade.
Its E.E. arch is C19. It probably belongs to the Norman nave.
But where can it have led to? w tower with diagonal buttresses
and battlements. Nave roof with collar-beams on arched
braces, two tiers of wind-braces, and queenposts set diagonally
so as to form with the rafters cusped quatrefoil patterns. –
REREDOS. By *Bodley & Garner*, of the 1890s; not of interest. –
PLATE. Chalice and Cover 1570. – MONUMENT. Francis
Thornes † 1678 and his wife † 1664. Brass inscription in the
heaviest surround. Gargantuan short Tuscan columns with
enormously projecting pieces of entablature above. An absurd
design, considering its date (cf. Onibury 1657).

CASTLE. Immediately to the w of the church tower are the ruins
of three walls of a small Keep. The castle was built by Edmund
Earl of Arundel in the early C14. He also created the borough
of Ruyton. Ruyton, being a borough, possesses a MACE (silver-
headed; C16).

RUYTON TOWERS (now Ruyton Manor). Built in 1860. The
disappearance of the Arundel castle is made good by this
startling piece of C19 castle-making. Red sandstone, broad
façade of nine bays lying high above elaborate garden terraces.
The three centre bays are raised to form a machicolated, crenel-
lated tower. There is a big porch in front of the tower. The
sides have arcaded windows on the ground floor, separate
arched windows on the upper floor. A tourelle at the l. angle,
a recessed turret with the side entrance behind the r.

RYTON

CHURCH. The w tower of 1710, the chancel of 1720, but the
whole entirely gothicized.

COYNTON HALL, 1 m. E. A handsome Regency house, ren-
dered, white. With a central bow-window and a one-storey
Tuscan colonnade of six columns around it. Service wings at
r. angles.

ST GEORGES, OAKENGATES

7010
Inset A

ST GEORGE. 1861 by *G. E. Street*, and one of his most interest-
ing early works. Nave and aisles and clerestory and almost
detached big N tower with pyramid roof behind battlements
and pinnacles. Odd rhythm in the fenestration of the clerestory
between lancets and groups of two lancets with plate tracery.
Even more inventive the plate tracery designs of the E and W
windows, combinations of five and three lancets with trefoils
and quatrefoils. The arcades inside have piers of different 20
shapes, octagonal, circular, and quatrefoil, and the walls and
arches are a combination of rough grey stone with buff and
red stone and red brick (the latter for the hood-moulds of the
arches). The chancel is tunnel-vaulted with closely set cham-
fered transverse arches or ribs. Everything is done to avoid the
conventional and the smooth.

ST MARTIN'S

3030

ST MARTIN. Big Perp W tower, short and sturdy, with diagonal
buttresses, with many set-offs, and with battlements. The
rest externally all very irregular and thereby unusually lively-
looking. In the S wall of the chancel a half-blocked E.E.
priest's doorway. Inside a low N arcade, of Perp date, though
clearly not the work of one plan. The E bays lower, the W bays
a little taller. The capitals in both cases very elementary.
Double-chamfered arches. Good Perp roofs, that in the nave
with collar-beams on arched braces, and queenposts forming
with the rafters thin pointed quatrefoils. In the chancel the
roof is boarded, and there is some carved decoration. –
WOODWORK. Box Pews, Vicar's and Squire's Pew, and three-
decker Pulpit all complete. In the Pulpit some Jacobean bits
are re-used. – COMMUNION RAIL, returned to the E wall l. and
r. of the altar. – PANELLING in the chancel with Jacobean
pieces. – STAINED GLASS. Two aisle windows with figures by
Evans. – MONUMENT. Richard Phillips † 1824, by *C. M.
Seddon* of Liverpool. Kneeling woman holding an urn.
ALMSHOUSES. W of the church. Though the date 1810 appears
on the front, the determining date is the 1698 on the E end.
One-storey range with central pediment and wooden cross-
windows.
SECONDARY MODERN SCHOOL. 1954–7. By *Basil Spence &*

Partners. Owing to the menace of mining subsidence the whole school was built no higher than two storeys and largely only one storey high. The plan is on the pavilion system with freely spreading steel frame, and infill-panels of vertical timber boarding.

SAMBROOK

7020

St Luke. 1856 by *Ferrey.* As wilful as his church at Chetwynd is correct. Nave and chancel, and N aisle, with a vaguely Scandinavian-looking belfry which is weatherboarded and crowned by a truncated pyramid with a steep broach spire on it. Shingled. – STAINED GLASS. By *Charles Gibbs* (TK). Dated 1856.

SANDFORD HALL
1½ m. E of Prees

5030

Early C18 house of red brick with stone quoins etc. Five bays, two storeys, hipped roof. The centre bay has its own quoins and a raised centre like a dormer with a heavy curved top. Added wing on the r.

SELATTYN

2030

St Mary. Medieval nave and chancel, w tower of 1703 (with twin windows typical of the provincial C17 in their shape), N transept of 1821, S transept of 1828, and N aisle by *Hodgson Fowler* of Durham, who restored the church in 1892. Good original roofs, in the nave with collar-beams on arched braces and two tiers of cusped wind-braces, in the chancel boarded and elaborately panelled with small panels with blank tracery at their top. Also carved or castellated purlins, and a wall-plate with a frieze of small quatrefoils. – C18 PULPIT and COMMUNION RAIL. – STAINED GLASS at the E end, 1892 by *Kempe.*

SHADE OAK *see* COCKSHUTT

SHAVINGTON

6030

The date 1685 on rainwater heads. The grandest house of its date in Shropshire. Built for the sixth Viscount Kilmorey. Very plain E front of red brick (approached by a drive which

leads across two charming C18 bridges). But as it is seventeen
bays wide, it is impressive all the same. The height is of two
storeys. Horizontal stone band and quoins of even lengths
dividing the front into three + three + five + three + three bays.
The only stronger accents are attic storeys above the end three
bays and the middle five. Along the sides of nine bays, the
attics are above the end two bays. The W side is different.
Here there are far-projecting wings and in the re-entrant
angles three-bay projections, leaving a recessed centre. This
side, oddly enough, is of red brick with a chequer-board
pattern of dark blue vitrified headers. The appearance is not
quite original. In 1885 *Norman Shaw* was called in, and he
added the middle porch and inserted the circular windows in
the corner projections (à la Hampton Court). Internally much
has been changed, first in 1822, then by Norman Shaw, and
again in 1903 by *Sir Ernest Newton*. Originally the entrance
was from the E, and there must have been here an Entrance
Hall of five bays and a height of two storeys. The back on the
first floor was then an arcade of timber, open into an upper
gallery. The arches and the beautifully carved fluted pilasters
with Corinthian capitals survive, but the hall was horizontally
subdivided in 1822, and the gallery closed. The staircase lies in
the SW projection, a staircase on a grand scale, square with a
wide, open well. Very broad handrail, very heavy newel posts.
Strong twisted balusters – everything, that is, entirely up-to-
date from the London point of view. The rest of the interior
decoration is *Shaw* and *Newton*, except for one pretty mid-C18
ceiling.

SHAWBURY 5020

ST MARY. Of Grinshill stone. Late Norman or Transitional nave
and arches. Both doorways are original, that on the S side with
an arch with a kind of lozenge decoration, that on the N side
with a segmental arch with small nail-head ornament. The
arcades inside are complete and beautifully proportioned. Three
bays, circular piers with square capitals and abaci (cf. High
Ercall). Most of the capitals have many small scallops, but two
have leaves instead. The arches are round with only one slight
chamfer. Hood-moulds. The chancel may be a little later – see
the two small blocked lancets and the chancel arch – still
round but with an E.E. arch moulding. Perp N chapel of one
bay; Perp W tower cutting into the W arcade arches. Tall

tower with angle buttresses, battlements, the usual quatrefoil frieze below, and eight pinnacles. Late C17 W porch with rusticated pilasters and two volutes on the gable. – FONT. Norman, tub-shaped, with bands of geometrical decoration, not very artfully applied. – PULPIT. 1612. With two tiers of fluted panels. – CHANDELIER. Brass, given in 1776. – STAINED GLASS. Chancel S. Some C15 fragments including a Virgin of the Annunciation. – PLATE. Flagon of *c.* 1650; Almsdish of 1683; Chalice and Paten of the late C17.

A very pretty corner in the village just N of the church, with a timber-framed cottage and opposite the red-brick Georgian Elephant and Castle Hotel (with a red-brick garden-house) and the adjoining Post Office of whitewashed brick with a trellis porch.

Large neo-Georgian BARRACKS to the NW, designed 1938 by the Works' Department of the Air Ministry, a standard design, used in many other places.

SHEINTON

6000
Inset A

ST PETER AND ST PAUL. Except for one cusped 'low-side' lancet with a transom on the N side of the chancel and parts of the S doorway, nothing externally visible that would be earlier than the C19, though the corbelled-out timber-framed belfry with its pyramid roof might be older. Inside, the belfry rests on two posts with arched braces, a tie-beam, and quatrefoil strutting. – PULPIT. Jacobean. – STAINED GLASS. E window signed by *H. Hughes*, 1877. – MONUMENT. Effigy of a woman, perhaps a child, C14, only 2 ft long.

SHELTON

4010

2 m. NW of Shrewsbury

CHRIST CHURCH. 1854 by *E. Haycock*. Lancet style.
SHELTON HOSPITAL. Large symmetrical neo-Elizabethan front of 1843 by *Gilbert Scott*, then of *Scott & Moffatt*.

SHELVE

3090

ALL SAINTS. 1839. A sweet little rubble church high up in the hills, below the Stiperstones, in the district of deserted LEAD
1b MINES. One with its ruined engine house like a small keep meets one on the way from the A489 road, another with more

confused and extensive ruins at Rennerley. Nave and chancel in one, lancet style, narrow W tower with parapet. – PLATE. Small Chalice said to date from 1580.

SHERIFFHALES

ST MARY. The original church is the present N aisle. The nave was added in 1661 with its piers and arches from Lilleshall Abbey. Arcade of four bays with short octagonal piers and double-chamfered arches. Windows of two lights, Dec. One seems original. Nave roof of 1661 with double hammerbeams. Of the original church the most important survival is some scanty evidence of its tower. The Norman window in the N wall of the nave, W of the aisle, belonged to it. The chancel dates from the C18 (see the cornice). Of the same century the W tower (N doorway).

SHIFNAL

ST ANDREW. A large and important church of red sandstone, at the W end of the town. The churchyard has as its background to the N the brick railway viaduct. The church consists of nave and aisles, transepts and a crossing tower, chancel and a S chancel chapel. The visible history starts with the chancel, which has on its N side Norman windows, nook-shafted outside, and with hood-moulds continued as a string-course inside. The Norman chancel was shorter than it is now. The chancel arch has compound responds, their main semicircular projections keeled. The capitals can no longer be recognized in their details. But there is some dog-tooth on the W side, which makes a date before 1190–1200 impossible. The door from the chancel to the vestry is simple E.E.; so there must have been a vestry here as early as the C13. The present vestry was added by *Caröe* in 1899. The Norman church also had transepts. The arch which now leads from the S transept into the S chancel chapel is Norman, and it is known from excavation that it was followed by an apse. The roof of the apse can still be seen against the W wall of the chancel chapel. In the S wall of the transept is a big doorway, again of *c.* 1190–1200 – a curious place to have such a doorway. However, the church was collegiate in the C12 and part of the C13; and that may perhaps explain it. The doorway has three orders of shafts

with shaft-rings, but the capitals are not yet Gothic, as far as one can see, and the arch is still round. In the w wall of the same s transept finally there is a window which now looks into the s aisle, but that part of the arch was widened in the C15. The original s aisle must have been much narrower. The window is nook-shafted to the w, and the shafts again have shaft-rings. In the N transept Norman evidence is confined to a part of the crossing pier, just N of the present NE pier.

The nave and aisles were added in the C13, starting perhaps just before 1200, i.e. continuing immediately after the work at the E end. N arcade of four bays. Octagonal piers, double-chamfered arches. The s arcade is more or less the same except for one very unusual irregularity. The s porch is a fine C13 piece. It is two-storeyed, and the upper storey reaches out above the s aisle. So, as seen from the nave, the second bay from the w is lower than the others. It is rib-vaulted too, as is the porch. The porch has an outer doorway with a complexly moulded arch, arch and supports being much renewed. The inner doorway has a plain continuous moulding with fillets. The ribs of the vault rest on fine shafts, and there is a stiff-leaf boss. The vaulted bay in the aisle also has a boss. The s window on the upper floor of the porch is of two lights with a trefoil above – plate tracery, i.e. probably c. 1250. Finally the w front with a plain E.E. w doorway and w window completely renewed, with an enriched cinquefoil in the head of a three-light window. That must be yet later, say c. 1275.

As for later work, the crossing tower was rebuilt c. 1300 on fine, tall and sheer triple-chamfered arches. The bell-openings are big lancets. Battlements and a higher, square NW stair-turret. Then follows the Dec style. The chancel was lengthened and partly re-windowed, and a s chapel was built. The chapel has a reticulated E window, the chancel an E window of five lights with cusped arches upon cusped arches, the three-light N and s windows of the chancel have unencircled quatrefoils and a little ogee. In the s wall outside also a crocketed ogee-headed tomb-recess. The s chapel is of two bays with an octagonal pier and complex arch mouldings.

As usual, the Perp contribution was mainly the provision of larger windows. The N transept received them (all of three lights) and the s aisle (which was also widened and embattled). Yet later, probably after the great fire of Shifnal in 1591, the nave and chancel were given their hammerbeam roofs on

carved brackets. Cranage also attributes one chancel N window to c. 1592.

St Andrew is 150 ft long. The church was restored in 1876–9 by *Sir G. G. Scott*.

FURNISHINGS. PULPIT. C17, but altered and enriched in the C19. – STAINED GLASS. W window; in memory of a vicar of 1848–52. – E window by *Hardman*, c. 1867. – S Transepts, two windows by *Powell's*, 1863. – MONUMENTS. Thomas Forster † 1526. Effigy of a priest in a recess with four-centred arch (chancel N). – Opposite Magdalen Briggs † 1698, white frontal bust in a circular niche; not very good. – In the S chapel Olive Brigges † 1596, alabaster, recumbent effigy on a tomb-chest. – Humphry Brigges † 1626, and wife. Recumbent effigies on a tomb-chest. At the feet of the lady two small kneeling figures.

St Mary (R.C.), Shrewsbury Road. 1860 by *Buckler*. Architecturally not remarkable. – PLATE. Chalice of c. 1500, found in Yorkshire and given to the church.

PERAMBULATION. The church is not really in the town. To its W a three-bay Georgian house. To its S the VICARAGE, Georgian, of five bays and two and a half storeys, with a pediment over the middle bay and a doorway with broken pediment of Roman Doric columns. To its E OLD IDSALL HOUSE, timber-framed, all with narrowly spaced uprights. From here Church Street leads up to the MARKET PLACE. This is crossed by the railway bridge, rebuilt in 1953. The former station building is of white brick with the typical grouped long arched windows of c. 1845–50. Half-timbered houses are Nos 8–10 and the charming Nos 14–15, which form one group with the first houses in PARK STREET: five gables and four lower gables. The ground floors are altered. Then the houses in the Market Place, a little more ambitious than those in Park Street, i.e. with lozenges within lozenges and an occasional baluster stud. Both houses have in the gables concave-sided lozenges. Lower down in Park Street IDSALL HOUSE, dated 1699, a good example of the William and Mary style: five bays, two and a half storeys, with quoins, two stone bands, and a hooded doorway. A little further on the r. the former WORKHOUSE (now Hospital) built in 1817, and not yet of the standardized style of after the new Poor Law of 1834. Neat low brick front, the ground-floor windows under blank arches. Additions of 1841 at the back.

Outside Shifnal a number of handsome Georgian houses,

notably Haughton Hall and Decker Hall. HAUGHTON HALL, to the NW, is dated 1718 on the parapet. Seven bays, two storeys, completely plain S side, with wings of c. 1820–30, separated by Tuscan porches *in antis*. On the N side doorway with pediment on Ionic pilasters, and an eared window above. The doorway had to have a lower arch fitted in, because it leads immediately under the stairs – a fine staircase with slender twisted balusters, three to the tread. DECKER HALL is later, c. 1810. It has as its entrance two giant unfluted Ionic columns *in antis*.

SHIPTON

ST JAMES. Nave and chancel and low W tower. Nave and tower are pink-washed. The upper part of the tower is weather-boarded and carries a pyramid roof. Norman nave; see the remains of a blocked S window. Norman chancel arch, plain with one-stepped arch. Later openings to its l. and r. The tower arch, completely plain and pointed, might be of 1200 or a little later. The chancel was rebuilt in 1589, according to a brass inscription inside ('re-edified and builded of newe from the foundation . . . by John, youngest son of Richard Lutwych 1589'). The most interesting aspect of this rebuilding is the windows, which are pure 1300 in style, especially the three-light E window with its intersected tracery. But the sections of the mullions are Elizabethan. The windows have original iron bars. The roof is of the trussed rafter type. – PULPIT. Plain Jacobean. – COMMUNION RAIL. With twisted balusters.

SHIPTON HALL. The house was built about 1587 by Richard Lutwyche. It is of local limestone and faces SE. Walled garden in front. The shape was the usual one of the letter H with the Hall in the cross-arm, and wings projecting further in the front than at the back. This symmetry is piquantly broken by the porch in the r. hand re-entrant angle. This has a four-storeyed tower over, higher than the gables of the wings and the gable over the centre, and about as high as the star-shaped brick chimneystacks. The entrance is from the side of the porch (cf. Ludstone). It has a round arch with a completely detached pediment over. The windows are mullioned and transomed, of five lights in the wings, of three in the centre. The three-light windows correspond to the hall on the ground floor and the former parlour above. The tower has cross-windows, the gables four-light windows with the two middle

lights raised one step up. The house was altered inside and enlarged at the back about 1750. Of that date the decoration of the hall with a Rococo fireplace and overmantel, and doorcases with open pediments. The busts may have been in the Library originally. The staircase has slender balusters and tread-ends with bits of Gothick arches. The ceiling also has Gothic details in the plasterwork. The main coffering is a centre lozenge and half-lozenges l. and r. Reception room with bay-window to the back, and library with handsome fireplace above it. The Georgian stable range to the r. of the walled garden is nine bays wide. Big arched entrance with a circular window l. and r. and another in the pediment over. Cupola on top. A Dovecote a little higher up behind the house and the stables.

SHRAWARDINE

3010

ST MARY. Nave and chancel of red sandstone, and weatherboarded belfry with pyramid roof. Nave and chancel masonry partly Norman, but most of the building post-Reformation. The nave was rebuilt in 1649, the chancel in 1722. Restoration (including the chancel arch) 1893. Yet the nave and chancel s doorways may well reproduce what was there in the C12. – FONT. Norman, circular, with scalloped underside. – SCREEN. Dado with Jacobean panels.

CASTLE. To the NE of the church three crags of masonry on a small mound. They are all that remains of the medieval Keep.

SHREWSBURY

INTRODUCTION

'The Towne of Shrewsbury standeth on a Rocky Hill of Stone', says Leland. That is one of its two chief visual characteristics. It renders its skyline memorable with the spires of St Mary and St Alkmund, the tower of the Market, and the other towers, and it adds changes of level to its other elements of successful townscape. The one chief characteristic is the loop of the river Severn which embraces the whole centre of Shrewsbury and leaves on its N end a bottleneck no wider than 300 yards. Hence there is an enviably long water-line, but there are also traffic problems. The water-line is made use of more intelligently than in almost any other English town. The lawns of the Quarry, the principal public park; and, opposite, the School, sports grounds and tennis courts; a main traffic route, Smithfield Street, set partly on piles and recently provided with a good-looking railing; tree-shaded promenades; and walking and cycling paths without any railing to the water. One can circumambulate the loop almost entirely by the very riverside. The traffic problem is a nightmare. There is a by-pass S of the town. But there is none on the N. All E–W traffic has to go through the town, up the hill and down again, the noise of heavy lorries reverberating from the fronts of the old houses. A fly-over or part fly-over N of the station seems imperative to save a town calling itself 'England's finest Tudor town'.

We can let that claim stand. There is no question that Shrewsbury is an exceedingly fine town, not only a museum of fine buildings. The beauty of the town as a town lies in the contrast between the closeness and intricacy of the centre and the wide green spaces to the S. Town and school have preserved the latter. The former must be preserved too. That is no vain warning. Bus station and parking spaces have already eaten out an indispens-

able chunk by the Welsh Bridge. Rowley's House and Mansion stand as a gaunt cliff in the smelly confusion of motor vehicles. But otherwise the spell of the Tudor town remains. A small market square with the old market house; no straight streets; the most attractive and curious courtyards and alleyways. Street names as tempting and mysterious as Shoplatch and Murivance, Wyle Cop and Dogpole, and then, between the centre and the park, to the s, Belmont, a name reflecting later tastes and snobberies and indeed marking a street whose best houses are William and Mary, Queen Anne, and later.*

Medieval Shrewsbury is confined to the Abbey and St Mary, several minor churches, the remains of the C13 town walls, and the Castle. Of stone houses of the Middle Ages no more remains than fragments of three (Vaughan's Mansion, see Music Hall, Benet's Hall Pride Hill, and another in Pride Hill). The three houses of the friars have also all but disappeared. The Dominicans came before 1232 and settled by St Mary's Watergate; the Franciscans came in 1245, and a little of one of their buildings stands incorporated into some cottages at St Julian Friars; the Austin Friars came in 1298 and built The Priory. But the castle is still impressive. It stands, with its Norman walls (and its romantic Gazebo by *Telford* on the height of the motte), at the bottleneck, where it enjoyed all strategic advantages. It could defend and dominate the town. This it did, until in 1848 the railway arrived, recognized the same advantages, and callously blocked the castle and the N views. The castle is thus now so much of a side-show that the age-old dichotomy of royal and civil Shrewsbury is no longer seen. The castle was built by the Conqueror's kinsman Roger de Montgomery and became royal in 1102. Henry II improved it, Henry III built new round towers and new town walls, Edward I the Hall in the castle. The outer bailey stretched right down to Castle Street. The first Parliament in which the Commons was properly represented met at the Castle before adjourning to Acton Burnell. That was in 1283. 1403 is the date of the battle of Shrewsbury, that cruel and bloody battle where Percy Hotspur was killed. It was at Shrewsbury that his body was rubbed in salt, placed between two millstones by the side of the pillory, and then cut to pieces and sent to the principal cities. Later the Council of the Welsh Marches met at Shrewsbury as well as at Ludlow (which was its seat) and Harford, and later still, in 1642, Charles I resided at Shrewsbury

* See F. L. Hobbs: *Shrewsbury street-names*, Shrewsbury 1954.

with Prince Rupert. The Parliamentarians captured the town in
1645.

These years between the establishment of the Council of the
Welsh Marches about 1500 and 1644 are the great years of the
black-and-white houses of Shrewsbury, some of them amongst
the proudest in England. They were built by the wool-merchants
48a and cloth-merchants, the Rowleys, the Owens, the Irelands. When
it comes to the finest houses of the C18, those who paid for them
were the Earl of Bradford and the Marquess of Bath. But the
textile trade still flourished sufficiently about 1800 to provide
Shrewsbury with one of its most memorable monuments,
61b Messrs Benyon & Bage's Flax Spinning Mill, the earliest of all
factories with a complete iron frame, of columns and beams and
iron window-frames.

To finish with, a few practical hints. The centre of Shrewsbury
is so small – no more than half a mile by half a mile – and so close
and intertwined that a normal Perambulation would not work.
The streets are therefore arranged alphabetically. But as experi-
ence has shown that amongst the users of *The Buildings of
England* many like conducted tours, the following routes are
recommended:

(A) From the Station to Castle Gates – Castle Street – Pride
Hill – Mardol Head to Shoplatch and off on the r. to
School Gardens, on the l. to Council House Courtyard,
St Mary's Water Lane, Windsor Place, Butcher Row,
and Market Street.

(B) From Rowley's Mansion by the Welsh Bridge by Mardol
to the High Street, Wyle Cop, and the English Bridge.
Off to the r. into the Square and Princess Street, Golden
Cross Passage and Milk Street, to the l. into Grope Lane
and by Fish Street to St Alkmund's Place.

(C) The South with Town Walls – Murivance – Claremont
Bank as the E–W spine and expeditions down into The
Quarry, and up Belmont, Swan Hill and College Hill, St
John's Hill, and Claremont Hill.

This list of perambulations gives an idea how much there is to
be seen at Shrewsbury. The town has no more than 47,000
inhabitants. Walking through it, it seems 100,000.

CHURCHES

ST MARY, St Mary's Place. The largest church in Shrewsbury
and a church which already by the early C13 had almost the

same size as now. The spire looks fine from a distance, but if one stands close, the church does not offer any picture of special beauty. This is partly due to the way in which St Mary's Place encloses it, not near enough for surprise glimpses, not far enough for wide vistas, and partly to the bafflingly ruthless way in which one period dealt with the other.

An Anglo-Saxon church preceded the present one. This was 76 ft long by 27 ft wide and had one apse. The present church is 185 ft long.

EXTERIOR. Big, dominating W tower of red sandstone, Late Norman. W doorway with a tympanum on a humped lintel, three-step arch. Norman windows above. The upper parts of the tower are of different stone and Perp: two two-light transomed bell-openings with cusped Y-tracery. Battlements and polygonal pinnacles. Octagonal stone spire – one of the three tallest spires in England (138½ ft). Three tiers of dormers, the ones below with ogee arches and crocketed gables. The top of the spire collapsed in 1894 and was carefully rebuilt. The W walls of the N and S aisles show the width of the original aisles. One lancet window of c. 1200 in the N, one in the S aisle. The aisle windows are Perp of three lights, the clerestory windows also Perp, in pairs of two-light windows with four-centred arches.

Beautiful S Porch of c. 1200, grey stone, two-storeyed. The upper storey is in its present form Dec – see the S window – and Perp. Outer doorway round-arched, with three orders of shafts carrying stiff-leaf capitals. Tall arch with complex zig-zag and crenellation motifs. E and W sides with (later?) two-light windows with quatrefoils in plate tracery above. Rib-vault on keeled shafts in the corners. Inner doorway with one order of shafts. The capitals look a little earlier than those of the outer doorway. Round arch with zigzag in the intrados. Hood-mould with a chain of crocus-like blossoms.

The S Transept is a little older than the W tower, say of c. 1170. Small S doorway with Late Norman capitals and a compound crenellation motif in the arch. E.E. upper parts. Group of three tall shafted lancets to the S, the middle lancet higher, the shafts with shaft-rings. Single lancets to the W.

S Chapel or Trinity Chapel, mid-C14, see the big S windows of three lights which are alternatingly provided with flowing tracery and with tracery already turning Perp. E window of 1888.

Chancel E window of 1858, but E.E. masonry at the E end. To

the N side Vestry added (quite prettily) by *Paley & Austin* in 1884. Above it an externally somewhat gaunt group of three steeply stepped lancet windows. Clerestory Perp again and of different stone. Then a confused corner E of the transept, where a Norman chapel with a low E window with C19 tracery carries a later upper chamber, and an E.E. chapel shows Dec fenestration. Window in the form of a sexfoiled spheric triangle to the E, above an E.E. lancet; richly Dec window to the N.

N Transept like the S transept with a small Norman N doorway. Trumpet capitals, round arch. Lancet group like the S transept. To the W two single lancets. N aisle like the S aisle: Perp. N Porch of 1897. N doorway much renewed. One order of shafts with fillets, capitals with upright leaves, round arch.

INTERIOR. Transepts and chancel come first. They represent a date *c.* 1170. The church then built was cruciform with no aisles, but perhaps the intention of a crossing tower. Remains of this church are the transept walls, a window in the W wall of the S transept which must be earlier than the aisle (see below), the semicircular part of a blocked window in the chancel N wall, and a blank arch in the chancel S wall, perhaps of a Sedilia. Stubby columns and an arch with three zigzag bands on the extrados. The Norman transepts had E chapels. That on the N side survives partly, covered by a tunnel-vault. That on the S is cut off at the start of the vault by the Trinity Chapel. The arches to the W into the later aisles are also of this period, see the semicircular respond on the N side and the trumpet capitals. It is hard to explain them. Do they presuppose aisles of a different size from those to be built so soon after? And in any case they cannot be of one design with the transept masonry – see the Norman windows in the W walls into which they almost cut. So the masonry here must be older than these arches and the clearly contemporary S and N doorways and E chapels. The blank arcading of intersected arches inside the S transept S wall is also obviously Late Norman, but mostly reconstruction. It is similar to that of the chapter house at Wenlock. The sub-arches have trumpet capitals and leaf capitals. Zigzag in the arches. The main arches with bands of pellets.

Next comes the W Tower, built at once, probably because the plan of building a crossing tower had been given up. The tower arch has heavy semicircular responds with one decorated scallop and one foliage capital. But the arch, which is single-

stepped, is pointed. Norman window above – which was an outer window before the aisles were built.

The finest piece of architecture in the church is the arcades 11a connected with the adding of aisles in the early C13. They are of four wide bays. The piers are slim and finely subdivided, of grey stone. Section of four groups of three slender shafts (cf. other West-Country churches such as Wells Cathedral, the chancel of Lichfield Cathedral, Abbey Dore, etc.), the centre one of each group filleted. Glorious stiff-leaf capitals, exhibiting 11b the development of this type of foliage most illuminatingly. Well moulded, still round arch with hood-mould. The wall above the arcades is, of course, the earlier Norman wall. C15 or early C16 clerestory and contemporary roof, much renewed after 1894. Slight camber, arched braces, decoration with bosses at the intersections and cusped quatrefoils in the panels. On the bosses a pelican, a pig among acorns, angels making music, the treading of grapes, etc.

Splendid chancel arch, taller than the arcade and pointed. Above it two wide airy two-light windows. They have round arches and pointed sub-arches. Style and date are the same as arcade and chancel arch – i.e. early C13. Again of the same style and date the arches from the transepts into the crossing, and from the crossing into the chancel. In the N transept the W wall is delightfully diapered. Again early C13 the arches from the chancel near its W end into the N and S chapels. On the N side of the chancel further E spectacular display inside the three-lancet group – wall passage and slim (renewed) detached shafts with shaft-rings. High up on the E.E. walls indications can be seen of vaulting or proposed vaulting. They are not clear. The blank arcading at the E end of the chancel is all C19.

Now for the S or Trinity Chapel. This is also known as the Drapers' Chapel, because it was established as theirs in 1460. But it is in fact more than a hundred years older, as the external description has shown. The arch towards the chancel, E of the E.E. one, also proves a date late in the Dec style. See e.g. the shafts with fillets. To the W in both S and N chancel walls arches are outlined at the same height. What is their explanation? An unexecuted project of rebuilding the E.E. S arch and adding a large N chapel as well?

FURNISHINGS. FONT. Octagonal, Perp, with openwork arcading on the stem and cusped lancets with flowers etc. on the bowl. – DOORS. S Porch. Made up with parts of the rood

screen; reticulated tracery. – S doorway, S transept. Panelled and studded; dated 1672. – ORGAN CASE. By *Renatus Harris* and *Byfield* 1729. – SCULPTURE. In the S chapel sedilia three alabaster panels, C15, the central one with a kneeling donor connected by scrolls with the seated groups above of the Trinity and the Virgin and Child. – PLATE. Chalice and Paten, silver gilt, 1636; Flagon 1651; two Patens (bases of silver candlesticks) 1686.

STAINED GLASS. The church is exceptionally rich in stained glass, but very little was made for it. The main treasure is the Jesse window, chancel E. The glass of this, except for the added lights at the sides, was probably made for the Franciscan church at Shrewsbury. It then went to St Chad, and from there in 1792 to St Mary. It is much restored, but preserves enough of its original colour and design to be without any doubt the most impressive glass in the county. No white backgrounds, all deep reds and greens. The figures in the tense attitudes and with the tense faces of the Dec style. The figures of the donors below, Sir John Charlton of Powis and his wife, allow indeed a dating between 1327 and 1353.

29 Almost as precious, even if not aesthetically as rewarding, is the glass in the chancel N windows and the middle window of the S aisle. This consists of panels with scenes from the life of St Bernard of Clairvaux. They were made for the Cistercian abbey of Altenberg near Cologne, between 1505 and 1532, and bought by the then vicar of St Mary, W. G. Rowland, in 1845 for £425. They are amongst the most valuable and most completely preserved German glass of their date. The scenes are described in detail in C. E. Jarman's guidebook to the church.

Most of the other figured glass in St Mary is also Continental, German as well as Netherlandish. The best comes from Trier, other panels 'from the Cistercian abbey of Herchenrode'. This presumably means the Cistercian nunnery of Herchen in the Rhineland. All this German glass was bought by Sir Brooke Boothby of Ashbourne in Derbyshire in 1801 for £200. Much of it went into the Lady Chapel of Lichfield Cathedral. The rest was given to Rowland, who had arranged the glass at Lichfield. From Trier the N aisle middle window with Eberhard von Hohenfels, Canon of Trier Cathedral, and a date in the 1470s. The window to the r. of this is of the same provenance and date Dated 1479 and again from the same place the easternmost window in the S aisle. The same date at the foot of the second

window from the E in the S chapel. There is also a fragment in the window to the r. of this. Again part of this Trier group is the westernmost window in the S aisle.

In the S chapel most of the glass in the second and third windows from the E is from St Jacques at Liège. Numbers one and four are copied from the same church.

The other glass can be taken topographically from N aisle W to the E end and back to S aisle W: N Aisle W. A large, much-renewed C14 figure of St John. – N Aisle N, first from W. Mostly C16 fragments. – N Porch l. and r. Flemish C16 and C17 panels. – Transept. One window with Flemish C17 roundels, the N window by *David Evans*, c. 1830. – N Chapel E and N. Very good glass of the late C15 to early C16, especially the figure of Christ in the upper E window. – Chancel Clerestory. Large angels and small figures in vesica shapes. By *David Evans* 1820–9 (TK). – Vestry. Flemish C17 roundels etc. – S Chapel E. The centre, sadly sickly next to all this medieval glass, of 1892. The rest mainly *David Evans* of 1846, including a scene copied from Murillo and one from Overbeck. – S Transept S. By *Charles Evans* 1851, incorporating some good C14 figures. – S Transept W. One window with 'Munich glass' (presumably *Mayer's*), the other copied from Ludlow church. – S Porch. Flemish C17 roundels etc. – S Aisle W window. A C15 figure.

PLATE. Chalice, silver-gilt, said to be Italian or Spanish and of c. 1500; Chalice, silver-gilt, foreign, a date 1522 scratched in; Chalice and Paten, silver-gilt, 1636; Flagon 1651; two Candlesticks 1686; Paten given in 1703; Chalice and Paten, silver-gilt, 1766; some more C18 pieces.

MONUMENTS. From W to E. Outside the tower on the W side the following inscription to commemorate Cadman, who died in 1739:

> Let this small monument record the name
> Of Cadman, and to future times proclaim
> How, by an attempt to fly from this high spire
> Across the Sabrine stream, he did acquire
> His fatal end. 'Twas not for want of skill,
> Or Courage, to perform the task, he fell:
> No, no – a faulty cord, being drawn too tight,
> Hurry'd his soul on high to take her flight,
> Which bid the body here beneath, good night.

Under the tower the recumbent effigy of Col. Cureton † 1848. By *Westmacott* (Kelly). – In the N transept against the W wall

John Brickdale Blakeway † 1826. Elaborate tripartite Gothic composition without figures. By *John Carline*, called 'a most elegant and chaste design' by the *Gentleman's Magazine*. – N wall: group of three similar Gothic monuments without figures, of *c*. 1825–30. – N Chapel, N wall: Nicholas Stafford † 1471 and wife. Incised slab. – E wall: Admiral Benbow. By *John Evan Thomas c.* 1840, in imitation of the style of the mid C18 – an unusual and interesting case. – Chancel N wall: Richard Lloyd. Cherub by urn in front of an obelisk. By *J. Nelson* 1785. – Mary Morhall † 1765 by *Thomas F. Pritchard* (Gunnis). Elegant large Rococo tablet with three cherubs' heads at the foot. – Chancel S wall: Mary Lyster † 1730. With two weepy putti and a heavy attic and pediment. By *Thomas White* of Worcester (Colvin). – In the arch between Chancel and S Chapel Knight on a tomb-chest, his legs crossed, early C14, i.e. very probably the founder of the chapel. – In the vestry (N wall) Anglo-Saxon grave-slab of *c*. 1100 with a cross and interlace.

ST ALKMUND. The medieval church was pulled down, with the exception of the tower, in the scare after the collapse of St Chad. The new building was designed by *Carline & Tilley* and built in 1793–5. The W tower is Perp and has a tall, slender spire, very much like that of St Mary's. Total height 184 ft. W doorway with two-centred arch and tracery in the spandrels, four-light W window, tall E arch into the nave, battlements and pinnacles, spire with three tiers of dormers. The new building is ashlar-faced, with thin panelled buttresses and large window-openings. These were filled with cast-iron tracery. Unfortunately much of it has been replaced in 1895–1900 by more respectable stone tracery, thereby depriving the building of some of its curious (and typical) papery thinness and weightlessness. Straight, slightly projecting chancel. Porches at the NE and SE ends. No aisles; flat ceiling. – STAINED GLASS. The E window is the only survival in the county of the sort of glass that preceded Evans's – still painted without any regard for the necessary structural subdivisions. The window represents Faith and is by *Francis Eginton* of Birmingham; 1795. It cost 200 gns. The main figure is a copy from Reni's Assumption of the Virgin (at Munich); only she kneels on a cross instead of clouds. Brownish colours dominate against the pale mauve to lilac and pale yellow sky. Not at all unattractive, however much one must object to the lack of any principles of design behind such a performance. – PLATE. Two Chalices and

31a

Covers and one Paten of 1683; Flagon of 1709; Paten of 1714; Almsdish of 1730 by *James Smith*. – MONUMENT. Sir Thomas Jones 1702 by *James Paget*. Good wall-monument with two mourning putti, and in the middle an urn below a draped baldacchino below a segmental pediment. On the pattern of the monument to Sir Thomas Richardson in the Temple in London. The pattern was set in the contract.

ALL SAINTS, North Street. 1875–6 by *Haycock Jun*. No tower, but big nave and aisles. Clerestory with alternating pointed and circular windows. – STAINED GLASS. N aisle a three-light window with Spes, Caritas, and Fides, very early *Kempe*, of 1886. An important example of Kempe's early style. – The N aisle E window also by *Kempe*, of 1887. – In a S aisle window *Morris* glass, as late as 1918, that is long after Morris's death. Yet Morris, as compared with Kempe, even in this diluted state glows and makes figures stand out firmly.

ST CHAD. 1790–2 by *George Steuart*, who had built Attingham 19b in 1785. An original and distinguished design and an uncommonly beautiful position, open entirely towards the Quarry and the river. Yet it is from that very side that one may find a flaw in the no doubt very thoughtful composition. The principal parts of the design are the W tower, as the main external accent, and the circular nave as the internal climax. Seen from the W (i.e. the ritual N), these two parts will not merge. Steuart has avoided that untidy merging which mars so many Georgian churches and which cannot be avoided, if the tower seems to stand on the pediment of the nave. But he has gone just a little too far in the logical separation of the two parts. He interpolates an anteroom of square shape with two apses, a room extremely effective inside, but a little troublesome outside. The nave is a rotunda, with square lower and arched upper windows. Smooth rustication below, elegant coupled Ionic pilasters above. Top parapet, with intermittent balustrading. Thus the room referred to seems from the W a small rotunda. The tower consists of a square lower part with smooth rustication, to which on the entrance side a stately portico of four tall Tuscan columns with pediment is added, and on the l. as well as the r. Vestries. These have end pediments and arched windows set in taller blank arches. Above the square stage of the tower a tall octagonal one with the same coupled Ionic pilasters as the rotunda, and then a circular stage with detached Corinthian columns. Dome and gilt cross. The building material is Grinshill stone of a pale mauve tone.

The interior is a remarkable spatial experience. Three stages – a circular hall under the tower, the anteroom with the two apsed ends in which most elegantly two arms of a staircase sweep up to the gallery, their handrail being of thin simple iron shapes, and the nave or rotunda with its gallery three-quarters round, converting the circular room into a horse-shoe auditorium and a separate chancel. The chancel is singled out by pairs of giant Corinthian columns placed behind one another and by a very large Venetian window. The gallery rests on short unfluted Ionic columns, and on these stand exceedingly attenuated Corinthian columns to support the flat ceiling. The columns are of cast iron. Sparing decoration. Very simple pews.*

FONT. Oval fluted marble bowl. Brought from Malpas in 1843. – PULPIT. Copper and brass; openwork; probably of c. 1890. – STAINED GLASS. The original glass is not preserved. The E window was by Eginton to a design of Romberg. What is there now is *David Evans*, a crude, blatantly coloured copy of Rubens's Antwerp triptych with the Descent from the Cross in the middle. 1842. Also by *Evans*, 1844, the four windows to the l. and r. of the entrance, again biblical scenes copied from paintings. – In the staircase hall, window of 1857 by *Hardman*. – MONUMENTS. Many tablets, the most interesting ones to John Simpson † 1815 who built the church (and also the Caledonian Canal). Bust by *Chantrey*, elegant Grecian surround by *J. & J. Carline*. – Opposite William Hazledine † 1815, iron master of Shrewsbury. He was the builder of the Menai Bridge. The bust again by *Chantrey* and the rest by *J. & J. Carline*. The same composition, but noteworthy changes in the details. – Monument to the Shropshire Regiment, 1863 by *Manning*. With urn, flags, and two standing soldiers; in the Vestibule.

OLD ST CHAD, Princess Street. St Chad was a large church before most of it collapsed in 1788. Its history goes back to Anglo-Saxon times, and the building of which one chapel survives to c. 1200 and later. It was the S chancel chapel, i.e. in the same position to the chancel as the Trinity or Drapers' Chapel is at St Mary. The chancel went further E and had a straight end. Its Sedilia are preserved, with pretty Perp lierne-

* Not everyone has always shared this author's enthusiasm for St Chad. Torrington, jaundiced as he is so often, calls the building immediately after its completion 'as ugly as improper', and Murray's Guide still in the 1897 edition says it is in an 'execrable taste'.

vaulting inside. Also a blocked lancet window. The division of the chancel into bays was done by triple shafts. w of the shafts the big blocked round arch towards the remaining chapel. Then the SE crossing pier. The details, as far as they can still be recognized, are all Transitional. The w side of the chapel has another blocked round arch. It opened originally into the s transept, of course. At its s end the stair-turret of the transept. The windows of the chapel are dated c. 1571 by Cranage, on the strength of good arguments. Their style is in imitation of that of the chapel's opposite number at St Mary. Early to mid C14 tracery shapes, arches upon arches on the one hand, and a shape on the other incorporating a little Perp panelling. – FONT. Outside. Circular, Norman, with a diaper pattern. – DOOR. With square and diamond panels etc., and studded. Dated 1663. – MONUMENT. Thomas Edwards † 1634 and wife. The usual Elizabethan type with two 'affronted' kneelers.

The CRYPT below the N transept was excavated in 1889. It lies open and is at the time of writing no more than a mucky pit. Originally it was divided by three circular piers into two naves.

HOLY CROSS (ABBEY), Abbey Foregate. Founded for Benedictines (from Séez) by Earl Roger de Montgomery about 1080. In 1094 he entered his own foundation as a monk and died three days later. He was buried, says Orderic, in the new church between the two altars. So at least the E part of the church and some monastic quarters must have been ready then. But unfortunately these are just the parts not preserved. However, the Norman transepts and nave also look so decidedly Early Norman in their almost brutal directness and the massive details that one would not like to date them later than 1100. But first a description of what is to be seen.

EXTERIOR. W Front with Norman masonry below. Flat buttresses, w doorway with round arch and a moulding of which at least the three outer rolls remain. The inner part of the doorway all altered. The Norman detail here is clearly after 1100. The W window is a Perp insertion, the most splendid early Perp window in Shropshire. Seven lights, steep two-centred arch, crocketed ogee gable, and tracery, still with Dec reminiscences, though also with plenty of close panels. Tower top with two two-light windows, and battlements. Canopied niche for figures to the l. and r. of the window and between the bell-openings. Norman s wall, but

the s doorway Transitional. The shafts have fillets and the capitals upright leaves. Perp windows, wholly renewed at the restoration of 1862–3. The N windows, except the westernmost, also all renewed. They have tracery gone angular, but are assigned by Cranage to the time of the W window all the same. In any case, there were repairs on this side after the Civil War. The N porch three-storeyed and Perp. One statue survives above the entrance, though not in a good state. The inner doorway however is Norman of the time of the first building, and our first introduction to its details. Two orders of sturdy shafts with capitals of one broad heavy scallop on each side. Above the N aisle signs of the Norman gallery. These however will be understood better from inside. Clerestory inserted in this gallery in the restoration of 1862. Imitation Norman clerestory erected on top of it during the more conscientious and intelligent restoration of *John Loughborough Pearson* in 1886–7. Of the Transepts one can outside see only the stumps of the NW, NE, SW, and SE walls. The apparent openings in the SW wall are explained by Cranage, not as doorways from transept to cloister, but as book-cupboards – not a wholly convincing explanation. The E end is entirely by *Pearson*, in the E.E. style with lancet windows and no tracery.

INTERIOR. One should always start examining churches at the E end; for here building usually began. At the Abbey however the E end is *Pearson*'s, a fine tall space, and vaulted, as Pearson liked it. The shape of the E end of Roger's church has not even been ascertained by excavations – a surprising state of affairs. It is in the transept however that one receives the strongest impact of Early Norman brutality. The arch from the N aisle to the N transept is overawingly narrowed by the massive respond shafts and their big, blocky, one-scallop capitals. Stilted arch, the moulding one step and one thick roll. The crossing arches are largely C19, but their evidence can be accepted. The semicircular shafts here are of course far higher, but the directness and the refusal to add any elegancies is the same. The transept apparently had E chapels. Pearson at least supposed so and built them (with straight ends, which is probably wrong).

Now the Nave and Aisles. The nave arcade has very stout short circular piers with hardly projecting circular capitals – a West-Country characteristic (cf. Hereford). The arches are single-stepped. Above was a gallery with yet shorter, equally

stout piers. Whether the arches were subdivided or not we cannot say; for the late C14 filled them in with their Perp windows, and the restoration of 1862 did untold aesthetic damage to the whole. The clerestory above, restoring the original or intended Norman height, is by *Pearson*. The aisles were groin-vaulted or (as Cranage thinks) intended to be groin-vaulted. The transverse arches and vaults rested on the outer walls on oblong responds with semicircular shafts. The capitals are again of the elementary one-scallop type. The W half of the nave is now in its details late C14 Perp. But the junction towards the E half shows a Norman beginning in the same style as the E half. Why then a piece of solid wall between the two parts? Dean Cranage suggests a division into monastic and lay halves. The W parts have no gallery, but tall clerestory windows.

FURNISHINGS. FONT. A very large moulded capital, said (by Dean Cranage) to be made from a Roman capital. – RERE-DOS. Large and lavish triptych with gilt ground, painted figures and much gilding. Designed by *Pearson* and made *c.* 1887. – PILLAR PISCINA. Norman, now in the N aisle. – DOORS. In the N Porch, both dated 1640. – SCULPTURE. Seated Virgin, stone, below a crocketed ogee gable, about the size of the head of a lantern cross. Probably C14; nave. – PAINTING. The Angels at the Sepulchre. First half C19; by *John Bridges*; SW crossing pier. The style is that of the fag-end of the Bolognese Baroque, sweetened in the Stothard way. – STAINED GLASS. E window designed by *Pearson* and made by '*Mr Jackson* of London', *c.* 1887, with a good sense of the demands of stained glass. – N aisle E. With a large figure; 1806; said to be by *Betton* of Shrewsbury. – SHRINE. In the N aisle the remains of the Shrine of St Winifred. Later C14, with small figures below crocketed ogee gables.* – MONUMENTS. The Abbey contains plenty of monuments, many assembled from other churches. They are here mentioned topographically from N aisle W to the E and back to S aisle W. At the N aisle W end three big tomb-chests with recumbent couples. William Charlton † 1544 and wife, alabaster, still entirely Gothic; from Wellington. – Richard Onslow † 1571, the tomb-chest divided by baluster colonnettes; from St Chad. – William Jones † 1612, the tomb-chest with shields in strapwork surrounds; from St Alkmund. – Also John Loyd † 1647, a badly carved frontal demi-figure in a niche flanked by columns.

* Mr C. A. R. Radford suggests that the remains come from a stone screen.

– A Lawyer, *c.* 1300; angels by his pillow; from St Chad. –
In the s aisle: Figure of a Knight, the head missing, slim and
originally well carved; late c13 and wrongly called Roger de
Montgomery. – Priest, *c.* 1300. Coffin lid with foliated cross
and below it the figure to the l. of the cross shaft, to the r.
incised (re-tooled) Chalice and book, an impressive piece.
From St Giles. – Two bearded men in long robes, later c14,
originally on one slab; from St Alkmund. – Cross-legged
Knight, in a very lively attitude, hand on sword; late c13;
from Wombridge. – Mary Anne Burd † 1859. By *Peter Hollins*
1860. Standing figure of Faith on a circular pedestal. –
Edward Jenkins † 1820. Gothic 'reredos', without figures. By
Carline. – In the nave: Nathaniel Betton † 1800, and other
members of the family († 1809–27). Relief of a young figure
writing.

MONASTIC BUILDINGS. Nearly all the monastic buildings
were wiped out when the London-Holyhead road was cut
through s of the church in 1836. Until then it had run to the N.
All that survives – and it is indeed a precious survival –
is the REFECTORY PULPIT, now by the side of a railway yard,
s of the E end of the nave. Tall lantern or oriel-like structure of
great elegance. Early c14. Corbelled out in three sides of an
octagon. Tall cusped lancet openings. Below each lancet two
small blank ogee arches, crocketed, and with small figures.
Vaulted inside, with a boss.

ST GEORGE, Drinkwater Street, Frankwell. 1832 by *Haycock.*
Grinshill stone; ashlar; in the lancet style. On the W front a
square turret. The interest of the church is its E window with
STAINED GLASS by *David Evans.* Three large figures of
Apostles with the big typical canopies above, and the typical
tracery ornament below, all big and crude forms, and strong
colours, with red, dark blue, yellow, and also mauve. The
windows are closely above the altar and the Gothick wooden
framing surrounds on the l. and r. The effect of the glass is
therefore as if it were a specially richly-glowing altar-piece.
In two nave windows single figures, l. 1874, r. 1899 (the latter
by *F. Curtis* of *Ward & Hughes*). To us the earlier piece seems
without doubt the better, i.e. more stained-glass-like and in
naive imitation of the best period of stained glass. The later
has the wretched yellow so beloved of the later Victorians, and
a generally inflated design. Yet Dean Cranage did not hesitate
to prefer the later.

ST GILES, Wenlock Road. Built 1860–3 by *Pountney Smith.*

Incorporating the substantial remains of the former church of a leper hospital (charter of *c.* 1154–62). Nave and chancel and much taller N aisle. The nave is essentially Norman. s doorway with two heavy continuous quadrant-mouldings. The s window of the transept s chapel looks as if it were Norman, with later Dec tracery. The N arcade is at least partly C14, see two bays with slim circular piers and double-chamfered arches. The Perp former chancel arch was re-used between N aisle and chancel. N aisle built in 1860. Chancel rebuilt in 1864. Pretty Vestry 1893 by *Lloyd Oswell.* – FONT. Norman, circular, zigzag decoration on the stem. The bowl has crude blank arches with almost incomprehensible carvings, a cross, a fleur-de-lis(?) – STAINED GLASS. N aisle E window. Three sacred pictures by *David Evans*, from the former E window, *c.* 1830. As often in Evans's glass, the scenes are copies of paintings or engravings. The Presentation in the Temple is the same composition as used in St Michael. – One s window with stories in medallions by *Powell* 1865, designed by *Casolani.* – E window 1906 by *Kempe.*

ST JULIAN. The W tower is of *c.* 1200 below, Perp above. The earliest parts of red sandstone, the younger yellow. Long W lancet, three-light Perp bell-opening, battlements and quatrefoil frieze below, eight pinnacles. The tower was intended to have a stone spire (see the squinches inside). In its lowest stage it opens to the N, S, and W. The responds of the arches are massive, short half-columns with semicircular, hardly-projecting capitals. They carry double-chamfered arches, that to the nave being uncommonly tall and steep. The church was rebuilt in 1749–50 to the design of *Thomas Farnolls Pritchard.* Unfortunately his building seemed too humble when the Victorian Age had appeared, and the s side, facing the end of the High Street, was beautified in 1846. Brick with stone dressings. Nave and aisles of the same height, slightly projecting chancel with a big Venetian window. The other windows arched. The Tuscan pilasters and the heavy debased Grecian details below the windows are of 1846. Good interior with Tuscan columns carrying a straight entablature. Coved nave ceiling adorned sparingly with some of the bosses of the Perp roof of the former church. – STAINED GLASS. Chancel s window. Large figure of the early C16; from Rouen; much restored. – E window by *David Evans*. In the centre a copy of Raphael's Transfiguration, in the side lights, four stories, also copied from paintings. The window was made in 1861

and was in its style of course wildly out of date. – PLATE.
Chalice given *c.* 1680–90.

ST MICHAEL, Spring Gardens. 1829–30, yellow brick, in the
classical style. By *John Carline* for a total cost of £2000. Nave
of five bays length with arched windows. Chancel added in
1873. W tower, square, with the two upper stages octagonal.
Interior with three galleries. Iron columns to support the
gallery, second tier to support the ceiling. – FONT. Baluster
shape; under the tower. – STAINED GLASS. One of the three
windows made by *David Evans* for the original apse now in a
S window. Large, wholly pictorial scene of the Presentation
in the Temple (cf. St Giles).

OUR LADY OF HELP (R.C. CATHEDRAL), Town Walls. By
Edward Welby Pugin 1856, though according to Mrs Stanton
the plans were first discussed with *Augustus W. N. Pugin*,
the more famous father, in 1851. An impressive church,
though without a tower. The impact is created by very tall
proportions of nave and aisle and a steep gable with big bell-
cote. Sand-coloured stone going grey. Dec tracery. Six-light
W, and seven-light E window. W porch. Clerestory with win-
dows in the shape of spheric triangles. The interior is dis-
appointing. Thin octagonal piers, partly carved capitals. –
SCULPTURE. Stations of the Cross by *Philip Lindsey Clarke*,
1952. – STAINED GLASS. E window 1862 (by *Hardman*?). – The
W window and chancel N and S windows by *Margaret Rope*.

HOLY TRINITY, Bellevue Road. 1885 by *A. E. Lloyd Oswell*.
Blatant red brick, lancets and Geometrical tracery.

CONGREGATIONAL CHURCH, Abbey Foregate. 1863 by *G.
Bidlake* of Wolverhampton. Gothic, and very assertive with
its tower and spire at the NW corner so as to dominate the view
across the bridge towards the Abbey.

FIRST CHURCH OF CHRIST SCIENTIST, Town Walls. Built in
1834 for the Methodists (New Connexion). Stuccoed brick.
Entrance from the broad side. Five bays, giant Corinthian
pilasters. One-bay pediment. Three long arched windows, the
middle one wider, with two mullions converted to form a sub-
arch, and one transom at the level of the springing of the arch.
In the bays between shorter arched windows and two heavy
Greek Doric porches. To the river the same rhythm, but no
porches, and the brickwork exposed.

PRESBYTERIAN CHURCH (ST NICHOLAS), Castle Street. 1870
by *R. C. Bennett* of Weymouth. In an atrocious neo-Norman,
very tall, stone-faced, and so short that from the side it looks

like a fragment. It replaces the Norman chapel of St Nicholas in the Outer Bailey of the Castle.

PRESBYTERIAN CHURCH (WELSH), *see* Dogpole.

UNITARIAN CHURCH, *see* High Street.

CEMETERY, Longden Road. The chapel by *Pountney Smith*, 1855–6, is large, Gothic, with spire.

PUBLIC BUILDINGS

CASTLE.* The Castle is splendidly placed to hinder access of enemies to the town. The loop of the river is so close that only 300 yards remain to guard. Here the Castle was raised with its high mound close to the river. The Castle was built by Roger de Montgomery before Domesday, i.e. in the 1070s or 80s. It became royal in 1102. The oldest remaining parts are probably of the time of Henry II, i.e. 1164–5, when building is recorded. More was done by Edward I. The castle was held for the King by Prince Rupert and dismantled after the defeat. *Telford* in 1790 made it habitable for Sir William Pulteney. Serious restoration by *Sir Charles Nicholson* in 1926. The WALLS surround the Inner Bailey. The Outer Bailey extended s probably as far as the Council House (*see* Castle Street). The only surviving buildings are the GATEWAY, Norman, round-arched, but segmental to the inside. Roll-mouldings. Later Barbican outside.‡ Smaller round arch on the l., with finer mouldings, *c.* 1200. The POSTERN GATE is in its present form much later, probably post-Reformation. On the mound stands LAURA'S TOWER, by *Telford*, 1790, the name a compliment to Sir William Pulteney (cf. Pulteney Bridge and Laura Place in Bath). Red sandstone, octagonal, embattled. The site was that of a medieval tower. Finally the HALL. This is the most substantial remaining part, though much altered. The building dates from Edward I and was heightened in the early C17. The Hall itself is on the first floor. The roof line before the heightening can be seen inside. The C13 windows to the courtyard are all modernized. Those to the outside are more reliable. Heavy timber-framed screen between Hall and

* It has been stated that Shrewsbury Castle is superimposed upon an earlier encampment dating from the Iron Age, but no acceptable evidence has been adduced to support this supposition. There is also no material evidence that a Roman township existed here. Small sporadic finds of New Stone Age, Bronze Age, and Iron Age date have come to light in the district throughout the years, though none of them are of great significance.

‡ Mr J. A. Morris dates this as late as the C17 and believes the gateway to be of the time of Edward I.

entrance. At the time of the restoration a jamb of the doorway was found, clearly late C13 work. Two massive round towers project at the SW and NE end of the Hall. In the SW tower *Telford* made a charming room which has a delightful Gothick fireplace of white and yellow marble. Above this, in the upper room, remains of vaulting with ribs and a fine corbel.

SHIRE HALL, The Square. By *Sir Robert Smirke* 1836–7. Large and dignified, though cool rather than warm. Ashlar faced, nine bays. The centre stressed by pedimented tripartite windows on the first and second floors. The entrance altered 1954. Extensions into High Street. The interior not original.

POST OFFICE, High Street. 1877. By the architects of the Office of Works. On the site of the old Butter Market. Red brick, with Gothic details.

OLD MARKET HOUSE, The Square. Designed in all probability by *Walter Hancock* (cf. p. 30) and built in 1596. Open ground floor, as usual. Towards the open space of the Square two diagonal buttresses and a broad segmental arch on Tuscan responds. On the first floor two cross-windows and a statue from the tower of the old Welsh Bridge between. Gable with heavy 'acroteria'. The rhythm along the long sides of the building is a solid centre and three round arches on Tuscan columns on either side. Upper windows of three or four lights with transoms. Parapet with volutes upside down instead of battlements.

JUBILEE BATHS, Priory Road. 1894 by *J. Chappel Eddowes*.

MUSIC HALL, The Square. 1840, by *Haycock*. Five-bay façade with three-bay attached fluted Ionic giant portico starting above the ground floor and crowned by a pediment. The first-floor windows have flanking Doric pilasters and the first, third, and fifth, pediments. Back into College Hill, with giant pilasters and pretty wreaths. The main hall has pilasters along the walls. From it opens, now used as Foyer and Bar, what remains of VAUGHAN'S MANSION, built early in the C14. Stone walls and windows l. and r. with depressed pointed arches, edged by a thin roll-moulding. Elizabethan or Jacobean mullion-and-transom crosses put in, and now blocked. At the far end a small single-chamfered doorway. Next to it the Screen, built up like a normal timber-framed wall, except for the decoration of one beam by panels with small blank two-light arches. Roof rebuilt correctly after a fire. Collar-beams and arched braces, and two tiers of very large wind-braces thinly cusped to form big quatrefoils.

LIBRARY AND MUSEUM, Castle Gates. This is the building of [46a] Shrewsbury School, founded in 1552. The building dates from the 1590s and 1630. Before then the school was probably in Rigg's Hall, the house behind it. This is supposed to date in its structure from before the Reformation. It has some Elizabethan panelling, and parts of the original timber roof. The new buildings are astonishingly stately. Few schools other than Eton and Winchester had such extensive and lavish premises. It must be remembered, however, that the first school list contains 266 names and that a witness in the C17 speaks of 600. The earlier building lies at r. angles to the present front. It is of ashlar and consists of a basement and two storeys and a tower by its other side. The basement has small mullioned windows, the first floor three-light and two-light mullioned and transomed windows, the third an even run of two-light mullioned and transomed (or cross) windows. The parapet is C19 and replaces a row of gables. The Gothic end window under its gable is also an unfortunate alteration. The tower is embattled. It contains the staircase.

In 1627–30 a second building was erected at r. angles, to form an L-shape embracing Rigg's Hall. This is similar in design to the older part, but yet more orderly. Ground floor with low two-light mullioned windows and the large archway. Elliptical arch. Fluted Corinthian columns on high bases l. and r., figures of two scholars on them, called in Greek letters Philomathon and Polymathon – he that wants to know, and he that knows much. A tablet above the archway records the date and says, again in Greek letters: If you are fond of learning you will soon be full of learning.

First floor with four- and five-light mullioned and transomed windows, second floor with two- and three-light windows also with transoms. The floors are separated from each other by friezes with finely carved geometrical patterns. On top the same crenellation with volutes upside down as on the Market Hall a generation before. The backs of both buildings correspond to the fronts.

As for the Interior, the older wing had the Chapel on the first floor (consecrated in 1617) and the Library on the second. The second building was provided for form-rooms. Boys slept in the adjacent houses and also in a long gallery in the attic above the library, long since demolished.

In front of the building seated STATUE of Charles Darwin, 1897 by *H. Montford*.

RADBROOK COLLEGE (Domestic Science), Radbrook Road.
1898–1900 by *C. R. Dalgleish* of Wellington. Red brick,
gabled, with symmetrical front.

TECHNICAL COLLEGE, Abbey Foregate, by the English Bridge
overlooking the river. 1936-8 by the then County Architect
A. G. Chant. In a tame neo-Georgian, symmetrical, nineteen
bays along the river. with centre pediment and cupola. Light
brick. In the ABBEY GARDENS in front of the College divers
architectural fragments. In the rockery a roundel of Justice,
heads and draperies of large figures etc. – from the Guildhall
preceding Smirke's. This was designed by *Haycock* and built
in 1785.

SHREWSBURY SCHOOL. The school was founded by Edward
VI in 1552. It moved from its original site (*see* LIBRARY) to
the present one in 1882. The main building it occupied
existed already. It stands in a dominating position on the other
bank of the Severn and had been built as Captain Coram's
Shrewsbury Foundling Hospital in 1765. Later it had been
used as a workhouse. *Sir Arthur Blomfield* in 1878–82 adapted
it to its present use and embellished it. Since the style of the
building differs so much from Blomfield's usual style and since
his son, the future *Sir Reginald Blomfield*, was in his father's
office from 1880 to 1883 before setting up on his own, the
design may be the younger man's. Block of thirteen bays width
and three storeys with balustrade, low pitched hipped roof,
and clock turret with cupola. The window pediments on the
first floor and all the embellishments of the centre front and
back are Blomfield's. Blomfield also built the CHAPEL to the
W, and this of course had to be Gothic at its noblest, i.e. E.E.
Red and yellow stone, stepped groups of lancet windows, a
somewhat underfed turret in the SE corner. No aisle, but
narrow chancel aisles. Long shafts with shaft-rings, some of
Purbeck marble. – STAINED GLASS. Much early glass by
Kempe. Choir N, E, and S 1899, 1890, 1891. – S aisle 1896 etc. –
To the E of the main building is SCHOOL HOUSE by *Blomfield*,
contemporary with the other buildings.

GIRLS' HIGH SCHOOL, Town Walls.1897 by *A. E. Lloyd Oswell*.

HOLY CROSS SCHOOL, Wenlock Road. 1951-3 by *A. G.
Chant*. A pleasant mid-C20 group, partly two-storeyed, partly
one-storeyed. Light brick.

PRIORY COUNTY SCHOOL FOR BOYS, Priory Road. 1910 by
F. H. Shayler and *J. A. Swan*. Large, two-storeyed building
in the William and Mary style, though in the details a little

inflated, as the Edwardian revival of William and Mary tends to be. Pale brick and generous stone dressings.

ALINGTON HALL was built in 1910 by *W. E. Willink*. It is of pale brick with stone dressings and has a Roman Doric façade. – KINGSLAND HOUSE is early C19 and is now the Headmaster's House. – STATUES. The seated statue of Samuel Buller by *Baily*, 1843, erected in St Mary's Church, is now in the N portico of MOSER BUILDING. The building is of 1914–16, by *W. A. Forsyth*. The free-standing bronze statue of Sir Philip Sidney is by *A. G. Walker*, 1923.

ROYAL SALOP INFIRMARY, St Mary's Place. 1826–30 by *Haycock*, a noble and ambitious building, with its tall and broad ashlar-faced front, its virile Greek Doric portico with columns of two storeys height and a pediment, and its giant Doric angle pilasters yet higher. It is a pity that the fussier brick building of 1908–10 stands to its l., and a greater pity that the additions on the river side are so presumptuous and forgetful of the town as a whole and its skyline. Here they pretty well ruin the view of Shrewsbury from the river.

EYE, EAR AND THROAT HOSPITAL, Murivance. By *C. O. Ellison* of Liverpool, 1879–81. But the *Shell Guide* will be forgiven if it attributes the building to Waterhouse. It is indeed in everything an imitation of Waterhouse's style and mannerisms. Fiery red Ruabon brick and red terracotta. No stone dressings at all. Polygonal angle tower. The windows partly Gothic, partly mullioned and transomed. Kelly's answer is 'in the Old English style'.

PRISON, Howard Street. 1787–93 by *Haycock*.* Brick, cross-shaped, with central octagonal chapel with pediment and arched windows and four principal courts. Lower entrance wing with rocky rustication to the façade. Archway, doorways l. and r., with circular windows over. Above the archway a bust of John Howard, the prison reformer (by *Bacon*).

GENERAL MARKET, Shoplatch. 1867–9 by *Griffiths* of Stafford. Red and yellow brick, with some vitrified blue bricks. Also Grinshill stone dressings. In an Italianate style. The chief Victorian contribution to public architecture in the town, and not one to be proud of. The tower is 151 ft high and thus plays its part in the skyline, and this part at least is not one that jars. Steep pyramid roof behind bulgy pinnacles. Iron columns and iron arches with tracery inside.

STATION. The large and regular façade familiar today is of

* Executed by *Telford* (Colvin).

1903–4, but it is closely similar to the original design by *T. Penson Jun.*, which dated from 1848. The building then was somewhat smaller, but the chief characteristics were the same. Grey stone, Tudor style, projecting wing on the l. The recessed centre with a grid of horizontal Tudor windows with diamond glazing. Asymmetrically placed embattled tower. As in other English towns (cf. e.g. Newcastle) the situation for the station has been chosen so as to ruin one of the chief views completely. The building makes nonsense of the Castle, and its outlines close the N view up the river most disagreeably.

THE QUARRY. Twenty-five acres of grass-land along the river – an infinite blessing to the town and well handled by its administrators. First laid out with lime avenues in 1719 (*see* Buck's engraving of 1732). The E part subdivided into sports fields and tennis courts. The main area has as its centre THE DINGLE, the former quarry, converted in 1879 into a doll's picturesque grounds. Even a toy lake is there with a toy island. The patterns are most gardenesque, i.e. irregular. The figure of Sabrina by *Peter Hollins* also seems a toy. Doll's-house-like too is the SHOEMAKERS' ARBOUR which once stood on Kingsland but was re-erected by the lake in 1879. Its date is 1679, and the semicircular pediment (with the statues of Crispin and Crispinian) is eminently typical of that date. The arch below is round and flanked by fluted pilasters with wildly ignorant Corinthian capitals. Ferns and rocks inside. At the entrance to the Dingle sham Gothic trimmings. Below the Dingle the BANDSTAND, 1879, of pretty iron construction with a low ogee roof. By the river a copy of the Farnese Hercules. By the exit towards St Chad the WAR MEMORIAL, 1922–3, designed as an open rotunda by *George Hubbard & Son*, the flamboyant bronze statue of St Michael by *A. G. Wyon*. Finally, near the exit towards St Julian Friars, a very pointed OBELISK with Gothic details below. This was erected in front of the station in 1874 and later removed.

CASTLE BRIDGE. 1949–50. By *T. P. Bennett & Son* and the Borough Engineer. Pre-stressed concrete, one elegant span of 150 ft clear. Long sleek segmental curve.

ENGLISH BRIDGE. 1768–74 by *John Gwynne* of Shrewsbury (*see* Atcham Bridge).* Widened and the pitch lessened in 1926.

* But according to Mr C. Gotch the designs were provided by *R. Mylne*. Francis Johnston, the Dublin architect, on his tour of 1796 gives Gwynne's name. (Information from Mr Neill Montgomery.)

Stone, of seven round arches, with stately stone balustrading and ball finials. The bridge replaced a medieval one with houses on.

KINGSLAND BRIDGE. 1883. Iron arched bridge with the roadway suspended. One span of 212 ft.

PORTHILL BRIDGE. A sweet suspension bridge, one is inclined to say, until one discovers the date 1922. The treatment of the steelwork is visually so naive that one automatically thinks in terms of Victorian decorative metalwork. A date only twenty-seven years before Castle Bridge is not what one would expect. The bridge forms a nice group with the OLD BOAT-HOUSE INN on the other side of the river – a much restored timber-framed building.

WELSH BRIDGE. 1791–5 by *Carline & Tilley*. Five arches, balustrade. The medieval bridge had a big gate tower, as can still be seen on Buck's engraving of 1732.

STREETS

BARKER STREET. Opposite the bus terminus the handsome house of the CAR AND GENERAL INSURANCE, dated 1725. Three bays, three storeys, with the usual quoins. Parapet with vases.

BEAR STEPS *see* ST ALKMUND'S PLACE.

BEECHES LANE *see* TOWN WALLS.

BELMONT. Belmont was apparently the fashionable new street of the early C18. That constitutes its interest. Shrewsbury was very prosperous then. Defoe calls it 'a beautiful and rich town', 'one of the most flourishing in England'. Houses built here overlooked the lawns down across the walls to the river, and their architectural attractions can indeed not be exhausted from the street but have to be seen from the Town Wall or the tennis courts below. No. 4 faces Old St Chad's. It has a late C18 front of seven bays, with the middle three set more closely and crowned by a pediment. Doorway with rusticated surround and pediment. Nice staircase with slim turned balusters. Behind the Georgian front timber-framing, exposed in the good gable towards Belmont Bank. Specially crisp and trustworthy carving of the bressumer below the gable: vine scrolls as usual. In Belmont follows the JUDGE'S LODGINGS, built *c.* 1701. The house lies back from the street and has its original gate-piers. Six bays, three storeys, quoins and stone bands; parapet. Front door with pediment on bracket. The garden

front has two canted bay-windows and two bays between them. Doorway with open segmental pediment on brackets. Staircase with slim turned balusters; panelled rooms. No. 7 must be of the same date; also lying back, also with original gate-piers, and with a staircase with turned balusters. On the other hand, no quoins, no stone band, no parapet; square eaves brackets instead. No. 8 is later C18 and has a semicircular window below a pediment-like gable on the garden side. No. 10 is early C18, of seven bays and two storeys. No quoins. Square eaves brackets. Some of the original glazing. Garden façade with a pretty late C18 doorcase. Staircase with thin twisted balusters, the tread-ends exposed but not carved. Nos 11–13 is a late C18 terrace of twelve bays and two and a half storeys. Finally No. 15, also late C18; three storeys. This has a projecting centre with an arched doorway and enriched window surrounds above, and an elaborate garden façade. Two canted bay-windows. The centre with a Venetian doorway, a Venetian window, and a tripartite semicircular window above that. After that Town Walls is reached, and one ought to walk back to see the s sides of the houses.

BUTCHER ROW. At the corner of Pride Hill GREYHOUND CHAMBERS, a long C16 range, timber-framed with big first-floor overhang, and again second-floor overhang. Five rectangular bay-windows on the first floor helping to support the second. No gables. Further on, Nos 16–17, dated 1715, brick with the typical quoins, stone band, and eaves brackets, and then, opposite, the ABBOT'S HOUSE, wrongly said to have been the town house of the abbots of Lilleshall, and a house of great interest, as it dates no doubt from before the Reformation. Three storeys with a gable over the l. side. The ground floor is all shop-fronts, said to be original. Two narrow doorways with four-centred heads and small friezes of intersected arches or quatrefoils above. The shop-windows have four-centred heads too. The timber-framing is almost entirely post-and-pan. The angle-post on the ground floor is decorated with some blank tracery. The bressumer of the second floor is castellated and rests on thin buttress-like shafts. There is also another frieze of intersected arches.

CASTLE STREET. From the Station Castle Gate rises between Castle and Library (i.e. the former Grammar School). Civic architecture starts on the l. with CASTLE GATES HOUSE. This stood originally in Dogpole and was re-erected by the Earl of Bradford in 1702. What the Americans could do with

42b

their balloon frames could be done in this country as well and much earlier. The Earl no doubt symmetricized the building a little to adapt it to a more civilized taste. The façade is not entirely symmetrical though, see the disposition of the very crisply cusped lozenges. (Good staircase. MHLG.) On the same side, past the regrettable neo-Norman of the Presbyterian Church, the COUNCIL HOUSE GATEHOUSE of 1620. This was built by one of the Owens (*see* below, and Condover). It has an archway flanked by fluted pilasters and to the street two dormers. The first-floor windows have below decorated blank arches, l. and r. concave lozenges, less elaborately cusped than in the previous house. In the dormers the black and white is reversed, the result being a clover-leaf pattern. Towards the courtyard, i.e. COUNCIL HOUSE COURTYARD, the window above the archway has a pediment. Good bargeboards with vine pattern.

Facing the gatehouse is the OLD COUNCIL HOUSE, the meeting-place of the Council of the Welsh Marches, built in 1502. The only original work is the stone walling and perhaps the long low mullioned ground-floor window. The doorway has a four-centred arch. The porch is of timber, with a round arch between tapering fancy pillars. Wooden vault inside. The courtyard is of dog-leg shape, and one does not at first see the handsome early C18 brick façades of Nos 1–2, six bays wide and three storeys high, to the courtyard with quoins. Their main frontage however is to the river, high above St Mary's Water Lane. Here they appear as a terrace of nine bays, the first and last lower with half a shaped gable reaching up to the parapet of the rest of the terrace. Aprons to the second-floor windows; quoins. Inside No. 1 a fine early C18 staircase with slim turned balusters and carved tread-ends.

Adjoining the gatehouse, in CASTLE STREET, a street originally called High Pavements, Nos 25–26 are late C18 with two Adamish Venetian windows on the first floor, a good contrast to the gatehouse. Then No. 29, timber-framed, with asymmetrically placed gable and bay, and some blank balustrading as an ornamental motif. No. 31 is one of those regrettable black-and-white imitations which have done so much harm to what is genuine at Shrewsbury. Imitation as such is no worse when applied to black-and-white than to Georgian, but the tendency has been to this day to make the new black-and-white bigger than the old. The danger is especially to increase height beyond the highest original buildings.

Opposite SCHOOL GARDENS, where on the l. at once again a tucked-away courtyard with Georgian houses; it is called SYDNEY COURT. Below Nos 1–3 are the cells of the OLD GAOL built in 1705. Then on the same side an early C17 timber-framed house, again with closely cusped concave lozenges on the first floor, and plainer lozenges in the gable. After that School Gardens opens towards the Museum and Library (*see* p. 267). There are here, facing one another, two terraces of houses, originally part of the school. Their façades are now imitation Tudor, that on the l. exposed brick and dated 1825, that on the r. rendered and also of *c.* 1830. That of 1825 was built as masters' houses, the other as the head-master's house. The façade dates from Dr Butler's time. Finally next to the terrace of 1825 No. 1, C18 with an open scrolly pediment.

Back into Castle Street, where, on the r. side, another curi-osity and warning, the RAVEN HOTEL, which would be a perfectly fitting and modest part of the street frontage if it had not been given large stone windows with tracery in a big-hearted Gothic style – perhaps in deference to the Randolph. After the Raven No. 8a ought to be examined. It is timber-framed and has an impressive arch-braced tie-beam truss with a kingpost on. Mr J. T. Smith regards it as of the C14 and the earliest of the timber-framed halls of Shrewsbury.

Off Castle Street to the l. ST MARY'S WATER LANE leads down the hill to the river. At the end, as part of the TOWN WALL, the WATER GATE, a simple single-chamfered two-centred arch, probably of the C13. Further on, also to the l., off Castle Street, a short passage to the Infirmary and St Mary's, WINDSOR PLACE. In it PERCHES HOUSE, dated 1581, but stuccoed over its timber frame. Then WINDSOR HOUSE, late C18, with a pretty doorcase and a semicircular end to St Mary's Place. Staircase with three slim balusters to each tread. Castle Street ends at the junction of St Mary's Street and Pride Hill. Here stands a recent successor to the HIGH CROSS, where Dafydd ap Gruffydd, Llewelyn's brother, was hung, beheaded, his heart burnt, and his body quartered after the parliament of 1283.

CHURCH STREET. No. 1 turns its interesting side to Dogpole. Brick gable with an ornamental brick frieze and l. and r. in the gable arched niches. That must be late C17 and has no parallel in Shropshire. Opposite in Church Street the PRINCE RUPERT HOTEL, built by Thomas Jones in the early C17.

Two-storeyed with four irregular gables. The decoration un-organized too. Baluster studs below the two middle gables. There was originally another exposed facade towards St Mary's Street. Staircase with square, heavily detailed balusters.

CLAREMONT HILL and CLAREMONT BANK. We start from the bus terminus between typical early C18 houses, one of them (No. 28) dated 1724. After that cottage scale until the top is reached. At the corner of Claremont Bank in its garden the VICARAGE of St Chad, large, red-brick, with a big bow-window. Early Georgian (with top storey and bay late Georgian (pre-1787).* Early Victorian. MHLG). Opposite in Claremont Bank CLAREMONT BUILDINGS, a fine early C19 terrace (pre-1815) by *Carline & Tilley*, fourteen bays, two and a half storeys, ashlar-faced, with arched ground-floor windows and later porches, somewhat of a Clifton character. Opposite another house, a little later – see the Greek Doric doorcase. This terrace climbs up the hill, again in the Clifton fashion. Four houses, of six bays each. All first-floor windows are set in blank arches.

CLAREMONT STREET. No. 7 has a good shop-front of *c*. 1825. Double-fronted; doorway flanked by Greek Doric columns.

COLLEGE HILL, from the E. Facing us as we start stands, by the side of the churchyard of Old St Chad's, No. 1 (originally the SAVINGS BANK), ashlar-faced and pedimented, of three bays with a smoothly rusticated ground floor and Tuscan pilasters above. Arched windows. Then the street turns and there is at once a passage to the S ending in the back gardens above the town walls. No. 3 here is a fine house, built or rather remodelled in 1752. Inside some timber-framing left. The house stands on the site of the college of St Chad. Lord Clive lived in it in 1762. (Good staircase hall and panelled rooms. MHLG.) The MASONIC HALL has the back façade of the Music Hall (*see* p. 266). At the Swan Hill end of College Hill No. 12 of *c*. 1700. A detached house, red-brick, though now rendered towards College Hill. Three-bay front of two storeys with hipped roof. The doorway with Ionic columns *in antis* is a Late Georgian alteration, as are also the windows. For the corner appearance *see* Swan Hill.

COUNCIL HOUSE COURTYARD *see* CASTLE STREET.

DOGPOLE, from St Mary's Street. Dogpole runs SE and then turns S. At the bend the GUILDHALL, formerly Newport House, built by Richard Earl of Bradford shortly after 1696.

* Information from Miss M. C. Hill.

He moved the house that had stood here to Castle Gate and re-erected it there (*see* Castle Street). The new house is of great dignity, and of course perfectly up-to-date in the London sense. Five bays to the street, five to the river. Two storeys, hipped roof with dormers with alternating pediments. Quoins and square eaves-brackets. Delightful carved door surround and carved brackets. The porch with the two pairs of slim Greek Doric columns must of course be an early C19 addition. Staircase with sturdy twisted balusters, newel posts with groups of four of them. Continuous string, not yet carved tread-ends. Panelled rooms. Opposite the Italianate long-windowed façade of the EGLWY Y TABERNACL, dated 1862. Again opposite the OLD HOUSE, timber-framed, of the early C16, altered in the mid C16, with a cobbled inner courtyard and a river range of the early C17 whose front was replaced in brick in the C18.* L-shaped front, doorway with Elizabethan angular balusters as posts, a row of baluster studs above, and star-shaped brick chimneystacks. Inside, an eminently inter-esting Fireplace, dated 1553, infinitely more classical and civilized than most Late Elizabethan and Jacobean woodwork. Long thin fluted Ionic pilasters l. and r., Ionic fluted colon-nettes in the overmantel, at the angles clusters of three, be-tween singles. Inlay panels, especially elaborate that in the centre, with a tarsia picture of a castle gate with portcullis in perspective, somewhat like a stage set. Again on the other side Nos 1–2, one of the rare cases of Gothic preferences in mid-Victorian domestic architecture in Shrewsbury.

FISH STREET *see* ST ALKMUND'S PLACE.

GOLDEN CROSS PASSAGE *see* HIGH STREET.

GROPE LANE *see* HIGH STREET.

HIGH STREET, from Pride Hill. At the corner of Mardol Head stands IRELAND'S MANSION, the only timber-framed house in Shrewsbury to which one might grant grandeur. It was built *c.* 1575 by Robert Ireland, a wool merchant. The façade is tall, broad, and symmetrical. Seven bays, three storeys, and dormers. The timber-framing is mostly by uprights. There are none of such pretty conceits as cusped lozenges or quatrefoils. At the ends slightly canted bay-windows. Over the two door-ways (cambered heads and spandrels with stylized leaf) oblong bays. Thin spiral-fluted buttress shafts. Decorated barge-boards. Opposite No. 25, a typical early C18 brick house with stone band and stone quoins; dated 1709. Then Nos 22–24,

* These are the dates worked out by Mr J. T. Smith.

dated 1592 and known as OWEN'S MANSION. Richard Owen was a wool merchant like Robert Ireland. The group faces the Square. It is timber-framed, partly two-, partly three-storeyed, and still has the decorative motifs of 1570, i.e. thin twisted shafts and a quatrefoil frieze. On the gable storey however there are now also diagonal struts arranged to form enriched cross-shapes, and there are studs in the shape of balusters. Next to these, also facing the square, the Alliance Assurance, built in 1892 by *A. E. Lloyd Oswell*, brick and stone with a big gable in a kind of Northern Renaissance. At the corner of GROPE LANE Nos 15–16 (formerly the Cross Keys Inn). This has the whole first floor of the façade coarsely cusped. In Grope Lane one gets an opportunity to see how close the over- 2b sailing upper storeys brought two frontages to one another. Life in these lanes was like living all in one house. Then follows an C18 house with typically Early Victorian fenestration and then one equally typical house of *c.* 1725 with segment-headed windows. On the other side of the street Della Porta's Store, yet another example of how C19 and C20 black-and-white building tends to dwarf original work. The UNITARIAN CHURCH of 1839–40 (façade of 1885) is Italianate, but in the details curiously close to what the mid C17 did in church architecture in England. Is that conscious? In the church Coleridge preached once, and Charles Darwin attended services.* Opposite Nos 9–3, all late C18, with one character-istic doorway (No. 3). Opposite No. 3: GOLDEN CROSS PASSAGE with the GOLDEN CROSS INN, timber-framed and probably pre-Reformation. First floor on far-projecting brackets, the framing in narrowly spaced uprights. At the r. end a stone archway, Tudor shape, which is said to form part of the Sextry of Old St Chad's.

HILL'S LANE. All that needs description is ROWLEY'S HOUSE, and this does not really now stand in a street. Shrewsbury has treated it cruelly. It is surrounded on three sides by bus bustle and car and lorry noise. Roger Rowley came to Shrewsbury shortly before 1600 and started business as a draper dealing in Welsh cloth, and at the same time brewer and maltster. Whether he built or took over the earlier part of the house is not certain. It is timber-framed, nearly exclusively with vertical members, and may well be earlier than the late C16. 'Piazzas' of plain posts to Barker Street. Abutting on this is Rowley's Mansion, built by Rowley's son

* PLATE. Two Cups of 1735.

in 1618. Brick with stone dressings. Straight gables, much altered mullioned and transomed and cross windows. No pleasure to the eye. Much restored in 1934 with timbers from demolished buildings.

MARDOL, from Pride Hill. At the corner of Pride Hill No. 78, with a plaster ceiling on the ground floor which looks c. 1600. Thin ribs forming lozenge, etc., patterns. Small motifs set into the spaces, fleurs de lis, small animals, etc. Then Nos 72 and down to 69 all early C18 of a familiar type. No. 70 is dated 1717. Opposite: No. 7 is late C18, see the tripartite windows with blank segmental arches, Nos 9–11 dated 1700 and 1710 but with a thin framing of the windows, not often found at Shrewsbury. The corner of Roushill opposite is a timber-framed house with an overhang into Roushill. Nos 15–16, again on the l. side, is an early C17 freak with most of the posts and studs baluster-shaped. No. 60, once more opposite, has segment-headed windows and is probably c. 1720–30, in opposition to Nos 20–21 on the other side which still has straight-headed windows and is dated 1706. More minor timber-framed and Georgian brick houses, and then on the r. the KING'S HEAD, C15 or early C16, picturesquely twisted, with, on the first floor, an original six-light window with ogee tracery. The second-floor overhang is on heavy brackets. No gable. The RIALTO CAFÉ is early C18 and chiefly notable for the way the top parapet projects above the intervals between the windows. Finally the BRITANNIA HOTEL, finishing the street and facing towards the river. It has a long plain front with a Tuscan porch. Rowley's Mansion forms part of this final picture, but is described under Hill's Lane.

MARINE COURT see WYLE COP.

MARINE TERRACE see WYLE COP.

MILK STREET. At the corner of Wyle Cop the premises of an auctioneer. Inside between the two houses, one facing Wyle Cop, the other Milk Street, a medieval masonry wall.* Small doorway with chamfer, and large Perp fireplace. Then No. 2, an interesting house. It was built by a draper named Powell in 1568. Narrowly spaced upright timbering. No decoration except in the heads of the three gables; and this is probably an alteration of c. 1600. The gables differ in shape as well as details. Not even the decoration is the same. In the centre a

* Behind Milk Street in OLD POST OFFICE YARD a medieval shop-front of timber (J. T. Smith).

lozenge with a cusped circle, on the sides squares with cusped concave-sided lozenges.

MURIVANCE *see* TOWN WALLS.

PRIDE HILL from Castle Street. No. 14, on the r., is obviously Early Victorian and seems in no way remarkable, until one realizes that its façade decorations are of cast iron. Opposite, at the corner of Butcher Row, the HONEYCHURCH CAFÉ, dated 1712, one of many houses typical of the early C18. They have quoins, a stone band to divide the storeys from one another, straight-headed windows, and eaves brackets. No. 40 on the same side is a nicely crooked timber-framed house. Narrow front with asymmetrically placed gable. Cusped concave lozenges below the first-floor windows. The balustrading l. and r. must be later C17. Nice bargeboards with a kind of strapwork decoration. Again on the other side, in one of the tucked-away courtyards so characteristic of Shrewsbury, is PRIDE HILL CHAMBERS. A stone stair on the l. of the courtyard leads down to back gardens. The town wall of the C12 and C13 ran from the castle along Pride Hill before turning down to the Welsh Bridge. The stair cuts through it and comes out under a simple two-centred arch. The arch is part of the N front of a C15 house of which also the jambs of the windows remain. The town wall runs under the S front of this house.*
On its r. the wall still stands some 15 ft up. Moreover, remaining to a height of about 20 ft a square projecting wall-tower survives. A little lower down, on the same side of Pride Hill, Boots the Chemist's premises are another awful warning how not to carry on the Shrewsbury tradition. This building was put up in 1907 and 1920, at a time when enlightened firms ought to have known better than so blatantly to outdo the proudest of the original buildings. In fact LLOYDS BANK a little further on, which was put up in 1876, is much more appreciative of the past in its scale, and at the same time with the plaster panels of sunflowers is very much more frankly of its own period. Behind No. 2 Pride Hill, a few steps back from Lloyds Bank another remarkable survival, the so-called MINT, identified by Mr J. T. Smith with BENET'S HALL. The evidence investigated by Mr Smith points to an oblong house of the mid C13 extending about 70 ft, and to the N behind the present house in Pride Hill. It consisted of two main apartments on the principal floor and an undercroft below. The undercroft had two large double-chamfered

* Observations of Mr J. T. Smith.

arches connecting the two parts. On the main floor this cross-wall carries a fine fireplace with shafts carrying late stiff-leaf capitals and, to its l. and r., one blank arch. In one of them, set asymmetrically, is a doorway with a tympanum and foliated cusps. There was also blank wall arcading against the E and W walls on this floor. The entrance to undercroft as well as main floor was from the w.*

PRINCESS STREET, from The Square. The S side is the continuation of The Square, though WIGHTMAN HALL, formerly the Working Men's Hall (by J. L. Randal, 1863), breaks the character rather with its jolt of tower and gable and of irregular fenestration. The 'piazzas' or colonnades of della Porta's Store on the other hand are a happy recent idea. The first section is Tuscan with arches, the second taller Tuscan with straight entablature. The idea of the 'rows' is a tradition of the West Country, the execution is not imitative of West Country precedent. The two parts were built for the County Council by its then architect A. G. Chant, in 1938–9 and 1935–6 respectively. Opposite, No. 30 is dated 1730 on its back gable. It is just a little out of the ordinary Shrewsbury routine: angles with even rustication. Windows with broad fluted pilasters and segmental heads. At the corner of Milk Street a house of the end of the C17. It has the quoins and the stone band of the early C18, but the steep pediments of the dormers still belong to the C17.

QUARRY PLACE. Quarry Place is the short continuation S of St John's Hill. The houses, especially on the r., have gardens towards the Quarry and the Dingle. No. 6 is the stateliest, late C18, of five bays, with arched ground-floor windows set in blank arches, an Adamish doorcase with enriched windows above, a pedimented coach-house on the l., and a garden façade with two canted bay-windows. Then Nos 5 and 4, an eight-bay terrace, also late C18. Windows with stepped keystones. No. 5 has a big Ionic bow-window at the back, No. 4 at the side, facing S. No. 5 has a square Summer House at the end of the garden, with a doorway carrying a segmental pediment on fluted pilasters. Opposite, Nos 1 and 2 are a pair of the same time.

ST ALKMUND'S PLACE and SQUARE. St Alkmund's Place should be reached from FISH STREET, which starts by St Julian, at the end of the High Street. There is nothing re-

* I am most grateful to Mr Smith for allowing me this preview of his yet unpublished research.

markable about Fish Street, except the general cottage scale of the houses, contrasting well with the main streets and the churches.* At the end, however, on the r. is BEAR STEPS, covered steps up to St Alkmund with some unexpected medieval masonry on one's l. Going up the steps one arrives in the NW corner of the churchyard. This is an excellent piece of townscape – two-storeyed timber-framed and stuccoed cottages, forming a modest but firm boundary. The other houses round the church – their address is partly St Alkmund's Place, partly St Alkmund's Square – are also appropriate. Only two call for comment, the Victorian VICARAGE because of its showy half-timbering and its monstrous size and symmetry, and KINGSTON HOUSE, an interesting late C17 house, with a hipped roof crowned by a square belvedere or tower with a pyramid roof. Equally odd is the division of ground floor from first floor by a full-blown entablature. Four bays, two storeys, brick, painted. The doorway has a pedimented frieze and a segmental pediment.

ST JOHN'S HILL. No. 12, HARDWICK HOUSE, dates from c. 1700. Five bays, two storeys, and a half-storey above the main cornice. Giant pilasters at the angles, doorway also with giant pilasters. To the l. and r. one-bay wings, one of them a coach-house. These are low and have (still) big shaped gables. The whole is more like a country house than a house in town. (Staircase inside with three thin balusters to each tread; probably c. 1730.) Opposite a long terrace, starting with a number of Early Georgian houses (Nos 31–25) characterized by segment-headed windows and dormers with alternating pediments. No. 24 is the former Friends' Meeting House and was built in 1807. Nos 23–19 are of about the same time. Nos 22 and 23 have Venetian doorways.

ST JULIAN FRIARS. An odd name; the first part refers to the church of St Julian, the second to the Greyfriars or Franciscans whose Shrewsbury house survives in a few fragments at the river end of the street. But first, as one walks S, one faces STONE HOUSE, a stately Late Georgian three-bay front with widely spaced windows and a Greek Doric porch of two pairs of slender columns. Then on the l., hidden in a group of nondescript brick houses, the stone walls and a few windows of the GREYFRIARS. The windows to the street have their original tracery (three lights, four-centred arches, and intersected

* Mr J. T. Smith mentions an open C15 hall behind oversailing frontage at Nos 1–3 Fish Street.

tracery), those to the river, visible from the footbridge, only the stone frames. They may have belonged to the refectory. They are clearly late Perp and probably belong to a rebuilding recorded for 1520. The Franciscans had settled at Shrewsbury in 1245. From here the Quarry can be reached by an asphalted footpath immediately by the river.

ST MARY'S COURT *see* ST MARY'S STREET.

ST MARY'S PLACE. This is really the churchyard of St Mary, except that the W side appears under St Mary's Street, and the E side is the Infirmary. On the N side No. 1, a restored C16 timber-framed house with a band of quatrefoils at the foot of the first-floor windows.* On the S side No. 10 is the DRAPERS' HALL, that is the guildhall of the powerful drapers' guild whose religious meeting-place was the S chancel chapel of St Mary's a few yards away. Timber-framed, Elizabethan, with thin twisted shafts at the first-floor angles and quatrefoiling on the beam at the level of the first-floor windows. The doorway has a cambered head with stylized flat leaf in the spandrels. In the Hall a stone fireplace, dated 1658, very simple, without any of the Jacobean flamboyancies.

ST MARY'S STREET, from Castle Street. The start is not promising. On the l. the Crown Hotel, large imitation half-timbering of 1908, on the r. the drab Gothic brick building of the Post Office. Then on the same side, facing St Mary the DRAPERS' ALMSHOUSES, rebuilt in 1825. Red brick, Tudor style. Symmetrical two-storey front with three straight gables on either side of an embattled gate tower. Cobbled court inside. A little further on, Nos 9 and 10 the lodges to ST MARY'S COURT. The lodges are of one bay with the ground floor windows set in a tall blank arch. Four such arches also at the back in the court, an addition on the r. side of a terrace of C18 houses of which the r. is St Mary's Vicarage.

ST MARY'S WATER LANE *see* CASTLE STREET.

SCHOOL GARDENS *see* CASTLE STREET.

SWAN HILL, from Market Street. The corner of College Hill is part of No. 12 College Hill, a good piece of *c.* 1700, with stone bands, square eaves brackets and dormers. Opposite: No. 22, late C18 with the ground-floor windows in blank arches. Then PORCH HOUSE dated 1628. Ground floor of upright posts and studs. Doorway with heavy carved brackets. First floor with more widely spaced timbers. Windows on

* No. 3 is called by Mr J. T. Smith an example of the latest phase of timber-building in Shrewsbury.

carved brackets. Three dormers. Opposite a long range of late
C18 houses, continued into SWAN COURT. The houses here
turn their faces to the s, the gardens and the river. The best is
called SWAN HILL COURT. It was the house of the Marquess
of Bath and is the most ambitious later C18 house at Shrews-
bury. The street front does not betray that. On the garden
side five bays, two and a half storeys, three-bay pediment with
arms and swags. Simple doorway with straight entablature on
brackets; enriched window surrounds above. Lower one-and-
a-half-storey, one-bay wings with Venetian windows and
broken pediments.

SYDNEY COURT see CASTLE STREET.

THE SQUARE. The Square is dominated by the Old Market
House and the Shire Hall, the former looking decidedly jolly
and amenable in comparison with the latter. In the square
STATUE of Clive of India, 1860 by *Marochetti*. Clive was M.P.
for Shrewsbury in 1761–74 and of course a Shropshire man
(*see* Walcot). Of individual houses not many need comment.
Facing the Shire Hall three presumably Early Victorian ashlar
fronts, undistinguished but laudable for their sense of con-
formity. Then Nos 5 and 5a, erected *c.* 1570, the second floor a
recent addition. The original first floor has thin twisted but-
tress shafts and two bands of quatrefoils. Nos 8–9 dates from
1730. It has the typical segment-headed windows and the
parapet slightly projecting above the windows. Quoins.
Aprons below the second-floor windows. Staircase with three
thin twisted balusters for each step. On the s side two houses
both dated 1713. The one still has straight-headed windows
and steep pediments to the dormers. The other has segment-
headed windows and no longer a stone band.

TOWN WALLS. Town Walls is an agreeable promenade – at
least early in the morning and in the evening – running along
the wall, halfway up the hill on which the town lies, with
views up to well-to-do Georgian houses and down to the
lawns and the river. To reach Town Walls from the E one has
to pass first through BEECHES LANE, and here is BOWDLER'S
SCHOOL of 1724, very characteristic of its date. Five bays
and two storeys, with hipped roof. The first and fifth bays
project slightly and are quoined. Stone band; square eaves
brackets, thinner and sparser than twenty years before.
Segment-headed windows, doorway with broad eared sur-
round and big segmental pediment. Then TOWN WALLS
proper begins. The wall is on the l., and fragments of medieval

masonry appear here and there. The walls were begun by
Henry III in 1226 and took about thirty years to build. Past
the Roman Catholic Cathedral a big garden gate with quoined
lodges, belonging to No. 12 Belmont. Then a pretty two-
storeyed Summer House, quoined, with segment-headed
windows and pyramid roof; *c.* 1725 no doubt. On the opposite
side THE CRESCENT, *c.* 1800, four houses on a shallow curve.
The doorways and ground-floor windows have blank seg-
mental arches with Adamish fan decoration. Opposite these
Nos 16–20, Early Victorian, with coupled doorways, each pair
flanked by Greek Doric columns. Again across the street the
best-preserved piece of wall, and the one surviving WALL
TOWER. Square; only the battlements are renewed. Single-
chamfered doorways into the street and also on to the former
wall-walk. Opposite, the gate-piers of Swan Hill Court (*see*
Swan Hill). After that the street degenerates as a street. A
muddle of buildings, including some incoherent public ones.
Finally on the r., in MURIVANCE, the continuation of Town
Walls, opposite the Ear, Eye and Throat Hospital the former
ALLATT'S SCHOOL (now Health Centre), founded in 1798.
Early C19 (pre 1815), by *Haycock*; ashlar-faced. The main
body is of two storeys and five bays with doorways with
Tuscan demi-columns in the end bays. Three-bay arcades on
square piers l. and r., and then two-bay wings of one storey
with windows in blank segment-headed arches.

WINDSOR PLACE *see* CASTLE STREET.

WYLE COP, down to the English Bridge. The interest is at first
on the r. side. The COUNTY LIBRARY has a quiet brick
front of *c.* 1720-30, with segment-headed windows. It adjoins
the LION HOTEL, a long, varied, very attractive front con-
sisting of three parts, the top of five bays and four storeys, red
on a stuccoed ground floor, with a Tuscan porch, on which a
lion made in 1777 by *John Nelson* (Gunnis). Then a lower,
white part with a gabled roof. This is timber-framed and dates
from the C15, but was remodelled in the C18 in the Gothick
taste. Then again three storeys, red over white, and later C18.
Inside a splendid Ball Room of *c.* 1775-80 with one apsed end.
Arched windows, two carved fireplaces and, on the opposite
wall between the windows, two oval mirrors. Facing the
exedra a 'minstrels' gallery' on Adamish columns. In the
centre of the ceiling a saucer dome. Restrained plasterwork.
Pretty paintings of dancers etc. on the panels of the doors.
Abutting on the Lion is HENRY TUDOR HOUSE, an extremely

interesting house of the early C15, with an original four-light traceried window on the first floor and one of two three-light windows on the second, original too. The timber-framing is also original, almost exclusively uprights. The composition is irregular. Remarkably deep coving above the projecting beams which carry the second floor. Henry VII stayed in this house in 1485 before Bosworth. Nos 65–69 is also timber-framed and of the C15 (Mytton's Mansion). Again all narrowly placed uprights. But the façade is much restored and the timbers are partly painted on. Doorway with depressed arch and crenellation over. Above the doorway coving to support the oriel window.

Then the interest shifts to the l. side of the street. Nos 22–26, nice group of C18 brick houses; then No. 27 and the UNICORN HOTEL timber-framed.

The end of the street towards the Bridge is of some interest from the townscape point of view. On the r. the BARGE HOTEL, simple with Tuscan porch and then, standing below the bridge by the water, MARINE TERRACE which starts with a convex curve. It thus carries on along the river. At its end is MARINE COURT, a square two-storeyed brick gazebo with quoins overlooking the river. At the l. end of Wyle Cop the brick house curves concavely to turn the corner to the river. Steps lead down here from the bridge approach, and one can start a PROMENADE all along that part of the Walls to the castle. It is an asphalted footpath without any railing to separate one from the water, and on the l. rise the back gardens and the house fronts high up. If only the Infirmary had been less possessive and remembered the amenities of others than their patients!

OUTER SHREWSBURY

There is not enough deserving special notice to make up into a proper perambulation. The best sequence is to the E.

TO THE EAST. From the English Bridge at once a glance to the S (or a detour) to see what is left in COLEHAM of the former iron foundry of William Hazledine. The remaining buildings are early C19. On the other side of the English Bridge Abbey Foregate starts, a street of considerable interest. In ABBEY FOREGATE, next to the Technical College, is MERIVAL (Nos 2–3) of c. 1601, an L-shaped timber-framed house, with the main gable on the l. Moulded bressumer below the first

floor, carved bressumer below the gable, a quatrefoil frieze at the level of the first-floor window. The street then widens to embrace the abbey church denuded of its monastic buildings. Nothing of interest on the s side. On the N of some interest Nos 26–27, dated 1725, with two shaped gables of different size, on short pilasters, giving quite a Vanbrughian touch. This Baroque heaviness ought to be compared with the similar character in No. 30 Princess Street of 1727. Close to Nos 26–27 the partly recessed premises of the HOSPITAL OF HOLY CROSS, by *Pountney Smith*, 1853, Gothic and brick, and then at the NE end of the precinct two detached houses of *c*. 1700: ABBEYDALE HOUSE of seven bays, with three dormers in the gabled roof, the dormers having curly volutes on their sides; and ABBEY HOUSE of *c*. 1725.* This is of six bays and two and a half storeys with quoins and segment-headed windows. Top parapet, projecting above each bay of windows, the projection carried by some stone dressing above the windows of the half-storey. Fine staircase with three slim twisted balusters to each tread. Fine wrought-iron gates.

Now first off along WHITEHALL STREET, where Nos 1–4 WHITEHALL TERRACE stand at r. angles to the street. Long veranda along the front and iron balcony along the first floor. The houses are of brick and probably Early Victorian. Nos 18–38 are another long terrace, but of smaller houses. Early C19, also with first-floor iron balconies. At the end of the street facing into it is WHITEHALL, built for Richard Prince, a lawyer, in 1578–82, on ground belonging formerly to the Abbey, incorporating some abbey buildings, and using stones from the abbey. Red sandstone. Mansion with separate gatehouse. The gatehouse has gables and cross-gables, an elliptical archway and cross as well as mullioned and tran-somed windows. Star chimneys. The house has a symmetrical façade with three straight gables and a handsome octagonal belvedere turret with ogee cupola, but a porch added in yellow stone quite asymmetrically and with the entrance from the side. The doorway into the porch has fluted pilasters and a metope frieze. The windows are mostly mullioned and transomed, also the wooden ones in the belvedere. Ground-floor room with some geometrical plasterwork between the beams, large oblongs and lozenges with small heraldic and floral motifs. Staircase with later balusters. Behind the house a long outbuilding said to incorporate an abbey barn, and also

* The date *c*. 1698 quoted in the literature cannot apply.

a polygonal DOVECOTE with brick corbel-table of trefoiled arches and cupola on top.

Back to the Abbey and on in ABBEY FOREGATE which now narrows again to the width of a normal wide street. There follows a variety of houses of little individual interest, timber-framed such as Nos 179–181 with a big moulded bressumer and Nos 164–166; Georgian, with porches, in terrace formation, such as No. 68; detached Georgian such as MONK-LANDS with a Tuscan porch and lower one-bay wings with Venetian windows. Towards the end there is ISLINGTON TERRACE, a fine reticent terrace of stone-fronted houses, fourteen bays, the middle six a half-storey higher than the rest. The date is probably *c.* 1820, that is the date of the Column which ends the street.

LORD HILL'S COLUMN. 1814–16 by *Thomas Harrison*, based on a design by *Haycock*. A magnificent Greek Doric column (said to be the largest in the world), and on it the statue of Viscount Hill by *Panzetta*. The first stone was laid only a few months after Waterloo. The statue is $17\frac{1}{2}$ ft high, the whole $133\frac{1}{2}$ ft. To the N of the column is a LODGE, with two Greek Doric columns *in antis*.

That is the end of the sequence. In the other directions from the centre there are only odd houses or groups that need picking out.

TO THE SOUTH. In BELLEVUE ROAD a house called OAKLEY MANOR, built by the local architect *Samuel Pountney Smith* with the use of timberwork from a house adjoining the Plough Inn and other houses. Stone tablet with a date 1596. Staircase with cut-out panels with broad strapwork, *c.* 1630.

TO THE NORTH. Just past the railway bridge to the r. is HOW-ARD STREET. Here, before one reaches the Gaol, one has on one's left the former terminal WAREHOUSE of the Shropshire Union Canal, built in 1835 and designed by *Fallows & Hart* of Birmingham. This is a remarkably austere building with a giant Greek Doric portico *in antis*, a heavy attic above, and three arched windows on either side of this centre, the outer bays carrying pediments. Iron columns, iron arches, wooden roof. Then, going back to the main N road and walking N, one comes, past St Michael's church, to SPRING GARDENS and the premises of MESSRS WILLIAM JONES, Maltsters, built in 1796 for Benyon, Bage & Marshall's Flax Spinning Mill, and the earliest multi-storeyed iron framed building ever erected. Brick walls with few remaining windows (the majority blocked),

61b three rows of iron columns of cruciform sections and iron beams, twenty bays of segmental brick vaults, iron window frames etc.

Another way out N is through the l. one of the two railway bridges and towards the Berwick and Baschurch road. Here, shortly after the railway bridge, on the l., in COTON HILL Nos 20–22, a timber-framed building, all narrowly placed uprights. This was originally the barn of Mytton's Mansion (*see* Wyle Cop).

TO THE WEST. On the other side of the Welsh Bridge FRANK-WELL starts. The street is old ribbon development at the bridge-head and has preserved more C16 and C17 timber-framing than any other of Shrewsbury. The majority of the examples are not of special value or interest, but they are listed here all the same. First Nos 165–166, then 126–127 in a quay branching off Frankwell. It used to be the Fox Inn. Probably C16. Heavy moulded bressumer; baluster studs in the gable. Opposite in the quay Nos 133–134, also C16. Then on the l. side Nos 4–6, where the second-floor windows stand on carved brackets. Again on the other side the good group Nos 113–116. The first of these has squat balusters below the second-floor windows and plain concave lozenges above them. In the second these lozenges are cusped but only used at the top of the dormers. Baluster studs below the first- and second-floor windows of the bays. Nos 110–112 has big cusped diagonal struts on the first floor.* Nos 104–106 is similar. Then follows on the l., at the corner of New Street, one of the most ambitious timber houses of Shrewsbury, not high (because not in the centre) but long towards both streets. Dated 1576. Only one gable, effectively facing down Frankwell. Heavy overhang, seen in profile as one walks up. Articulation by the usual fine twisted shafts on the first floor. At window height the equally usual beams with quatrefoil decoration. The bressumer of the gable is embattled. In the gable diagonal struts forming lozenges within lozenges. The composition runs from No. 29 to No. 40 in Frankwell. Then, almost as interesting, opposite on the corner of Drinkwater Street No. 92, a perfectly plain nondescript brick cottage from the front, but from the side revealing cruck construction – the most instructive example of the technique at Shrewsbury. After that the close terraces cease.

* Mr J. T. Smith calls it the earliest surviving timber-framed house in Shrewsbury with jettied upper storeys.

On the r. higher up in its gardens THE MOUNT, where Charles
Darwin was born. Late Georgian, red brick, five bays and
two and a half storeys, quite plain. Deep Tuscan porch.
Lower wings of different length and height, that on the l. of
four bays, one-storeyed with windows in blank arches.

Opposite MILLINGTON'S HOSPITAL, rebuilt in 1794. An
ambitious composition. Brick, two-storeyed, with its façade
raised on a big brick terrace. Centre with quoins, Tuscan
porch, three-bay pediment and wooden cupola with open
sides. Ends also varied, also with quoins, but ending a little
awkwardly in high parapet walls, with one urn on. The main
ground-floor windows are set in blank arches.

SIBDON CARWOOD

4080
Inset B

St MICHAEL. 1741, apse and general gothicizing 1871. Nave
and chancel, and thin w tower.

SIBDON CASTLE. Close to the church, seven bays wide, two
storeys high, with higher castellated accent on the sides and in
the middle. Segment-headed windows. Castellated kitchen
garden on the l., with a stone building of the early C18. The
house itself is supposed to be mid C17, modernized early in
the C18 and gothicized about 1800.

SIDBURY

6080

HOLY TRINITY. Early Norman – see the original patches of
herringbone masonry – but entirely renewed in 1878–81.
Nave and chancel, and timber-framed belfry with pyramid
roof. – FONT. Norman, tub-shaped, with intersected arches
below, thick snake-like scrolls above; no doubt re-tooled. –
PLATE. Engraved Elizabethan Chalice. – MONUMENTS. Two
identical tablets referring to 1705 and 1708 with oval inscrip-
tion plates, urns on top, divers garlands; also cherubs' heads.
All rather rustic.

SILVINGTON

6070

St NICHOLAS. Norman to C13. Nave and lower chancel, and
w tower. The windows mostly renewed in an early C14 way.
Norman s doorway with one order of colonnettes, scalloped
capitals, and thick roll-moulding in the arch. Blocked simple
n doorway. w tower unbuttressed with Transitional w lancet.

Tower arch inside single-stepped and pointed. Very raw flat leaf capitals. Below them a diagonal, 1 ft 9 in. deep, cuts across the stepping of the responds. The chancel arch looks C13, but much renewed. The s porch has a round arch and no other details of interest. It is dated 1662. – PANELLING in the chancel, probably C17.

MANOR HOUSE, to the w of the church. The s end of the L-shaped stone house is medieval, with some lancet windows (and a winding oak staircase. MHLG).

SMETHCOTT

4090

St MICHAEL. Largely rebuilt in 1850. Nave and chancel and small wooden belfry. In the N wall of the chancel one Norman window. The priest's doorway with an odd lumpy tympanum might be Norman too. Roof with hammerbeams, collar-beams on arched braces, and one tier of cusped straight wind-braces. – PLATE. Chalice of *c.* 1480 with cover. Several alterations of *c.* 1630.*

SOULTON HALL
2¼ m. NE of Wem

5030

Interesting and impressive Carolean house. The date is known: 1668. The building looks very cubic now, but it must be assumed that it had gables originally, and that the parapet is an C18 alteration. Red-brick and stone dressings. Three storeys, symmetrical three-bay façade. Five-light mullioned and transomed windows l. and r., doorway with Roman Doric columns, a metope frieze and then an almost semicircular open pediment, very typical of *c.* 1660–70 in the provinces. Walled garden with fine gate-piers. Inside, a passage behind the doorway, not an entrance hall.

STANLEY HALL
½ m. E of Astley Abbots

7090

Jacobean house of red sandstone, partly brick-faced. Neale in 1820 gives the date 1642. Plain gables, mullioned and tran-somed windows, several with pediments. The entrance side has a porch and a gable next to it, both with original nicely patterned bargeboarding. Projecting on the r. of the entrance

* According to Mr C. Oman.

stabling wing with C18 detail. A large addition, larger than the original house (1816 by *Thomas Cundy*), has been pulled down recently.

STANTON LACY

St Peter. A beautifully proportioned cruciform church. Archaeologically its chief interest is the nave W and N walls and the N transept and N walls: Anglo-Saxon work with the typical thin lesenes or pilaster strips (of square section). Some have short cross-pieces. One starts above the N doorway with a bracket with four pellets. The doorway is characteristically Saxon too, framed by an outer moulding. But the imposts are Norman in type and the arch is well cut. The date of the whole is no doubt the C11. In the N transept is indeed a trace of a window which was single-splayed (inside) as was the Norman habit, and not double-splayed (outside and inside) as did the Saxons.* The Saxon church must have been remarkably spacious. Early C14 the chancel, see the windows (E window C19; restoration 1847–9 by *T. H. Wyatt*), and the outer RECESSES with completely defaced effigies. See also the chancel arch, the crossing arch, and the transept arches. They are identical, double-chamfered. But the W and E arches have in the capitals of the responds ball-flower ornament. The transept windows are also early C14 (pre-Dec). The details of the crossing tower are no later, and one cannot accept Dean Cranage's date of *c.* 1360–70 for it. Finally the S aisle. Again evidently of the C14, and no doubt before the middle. Doorway with fine continuous moulding. In the outer wall two tomb recesses. Arcade of two bays, octagonal pier and double-chamfered arches. – STAINED GLASS. Much obviously by *Evans* of Shrewsbury. The dates are in the thirties to fifties. – MONUMENT. Elizabeth Onslowe † 1613, with very primitive Renaissance detail; no figures.

STANTON LONG

St Michael. Nave and chancel, and weather-boarded belfry with pyramid roof. Much restored in 1869–70. Lancets in nave and chancel, S doorway Norman-looking, but with a pointed arch, i.e. *c.* 1200 and later. In the chancel S wall a handsome recess with a depressed two-centred arch running

* The window in the gable is not original.

into the uprights in a continuous roll-moulding, probably late
C13 or early C14. Good nave-roof with wind-braces forming
quatrefoils. – DOOR. With iron scroll-work; could also be
c. 1200.

STANTON-UPON-HINE-HEATH

5020

ST ANDREW. Nave and chancel and W tower. Nave and
chancel are Early Norman and quite large and spacious. In
the chancel two original N windows, in the nave one, quite
high up. The nave has two simple Norman doorways, and in
the N wall some herringbone masonry. The N doorway has
one order of shafts, the capitals with upright leaves. The W
tower is C13 below (see one small W lancet), Perp above.
Battlements and eight pinnacles. There was formerly a short
S aisle. The two-bay arcade with a simple octagonal pier can
be seen inside. – COMMUNION RAIL. C18.

STANWARDINE-IN-THE-WOOD

4020

STANWARDINE HALL. An odd building, Elizabethan, with a
date 1588 inside the Hall. There is also a sun-dial in the
garden with a date 1560 (Mrs Stackhouse Acton). The
S front is clearly not the result of one design or one building
operation. The r. side has a big gable over a broad pro-
jection. The l. side has a steep shaped gable over a much
narrower projection. The centre contains the porch, with
just such a steep shaped gable over. But the house including
the l. projection is of brick, whereas the porch projection
is ashlar-faced. That may be a way to distinguish it, but
the discrepancy between the l. and r. gables remains. In
addition, the windows are mostly mullioned and transomed,
but that of the Hall to the l. of the porch is mullioned only and
has quite different mouldings. The Hall has a plaster frieze
with scrolls and shields. Gough says that the house was built
by Robert Corbet, brother of Sir Andrew of Moreton Corbet
(† 1578), and enlarged by his son who married the daughter of
Sir Andrew's son, Sir Vincent Corbet. The shaped gables of
Stanwardine are indeed poor relations of those of Moreton
Corbet.

STANWAY MANOR *see* RUSHBURY

STAPLETON

St John Baptist. Red sandstone. Nave and chancel, and narrower w tower. The church may well be unique in being an undercroft and a church in one, with the floor between taken out. The whole was probably built between *c.* 1190 and 1210 or 1220. Why it should have been made two-storeyed, the feature characteristic of palace chapels, is not known. Rebuilding took place in 1786. It was then that the two parts were thrown into one. The w tower was added about 1840, although in general shape (though not in the quoins) it looks rather more like 1786. General restoration in 1867 (by *Slater & Carpenter*), when the heavy details were introduced which now detract much from the impression of the interior. The undercroft has straight-headed slit windows and a s doorway, now half buried, with a round arch. The upper church has lancet windows, three of them stepped at the E end, a priest's doorway of typical moulding, a N doorway which originally seems to have had the same moulding, and two s windows of 1867. – CANDLESTICKS. Two fine wooden German candlesticks with Late Gothic foliage decoration, *c.* 1500. About 6 ft tall.

Moat Farm, 1¼ m. sw. Within the moat three ranges, two connected into an L-shape, with tall stone plinths, 15 to 20 ft up. They no doubt formed part of a medieval fortified house. The house now on this plinth is timber-framed and has in one room heavy moulded beams and a boss *temp.* Henry VIII. In the same room a Jacobean overmantel.

STEVENTON
1 m. se of Ludlow

Manor House. Jacobean, of stone, with a front on the E-plan and three gables. Porch with round-arched entrance. All windows sashed. Chimneys with star-shaped stacks at the end. Hall with original fireplace and panelling.

STIRCHLEY

St James. A small C18 church of brick with a w tower. The chancel, however, is Norman, has its original windows on the s, N, and E, and in addition a quite incongruously ornate chancel arch. Two orders of strong shafts. Three orders of

voussoirs, the inner with elongated chain-links, the other two with variations on the zigzag theme, with the zigzags also at r. angles to the wall. – Nice C18 FURNISHINGS, i.e. high box-pews, reader's desk, and pulpit.

STIRCHLEY HALL. Dated 1653. Gabled stone house, SW of the church, with mullioned windows. C18 brick additions. (In the kitchen moulded beams and a carved boss with arms. MHLG.)

STOCKTON

7090

ST CHAD. The church except for the W tower looks all of the date of the restoration: 1860. Yet the chancel is Norman, as is proved by one N window, now visible only from inside, and there terribly dolled up. Short W tower with diagonal buttresses, C15 below, C17 on top. The tower arch has polygonal responds with concave sides (cf. Quatt). – FONT. Octagonal, Perp, with blank arches and quatrefoiled circles on stem and bowl. – PULPIT. Jacobean. Two tiers of blank arches filled with flowers. – STAINED GLASS. Of the time of the restoration.

RECTORY to the S. Red brick house of 1702. Five-bay centre of two and a half storeys, two-bay wings of two storeys.

STOKE COURT see GREETE

STOKE ST MILBOROUGH

5080

ST MILBURGH. Nave and chancel, and embattled W tower. The W tower is E.E. up to the corbel-table. The rest of it is probably Perp. Most of the windows seem C14, the triple-chamfered tower arch a little earlier. Timber-framed S porch with brick-nogging. The nave roof is sturdy work which might be found in a barn, with collar-beams, arched braces, queen-posts, and plain wind-braces. There is, however, a date 1707 on one of the collars.

STOKESAY

4080

Inset B STOKESAY CASTLE. Stokesay Castle is one of the earliest fortified houses (as against fortresses) of England, at least one of the first of any architectural ambition. The Great Hall was built c. 1270–80, and it is most remarkable that at so early a

date such a Hall with windows of that size to the outer world
across the moat could be risked. In no other country would
there have been enough security. The wide valley with the
river Onny and the gently rising hills to the w and e looks
indeed the epitome of peace. Stokesay Castle is approached
through a GATEHOUSE which comes straight from a picture
book. The ground floor is of stone, but the upper parts, late
C16 work, are gaily timber-framed, with narrowly placed
posts below, with lozenges above, and with cusped concave
lozenges in the gable. The doorway is flanked by pilasters and
figure brackets. There are brackets also at the angles, and to
the inner court there is yet more carving, including two low
segment-headed blank arches supporting an oriel above the
gateway.

Opposite the Gatehouse is the HALL RANGE. It is flanked 10b
by two towers, but only that on the s (l.) side is a real asset from
the point of view of defence, and that is clearly a later, though
only slightly later, addition. Licence to crenellate was granted
in 1291. The builder Laurence de Ludlow was the son of a
clothier. There is another tower to the N, but less strong and
less pronounced. This stood before the Hall was built. It is
assigned to the C12, except of course for its again extremely
pretty timber-framed upper parts. The basement must have
been used as the kitchen. In any case it has the well. The second
floor was an additional living room, as in it there is a fine
fireplace looking early C14 rather than late C13. Keeled shafts
to the r. and l. with finely moulded capitals carry plain
brackets on which rests a far-projecting hood.

The HALL is entered at its N (r.) end, close to the N tower.
The doorway is single-chamfered. The windows both to the
court and to the moat, i.e. the w, are tall, of two lights, with a
transom and with cusped heads to the lights and an unfoiled
circle over. There are windows of the same shape but much
shorter above the doorway (blocked), above where a back
doorway would be expected. The timber roof, according to
recent research by Mr J. T. Smith, belongs to two periods, the
late Middle Ages and the time of the buildings of the Hall.
The early timbers seem to prove that the Hall originally had
aisles divided from the 'nave' by wooden posts (cf. such Halls
as those at Tiptofts, Wimbish, Essex). The upper part of the N
tower was reached by a plain, rough wooden staircase in the
hall which must have arrived above the screen, if a screen can
be assumed. The SOLAR RANGE belongs in date to the s tower

not the hall.* The Solar is accessible exclusively from the outside by an outer stair which was originally roofed. It has windows of the same type as the Hall. The room has Elizabethan panelling and a sumptuous fireplace with three-dimensional strapwork and caryatids. The moulded s doorway of the Solar indicates that here there was originally an outer wall, and that the passage to the s tower is an addition made when the tower had been built.

The SOUTH TOWER, which by its erection converted the house into a castle, is of a very curious shape. Three sides of an octagon to the courtyard, twice three sides of smaller octagons to the sw. The rooms have lancet windows, except that there is one pair of lancets on the second floor facing sw.

St JOHN BAPTIST. Norman s doorway. One order of shafts with scalloped capitals. Single-chamfered arch. Later medieval w tower and chancel, both as far as one can see Perp, though the masonry may be older. The chancel has two Perp windows, the tower arch is elaborately moulded and was, according to an inscription, given (i.e. the renewed part) by Johne Cheshire, joiner. That takes us to the mid C17, when the church was largely rebuilt: the nave in 1654 (a rare date in church architecture, because a Commonwealth date), the tower in 1664. Round-headed windows. Ceiled nave. Traditional chancel roof, dated 1664. – PULPIT with tester, and CANO-PIED PEW, both still Jacobean in character, though no doubt also c. 1660. – PAINTINGS. Inscriptions of Commandments and Creed and Exodus XX on the nave walls, also mid C17 (cf. Wistanstow). – STAINED GLASS. Ernest Davey Tredin-nick Memorial, † 1902. The inscription tablet has two female figures in purely Pre-Raphaelite enamel.

ONNY BRIDGE. By *Telford*, 1823. Cast iron, single span, with elegant segmental arch and thin, fence-like parapet.

4070
Inset B

STOKESAY COURT
½ m. sw of Onibury

Built 1889 by *Thomas Harris*, but not as original as his early work. Symmetrically Elizabethan. The entrance side with two far-projecting wings is rather severe, with small horizontal windows. Rustication with Grinshill ashlar trim. The garden front has two canted bay-windows and a semicircular one in the middle. Shaped gables, mullioned and transomed

* Observation by Mr J. T. Smith.

windows. Large central hall with glazed roof, and ambitiously carved staircase off it.

STOKE-UPON-TERN

St Peter. Big Victorian church, built in 1874–5. Nave and chancel, s aisle and sw tower with a polygonal stair-turret rising too high above the tower. – STAINED GLASS. Some of the earliest *Kempe* glass (1876) in the E window and the s aisle E window, the latter, three oblong panels with the Adoration of the Magi, being specially attractive. – MONUMENT. Sir Reginald Corbet, Justice of the King's Bench, † 1566, and wife. Recumbent alabaster effigies on a big tomb-chest. On the side three panels with two standing figures each, widely spaced. Flat spiral-fluted colonnettes. The arrangement is reminiscent of Albrighton and Claverley.

Petsey. A charming black-and-white house with some unusual details. Dated 1634. Main gables with diagonal strutting turned outward instead of inward towards the post. The brick chimney has below the stacks some lozenge or diamond patterning in brick. (Inside STAINED GLASS: a circular window of the C15. It represents the Tree of Jesse. Cranage.)

STOTTESDON

St Mary. One of the most important churches of its district, though situated in a village far away from any main traffic. The oldest relic is the w doorway, now inside the tower. This has a lintel and tympanum, certainly of the C11 and possibly 6a of before the Conquest. The lintel looks decidedly Anglo-Saxon, the raised triangular frame of the tympanum also, but the tympanum itself with saltire-crosses as its pattern appears Norman rather than earlier. A bearded, Norman-looking head at the apex of the triangle. On the lintel beasts in profile, two standing on their heads, as if the lintel had been meant to be used the other way round, but the third standing quite normally. Interlace on the l. The w tower itself is Early Norman, except for the late medieval top storey and battlements. Next follows the N arcade inside, sturdy Late Norman work of five bays with circular piers and flat square abaci decorated with rough foliage motifs. The arches are single-stepped and round. The w respond is tripartite and the middle

shaft has a fillet. The w respond of the aisle corresponds, as does the small w lancet window, but the rest of the aisle is later: clearly Dec work of *c.* 1330, though the wide four-bay arcade was put up only in 1868. Dec (renewed) s windows, and Dec E window of three lights with flowing tracery. The chancel is usually given the same date, though it may be a little earlier. Splendid five-light E window (cf. Kinlet and Chelmarsh) with intersected cusped tracery interrupted at the top to allow for a sexfoiled circle. That is a typical design of *c.* 1300, but the (renewed) N and s windows have reticulated tracery. Further w a cusped lancet of the low-side variety. Priest's Door with ogee top to the arch, curiously cusped inside. Door opposite in the chancel also with ogee top. Sedilia with crocketed gables. When the chancel was built, the aisles were extended to the E so as to allow for arches into the chancel. These have continuous mouldings. Finally the somewhat puzzling s doorway and outer doorway of the s porch. The latter clearly goes with the N arcade but must be re-set, the former has a pointed arch with quadrant-mouldings and may be of the time of the renewal of the s aisle. – FONT. The most sumptuous Norman font in Shropshire, probably of *c.* 1160, and work of the Hereford School whose more famous carvings are at Shobdon, Kilpeck, etc. Bands of scrolls and leaves on foot and stem. On the bowl below a band of ribbed interlace a series of medallions with the lamb and cross, beasts, a frontal figure of a man with parallel ribbing to represent drapery, and leaf motifs. – PULPIT. Jacobean, with at the top a band of short blank arches separated by caryatids (cf. Cleobury North). – SCREEN. Nice Arts and Crafts Gothic; 1901. – STAINED GLASS. In a s window fragments of medieval glass, e.g. a C14 head of a Knight with mail coif.

₂₃

₃₀₇₀

STOW
2½ m. w of Bucknell

ST MICHAEL. A beautiful setting, up a secluded valley off the Teme valley. The small church stands against a screen of fir-trees with a yew-tree in front. Nave and chancel, and weatherboarded belfry with pyramid roof. The masonry is medieval, the dressings are renewed. Good roof with tie-beams and queen-posts, collar-beams, and two tiers of curved wind-braces. – REREDOS. Of *c.* 1901. In the Arts and Crafts taste, the ornament rather Art Nouveau. St Michael

and St George l. and r. Mosaic of stones of various colours, copper, mother of pearl etc. (by *Powell's*). – STAINED GLASS. Dates from *c.* 1878 to *c.* 1895, three windows in the Walter Crane style (by *Powell's?*).

STYCHE HALL
2¼ m. NW of Market Drayton

6030

In a fine position against a hillside. Brick, whitewashed seven-bay front of two and a half storeys, quite unadorned, except now by dark green shutters. To the E, doorway in a closed (later) porch with fluted Corinthian pilasters and, on the r. and l., canted bay-windows. The staircase is below an oval glazed dome. The handrail is not original. Original two fireplaces and some fine doorcases. The house was rebuilt by *Sir William Chambers* between 1760 and 1764. The Stables may also be by him.

SUNDORNE CASTLE
½ m. W of Haughmond Abbey

5010

Castellated brick mansion with a symmetrical S front and divers interiors, all of the early years of the C19 (before 1831). But there are older parts as well. In the house itself is a fine staircase of *c.* 1740, with three twisted balusters to each step and carved tread-ends. The newel-post at the foot is a bearded term-caryatid. So the core of the house is Early Georgian at the latest. Other rooms redecorated (according to Mr C. Gotch) by *Mylne c.* 1774. The castellated gatehouse to the E shows Georgian or even older brick. The entrance with a big porch of *c.* 1830 is on the W side; to the N from here extends a long castellated wall. Since writing this, the house has been pulled down.

SUTTON
1½ m. S of Shrewsbury

4010

ST JOHN. Ruinous former church now belonging to farm buildings. The chancel is all that remains, closed on the W side by a brick wall. The windows are lancets; in the E wall there are three, the middle one starting higher than the others. Elizabethan roof inside with one tie-beam connected with the collar-beam by three posts. No fitments except a perfectly plain Norman FONT and a COMMUNION RAIL of 1582.

SUTTON MADDOCK

ST MARY. 1888 (by *Nicholson & Son*; GR), except for the w tower which is dated 1579. The lower parts may be Perp, but the bell-openings are an interesting Tudor motif: straight-headed, of three tall arched lights. Battlements and pinnacles.

SWANCOTE FARM *see* WORFIELD

SWEENEY HALL
2 m. s of Oswestry

Five-bay stone house of 1805. Two storeys high with a one-storey closed porch with pilasters. Giant Tuscan pilasters at the angles and flanking the porch.

TASLEY

ST PETER AND ST PAUL. 1840 by *Josiah Griffith* (GR). A depressing building of only too well preserved yellow brick. Nave and chancel, and bellcote. Lancet style. – PULPIT. Jacobean. – SCREEN. Perp, thin, with one-light divisions.

THE LYTH *see* ELLESMERE

THONGLANDS
1 m. sw of Holdgate

Moated manor house partly of stone, partly timber-framed, with a gabled front, of post-and-pan work below, then lozenges within lozenges, and then concave lozenges.

TIBBERTON

ALL SAINTS. 1842. By *J. Baddeley*, surveyor (GR). Red sandstone ashlar. Nave and chancel, and w tower with battlements and heavy pinnacles. Windows pointed with thin Y-tracery.

TILLEY

1 m. sw of Wem

Two pretty black-and-white houses: OAK COTTAGE which has diagonal strutting even on the ground floor, and TILLEY HALL, with a date 1613 over the door which is in C19 numerals. Two gabled projecting wings and recessed centre. The decoration of the gables differs. That on the l. has more motifs: in the gable itself there are one above the other a diamond, a cross, and a concave-sized lozenge.

TILSTOCK

CHRIST CHURCH. 1835. Quite a pretty sight from the street. Red brick with a slim w tower. The pyramid roof of the tower is so steep that it looks somewhat like a campanile. Along the long side five arched windows. The glazing bars are of cast iron (cf. e.g. St Alkmund Shrewsbury).

ALKINGTON HALL, see p. 58.

TITTERSTONE CLEE HILL

TITTERSTONE CAMP. A magnificent Iron Age hill camp. It covers the staggering area of 71 acres, occupying the entire flat top of the hill at the unusual altitude of nearly 1800 ft above sea-level. It consisted originally of an earth-and-timber structure with a single rampart, but at a later date sections of this rampart were strengthened by means of a second line of defence, and the entire edifice was reinforced by means of rough-hewn blocks of basalt.

TONG

ST BARTHOLOMEW. The church is entirely Perp, built after Elizabeth, widow of Sir Fulke de Pembruge, had founded a chantry college in 1410. The terms of the foundation are quoted in Griffiths's *History of Tong*. There were to be a warden and four priests, two clerks, and thirteen poor people. The priests were to live together, each with a chamber to himself, and they were to be careful to talk in a low voice, to eat and drink modestly, and to refrain from hunting and hawking. The collegiate buildings were to the s of the church,

but have disappeared. The church was almost entirely rebuilt. Earlier only part of the s arcade and especially its w respond. The date must be C13. The arch has the hood-mould towards the aisle, so probably the earlier church had its nave where the aisle now is. The new church of the C15 is a very spiky, battlemented and pinnacled building of red sandstone with a tower over the crossing. The tower starts square and turns octagonal. It ends with battlements and pinnacles and a stone spirelet. Chancel E window of five lights with a transom, N and S three lights. W window of four lights. The interior can scarcely be taken in. The eye turns at once to the tombs and monuments. Tong church is a museum of effigies, to the detriment of the architecture and the individual monuments. N and S arcades of five bays with octagonal piers, arches with two sunk wave mouldings. The crossing and transept arches have the same mouldings. To the s of the chancel the Vernon Chapel of 1515 which will be described in connexion with its monuments. Fine low-pitched nave roof with arched braces, moulded beams, and bosses. s transept roof of lean-to type with carved beams.

FURNISHINGS. FONT. Octagonal, Perp, with shields; plain. – SCREENS. Rood Screen of tall one-light divisions. Also screens between aisles and both transepts. – CHANCEL STALLS. Tall backs with close tracery. The chancel seats have MISERICORDS, mostly of foliage, but also two angels, an eagle, and an Annunciation. Figures in relief between the seats. Poppy-heads with figures, e.g. the soldiers at the Sepulchre, Christ risen, and the Twelve Apostles. – PULPIT. 1629, with two tiers of short blank decorated arches. – ROYAL ARMS. Of 1814, richly carved. – DOOR. Original door from chancel to vestry, with some tracery. – SCULPTURE. Panel with two angels holding a shield; no doubt from a tomb-chest. – STAINED GLASS. W window with C15 figures, very light silvery colour. – E window, by *Kempe*, 1900. – EMBROIDERY. Vestment of *c.* 1600, plum-coloured velvet, with a sun and IHS in the middle, a leaf border, and scrolls, stars, and a thickly embossed cherub's head. – PLATE. Exquisite standing Cup of *c.* 1540–50, silver-gilt, 11 in. tall. Given in 1629.

MONUMENTS (chronologically). Incised slab to a priest; C13 (N transept floor). – Sir Fulke and Lady Elizabeth de Pembruge (founders of the college). Alabaster monument of surprising plainness. Recumbent effigies. The sides of the tomb-chest just decorated with arches in single alternating

30a

with double tiers; angels only on the E side (crossing N). – Sir Richard Vernon of Haddon Hall † 1451 and wife. Alabaster 33a monument, of splendid quality, with, against the tomb-chest, angels alternating with frail-looking saints. Fine canopies (crossing S side). – Sir William Vernon, Lord High Constable 33b of Henry V, † 1467, and wife. Tomb-chest with elaborately cusped quatrefoils and gablets. On the lid brasses, the children kneeling small below. The principal figures 3 ft 3 in. long. Helm with feathers behind Sir William's head (nave S side). – Ralph Elcott † 1510, brass of a priest, the figure only 2 ft long (S aisle wall). – Sir Harry Vernon † 1515, founder of the Vernon chapel S of the S transept. The monument is placed under a panelled elliptical arch. Big superstructure with four brackets and canopies for images. Their heads have been knocked off. The brackets have little vaults below; so have the canopies above the figures. The monument has two recumbent effigies, the tomb-chest a lively rhythm of narrow bays with angels under stilted steeply pointed arches and wide bays with shields under very depressed four-centred arches. Fine details. The chapel is fan-vaulted with pendants. – On the floor brass to Arthur Vernon † 1517, M.A. Cantab. ('Orate specialiter pro anima . . .'). The figure is 3 ft 6 in. long. On the W wall, the most impressive of the monuments at Tong, a 34a demi-figure on a bracket, frontal, and with a book in his hand: probably the same Arthur. This is a type popular for divines in the C17, but at this time familiar rather from choir stalls in Germany (Syrlin) than from English funeral monuments. – Richard Vernon † 1517 and wife. Alabaster. Tomb-chest with the same rhythm of figures and shields as on the tomb of 1515; but bedesmen instead of angels (nave N side). – Humphrey Vernon † 1542 and wife. Incised slab on a plain tomb-chest (N transept). – Mrs Wylde † 1624. Small frontally kneeling figure (chancel S wall). – Sir Edward Stanley † 1632 and his parents Sir Thomas Stanley † 1576 and Margaret Vernon. Large free-standing monument in two tiers. Below, an eight-poster arrangement with short black columns placed in front of cross-arches. Effigy of Sir Edward on a half rolled-up mat. Above, the parents and at the angles four large obelisks. Above the tomb allegorical figures in niches. These were originally on the corners, and the obelisks stood on the ground (cf. Russell Monument Chenies, Aston Monument Cranford Mddx, Thornhaugh Monument Thornhaugh Northants). – Elizabeth Pierrepont † 1696, with relief portrait

in a medallion (chancel N wall). – George Durant † 1780. Large seated woman mourning below an urn. Unsigned, but by its style most probably by *John Bacon* (crossing).

THE VILLAGE. Immediately E of the church a nice group of houses. First CHURCH FARM, timber-framed, then the POST OFFICE, of brick, three bays wide. The side bays have lean-to roofs, the middle bay on the upper floor a Venetian window and a pediment. Then the RED HOUSE, Georgian, brick, of three bays. After that the ALMSHOUSES, three sides of a square, open to the street. One-storeyed, brick, C18. The centre with an archway and a pediment over. Finally the VICARAGE, early C18, of five bays, brick, with segment-headed windows. Doorway with Tuscan pilasters carrying a big segmental pediment.

TONG CASTLE. *Capability Brown*'s masterpiece of 1765, in its oddly moorish Gothick taste, was pulled down in 1954. It had been built for George Durant to replace the mansion of the Vernons. The main gate and lodges (Convent Lodge) S of the village are in decay. To their S a GAZEBO, small, like a sentry box.

To the N of the village on Tong Knoll an embattled TOWER, belonging to the Weston estate in Staffordshire.

TOTTERTON HALL
3080
1 m. NE of Lydbury North

Late Georgian brick house of five bays and two storeys. The centre bay has a pediment and a porch of two pairs of Tuscan columns. The façade is further divided by brick giant pilasters or pilaster-strips.

TREFLACK HALL
2020
2¾ m. NE of Llanyblodwel

The house must be of *c.* 1700. Stone. Recessed three-bay centre, two-bay projecting wings. Quoins. Hipped roof. Some typical Queen Anne panelling. Small staircase with heavy twisted balusters, but a still Jacobean-looking newel-post.

TREFONEN
2020

CHURCH. 1821 and 1828. Grey stone. Low broad nave with pediment-like gable. Bellcote. This was renewed, the chancel and apse were added, and the windows gothicized in 1876.

TUCK HILL *7080*

HOLY INNOCENTS. 1865 by *St Aubyn*. Nave and chancel, with timber bellcote with a spire. – STAINED GLASS. S aisle W window 1892, S window 1891, both by *Kempe*.

TUGFORD *5080*

ST CATHERINE. Norman nave, E.E. chancel and E.E. W tower. A reference to a chapel at Tugford occurs in 1138. Norman first of all the S doorway with one order of shafts carrying a trumpet and an upright stiff-leaf capital. Arch with lozenges laid on a keeled roll-moulding. Hood-mould on head-stops. All this is clearly late C12. Norman, and equally clearly earlier, probably before 1138, one N window in the nave. The other windows are late C13 to early C14. In the outside walls of the chancel several recesses, three on the N side, one on the S. They also look late C13. – FONT. Fluted circular bowl on moulded C13 stem. – WEST GALLERY. Perhaps made up of parts of the former Screen. – COMMUNION RAIL. Jacobean. – SCULPTURE. (Two Sheila-na-gigs, l. and r. of the S doorway inside. E. Vale.)

TUNSTALL HALL *6030*
1½ m. NE of Market Drayton

Built *c.* 1732. Red brick, nine bays, two and a half storeys. Parapet and hipped roof. The ground-floor windows on the entrance side all pedimented. Doorway with segmental pediment. To the garden the doorway has a heavy Gibbs surround and a triangular pediment. To the S a bow-window, semicircular inside but outside with two segments between straight pieces. Entrance Hall with a decorated metope frieze all round, an open gallery at the back, and a plaster ceiling with an oval centre piece. In the dining room plasterwork with vine trails and grapes.

UFFINGTON *5010*

HOLY TRINITY. 1856 by *S. P. Smith*. Nave and chancel in one, and bellcote. – STAINED GLASS. In the N aisle roundels etc. of Netherlandish C16–C17 glass; in the S windows more colourful German C17 glass.

UPPINGTON

HOLY TRINITY. Nave and chancel and w tower, so heavily
restored by *J. P. Pritchard* of Darlington* in 1885 that the
result is virtually a Victorian church. There is, however, in
the N wall of the nave, one Norman window and one doorway
with a late C11 tympanum, more Anglo-Saxon than Norman
in style – a long dragon with various loose knots in his tail. s
porch with a date 1678 in the timberwork.

TUDOR HOUSE. Timber-framed house with a lavishly orna-
mented porch. The motifs, carved boards, black decorated
arches, etc., look as if they may not originally have belonged
to the house.

UPTON CRESSETT

Hall and church lie high on a hill, away from anything and only
accessible by one road.

ST MICHAEL. Nave and chancel, and weatherboarded belfry
with short lead spire. The s chapel was added in the C19.
There was, however, a medieval N aisle, which was pulled
down later. The church is Norman, see the s doorway with
two orders of shafts and zigzag in the arches, and also several
windows. The chancel arch has three orders of shafts, with
much zigzag in the arch. The E window, however, is a lancet,
perhaps remade in the C13. In the same century the N aisle
was built. The two-bay arcade, now visible from outside
only, has a circular pier with circular capital and double-
chamfered arches. Timber-framed porch. – FONT. Nor-
man, of tub shape, with tall somewhat leaning arches. –
STAINED GLASS. Some Flemish or German C16–C17
roundels in the E window. – MONUMENT. Brass plate with
kneeling figures (R. Cressett) dated 1640 and signed (a very
unusual thing). The signature is *Fr. Grigs*. Grigs is very little
known, although he signed the uncommonly excellent and
original monument to Sir Robert Hitcham at Framlingham in
Suffolk.

UPTON HALL. A remarkable Tudor house of brick. Built at
two dates, the earlier probably *c.* 1540, the later dated 1580.
To this belongs the detached GATEHOUSE. This is gabled
and has two polygonal turrets on the side towards the Hall.

* Or by *S. Pountney Smith*?

Narrow entrance with four-centred head. The room above has a four-light mullioned and transomed window and a plaster ceiling by the same men who worked at Morville and Wilderhope. The chimneystacks are set diagonally. The earlier part of the house still has twisted chimneystacks (cf. Plaish), in the later they are star-shaped. Mullioned and transomed windows of brick (which is unusual). Much blue brick diaper decoration. Inside, remains of the Hall roof with big arched braces (the so-called chapel) and of the oak newel staircase. The house deserves more intensive study.

UPTON MAGNA

5010
Inset A

S t L u c y. An unusual dedication in England. Naveand chancel Norman – see the plain s doorway, and the Norman windows in the chancel. There are two on each side, one close to the e end longer and higher up than the other next to it. In 1856 G. E. *Street* restored the church, added the n aisle and rebuilt the e wall. The w tower however is Perp, ashlar-faced, with diagonal buttresses, battlements, a quatrefoil frieze below them, and no pinnacles. Three-light w window. – MONU-MENT. Walter Barker † 1644. Semi-reclining figure on a half-rolled-up mat; not stiff, quite at ease. The hands specially well carved. Reredos background with Corinthian pilasters and a large open segmental pediment. The inscription plate is oval, and framed by a garland with four keystone-like masks. A good work of its date.

Several black-and-white houses round the church, especially one to the NE with cruck construction and one to the SW with much diagonal strutting.

WALCOT

3080

¼ m. SSW of Lydbury North

Large red-brick house in splendid grounds with a large lake in front. Built for Lord Clive of India after 1763 by *Sir William Chambers*. Two storeys; eleven bays by eight bays. Centre with a one-storeyed portico of four Tuscan columns. Top balustrade. Attached to the w an early C19 ballroom. Much altered in 1933. (Two original plaster ceilings and fire-places by Chambers.) Stable-range of brick to the w. Blank arches on the ground floor, and a centre with large archway and lantern.

WATERS UPTON

St Michael. By *G. E. Street*, but not of great interest. Nave and chancel, and polygonal bell-turret with steep roof. Red sandstone. The w fenestration is three cusped lancets and a rose window above. At the e end intersected tracery.

WAT'S DYKE

A short Earthwork in the rear of Offa's Dyke and running through Old Oswestry.

WATTLESBOROUGH HALL

A five-bay Georgian farmhouse, stone built, and immediately attached to it the keep of a castle, with, at r. angles, a later medieval wing. The keep is square and still *c.* 50 ft high. The castle stands mid-way between Alberbury and Caus in the chain of defences of the Welsh Marches. Remains of Norman window reveals, remains of later medieval straight-headed windows with cusped lights.

WELLINGTON

Wellington, for its size (over 10,000 inhabitants), is depressingly poor in works of architectural value. The centre is small and cut in half by the railway. There is not one specially good building in it, either of black-and-white or of Georgian brick. The only noteworthy black-and-white house is Old Hall, on the Watling Street or A5 road, now part of a school. This has close uprights and no decoration.

A start has recently been made on some civic improvements. The first part of a future Civic Centre has been completed: the Police Headquarters in Glebe Street. This is by *C. H. Simmons*, the county architect, and friendly in design. It will fall nicely into place, if and when the rest of Mr *G. A. Jellicoe's* Civic Centre is executed.

All Saints. 1790 by *George Steuart*. A fine, dignified stone building, but, as it is to-day, presented far too self-consciously. The churchyard, except for a few tombs with iron rails round, is turfed. The building stands on a platter. A timber-framed villagey Lychgate is the last thing that would be able

to help it. The railway moreover cuts it off from the market place and its proper urban context (and, in addition, blackens it). w front of three bays with giant Tuscan pilasters and pediment. Doorway and two windows straight-headed. Semicircular windows in blank arches above. Square tower above the pediment in two stages. The sides of five bays with windows in two tiers, united into blank arches and finely detailed and ornamented. Shallow apse. The interior unfortunately altered in 1898 (by *Dalgleish*). The galleries were originally on cast-iron shafts quatrefoil in section. The present upper columns also were originally cast-iron shafts. – MONUMENT. Martha Oliver † 1839. By *Peter Hollins*. Large seated woman looking up. Doric columns in relief behind.

CHRIST CHURCH. 1838 by *Thomas Smith* of Madeley, and very similar to his other church, at Ironbridge. Yellow brick, in the lancet style. w tower with big pinnacles. E end with big pinnacles. The three galleries inside awkwardly cut through the long lancets.

WELSHAMPTON

ST MICHAEL. 1863 by *Sir George Gilbert Scott*. Rather a smooth design. Nave and s aisle, chancel and apse. Yellow stone in small blocks. Slate roof with diaper pattern. Bellcote over the junction of nave and chancel. Lancet windows and windows with plate tracery. s aisle with circular black marble piers with moulded capitals. Hood-moulds on naturalistic foliage. – STAINED GLASS. Chancel and apse with scenes in good, deep colours; could well be of *c.* 1863.

WEM

ST PETER AND ST PAUL. The w tower has an early C14 doorway of uncommon design: four orders of continuous mouldings (probably with fillets). At the foot they all bend outwards. The upper parts of the tower are Perp. Thin diagonal buttresses, battlements, pinnacles. A statue on the w wall below the bell-opening, another on the E wall. The w window of debased Gothic character is dated 1667. The nave was built in 1809–13, the N and s windows were altered in 1840, the chancel is of 1886. Aisleless nave, the width of the medieval nave and its aisles. Three galleries on iron columns. – PULPIT. Of wrought iron; dated 1887. – CHANDELIER. Of brass;

given in 1733. – GATES to the churchyard. The gate-piers are rusticated and carry big vases. The gates are of wrought iron, C18 rather than of c. 1810.

PERAMBULATION. To the W of the church in HIGH STREET the former MARKET HOUSE with a ground floor with Tuscan columns and elliptical arches originally open. The date is probably the early C19. Further on, No. 91, Late Georgian with two bow-windows, and Nos 93–95 of 1677, still timber-framed. To the E of the church down MILL STREET lies RODEN HOUSE, a good example of the urban early C19 house on the outskirts of a small town. Three bays, rendered, and with an Ionic porch. The HIGH STREET continues E of the church to the E. In it the TOWN HALL of 1903–5 (by *James Brown* of Shrewsbury), typical of its date with its bright red brick and with the jaunty turret on the l., to make the façade asymmetrical. To the S CHAPEL STREET turns off. Here the CONGREGATIONAL CHAPEL with an ashlar façade of 1834: three bays, two storeys, angle pilasters, arched windows, and a big pediment. To the N NOBLE STREET. This turns W after a bit, and in the end joins up with the High Street again. In Noble Street the CONSERVATIVE CLUB, a modest Early Georgian house of five bays and two storeys with quoins and a doorway with a straight entablature (pulvinated frieze). Finally also off N from the High Street yet further E NEW STREET with the two best houses, badly injured by a garage in front. One is timber-framed with a projecting porch which has at its dormer stage on the side the motif of crosses in circles (really another expression for concave-sided lozenges). The other is THE HALL, a fine Georgian brick house of five bays and two and a half storeys with a three-bay pediment and an Ionic porch.

DITCHES, 1½ m. NW. Dated on a door-handle 1612. Timber-framed with a central porch. All post-and-pan, except for the end gables which have close diagonal strutting.

LOWE HALL, 1½ m. NNW. The plain early C19 brick front has a date plate 1666, and inside is a fine Jacobean staircase carried up through the storeys. Flat openwork balusters and big finials on the newel-posts. Simple ornamental plaster panels below the stairs and landings.

NORTHWOOD HALL, 2 m. NNW. Small early C18 brick house of five bays and two storeys, with quoins and hipped roof.

WENLOCK EDGE SCHOOL *see* LUTWYCHE HALL

WENTNOR

3090

ST MICHAEL. Built in 1885 by *Henry Curzon*. He must however have used old parts to a considerable extent. In the nave is one Norman window, and one blocked Norman doorway. The doorway has interesting imposts, one with saltire crosses, the other with a kind of horizontal fluting or shelving. The S doorway is pointed and single-chamfered. The nave roof also seems reliable Perp work, with tie-beams, collar-beams on arched braces, and one tier of wind-braces arranged quatrefoil-wise. – PULPIT. Jacobean.

WESTBURY

3000

ST MARY. Nave and chancel, and N aisle, and W tower. The tower dates from 1753. It is ashlar-faced, has a doorway with a flat rusticated surround, a large plain impressive Venetian window above, then a circular window, and the arched bell-openings with alternating rustication. Parapet rising at the angles. E.E. evidence inside, especially the arcade. Five bays, circular piers with circular capitals, the arches with one chamfer and one roll-moulding. In the W wall a lancet window, also the doorways with depressed two-centred arches. Many new windows, E.E. and Dec in style, from the restoration of 1878. – MONUMENT. Richly Grecian large tablet to John Topp of Whitton Hall † 1837.

WEST FELTON

3020

ST MICHAEL. The interior here must have precedence over the exterior. C12 N arcade of four bays with very primitive circular piers with square capitals and abaci. Round arches of one step and one chamfer. The same arches in the S arcade, but slenderer circular piers, circular capitals, and octagonal abaci. Perp roof with collar-beams on arched braces and queen-posts making a lozenge pattern with the rafters. The W tower is Georgian and may date from the time when the aisles were removed, i.e. 1798. Arched and circular windows, and parapet. Chancel by *Sir G. G. Scott* 1841, the renewal of the rest of the exterior of 1841 (N Aisle) and 1879 (S Aisle etc.) – STAINED GLASS. The E window probably, and the N aisle E and NE windows certainly, by *Evans*. The use of

famous pictures is typical, also the small medallions with such famous pictures as Raphael's Transfiguration, Rubens's Christ taken down from the Cross, etc. – One N aisle window with two large figures also by *Evans*, another 1902 by *Kempe*. To the W of the church the moat and mound of the former CASTLE.

4080

WESTHOPE
3¼ m. NE of Craven Arms

WESTHOPE MANOR. By *Sir Guy Dawber*, 1901. Roughcast and tiled, with divers gables; a handsome example of the neo-Tudor of those years.

5020

WESTON
1 m. SW of Hawkstone

ST LUKE. Built in 1791, but all gothicized, except for the W tower whose angle pilasters and parapet fit the Georgian date. Chancel of 1879. No remarkable furnishings.

STOCKS. Outside the churchyard.

HAWKSTONE PARK HOTEL. The centre is Georgian (before 1799), with a seven-bay façade, rendered, two and a half storeys high, three-bay pediment. One-bay wings with Venetian windows below, semicircular windows above.

4020

WESTON LULLINGFIELD

HOLY TRINITY. 1857 by *E. Haycock Jun.* (GR). The vicarage is in the same style.

2030

WESTON RHYN

ST JOHN THE DIVINE.·1878 by *H. Kennedy* (GR).

QUINTA. Quite a lavish though not a very big house in the Gothic style of *c.* 1850–60. On a turfed hill to the NE a copy of Stonehenge.

MORETON HALL, 1 m. E. An interesting C17 brick house. Seven-bay front of two storeys with projecting two-bay wings. Hipped roof on carved brackets. The windows, of broad cross-form, seem renewed. The doorway has still a cambered head, and inside is a Jacobean-looking staircase with flat openwork balusters and big finials.

VIADUCTS, ¾ m. NE. Across the river Dee and the Welsh border into Chirk. Two parallel viaducts of brick, arched to carry the railway and the Shropshire Union Canal. The number of arches is the same, but the railway viaduct is higher. The canal viaduct is by *Telford* 1796–1801, the railway viaduct was added in 1846–8 (partly rebuilt 1858).

LODGE to Brinkynalt Hall, nr. Chirk, 1¾ m. E. Castellated, of tripartite composition. The date is probably early C19.

WHEATHILL 6080

HOLY TRINITY. Mainly Norman. Nave and chancel, and bellcote. One Norman N window. Norman S doorway and chancel arch, both with the same motifs. Thick roll-moulding in the arch, one order of colonnettes, very coarse scroll capitals. The doorway has a tympanum with raw triangle friezes. Handsome C17 roof in the nave with tie-beam, and queen-posts connected by round arches. The centre arch carries the collar-beam.

WHITCHURCH 5040

ST ALKMUND. 1712–13, 'according to a design drawn by *John Barker*' (Colvin). Built by *William Smith*. The largest C18 church in the county, outside Shrewsbury. Red sandstone. Big W tower with balustrade and decorated pinnacles. The round-headed bell-openings are of two round-headed lights with the odd motif of the mullion running up into the apex of the main arch. Below on the S side the arms of the Earl of Bridgewater who was patron of the church. On the S side also a semicircular porch attached to the tower. The semicircular shape derived, of course, from Wren's transepts of St Paul's. The porch was rebuilt in 1925, but in accordance with existing illustrations of the original. Along the side of the church six tall round-arched windows. The interior is quite majestic, with tall Tuscan columns and arches. The wooden galleries are fitted in without structural connexion. Coved ceiling. Apse with three windows. Under the tower is a vestry, entered by a fine big wooden doorway with fluted columns. – FONT. Octagonal, C17, with Tudor rose and Prince of Wales's feathers. – ORGAN CASE. A fine piece of no doubt *c.* 1715. Scroll work and cherubs' heads below, a trumpeting angel at the top. – CHANDELIERS. Two C18 brass chandeliers.

– STAINED GLASS. In the apse rather coarse glass with big figures in a kind of Holbein style. Signed by *Warrington*, 1860. – MONUMENTS. John Talbot, First Earl of Shrewsbury, † 1453. The effigy comes from the church which collapsed in 1711, but is much restored. The arch is of 1874. – Sir John Talbot † 1550. Alabaster effigy under an arch like the other.
ST CATHERINE, Dodington. 1836, in the Grecian taste. Five-bay front with giant pilasters. Entrance with attached un-fluted giant Ionic columns *in antis*. W tower over the entrance, octagonal top with tall, narrowly spaced Tuscan pillars. – Interior with galleries. – (PAINTING. Last Supper, 18 ft 6 in. by 11 ft, given in 1911 and attributed to *Bonifazio Veronese*.)

PERAMBULATIONS

Immediately N of the tower of St Alkmund's HIGGINSON'S ALMSHOUSES, a long low brick range with a centre raised in a pedimented gable. Inscription tablet and arched niche below. The foundation is of 1647, the building Georgian. To the N of the Almshouses the former Infants' School, a small building of 1708. It is of brick with quoins, five bays, single-storeyed, with a pediment. N of this the former Grammar School, partly of 1848, partly early C20; Elizabethan style with shaped gables. The old town comes to an end here, and the elaborate system of new by-pass or circle roads is first met. It forms the end of perambulations in all directions.
Down to the S from the church the HIGH STREET. Here Nos 42–44 a good Early Georgian house of five bays and three storeys with segment-headed windows. Then No. 40 with a complete cast-iron façade, an interesting and quite attractive rarity. Built as late as 1901–2 (by *W. Webb*). Opposite, the TOWN HALL, 1872 in a 'domestic Gothic style' (Kelly). By *Thomas Lockwood* of Chester. The upper storey burnt out in 1941. More Georgian brick houses such as Messrs Bradley's and Lloyds Bank. Nos 21–23 next to this has a symmetrical timber-framed front of 1677 (much pulled about). Opposite, the National Provincial Bank, spick-and-span timber-framed, with four gables, an imitation taller than any local original building. Well-meaning but presumptuous. Opposite Bar-clays Bank, the former Market Hall. On the ground floor three arches on Tuscan columns, no doubt originally open. Here ST MARY STREET branches off, in which on the r. the TRUSTEE SAVINGS BANK, dated 1846. It is ashlar-faced to

establish trustworthiness, and Grecian – a safe style. Then a
bend to the N, towards the churchyard, and the POST OFFICE,
formerly a Methodist chapel. This is of 1810 and has a three-
bay front with a doorway with Tuscan pilasters, and a depth
of five arched windows. Above the doorway a plainly detailed
Venetian window and a one-bay pediment. Nearer the
churchyard ST MARY'S HOUSE, five-bay brick, two and a
half storeys high with a one-bay pediment.

Back to the High Street. At its end Green End turns l., Water-
gate Street r. Along GREEN END to the r. at once Messrs
W. H. Smith's premises, to which applies what has been said
about the National Provincial Bank. Then to the l. the
WHITCHURCH INSTITUTE, nice restrained stuccoed front of
c. 1850, and next to it a slightly recessed three-bay house of
c. 1700 with a semicircular hood over the doorway. Towards
the end of Green End, outside the old centre and close to the
modern by-pass ring, bigger Georgian houses, especially
TALBOT HOUSE and HUGHES'S HOTEL. The hotel is of
three bays and two and a half storeys with one-bay, one-
storeyed wings. From the end of Green End one can turn l.
down Brownlow Street to the former WORKHOUSE (now
Deermoss Hospital), a large symmetrically-planned group of
red-brick buildings, largely of c. 1840. Or one can go on for a
moment into TALBOT STREET with typical Early Victorian
terraces of brick cottages, two storeys high and two bays wide.
Or one can go half r. to see in Station Road a terrace of
tumble-down timber-framed cottages, also of two storeys
only. Finally one can turn r. and join up with Dodington.

Dodington, the best street in Whitchurch, is reached by
WATERGATE STREET from the High Street. At the very
junction of High Street and Watergate a brick house on the
S side with a stuccoed ground floor of c. 1840 or so, including
a handsome pedimented shop-front. Then soon DODINGTON.
Again the same pattern. At first timber-framed houses such
as Nos 10 and on the other side 7, then the CONGREGA-
TIONAL CHURCH of 1846, debased-classical, of three bays,
with big pediment and porch with Tuscan columns *in antis*,
then No. 19, a symmetrical gabled C18 front with a recessed
centre and a Tuscan porch, but hiding older timber-framing
in its r. half. Next to this the MANSION HOUSE, the most
ambitious private house at Whitchurch: five bays, two and a
half storeys, quoins, one-bay pediment, doorway with pedi-
ment on brackets, centre window on the second floor with an

enriched surround. Opposite a range of modest almshouses of
1829, one-storeyed, in the Tudor style. Near the end of
Dodington looser building. CHERWELL HOUSE has three
bays with a one-bay pediment, and DODINGTON LODGE a
pretty porch with attenuated Greek Doric columns.

About 1 mile further out DEARNFORD HALL, quite an interest-
ing building, no doubt of c. 1840, in a very restrained classical
style, almost reminiscent of the William and Mary, but much
heavier. The style is more familiar from Court Houses and
such like official buildings. It is rare in private houses. Brick,
seven bays, two storeys, hipped roof.

(HINTON HALL, 1 m. N. By *S. Pountney Smith*.)

8000
WHITELADIES
1 m. SW of Boscobel House

Ruins of a nunnery, probably Augustinian. Late Norman. Nave
without aisle, transepts without chapels (?), and square-
headed chancel. In the chancel N wall broad buttresses and
two complete windows. In the nave N wall three windows
complete. No W doorway, but windows high up. N transept
arch with responds with four shafts. The capitals partly with
leaf, partly of the characteristic trumpet type. The arch has
one step and one slight chamfer. Hood-mould above. In the
nave S wall a simple doorway near the W end. One order of
shafts outside with decorated scallop capitals. Opposite a
more interesting N doorway. This also has one order of shafts,
but the arch has a lobed frieze around, familiar from the W of
France (Le Puy etc: *arc polylobé*), where it is derived from
Mohammedan architecture.

4000
WHITLEY
¼ m. ESE of Great Hanwood

The house is dated 1667. Tall, somewhat gaunt red-brick house
with altered windows. Brick friezes with the bricks set so as to
project in a zigzag. Staircase inside with sturdy newel-posts
(diamond and oval-studded) and square, heavily profiled
balusters.

3030
WHITTINGTON

ST JOHN BAPTIST. Red brick. W tower of 1747. C18 work is
still recognizable in the upper parts. Nave of 1804 (by *Harrison*

of Chester). The E pediment of the nave and the parts of the W pediment visible l. and r. of the tower, and also the basic arched shape of the windows, can still be seen. But *Eustace Frere*, who improved the church in 1894, obliterated as much as he could by more decorative means. He gave the tower its heavier doorway with alternating rustication, and the window above columns, and he made the nave and chancel windows Venetian Quattrocento by means of tracery. – STAINED GLASS. E window by *F. C. Eden* 1934.

CASTLE. Compared with the original size of the castle, what remains is little. Yet the Gatehouse with the two big circular towers and the broad archway (arch with one chamfer and one roll) is impressive enough. It dates from the time of Fulke Fitz Warine, who obtained licence in the fifth year of Henry III. Apart from the gatehouse there is now only one more round tower standing, to the l., and separated from the gatehouse by a ditch. In 1760 there were still four towers. The keep stood on a mound, 30 ft high and 150 by 100 ft in diameter on the summit. There were in addition three platforms and a whole system of ditches to the S and W. The N and E sides were defended by bog.

WHITTON 5070

ST MARY. Norman nave and chancel, 1891 extension of the chancel (by *Sir Aston Webb*), short C14 W tower. Norman windows and plain S doorway in the nave, blocked N doorway C14. – E window with STAINED GLASS by *William Morris* (and *Burne-Jones*), three large figures above, three small square scenes below, the colour of the rich and pure character typical of later Morris work. Said to date from 1893. Another window by *Morris & Co. c.* 1911.

WHITTON COURT. A house both very interesting and eminently attractive. The S front of Tudor brick is partly a refacing of a stone hall of the C14 (see the doorway with ogee head and two quarter-mouldings) with C15 windows (see the N side). The windows are of two ogee-headed lights straight-headed, and in two tiers; so the hall must already then have been one-storeyed. The Tudor work was added to in 1621 (date on a S gable) and altered again in 1682 (date inside the Hall). As it now is, the house has an E-shaped S front with three plain gables with finials. Bay-windows at the ends. The porch not symmetrically placed, owing to the

medieval conditions. It is embattled. So are the bay-windows. Mullioned and transomed windows with straight moulded hoods. Tudor brickwork at the back of the house too, and one older stone arch. The house now encloses a small courtyard. Facing this the w range is of fine gabled black-and-white work with lozenges within lozenges and cusped concave lozenges. Inside the house much C17 panelling. In the Hall big screen with square, deeply moulded C16 panelling. Also good ornamental fresco painting dated 1682, and an C18 hunting scene in fresco over the fireplace. Above the hall the solar with plasterwork of *c.* 1682 applied to the beams. The staircase also is an addition.

WHITTON HALL
1½ m. w of Westbury

3000

Early Georgian house of red brick. The only guidance on the date is the fact recorded by Forrest that in the garden wall re-set stones exist with dates 1727, 1731, etc. Three-bay centre and gabled two-bay wings. In the middle of the centre, doorway with pediment and top pediment on odd corbels. Independent service wings at r. angles to the l. and r., that on the r. structurally older than the house, that on the l. with a weathervane dated 1756. Small but very pretty staircase with three slim balusters to each tread, one turned, one fluted, one spiral. – Circular DOVECOTE. – Also a FOLLY on the hill opposite; now derelict.

WHIXALL

3030

ST MARY. By *G. E. Street*, 1867. Not specially interesting. Red brick with slate roof. Nave with N aisle, and chancel; lead-covered belfry at the E end of the nave. Geometrical tracery in stone. Inside the brick is exposed. Trussed rafter roof, boarded in the chancel.

BOSTOCK HALL. Small C17 brick house with slightly recessed centre, gables, and quoins. In one room a ceiling with two modest strapwork motifs in plaster.

WILDERHOPE MANOR
2 m. sw of Easthope

3090

Late C16 manor house of stone, lying entirely on its own. Front with four gables. No regular pattern. The second gable above

the porch, the third above the broad bay-window of the hall, the fourth above the parlour window. The hall has always been single-storeyed with the Great Chamber above. The hall-bay is six lights wide and projects by three lights. Two transoms, as also in the five-light parlour window. The upper-floor windows have one transom only. At the back of the house a projecting semicircular stair turret with conical roof. Inside several plaster ceilings; that of the parlour most elaborate with thin ribs forming star patterns. The other ceilings, including that of the hall, have only centre-pieces. The plasterers are the same that worked at Morville and Upton Cressett.

WILLEY 6090

WILLEY HALL. Built by *Lewis Wyatt*, 1812–15, or according to the *Dictionary of Architecture* in 1821, and in any case before 1825, the date of publication of the volume of Neale's *Seats* in which it is illustrated. Wyatt's drawings, preserved at the house, are dated 1812 and 1813. A very elegant design, and superbly placed. The entrance side is nine bays wide and two storeys high, rendered. Giant portico of four Corinthian columns carrying a pediment. Very excellently carved garlands and cornucopias in the frieze. To the r., that is on the SW side, a big central bow with detached giant columns around. One bay only to the l., one to the r. At the back the centre on the ground floor is the flat glazed expanse of the five-bay conservatory, with slim pilasters. The plan of the house is clear in its main axis and astonishingly grand. Very bare Entrance Hall with an apse l. and r. Then at once the powerful effect of the large Hall. This has two widely spaced 63a giant columns of yellow marble on the l., and two on the r., and at the far end a screen of two pairs of columns arranged in depth to separate it from the Staircase. The columns carry a gallery with brass and bronze railing. The hall has a spendidly wide shallow tunnel-vault with bold diagonal coffering, and the panels of the coffering are left out in the three centre bays so as to reveal an oblong glazed lantern above. All this is on a grander scale than the description, or indeed a view of the exterior, would make one expect. The staircase is no less original and successful. To the l. and r. two arms rise in a curve below coffered semi-domes and meet on the first floor where a bridge connects them with the gallery above the Hall. Shallow oval dome over this centre. The centre of the SW

front, leading off from the middle of the Hall, is the Library, apsed at both ends and with a fine honeysuckle frieze. The design establishes Lewis Wyatt, who was born in 1778, as one of the most ingenious creators of processional spaces in England. The decoration is equally remarkable and somewhat puzzling. The idea of the glazed lantern above the diagonal coffering is much more like what was introduced in the works of Benjamin Dean Wyatt, a cousin of Lewis, between 1825 and 1827 (Apsley House, York House, Londonderry House, Crockford's Club) than like designs of 1812–20. Exquisite stucco details, especially the frieze of the Hall and four large plaques illustrating hunting, shooting, fishing, and racing.

Equally superb the decoration of the other principal rooms. Original silk hangings, original window draperies, original wallpaper (in one room with small sparsely placed flowers), original gilt chandeliers, etc. Much of this again looks more 1830 than 1815. Much variety in the composition of the plaster ceilings.

Willey Hall replaces OLD HALL further E, of which no more than two ranges of a stable-yard remain, stone with gables and mullioned windows. Close to the old hall lies the church.

(In SHIRLETT HIGH PARK, I m. s, MONUMENT to a Retriever who fell down a coal-shaft.)

ST JOHN. C18 W tower with arched windows and battlements. Norman nave and chancel, see the few remaining windows. Aisles and family chapel 1880 by *Sir A. Blomfield*. – Some Jacobean WOODWORK. – STAINED GLASS. E window with large figures of no distinction, yet signed *Morris & Co*. It is of as late a date as 1933. That explains it. – MONUMENTS. George Weld and others, *c*. 1730. Signed by *R. Eykyn* (of Wolverhampton). – Second Lord Forester † 1874, relief of the three Maries at the Sepulchre, by *Boehm*.

WISTANSTOW

HOLY TRINITY. Cruciform church of *c*. 1200. The upper part of the tower probably of 1712. The dating of the church is not easy. The N transept W and E windows are small and straight-headed but round-arched inside and must really be Norman. The other oldest original windows are equally small but pointed. Perhaps the walls of the N transept went up first. The only piece of more ambitious display is the s chancel doorway, which must be re-set. One order of shafts, the

capitals one with a beast's head, the other with upright leaves; hood-mould with dog-tooth on two heads. An odd detail is the way in which both the nave doorways, N and S (N blocked), cut into lancets. The original doorway must therefore have been at the W end, probably the one now in the chancel. But the jambs of the large W lancet are also original according to Dean Cranage. Some late C13 and early C14 windows. Plain double-chamfered crossing arches. The nave roof, with collar-beams, arched braces, and four tiers of quatrefoil wind-braces, is of 1630. The plain trussed rafter roof of the N transept on the other hand Dean Cranage dates c. 1200. – PAINTINGS. Inscriptions in ornamental frames in the S transept, probably mid-C17 (cf. Stokesay).

WITHINGTON

5010

ST JOHN BAPTIST. By *G. E. Street* 1874. Nave and chancel of rock-faced red sandstone. Windows and plate tracery also of red sandstone. W tower with a short broach spire almost like a steep pyramid roof. The REREDOS with a relief of the Crucifixion is designed as part of the E wall. The low STONE SCREEN and the PULPIT also belong to the architect's design. – BRASSES. Nave S wall John Onley † 1512 and wife (1 ft 10 in. figures). – Chancel N wall. Master Adam Grafton † 1530 (2 ft 6 in. figure). The inscription calls him 'the most worshipful prest lyvying in his days'.

WOLLASTON

3010

ST JOHN. Built in 1788. From that date the structure with quoins and the civilized moulding of the cornice. The restoration of 1885 chose to put in windows with so-called Venetian tracery.

WOLLERTON
1 m. NE of Hodnet

6020

OLD HALL. Black-and-white house with end gable on over-hang; corner brackets.

WOODCOTE

7010

WOODCOTE HALL. 1875 by *F. P. Cockerell*. A characteristic Late Victorian mixture of Blickling with Gibbs surrounds, i.e.

Jacobean with Georgian motifs. Brick with stone dressings, lively skyline (with ogee-capped turrets); lively surface patterns.

CHAPEL. Nave and chancel; red sandstone. The upper part of the W gable and the lantern restoration. Late C12. S doorway with two orders of shafts with shaft-rings (cf. Shifnal); crocket capitals. Arch with one keeled order. Later windows. – MONUMENT. Incised slab, probably to Humphry Cotes † 1485, and wife.

3020

WOODHOUSE
2¾ m. SE of Whittington

An interesting brick house of 1773–4. By *Robert Mylne*.* The entrance is a very curious and original composition. Stone Ionic pilasters at the angles and the angles of the centre. This centre is recessed and two giant Ionic columns are set in flush with the rest of the façade. Two more Ionic columns are set in front of these so as to produce the effect of a porch. The S side has a large bow-window with Ionic columns standing around it. Entrance Hall with a screen of two Ionic columns at the end and a staircase behind which starts in one arm and returns in two. The whole of this is a fine spatial effect.

4090

WOOLSTASTON

ST MICHAEL. Nave and chancel, and very Victorian bell-turret with pointed broach spirelet. Restoration 1864–6. Original C13 lancet windows in chancel and nave. C13 S doorway, single-chamfered and pointed. – FONT. Apparently two C12 fonts set one inside the other. – WOODWORK. Much heavily carved woodwork of the 1860s by *William Hill*, a local carpenter.

WOOLSTASTON HALL. Late C17. Brick, with stone dressings. Hipped roof. The present building is only one wing of a much larger, originally H-shaped mansion. The front now is of seven bays and two storeys. The doorway with its odd pilasters on which garlands hang down and its straight hood rising in a gable is very probably the work of the stone-carver of Minsterley church.

* Date and name were found out by Mr C. Gotch.

WOOLSTON

3020

1½ m. NW of Knockin

ST WINIFRED'S WELL. One of the most moving of the holy
wells in England. It commemorates the miracle of a well
gushing forth in the place where the body of St Winifred
rested on the way from Holywell to Holy Cross Shrewsbury.
A timber-framed cottage against the hillside on a stone plinth
and with a square projecting gabled porch – that is the first
impression. But below the porch the well emerges, and so the
stone substructure here, the height of a full low storey, owing
to the fall of the site, is open to the front. The l. and r. walls
are of greenish stone. There is a tiny side entrance into this
inner chamber. In front of it an open basin with a stone floor,
oblong with steps leading down to it from the l. and r. The
water from here runs through a hole in a low wall into a
lower oblong basin with a stone floor, and with fewer steps into
it, and from there through another low wall with a hole it runs
away and forms a little stream. The faithful bathed in the
basins.

WOORE

7040

ST LEONARD. 1830, by *G. E. Hamilton* (GR). Small and a little
disjointed, but quite individual. Stucco with a little yellow
stone trim. W front in three bays, with pilasters with sunk
panels. In the side bays semicircular windows. Above the
doorway a piece of balustrading, and behind that the square
W tower. Nave with five arched windows on either side.
Chancel rebuilt in 1887.

Opposite the SWAN HOTEL, of about the same time – three bays,
with a Tuscan porch.

WORFIELD

7090

ST PETER. The church looks very handsome from a distance,
with its elegant recessed grey spire on its red tower. As one
gets near, it becomes however disappointingly clear that
restorers (*F. & H. Francis* 1861–2) have made nearly all the
external details look desperately new. It is a large church with
nave and aisles, and its tower is placed surprisingly at the SW
end. The detail is mostly a sumptuous Dec, with, as its domi-
nant motif, a quatrefoil placed diagonally and with spikes
coming out between the lobes. This occurs in trustworthy

condition in the N aisle on the N and E sides. It also occurs in the nave W window. Motifs of the same mid-C14 date in the chancel. There are a few indications of an earlier date, but they are somewhat puzzling, and the places where they are to be found have not even been explained by Dean Cranage. There is a tiny window of two pointed lights in the S wall between tower and porch, and in the N wall of the tower, facing into the nave, is an aumbry next to something that looks like a double piscina but has no drain. Dean Cranage attributes the tower to the late C14, but the lower part of its N wall to the C13, and these motifs confirm such a date. But they do not fit into any comprehensible shape of a C13 church. Dean Cranage then suggests a late C13 (or should one rather say early C14?) date for the chancel and the last bay of the nave arcade, which represents a former transept; see the chancel arch with some ball-flower decoration and the corresponding nave responds. But what is the decidedly Norman nook-shaft doing above this respond? Dean Cranage has no answer. That there were transepts at that time, however, is amply proved by him. Only thus can the curious state of the aisle arcades be explained. They were erected about the middle of the C14, i.e. at the time when so much was done to the windows, and their E bay shows an irregularity clearly caused by pre-existing transepts. The arcades are not identical, but very similar: octagonal piers, arches with two quadrant-mouldings, hood-moulds with plenty of head-stops. There is yet another puzzle to be mentioned, a large cusped single lancet window now inside the church S from the nave just E of the tower. It probably belongs to a former aisleless nave. But how far does it connect with the outer small C13 window? The only possible answer seems to be that the latter was re-set when the tower was built.

FURNISHINGS. FONT. Perp, with blank panelling and quatrefoils. – SCREEN. Partly original, Perp, with two-light divisions. – STAINED GLASS. E window 1846, with C14 fragments. – MONUMENTS. Sir George Bromley † 1588 and wife. Alabaster, of good quality. Two recumbent figures, she behind and a little above him. Shallow back arch between two columns with pretty arabesque decoration, nice ribbonwork in the spandrels, achievement and two obelisks on top. – Opposite, Sir Edward Bromley † 1626 and wife, a heavy six-poster with recumbent effigies, and strapwork cartouches on the base. Also alabaster.

LOWER HOUSE. A delightful timber-framed building of two ranges, in line with one another. The part further back is earlier. At the junction a turret. The front rendered and sashed in the C18. Three gables, the middle one lower than the others. Five bays, two storeys, and the gables. Only here the window frames show the former horizontal shape of the windows. Behind the lower gable a circular window. All this indicates a later C17 date. Diagonally placed chimneystacks.

Lately much council housing has gone on at Worfield, and there is some danger that it may spoil the visual integrity of the village.

DAVENPORT HOUSE, see p. 118.

CHESTERTON FARM, see p. 96.

EWDNESS MANOR HOUSE, 2¼ m. NW. Good symmetrical red stone house with two projecting gabled wings. C17. Mullioned and mullioned and transomed windows. Big end chimneys with star-shaped stacks.

SWANCOTE FARM, 1½ m. SW. Late C18 brick house with widely spaced windows, two and a half storeys high. The ground-floor windows are tripartite. To the l. a square summer house with dovecote over and pyramid roof.

WORTHEN

3000

ALL SAINTS. Strong, rough N tower, below of the late C12 (see the doorway), above Perp, and with an C18 parapet. E.E. nave with windows evidently dating from the restoration of the church. Original S doorway with fine continuous mouldings. Fine, spacious interior. Brick chancel of 1761 with plain arched windows. Handsome C17 S porch with balustraded sides. – Jacobean WOODWORK. Chancel-pews, door and panelling of the vestry entrance, and especially the BENCHES. These are a very complete set, most interesting and engaging the ones with open backs – just a rail – and bulbous finials. The type is still entirely medieval, and Dean Cranage has suggested that they may indeed be medieval and reconstructed in the early C17. – MONUMENT. Dr Daniel Price † 1633. Two columns and much strapwork; no figures.

HAMPTON HALL, see p. 138.

WOUNDALE FARM see CLAVERLEY

6000

WREKIN

IRON AGE HILL FORT. Begun about 200 B.C., it originally possessed a double rampart and ditch. A series of outworks were added later. Its architectural evolution and history run parallel to those of Old Oswestry.

6010
Inset A

WROCKWARDINE

ST PETER. Nave and chancel, transepts and crossing tower. Also two chancel chapels. Norman evidence in the nave: masonry and blocked N and S doorways. Most of the church is of the late C12 to early C13. Chancel with one surviving lancet window, S transept with a blocked S doorway which has two fat continuous quarter-rolls. N transept with N doorway which has one order of shafts and trumpet and leaf capitals, and crossing with strong crossing piers of oddly indecisive shapes. The capitals of the shafts are clearly Late Norman, two with curious very narrow fluting. The crossing tower has lancet windows below. The upper parts of the tower are Dec. Embattled top and pyramid roof behind. Whether the remarkable strainer half-arches or flying buttresses built into the walls are a repair of the C14 or were there from the beginning, it is not easy to say. Even more puzzling are two blocked arches of different size and design in the W walls of the transepts. They look as if they had been intended to lead to aisles of a wider nave. This view would presuppose an intention to rebuild the nave very shortly after it had first been built. Dec additions the reticulated E window and the N chapel with Dec E window and double-chamfered arches with continuous mouldings to S and W. Perp windows in the transept ends, and small Perp S chapel. The nave W window is C19. – PULPIT. Jacobean. – STAINED GLASS. N Chapel by O'Connor 1861 (signed). – Several early windows by Kempe (Chancel E 1887, N Transept N 1887, S Transept S 1902). – Good R. D. Newill memorial window, 1906, designed in the style of English book-art of about 1900, signed by Mary Newill. – MONUMENT. Fine large Rococo tablet to William Chudde † 1765 (cf. Cound, Fowler Monument).

WROCKWARDINE HALL, to the NE. Two-storeyed house, the r. half of 1628 (date on the chimneystack) the l. half Georgian. The Georgian front is of seven bays with hipped roof. Door-

way with segmental pediment on fluted pilasters. (Two stair-
cases inside, one with turned balusters of 1628, the other,
more ambitious one, Georgian.)

WROCKWARDINE WOOD
1 m. N of Oakengates

7010
Inset A

HOLY TRINITY. 1833 by *Samuel Smith* of Madeley. Red
brick, with arched windows, nicely set out with thin pilasters
inside, and a small W tower with parapet and obelisks. Flat
ceiling. W Gallery. The apse is a later addition, and the
Transitional chancel arch in this setting a curious aberration.
Yet Dean Cranage calls it 'good'.

WROXETER

5000

ST ANDREW. Nave and chancel and W tower. Part of the N
wall is Anglo-Saxon. The stones are Roman. Norman chancel
of fine proportions; two windows survive on the S side, two
on the N (see inside). Also a small Norman window in the E
gable. On the S side of the chancel also a blocked doorway
with one order of shafts and zigzag on the hood-mould which
rests on big round volutes and is carried on as a slightly
decorated string-course. To the inside also a hood-mould
with a kind of enriched dog-tooth ornament. The chancel
arch seems a little later. It is pointed, and the responds have
stiff-leaf as well as trumpet capitals. The tower must be con-
temporary with the chancel. The masonry of the lower stage
is clearly Norman, and the tower arch towards the nave has
polygonal responds with leaf capitals. The arch is pointed.
The present nave is not in line with tower arch and chancel
arch. Clearly a S arcade has at some stage been taken out. Later
medieval contributions are a Dec recess in the chancel N wall,
pointed-trefoiled with ball-flower decoration, the tower top,
with battlements and a quatrefoil frieze below them, the tower
W window, and the chancel E window (Late Perp). The S aisle
still existed in 1709. The S wall was rebuilt in the C18, when
the aisle was abolished. The porch is Victorian.
 FONT. Round; of huge girth; probably the base of a Roman
column. – PULPIT. Jacobean. – BOX PEWS. Jacobean. – COM-
MUNION RAIL. 1637. – CHEST. Of the C13, with contemporary
ironwork. – STAINED GLASS. The E window with the twelve
Apostles and two stories, probably by *Evans*. – SCULPTURE.
In the S wall of the nave high up and placed horizontally part

of an Anglo-Saxon CROSS SHAFT with foliage scrolls,
interlace and a dragon, probably C9. To the l. and r. two small
panels with a beast and a bird. What is their context?

MONUMENTS. In the chancel four major monuments: Lord
35a Chief Justice Bromley † 1555 and wife. An outstandingly
good alabaster piece with recumbent effigies. On the front of
the tomb-chest three panels divided by strips with candelabra
decoration. In the middle panel stands a young woman; in the
side panels shields surrounded by scrolls (NW). – Sir Richard
Newport † 1570 and his wife, daughter of the Lord Chief
Justice. Two recumbent alabaster effigies. Against the tomb-
chest a chain of mourners holding shields between each pair.
Square spiral-fluted angle piers. Probably of the school of
Burton-on-Trent (SW). – John Barber and his wife who died
in 1618. The recumbent effigies similar to the previous.
Tomb-chest with Tuscan columns and two big panels with
shields in strapwork surrounds (NE). – Francis Newport, Earl
of Bradford, † 1708. Marble. No figures except two mourning
putti kneeling l. and r. of a reredos background, with an arch
on pilasters and a large urn inside.

VIROCONIUM (Wroxeter) was the capital of the Roman pro-
vince called Britannia Secunda. In its prime, it was the fourth
largest city in these islands, and its defences enclosed an
area of 180 acres, as against Roman London with 325 acres.
Its ruins still possess the ability to move and impress the
imaginative spectator, much as they impressed A. E. Housman
when he visited them during the course of an early series of
excavations. His experiences prompted him to write the cele-
brated poem about the fate of Uricon which appears in his
Shropshire Lad.

On the E or l. side of the secondary road that bisects the site an
area of approximately 370 by 220 ft has been uncovered for
public inspection. This area consists of a section of the C2
Baths, and includes the high portion of wall known as the
4 'Old Work of Wroxeter', comprising the wall itself with four
massive buttresses with shallow niches between that may once
have held statues or altars. The foundation of the 'Old Work',
which formed part of a large four-roomed building of un-
known purpose, is nearly 7 ft thick. The precise function of
the individual rooms of the Baths which now lie open to
inspection can only be guessed at; but it seems likely that
certain of them can be identified as undressing rooms (*apody-
teria*), warm rooms (*tepidaria*), hot rooms (*calidaria*), and

probably a sweat room (*sudatorium*) and a cold bath (*frigidarium*). There are also the more readily identifiable remains of furnaces and hypocausts. One of the hypocausts was the scene of a pathetic discovery. Somewhere about the year A.D. 370 an old man and two women had crept into it to die, presumably in an attempt to conceal themselves during the course of a barbarian raid.

On the w or r. side of the secondary road can be seen a wide and deep slot in the surface of the earth, into which one can descend by means of a flight of stone steps. At the bottom of the slot stand the bases of sixteen carved stone pillars, connected by a course of huge square blocks hewn from the same grey stone. This row of shattered pillars is all that now testifies to the existence of a magnificent colonnaded portico, erected to give dignity to the w entrance to the City Forum. Over the portico once stood the superb tablet of A.D. 129–30 which commemorated the dedication of the colonnade to the Emperor Hadrian. The tablet consist of five lines of magnificently-cut inscription: IMP. CAES. DIVI TRAIANI PARTHI / CI FIL. DIVI NERVAE NEPOTI TRA / IANO HADRIANO AVG. PONTIFI / CI MAXIMO TRIB. POT. XIIII COS. III P.P. / CIVITAS CORNOVIORUM. It is in the Victoria and Albert Museum in London.

After Viroconium had been founded in modest circumstances about A.D. 60, work was started on a Basilica, Forum, and public Baths, all of regal proportions, about the year A.D. 90, only to be discontinued at the end of a single decade. None of this first set of ambitious civic buildings was ever finished, although the Baths (situated beneath the colonnaded portico referred to above) actually reached roof level. About A.D. 100 the civic enthusiasm of the Cornovii appears to have flagged; or there may have been a recrudescence of border-warfare that forced them to divert their energies to their military defences.

The visit to Britain of the vigorous and far-sighted Emperor Hadrian in A.D. 121 or 122 was the signal for a general outburst of activity throughout the length and breadth of these islands. The citizens of Viroconium were not slow to share in the prevailing spirit of optimism and endeavour. They laid out a completely new set of public buildings and rapidly erected them, and also strengthened and extended their defences. The prosperity of the Hadrianic settlement and the Antonine period which followed is attested at Viroconium by

the fact that, when the Forum and Basilica were accidentally
burned down about A.D. 155, they were immediately rebuilt
on an even more grandiose scale.

Between the coming of Hadrian and about the year A.D. 250 the
townsfolk of Viroconium waxed rich. Professor Ian Richmond
describes it as it was in its heyday,* and speaks of 'the planned
street-system, dividing at least 180 acres into spacious
rectangular building-blocks, many of which were occupied by
the large residences of tribal magnates. The spectacle was
somewhat like the English county town of the eighteenth
century, wherein important local landowners had their town-
houses, used periodically when their duties as councillors or
justices required a stay in town or when the family came in for
a season of entertainment.'

In the middle of the C3 A.D. the picture changed. For Viro-
conium, as for its companion cities, a process of demoraliza-
tion set in and swiftly gathered momentum. The government
of the Empire was increasingly losing stability and firm
direction from the centre, and in A.D. 287 the province of
Britain was temporarily sundered from the Continent by the
revolt of a soldier-of-fortune called Carausius. More, the
barbarians – Saxons, Franks, Picts, and the Scotti of Ireland –
were quick to take advantage of the administrative disruption
of these islands and began to make significant inroads into
Britain by land and sea. It was about the time of the mutiny
of Carausius that the Forum and Basilica of Viroconium were
burned down for the second time, and it is a measure of the
paralysis that was creeping over the countryside at large that
the citizens lacked the heart to rebuild them. True, the Baths,
which had been damaged in the same conflagration, were
patched up to some extent and continued in use for a further
century; but the town's good times were over, and the
remainder of the story is a melancholy chronicle of decay.

By the end of the C4 A.D. the town had degenerated to a shocking
degree, and we may suppose that after the Emperor Honorius
issued his rescript in A.D. 410, ordering the Legions to with-
draw from Britain and advising the urban population to fend
for itself, Viroconium was speedily abandoned. When sound
government was once more established, under the Anglo-
Saxons, Shrewsbury was designated as the head of local
affairs. Viroconium, left desolate, served merely as a con-
venient stone-quarry for its thriving neighbour.

* *Roman Britain*, Penguin Books (1955), p. 75.

WYCHERLEY HALL *see* COCKSHUTT

YEATON PEVERY

1¾ m. SE of Baschurch

4010

Built in 1890–2 by *Aston Webb*. Red sandstone. The entrance side is an astonishing Jacobean fantasy, much less thoughtful and truly original than Norman Shaw. The façade, in spite of the walled garden with its two domed summer-houses in the corners (à la Montacute), shuns all the symmetry and logicality of the major Elizabethan and Jacobean houses. Entrance tower with asymmetrically placed and detailed much higher turret, big mullioned and transomed windows not matching each other. The garden side has two symmetrical gables, but between them the upper floor is half-timbering. It rests on a stone ground floor with three bay-windows, the middle one suddenly provided with Gothic cusping. No interior of special distinction.

YOCKLETON

3010

HOLY TRINITY. 1861 by *Edward Haycock Jun.* Thoroughly High Victorian, with the tower rather thin at the SW corner, the use of stone of three different colours, and the demonstratively uncouth dormer-windows in the spire.

GLOSSARY

Abacus: flat slab on the top of a capital (q.v.).

ABUTMENT: solid masonry placed to resist the lateral pressure of a vault.

ACANTHUS: plant with thick fleshy and scalloped leaves used as part of the decoration of a Corinthian capital (q.v.) and in some types of leaf carving.

ACHIEVEMENT OF ARMS: in heraldry, a complete display of armorial bearings.

ACROTERION: foliage-carved block on the end or top of a classical pediment (q.v.).

ADDORSED: two human figures, animals, or birds, etc., placed symmetrically so that they turn their backs to each other.

AEDICULE, AEDICULA: framing of a window or door by columns and a pediment (q.v.).

AFFRONTED: two human figures, animals, or birds, etc., placed symmetrically so that they face each other.

AGGER: Latin term for the built-up foundations of Roman roads; also sometimes applied to the banks of hill-forts or other earthworks.

AMBULATORY: semicircular or polygonal aisle enclosing an apse (q.v.).

ANNULET: see Shaft-ring.

ANSE DE PANIER: see Arch, Basket.

ANTEPENDIUM: covering of the front of an altar, usually by textiles or metalwork.

ANTIS, IN: see Portico.

APSE: vaulted semicircular or polygonal end of a chancel or a chapel.

ARABESQUE: light and fanciful surface decoration using combinations of flowing lines, tendrils, etc., interspersed with vases, animals, etc.

ARCADE: range of arches supported on piers or columns, free-standing: or, BLIND ARCADE, the same attached to a wall.

ARCH: round-headed, i.e. semicircular; pointed, i.e. consisting of two curves, each drawn from one centre, and meeting in a point at the top; segmental, i.e. in the form of a segment; pointed; four-centred (a late medieval form), see Fig. 1(a);

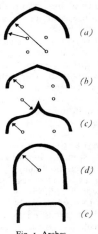

Fig. 1. Arches

Tudor (also a late medieval form), see Fig. 1(*b*); Ogee (introduced *c.* 1300 and specially popular in the C14), see Fig. 1(*c*); Stilted, see Fig. 1(*d*); Basket, with lintel connected to the jambs by concave quadrant curves, see Fig. 1(*e*) for one example; Diaphragm, a transverse arch with solid spandrels carrying not a vault but a principal beam of a timber roof. *See also* Strainer Arch.

ARCHITRAVE: lowest of the three main parts of the entablature (q.v.) of an order (q.v.) (see Fig. 12).

ARCHIVOLT: a continuous moulding on the face of an arch and following its contour.

ARRIS: sharp edge at the meeting of two surfaces.

ASHLAR: masonry of large blocks wrought to even faces and square edges.

ATLANTES: male counterparts of caryatids (q.v.).

ATRIUM: inner court of a Roman house, also open court in front of a church.

ATTACHED: *see* Engaged.

ATTIC: topmost storey of a house, if distance from floor to ceiling is less than in the others.

AUMBRY: recess or cupboard to hold sacred vessels for Mass and Communion.

BAILEY: open space or court of a stone-built castle; *see also* Motte-and-Bailey.

BALDACCHINO: canopy supported on columns.

BALLFLOWER: globular flower of three petals enclosing a small ball. A decoration used in the first quarter of the C14.

BALUSTER: small pillar or column of fanciful outline.

BALUSTRADE: series of balusters supporting a handrail or coping (q.v.).

BARBICAN: outwork defending the entrance to a castle.

BARGEBOARDS: projecting decorated boards placed against the incline of the gable of a building and hiding the horizontal roof timbers.

BARREL-VAULT: *see* Vault.

BARROW: *see* Bell, Bowl, Disc, Long, *and* Pond Barrow.

BASILICA: in medieval architecture an aisled church with a clerestory.

BASKET ARCH: *see* Arch (Fig. 1*e*).

BASTION: projection at the angle of a fortification.

BATTER: inclined face of a wall.

BATTLEMENT: parapet with a series of indentations or embrasures with raised portions or merlons between. Also called Crenellation.

BAYS: internal compartments of a building; each divided from the other not by solid walls but by divisions only marked in the side walls (columns, pilasters, etc.) or the ceiling (beams, etc.). Also external divisions of a building by fenestration.

BAY-WINDOW: angular or curved projection of a house front with ample fenestration. If curved, also called bow-window: if on an upper floor only, also called oriel or oriel window.

BEAKER FOLK: Late New Stone Age warrior invaders from the Continent who buried their dead in round barrows and introduced the first metal tools and weapons to Britain.

BEAKHEAD: Norman ornamental motif consisting of a row of bird or beast heads with beaks biting usually into a roll moulding (q.v.).

BELFRY: turret on a roof to hang bells in.

BELGAE: aristocratic warrior bands who settled in Britain in two main waves in the CI B.C. In Britain their culture is termed Iron Age C.

BELL BARROW: Early Bronze Age round barrow in which the mound is separated from its encircling ditch by a flat platform or berm (q.v.).

BELLCOTE: framework on a roof to hang bells from.

BERM: level area separating ditch from bank on a hill-fort or barrow.

BILLET FRIEZE: Norman ornamental motif made up of short raised rectangles placed at regular intervals.

BIVALLATE: of a hill-fort: defended by two concentric banks and ditches.

BLIND ARCADE: see Arcade.

BLOCK CAPITAL: Romanesque capital cut from a cube by having the lower angles rounded off to the circular shaft below. Also called Cushion Capital (Fig. 2).

BOSS: knob or projection usually placed to cover the intersection of ribs in a vault.

BOWL BARROW: round barrow surrounded by a quarry ditch. Introduced in Late Neolithic times, the form continued until the Saxon period.

BOW-WINDOW: see Bay-Window.

BOX: small country house, e.g. a shooting box. A convenient term to describe a compact minor dwelling, e.g. a rectory.

BOX PEW: pew with a high wooden enclosure.

BRACES: see Roof.

BRACKET: small supporting piece of stone, etc., to carry a projecting horizontal.

BRESSUMER: beam in a timber-framed building to support the, usually projecting, superstructure.

BRICKWORK: *Header:* brick laid so that the end only appears on the face of the wall. *Stretcher:* brick laid so that the side only appears on the face of the wall. *English Bond:* method of laying bricks so that alternate courses or layers on the face of the wall are composed of headers or stretchers only (Fig. 3a). *Flemish Bond:* method of laying bricks so that alternate headers and

Fig. 2. Block capital

BOND, ENGLISH or FLEMISH: *see* Brickwork.

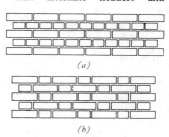

(a)

(b)

Fig. 3. Brickwork

stretchers appear in each course on the face of the wall (Fig. 3*b*). *See also* Herringbone Work, Oversailing Courses.

BROACH: *see* Spire.

BROKEN PEDIMENT: *see* Pediment.

BRONZE AGE: in Britain, the period from *c.* 1600 to 600 B.C.

BUCRANIUM: ox skull.

BUTTRESS: mass of brickwork or masonry projecting from or built against a wall to give additional strength. *Angle Buttresses:* two meeting at an angle of 90° at the angle of a building (Fig. 4*a*). *Clasping Buttress:* one which encases the angle (Fig. 4*d*). *Diagonal Buttress:* one placed against the right angle formed by two walls, and more or less equiangular with both (Fig. 4*b*). *Flying Buttress:* arch or half arch transmitting the thrust of a vault or roof from the upper part of a wall to an outer support or buttress. *Setback Buttress:* angle buttress set slightly back from the angle (Fig. 4*c*).

CABLE MOULDING: Norman moulding imitating a twisted cord.

CAIRN: a mound of stones usually covering a burial.

CAMBER: slight rise or upward curve of an otherwise horizontal structure.

CAMPANILE: isolated bell tower.

CANOPY: projection or hood over

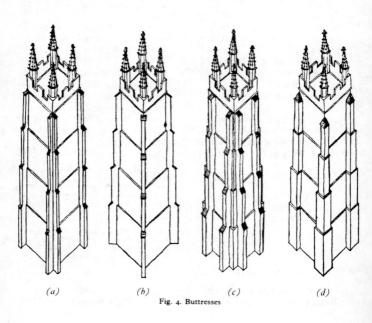

(a) *(b)* *(c)* *(d)*

Fig. 4. Buttresses

an altar, pulpit, niche, statue, etc.

CAP: in a windmill the crowning feature.

CAPITAL: head or top part of a column. *See also* Block Capital, Crocket Capital, Order, Scalloped Capital, Stiff-leaf, *and* Waterleaf.

CARTOUCHE: tablet with an ornate frame, usually enclosing an inscription.

CARYATID: whole female figure supporting an entablature or other similar member. *Termini Caryatids:* female busts or demi-figures or three-quarter figures supporting an entablature or other similar member and placed at the top of termini pilasters (q.v.). Cf. Atlantes.

CASTELLATED: decorated with battlements (q.v.).

CELURE: panelled and adorned part of a wagon roof above the rood or the altar.

CENSER: vessel for the burning of incense.

CENTERING: wooden framework used in arch and vault construction and removed when the mortar has set.

CHALICE: cup used in the Communion service or at Mass. *See also* Recusant Chalice.

CHAMBERED TOMB: burial mound of the New Stone Age having a stone-built chamber and entrance passage covered by an earthen barrow or stone cairn. The form was introduced to Britain from the Mediterranean.

CHAMFER: surface made by cutting across the square angle of a stone block, piece of wood, etc., usually at an angle of 45 to the other two surfaces.

CHANCEL: that part of the E end of a church in which the altar is placed, usually applied to the whole continuation of the nave E of the crossing.

CHANCEL ARCH: arch at the W end of the chancel.

CHANTRY CHAPEL: chapel attached to, or inside, a church, endowed for the saying of Masses for the soul of the founder or some other individual.

CHEVET: French term for the E end of a church (chancel, ambulatory, and radiating chapels).

CHEVRON: Norman moulding forming a zigzag.

CHOIR: that part of the church where divine service is sung.

CIBORIUM: a baldacchino (q.v.).

CINQUEFOIL: *see* Foil.

CIST: stone-lined or slab-built grave. First appears in Late Neolithic times. It continued to be used in the Early Christian period.

CLAPPER BRIDGE: bridge made of large slabs of stone, some built up to make rough piers and other longer ones laid on top to make the roadway.

CLASSIC: here used to mean the moment of highest achievement of a style.

CLASSICAL: here used as the term for Greek and Roman architecture and any subsequent styles inspired by it.

CLERESTORY: upper storey of the nave walls of a church, pierced by windows.

COADE STONE: artificial (cast) stone made in the late C18 and the early C19 by Coade and Sealy in London.

COB: walling material made of mixed clay and straw.

COFFERING: decorating a ceiling

with sunk square or polygonal ornamental panels.

COLLAR-BEAM: *see* Roof.

COLONNADE: range of columns.

COLONNETTE: small column.

COLUMNA ROSTRATA: column decorated with carved prows of ships to celebrate a naval victory.

COMPOSITE: *see* Order.

CONSOLE: bracket (q.v.) with a compound curved outline.

COPING: capping or covering to a wall.

CORBEL: block of stone projecting from a wall, supporting some feature on its horizontal top surface.

CORBEL TABLE: series of corbels, occurring just below the roof eaves externally or internally, often seen in Norman buildings.

CORINTHIAN: *see* Order.

CORNICE: in classical architecture the top section of the entablature (q.v.). Also the term for a projecting decorative feature along the top of a wall, arch, etc.

CORRIDOR VILLA: *see* Villa.

COUNTERSCARP BANK: small bank on the down-hill or outer side of a hill-fort ditch.

COURTYARD VILLA: *see* Villa.

COVE, COVING: concave undersurface in the nature of a hollow moulding but on a larger scale.

COVER PATEN: cover to a Communion cup, suitable for use as a paten or plate for the consecrated bread.

CRADLE ROOF: *see* Wagon Roof.

CRENELLATION: *see* Battlement.

CREST, CRESTING: ornamental finish along the top of a screen, etc.

CRINKLE-CRANKLE WALL: undulating wall.

CROCKET, CROCKETING: decorative features placed on the sloping sides of spires, pinnacles, gables, etc., in Gothic architecture, carved in various leaf shapes and placed at regular intervals.

CROCKET CAPITAL: *see* Fig. 5. An Early Gothic form.

Fig. 5. Crocket capital

CROMLECH: word of Celtic origin still occasionally used of single free-standing stones ascribed to the Neolithic or Bronze Age periods.

CROSSING: space at the intersection of nave, chancel, and transepts.

CROSS-VAULT: *see* Vault.

CROSS-WINDOWS: windows with one mullion and one transom.

CROWN-POST: *see* Roof (Fig. 15).

CRUCK: cruck construction is a method of timber framing by which the ridge beam is supported by pairs of curved timbers extending from floor to ridge.

CRYPT: underground room usually below the E end of a church.

CUPOLA: small polygonal or circular domed turret crowning a roof.

CURTAIN WALL: connecting wall between the towers of a castle. In C20 architecture, a non-load-bearing wall which can be applied in front of a framed structure to keep out the

weather; sections may include windows and the spans between.

CUSHION CAPITAL: *see* Block Capital.

CUSP: projecting point between the foils (q.v.) in a foiled Gothic arch.

DADO: decorative covering of the lower part of a wall.

DAGGER: tracery motif of the Dec style. It is a lancet shape rounded or pointed at the head, pointed at the foot, and cusped inside (Fig. 6).

Fig. 6. Dagger

DAIS: raised platform at one end of a room.

DEC ('DECORATED'): historical division of English Gothic architecture covering the period from *c.* 1290 to *c.* 1350.

DEMI-COLUMNS: columns half sunk into a wall.

DIAPER WORK: surface decoration composed of square or lozenge shapes.

DIAPHRAGM ARCH: *see* Arch.

DIOCLETIAN WINDOW: semicircular, with two mullions.

DISC BARROW: Bronze Age round barrow with inconspicuous central mound surrounded by bank and ditch.

DOGTOOTH: typical E.E. ornament consisting of a series of four-cornered stars placed diagonally and raised pyramidally (Fig. 7).

DOMICAL VAULT: *see* Vault.

DONJON: *see* Keep.

Fig. 7. Dogtooth

DORIC: *see* Order.

DORMER (WINDOW): window placed vertically in the sloping plane of a roof.

DRIPSTONE: *see* Hoodmould.

DRUM: circular or polygonal vertical wall of a dome or cupola.

DUTCH GABLE: *see* Gable.

E.E. ('EARLY ENGLISH'): historical division of English Gothic architecture roughly covering the C13.

EASTER SEPULCHRE: recess with tomb-chest (q.v.), usually in the wall of a chancel, the tomb-chest to receive an effigy of Christ for Easter celebrations.

EAVES: overhanging edge of a roof.

EAVES CORNICE: cornice below the eaves of a roof.

ECHINUS: convex or projecting moulding supporting the abacus of a Greek Doric capital, sometimes bearing an egg and dart pattern.

EMBATTLED: *see* Battlement.

EMBRASURE: small opening in the wall or parapet of a fortified building, usually splayed on the inside.

ENCAUSTIC TILES: earthenware glazed and decorated tiles used for paving.

ENGAGED COLUMNS: columns attached to, or partly sunk into, a wall.

ENGLISH BOND: *see* Brickwork.

ENTABLATURE: in classical architecture the whole of the horizontal members above a column

(that is architrave, frieze, and cornice) (*see* Fig. 12).

ENTASIS: very slight convex deviation from a straight line; used on Greek columns and sometimes on spires to prevent an optical illusion of concavity.

ENTRESOL: *see* Mezzanine.

ESCUTCHEON: shield for armorial bearings.

EXEDRA: the apsidal end of a room. *See* Apse.

FAN-VAULT: *see* Vault.

FERETORY: place behind the high altar where the chief shrine of a church is kept.

FESTOON: carved garland of flowers and fruit suspended at both ends. *See also* Swag.

FILLET: narrow flat band running down a shaft or along a roll moulding.

FINIAL: top of a canopy, gable, pinnacle.

FIRRED: *see* Roof.

FLAGON: vessel for the wine used in the Communion service.

FLAMBOYANT: properly the latest phase of French Gothic architecture where the window tracery takes on wavy undulating lines.

FLÈCHE: slender spire on the centre of a roof. Also called Spirelet.

FLEMISH BOND: *see* Brickwork.

FLEURON: decorative carved flower or leaf.

FLUSHWORK: decorative use of flint in conjunction with dressed stone so as to form patterns: tracery, initials, etc.

FLUTING: vertical channelling in the shaft of a column.

FLYING BUTTRESS: *see* Buttress.

FOIL: lobe formed by the cusping

(q.v.) of a circle or an arch. Trefoil, quatrefoil, cinquefoil, multifoil, express the number of leaf shapes to be seen.

FOLIATED: carved with leaf shapes.

FOSSE: ditch.

FOUR-CENTRED ARCH: *see* Arch (Fig. 1*a*).

FRATER: refectory or dining hall of a monastery.

FRESCO: wall painting on wet plaster.

FRIEZE: middle division of a classical entablature (q.v.) (*see* Fig. 12).

FRONTAL: covering for the front of an altar.

GABLE: *Dutch gable:* a gable with curved sides crowned by a pediment, characteristic of *c.* 1630–50 (Fig. 8*a*). *Shaped gable:* a gable with multi-curved sides characteristic of *c.* 1600–50 (Fig. 8*b*).

GADROONED: enriched with a series of convex ridges, the opposite of fluting (q.v.).

GALILEE: chapel or vestibule usually at the W end of a church

(*a*)

(*b*)

Fig. 8. Gables

enclosing the porch. Also called Narthex (q.v.).

GALLERY: in church architecture upper storey above an aisle, opened in arches to the nave. Also called Tribune and often erroneously Triforium (q.v.).

GALLERY GRAVE: chambered tomb (q.v.) in which there is little or no differentiation between the entrance passage and the actual burial chamber(s).

GARDEROBE: lavatory or privy in a medieval building.

GARGOYLE: water spout projecting from the parapet of a wall or tower; carved into a human or animal shape.

GAZEBO: lookout tower or raised summer house in a picturesque garden.

'GEOMETRICAL': see Tracery.

'GIBBS SURROUND': of a doorway or window. An c18 motif consisting of a surround with alternating larger and smaller blocks of stone, quoin-wise, or intermittent large blocks, sometimes with a narrow raised band connecting them up the verticals and along the face of the arch (Fig. 9).

GROIN: sharp edge at the meeting of two cells of a cross-vault.

GROIN-VAULT: see Vault.

Fig. 9. 'Gibbs surround'

GROTESQUE: fanciful ornamental decoration: see also Arabesque.

Hagioscope: see Squint.

HALF-TIMBERING: see Timber-Framing.

HALL CHURCH: church in which nave and aisles are of equal height or approximately so.

HAMMERBEAM: see Roof (Fig. 18).

HANAP: large metal cup, generally made for domestic use, standing on an elaborate base and stem; with a very ornate cover frequently crowned with a little steeple.

HEADER: see Brickwork.

HERRINGBONE WORK: brick, stone, or tile construction where the component blocks are laid diagonally instead of flat. Alternate courses lie in opposing directions to make a zigzag pattern up the face of the wall.

HEXASTYLE: having six detached columns.

HILL-FORT: Iron Age earthwork enclosed by a ditch and bank system; in the later part of the period the defences multiplied in size and complexity. They vary from about an acre to over 30 acres in area, and are usually built with careful regard to natural elevations or promontories.

HIPPED ROOF: see Roof.

HOODMOULD: projecting moulding above an arch or a lintel to throw off water. Also called Dripstone or Label.

Iconography: the science of the subject matter of works of the visual arts.

IMPOST: bracket (q.v.) in a wall, usually formed of mouldings, on which the ends of an arch rest.

INDENT: shape chiselled out in a stone slab to receive a brass.

INGLENOOK: bench or seat built in beside a fireplace, sometimes covered by the chimneybreast, occasionally lit by small windows on each side of the fire.

INTERCOLUMNIATION: the space between columns.

IONIC: see Order (Fig. 12).

IRON AGE: in Britain the period from c. 600 B.C. to the coming of the Romans. The term is also used for those un-Romanized native communities which survived until the Saxon incursions.

JAMB: straight side of an archway, doorway, or window.

KEEL MOULDING: moulding whose outline is in section like that of the keel of a ship.

KEEP: massive tower of a Norman castle. Also called Donjon.

KEYSTONE: middle stone in an arch or a rib-vault.

KINGPOST: see Roof (Fig. 14).

KNEELER: horizontal decorative projection at the base of a gable.

KNOP: a knob-like thickening in the stem of a chalice.

LABEL: see Hoodmould.

LABEL STOP: ornamental boss at the end of a hoodmould (q.v.).

LACED WINDOWS: windows pulled visually together by strips, usually in brick of a different colour, which continue vertically the lines of the vertical parts of the window surrounds. The motif is typical of c. 1720.

LANCET WINDOW: slender pointed-arched window.

LANTERN: in architecture, a small circular or polygonal turret with windows all round crowning a roof (see Cupola) or a dome.

LANTERN CROSS: churchyard cross with lantern-shaped top usually with sculptured representations on the sides of the top.

LEAN-TO ROOF: roof with one slope only, built against a higher wall.

LESENE or PILASTER STRIP: pilaster (q.v.) without base or capital.

LIERNE: see Vault (Fig. 23).

LINENFOLD: Tudor panelling ornamented with a conventional representation of a piece of linen laid in vertical folds. The piece is repeated in each panel.

LINTEL: horizontal beam or stone bridging an opening.

LOGGIA: recessed colonnade (q.v.).

LONG AND SHORT WORK: Saxon quoins (q.v.) consisting of stones placed with the long sides alternately upright and horizontal.

LONG BARROW: unchambered Neolithic communal burial mound, wedge-shaped in plan, with the burial and occasional other structures massed at the broader end, from which the mound itself tapers in height; quarry ditches flank the mound.

LOUVRE: opening, often with lantern (q.v.) over, in the roof of a room to let the smoke from a central hearth escape.

LOWER PALAEOLITHIC: see Palaeolithic.

LOZENGE: diamond shape.

LUCARNE: small opening to let light in.

LUNETTE: tympanum (q.v.) or semicircular opening.

LYCH GATE: wooden gate structure with a roof and open sides placed at the entrance to a churchyard to provide space for the reception of a coffin. The word *lych* is Saxon and means a corpse.

LYNCHET: long terraced strip of soil accumulating on the downward side of prehistoric and medieval fields due to soil creep from continuous ploughing along the contours.

MACHICOLATION: projecting gallery on brackets (q.v.) constructed on the outside of castle towers or walls. The gallery has holes in the floor to drop missiles through.

MAJOLICA: ornamented glazed earthenware.

MANSARD: *see* Roof.

MATHEMATICAL TILES: small facing tiles the size of brick headers, most often applied to timber-framed walls to make them appear brick-built.

MEGALITHIC TOMB: stone-built burial chamber of the New Stone Age covered by an earth or stone mound. The form was introduced to Britain from the Mediterranean area.

MERLON: *see* Battlement.

MESOLITHIC: 'Middle Stone' Age; the post-glacial period of hunting and fishing communities dating in Britain from *c.* 8000 B.C. to the arrival of Neolithic communities, with which they must have considerably overlapped.

METOPE: in classical architecture of the Doric order (q.v.) the space in the frieze between the triglyphs (Fig. 12).

MEZZANINE: low storey placed between two higher ones. Also called Entresol.

MISERERE: *see* Misericord.

MISERICORD: bracket placed on the underside of a hinged choir stall seat which, when turned up, provided the occupant of the seat with a support during long periods of standing. Also called Miserere.

MODILLION: small bracket of which large numbers (modillion frieze) are often placed below a cornice (q.v.) in classical architecture.

MOTTE: steep mound forming the main feature of C11 and C12 castles.

MOTTE-AND-BAILEY: post-Roman and Norman defence system consisting of an earthen mound (the motte) topped with a wooden tower eccentrically placed within a bailey (q.v.), with enclosure ditch and palisade, and with the rare addition of an internal bank.

MOUCHETTE: tracery motif in curvilinear tracery, a curved dagger (q.v.), specially popular in the early C14 (Fig. 10).

Fig. 10. Mouchette

MOURNERS: *see* Weepers.

MULLIONS: vertical posts or uprights dividing a window into 'lights'.

MULTIVALLATE: of a hill-fort: defended by three or more concentric banks and ditches.

MUNTIN: post as a rule moulded and part of a screen.

NAIL-HEAD: E.E. ornamental motif, consisting of small pyramids regularly repeated (Fig. 11).

Fig. 11. Nail-head

NARTHEX: enclosed vestibule or covered porch at the main entrance to a church (*see* Galilee).

NEOLITHIC: 'New Stone' Age, dating in Britain from the appearance from the Continent of the first settled farming communities *c.* 3500 B.C. until the introduction of the Bronze Age.

NEWEL: central post in a circular or winding staircase; also the principal post when a flight of stairs meets a landing.

NOOK-SHAFT: shaft set in the angle of a pier or respond or wall, or the angle of the jamb of a window or doorway.

NUTMEG MOULDING: consisting of a chain of tiny triangles placed obliquely.

OBELISK: lofty pillar of square section tapering at the top and ending pyramidally.

OGEE: *see* Arch (Fig. 1c).

OPEN PEDIMENT: *see* Pediment.

ORATORY: small private chapel in a house.

ORDER: *see* Fig. 12. (1) *of a doorway or window:* series of concentric steps receding towards the opening; (2) *in classical architecture:* column with base, shaft, capital and entablature (q.v.) according to one of the following styles: Greek Doric, Roman Doric, Tuscan Doric, Ionic, Corinthian,

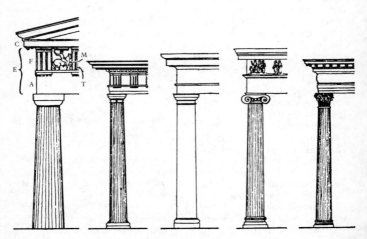

Fig. 12. Orders of columns (Greek Doric, Roman Doric, Tuscan Doric, Ionic, Corinthian) E, Entablature; C, Cornice; F, Frieze; A, Architrave; M, Metope; T, Triglyph

Composite. The established details are very elaborate, and some specialist architectural work should be consulted for further guidance.

ORIEL: *see* Bay-Window.

OVERHANG: projection of the upper storey of a house.

OVERSAILING COURSES: series of stone or brick courses, each one projecting beyond the one below it.

OVOLO: convex moulding.

PALAEOLITHIC: 'Old Stone' Age; the first period of human culture, commencing in the Ice Age and immediately prior to the Mesolithic; the Lower Palaeolithic is the older phase, the Upper Palaeolithic the later.

PALIMPSEST: (1) *of a brass:* where a metal plate has been re-used by turning over and engraving on the back; (2) *of a wall painting:* where one overlaps and partly obscures an earlier one.

PALLADIAN: architecture following the ideas and principles of Andrea Palladio, 1508–80.

PANTILE: tile of curved S-shaped section.

PARAPET: low wall placed to protect any spot where there is a sudden drop, for example on a bridge, quay, hillside, housetop, etc.

PARCLOSE SCREEN: *see* Screen.

PARGETTING: plaster work with patterns and ornaments either in relief or engraved on it.

PARVIS: term wrongly applied to a room over a church porch. These rooms were often used as a schoolroom or as a store room.

PASSING-BRACE: *see* Roof (Fig. 16).

PATEN: plate to hold the bread at Communion or Mass.

PATERA: small flat circular or oval ornament in classical architecture.

PEDIMENT: low-pitched gable used in classical, Renaissance, and neo-classical architecture above a portico and above doors, windows, etc. It may be straight-sided or curved segmentally. *Broken Pediment:* one where the centre portion of the base is left open. *Open Pediment:* one where the centre portion of the sloping sides is left out.

PENDANT: boss (q.v.) elongated so that it seems to hang down.

PENDENTIVE: concave triangular spandrel used to lead from the angle of two walls to the base of a circular dome. It is constructed as part of the hemisphere over a diameter the size of the diagonal of the basic square (Fig. 13).

PERP (PERPENDICULAR): historical division of English Gothic architecture covering the period from *c.* 1335–50 to *c.* 1530.

PIANO NOBILE: principal storey of a house with the reception rooms; usually the first floor.

PIAZZA: open space surrounded by

Fig. 13. Pendentive

buildings; in c17 and c18 England sometimes used to mean a long colonnade or loggia.

PIER: strong, solid support, frequently square in section or of composite section (compound pier).

PIETRA DURA: ornamental or scenic inlay by means of thin slabs of stone.

PILASTER: shallow pier attached to a wall. *Pilaster Strip: see* Lesene. *Termini Pilasters:* pilasters with sides tapering downwards.

PILLAR PISCINA: free-standing piscina (q.v.) on a pillar.

PINNACLE: ornamental form crowning a spire, tower, buttress, etc., usually of steep pyramidal, conical, or some similar shape.

PISCINA: basin for washing the Communion or Mass vessels, provided with a drain. Generally set in or against the wall to the S of an altar.

PLAISANCE: summer house, pleasure house near a mansion.

PLATE TRACERY: *see* Tracery.

PLINTH: projecting base of a wall or column, generally chamfered (q.v.) or moulded at the top.

POND BARROW: rare type of Bronze Age barrow consisting of a circular depression, usually paved, and containing a number of cremation burials.

POPPYHEAD: ornament of leaf and flower type used to decorate the tops of bench- or stall-ends.

PORTCULLIS: gate constructed to rise and fall in vertical grooves; used in gateways of castles.

PORTE COCHÈRE: porch large enough to admit wheeled vehicles.

PORTICO: centrepiece of a house or of a church, with classical detached or attached columns and a pediment. A portico is called *prostyle* or *in antis* according to whether it projects from or recedes into a building. In a portico *in antis* the columns range with the side walls.

POSTERN: small gateway at the back of a building.

PREDELLA: in an altarpiece the horizontal strip below the main representation, often used for a number of subsidiary representations in a row.

PRESBYTERY: the part of the church lying E of the choir. It is the part where the altar is placed.

PRINCIPAL: *see* Roof (Figs. 14, 17).

PRIORY: monastic house whose head is a prior or prioress, not an abbot or abbess.

PROSTYLE: with free-standing columns in a row.

PULPITUM: stone screen in a major church provided to shut off the choir from the nave and also as a backing for the return choir stalls.

PULVINATED FRIEZE: frieze (q.v.) with a bold convex moulding.

PURLINS: *see* Roof (Figs. 14–17).

PUTHOLE or PUTLOCK HOLE: putlocks are the short horizontal timbers on which during construction the boards of scaffolding rest. Putholes or putlock holes are the holes in the wall for putlocks, which often are not filled in after construction is complete.

PUTTO: small naked boy.

QUADRANGLE: inner courtyard in a large building.

QUARRY: in stained-glass work, a small diamond- or square-

shaped piece of glass set diagonally.

QUATREFOIL: see Foil.

QUEENPOSTS: see Roof (Fig. 16).

QUEEN-STRUTS: see Roof (Fig. 17).

QUOINS: dressed stones at the angles of a building. Sometimes all the stones are of the same size; more often they are alternately large and small.

R ADIATING CHAPELS: chapels projecting radially from an ambulatory or an apse.

RAFTER: see Roof.

RAMPART: stone wall or wall of earth surrounding a castle, fortress, or fortified city.

RAMPART-WALK: path along the inner face of a rampart.

REBATE: continuous rectangular notch cut on an edge.

REBUS: pun, a play on words. The literal translation and illustration of a name for artistic and heraldic purposes (Belton = bell, tun).

RECUSANT CHALICE: chalice made after the Reformation and before Catholic Emancipation for Roman Catholic use.

REEDING: decoration with parallel convex mouldings touching one another.

REFECTORY: dining hall; see also Frater.

RENDERING: plastering of an outer wall.

REPOUSSÉ: decoration of metal work by relief designs, formed by beating the metal from the back.

REREDOS: structure behind and above an altar.

RESPOND: half-pier bonded into a wall and carrying one end of an arch.

RETABLE: altarpiece, a picture or piece of carving, standing behind and attached to an altar.

RETICULATION: see Tracery (Fig. 22e).

REVEAL: that part of a jamb (q.v.) which lies between the glass or door and the outer surface of the wall.

RIB-VAULT: see Vault.

ROCOCO: latest phase of the Baroque style, current in most Continental countries between c. 1720 and c. 1760.

ROLL MOULDING: moulding of semicircular or more than semicircular section.

ROMANESQUE: that style in architecture which was current in the C11 and C12 and preceded the Gothic style (in England often called Norman). (Some scholars extend the use of the term Romanesque back to the C10 or C9.)

ROMANO-BRITISH: a somewhat vague term applied to the period and cultural features of Britain affected by the Roman occupation of the C1–5 A.D.

ROOD: cross or crucifix.

ROOD LOFT: singing gallery on the top of the rood screen, often supported by a coving (q.v.).

ROOD SCREEN: see Screen.

ROOD STAIRS: stairs to give access to the rood loft.

ROOF: see Figs. 14–18. Single-framed: if consisting entirely of transverse members (such as rafters with or without braces, collars, tie-beams, etc.) not tied together longitudinally. Double-framed: if longitudinal members (such as a ridge beam and purlins) are employed. As a rule in

such cases the rafters are divided into stronger principals and weaker subsidiary rafters. *Hipped:* roof with sloped instead of vertical ends *Mansard:* roof with a double slope, the lower slope being larger and steeper than the upper. *Saddleback:* tower roof shaped like an ordinary gabled timber roof. The following members have special names: *Rafter:* roof-timber sloping up from the wall-plate to the ridge. *Principal:* principal rafter, usually corresponding to the main bay divisions of the nave or chancel below. *Wall-plate:* timber laid longitudinally on the top of a wall. *Purlins:* longitudinal members laid parallel with wall-plate and apex some way up the slope of the roof. These are side purlins and may be *tenoned* into the principal rafter, or they may be *through purlins,* i.e. resting in slots cut into the back of the principals. *Clasped purlins:* purlins held between collar-beam and principal rafter. *Collar purlin:* a lengthwise beam supporting the collar-beams, found in the context of crown-post roofs, which do not have a ridge-piece. *Tie-beam:* beam connecting the two

slopes of a roof at the height of the wall-plate, to prevent the roof from spreading. *Cambered tie-beam roof:* one in which the ridge and purlins are laid directly on a cambered tie-beam; in a *firred tie-beam roof* a solid blocking piece (firring piece) is interposed between the cambered tie-beam and the purlins. *Collar-beam:* tie-beam applied higher up the slope of the roof. *Strut:* an upright or sloping timber supporting a transverse member, e.g. connecting tie-beam with rafter. *Post:* an upright timber supporting a lengthwise beam. *Kingpost:* an upright timber carried on a tie-beam and supporting the ridge-beam (*see* Fig. 14). *Crown-post:* an upright timber carried on a tie-beam and supporting a collar purlin, and usually braced to it and the collar-beam with four-way struts (*see* Fig. 15). *Queenposts:* two upright timbers placed symmetrically on a tie-beam and supporting purlins (*see* Fig. 16); if such timbers support a collar-beam or rafters they are *queenstruts* (*see* Fig. 17). *Braces:* inclined timbers inserted to strengthen others. Usually

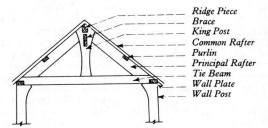

Ridge Piece
Brace
King Post
Common Rafter
Purlin
Principal Rafter
Tie Beam
Wall Plate
Wall Post

Fig. 14. Kingpost roof

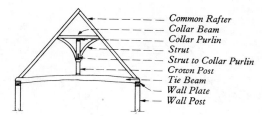

Common Rafter
Collar Beam
Collar Purlin
Strut
Strut to Collar Purlin
Crown Post
Tie Beam
Wall Plate
Wall Post

Fig. 15. Crown-post roof

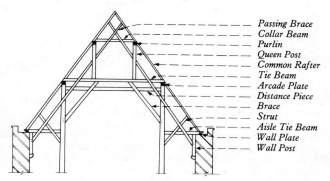

Passing Brace
Collar Beam
Purlin
Queen Post
Common Rafter
Tie Beam
Arcade Plate
Distance Piece
Brace
Strut
Aisle Tie Beam
Wall Plate
Wall Post

Fig. 16. Queen post roof

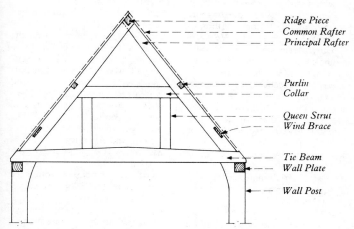

Ridge Piece
Common Rafter
Principal Rafter

Purlin
Collar

Queen Strut
Wind Brace

Tie Beam
Wall Plate

Wall Post

Fig. 17. Queen-strut roof

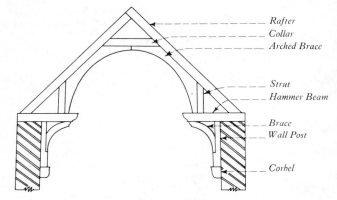

Rafter
Collar
Arched Brace

Strut
Hammer Beam

Brace
Wall Post

Corbel

Fig. 18. Hammerbeam roof

braces connect a collar-beam with the rafters below or a tie-beam with the wall below. Braces can be straight or curved (also called arched). *Passing-brace:* a brace, usually of the same scantling as the common rafters and parallel to them, which stiffens a roof laterally by being halved across one or more intermediate timbers within its length (*see* Fig. 16). *Hammer-beam:* beam projecting at right angles, usually from the top of a wall, to carry arched braces or struts and arched braces (*see* Fig. 18). *See also* Wagon Roof.

ROSE WINDOW (or WHEEL WINDOW): circular window with patterned tracery arranged to radiate from the centre.

ROTUNDA: building circular in plan.

RUBBLE: building stones, not square or hewn, nor laid in regular courses.

RUSTICATION: *rock-faced* if the surfaces of large blocks of ashlar stone are left rough like rock;

smooth if the ashlar blocks are smooth and separated by V-joints; *banded* if the separation by V-joints applies only to the horizontals; *vermiculated*, with a texture like worm-holes.

Saddleback: *see* Roof.

SALTIRE CROSS: equal-limbed cross placed diagonally.

SANCTUARY: (1) area around the main altar of a church (*see* Presbytery); (2) sacred site consisting of wood or stone uprights enclosed by a circular bank and ditch. Beginning in the Neolithic, they were elaborated in the succeeding Bronze Age. The best known examples are Stonehenge and Avebury.

SARCOPHAGUS: elaborately carved coffin.

SCAGLIOLA: material composed of cement and colouring matter to imitate marble.

SCALLOPED CAPITAL: development of the block capital (q.v.) in which the single semicircular

Fig. 19. Scalloped capital

surface is elaborated into a series of truncated cones (Fig. 19).

SCARP: artificial cutting away of the ground to form a steep slope.

SCREEN: *Parclose screen:* screen separating a chapel from the rest of a church. *Rood screen:* screen below the rood (q.v.), usually at the w end of a chancel.

SCREENS PASSAGE: passage between the entrances to kitchen, buttery, etc., and the screen behind which lies the hall of a medieval house.

SEDILIA: seats for the priests (usually three) on the s side of the chancel of a church.

SEGMENTAL ARCH: see Arch.

SET-OFF: see Weathering.

SEXPARTITE: see Vault.

SGRAFFITO: pattern incised into plaster so as to expose a dark surface underneath.

SHAFT-RING: motif of the C12 and C13 consisting of a ring round a circular pier or a shaft attached to a pier. Also called Annulet.

SHAPED GABLE: see Gable.

SHEILA-NA-GIG: fertility figure, usually with legs wide open.

SILL: lower horizontal part of the frame of a window.

SLATEHANGING: the covering of walls by overlapping rows of slates, on a timber substructure. Tilehanging is similar.

SOFFIT: underside of an arch, lintel, etc. Also called Archivolt.

SOLAR: upper living-room of a medieval house.

SOPRAPORTA: painting above the door of a room, usual in the C17 and C18.

SOUNDING BOARD: horizontal board or canopy over a pulpit. Also called Tester.

SPANDREL: triangular surface between one side of an arch, the horizontal drawn from its apex, and the vertical drawn from its springer; also the surface between two arches.

SPERE-TRUSS: roof truss on two free-standing posts to mask the division between screens passage and hall. The screen itself, where a spere-truss exists, was originally movable.

SPIRE: tall pyramidal or conical pointed erection often built on top of a tower, turret, etc. *Broach Spire:* a broach is a sloping half-pyramid of masonry or wood introduced at the base of each of the four oblique faces of a tapering octagonal spire with the object of effecting the transition from the square to the octagon. The *splayed foot spire* is a variation of the broach form found principally in the south-eastern counties. In this form the four cardinal faces are splayed out near their base, to cover the corners, while oblique (or intermediate) faces taper away to a point. *Needle Spire:* thin spire rising from the centre of a tower roof, well inside the parapet.

SPIRELET: see Flèche.

SPLAY: chamfer, usually of the jamb of a window.

SPRINGING: level at which an arch rises from its supports.

Fig. 20. Squinch

SQUINCH: arch or system of con-
centric arches thrown across the
angle between two walls to sup-
port a superstructure, for
example a dome (Fig. 20).

SQUINT: a hole cut in a wall or
through a pier to allow a view of
the main altar of a church from
places whence it could not other-
wise be seen. Also called Hagio-
scope.

STALL: carved seat, one of a row,
made of wood or stone.

STAUNCHION: upright iron or
steel member.

STEEPLE: the tower of a church
together with a spire.

STIFF-LEAF: E.E. type of foliage
of many-lobed shapes (Fig. 21).

Fig. 21. Stiff-leaf capital

STILTED: see Arch (Fig. 1d).

STOREY-POSTS: the principal
posts of a timber-framed wall.

STOUP: vessel for the reception of
holy water, usually placed near
a door.

STRAINER ARCH: arch inserted
across a room to prevent the
walls from leaning.

STRAPWORK: C16 decoration con-
sisting of interlaced bands, and
forms similar to fretwork or cut
and bent leather.

STRETCHER: see Brickwork.

STRING COURSE: projecting hori-
zontal band or moulding set in
the surface of a wall.

STRUT: see Roof.

STUCCO: plaster work.

STUDS: the subsidiary vertical
timber members of a timber-
framed wall.

SWAG: festoon (q.v.) formed by a
carved piece of cloth suspended
from both ends.

TABERNACLE: richly orna-
mented niche or free-standing
canopy. Usually contains the
Holy Sacrament.

TARSIA: inlay in various woods.

TAZZA: shallow bowl on a foot.

TERMINAL FIGURES (TERMS,
TERMINI): upper part of a
human figure growing out of a
pier, pilaster, etc., which tapers
towards the base. See also
Atlantes, Caryatid, Pilaster.

TERRACOTTA: burnt clay, un-
glazed.

TESSELLATED PAVEMENT: mosaic
flooring, particularly Roman,
consisting of small 'tesserae'
or cubes of glass, stone, or
brick.

TESSERAE: see Tessellated Pave-
ment.

TESTER: see Sounding Board.

TETRASTYLE: having four de-
tached columns.

THREE-DECKER PULPIT: pulpit with clerk's stall below and reading desk below the clerk's stall.

TIE-BEAM: *see* Roof (Figs. 14–17).

TIERCERON: *see* Vault (Fig. 23).

TILEHANGING: *see* Slatehanging.

TIMBER-FRAMING: method of construction where walls are built of timber framework with the spaces filled in by plaster or brickwork. Sometimes the timber is covered over with plaster or boarding laid horizontally.

TOMB-CHEST: a chest-shaped stone coffin, the most usual medieval form of funeral monument.

TOUCH: soft black marble quarried near Tournai.

TOURELLE: turret corbelled out from the wall.

TRACERY: intersecting ribwork in the upper part of a window, or used decoratively in blank arches, on vaults, etc. *Plate tracery: see* Fig. 22(*a*). Early form of tracery where decoratively shaped openings are cut through the solid stone infilling in a window head. *Bar tracery:* a form introduced into England *c.* 1250. Intersecting ribwork made up of slender shafts, continuing the lines of the mullions of windows up to a decorative mesh in the head of the window. *Geometrical tracery: see* Fig. 22(*b*). Tracery characteristic of *c.* 1250–1310 consisting chiefly of circles or foiled circles. *Y-tracery: see* Fig. 22(*c*). Tracery consisting of a mullion which branches into two forming a Y shape; typical of *c.* 1300. *Intersecting tracery: see* Fig. 22(*d*). Tracery in which each mullion of a window branches out into two curved bars in such a way that every one of them is drawn with the same radius from a different centre. The result is that every light of the window is a lancet and every two, three, four, etc., lights together form a pointed arch. This treatment also is typical of *c.* 1300. *Reticulated tracery: see* Fig. 22(*e*). Tracery typical of the early C14 consisting entirely of circles drawn at top and bottom into ogee shapes so that a net-like appearance results. *Panel tracery: see* Fig. 22(*f*) and (*g*). Perp tracery, which is formed of upright straight-sided panels above lights of a window.

TRANSEPT: transverse portion of a cross-shaped church.

TRANSOM: horizontal bar across the openings of a window.

TRANSVERSE ARCH: *see* Vault.

TREFOIL: *see* Foil.

TRIBUNE: *see* Gallery.

TRICIPUT, SIGNUM TRICIPUT: sign of the Trinity expressed by

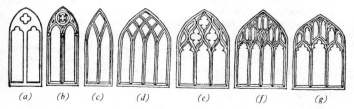

(*a*) (*b*) (*c*) (*d*) (*e*) (*f*) (*g*)

Fig. 22. Tracery

three faces belonging to one head.

TRIFORIUM: arcaded wall passage or blank arcading facing the nave at the height of the aisle roof and below the clerestory (q.v.) windows. (*See also* Gallery.)

TRIGLYPHS: blocks with vertical grooves separating the metopes (q.v.) in the Doric frieze (Fig. 12).

TROPHY: sculptured group of arms or armour, used as a memorial of victory.

TRUMEAU: stone mullion (q.v.) supporting the tympanum (q.v.) of a wide doorway.

TUMULUS: *see* Barrow.

TURRET: very small tower, round or polygonal in plan.

TUSCAN: *see* Order.

TYMPANUM: space between the lintel of a doorway and the arch above it.

U NDERCROFT: vaulted room, sometimes underground, below a church or chapel.

UNIVALLATE: of a hill-fort: defended by a single bank and ditch.

UPPER PALAEOLITHIC: *see* Palaeolithic.

V AULT: *see* Fig. 23. *Barrel-vault:* see Tunnel-vault. *Cross-vault:* see Groin-vault. *Domical vault:* square or polygonal dome rising direct on a square or polygonal bay, the curved surfaces separated by groins (q.v.). *Fan-vault:* late medieval vault where all ribs springing from one springer are of the same length, the same distance from the next, and the same curvature. *Groin-*

vault or *Cross-vault:* vault of two tunnel-vaults of identical shape intersecting each other at r. angles. Chiefly Norman and Renaissance. *Lierne:* tertiary rib, that is, rib which does not spring either from one of the main springers or from the central boss. Introduced in the C14, continues to the C16. *Quadripartite vault:* one wherein one bay of vaulting is divided into four parts. *Rib-vault:* vault with diagonal ribs projecting along the groins. *Ridge-rib:* rib along the longitudinal or transverse ridge of a vault. Introduced in the early C13. *Sexpartite vault:* one wherein one bay of quadripartite vaulting is divided into two parts transversely so that each bay of vaulting has six parts. *Tierceron:* secondary rib, that is, rib which issues from one of the main springers or the central boss and leads to a place on a ridge-rib. Introduced in the early C13. *Transverse arch:* arch separating one bay of a vault from the next. *Tunnel-vault* or *Barrel-vault:* vault of semicircular or pointed section. Chiefly Norman and Renaissance.

VAULTING SHAFT: vertical member leading to the springer of a vault.

VENETIAN WINDOW: window with three openings, the central one arched and wider than the outside ones. Current in England chiefly in the C17–18.

VERANDA: open gallery or balcony with a roof on light, usually metal, supports.

VESICA: oval with pointed head and foot.

VESTIBULE: anteroom or entrance hall.

VILLA: (1) according to Gwilt (1842) 'a country house for the residence of opulent persons'; (2) Romano-British country houses cum farms, to which the description given in (1) more or less applies. They developed with the growth of urbanization. The basic type is the simple corridor pattern with rooms opening off a single passage; the next stage is the addition of wings. The courtyard villa fills a square plan with subsidiary buildings and an enclosure wall with a gate facing the main corridor block.

VITRIFIED: made similar to glass.

VITRUVIAN OPENING: a door or window which diminishes towards the top, as advocated by Vitruvius, bk. IV, chapter VI.

VOLUTE: spiral scroll, one of the component parts of an Ionic column (*see* Order).

VOUSSOIR: wedge-shaped stone used in arch construction.

WAGON ROOF: roof in which by closely set rafters with arched braces the appearance of the inside of a canvas tilt over a wagon is achieved. Wagon roofs can be panelled or plastered (ceiled) or left uncovered. Also called Cradle Roof.

WAINSCOT: timber lining to walls.

WALL-PLATE: *see* Roof.

WATERLEAF: leaf shape used in later C12 capitals. The waterleaf is a broad, unribbed, tapering leaf curving up towards the angle of the abacus and turned in at the top (Fig. 24).

WEALDEN HOUSE: timber-framed house with the hall in the centre and wings projecting only slightly and only on the jutting upper floor. The roof, however, runs through without a break between wings and hall, and the eaves of the hall part are therefore exceptionally deep. They are supported by diagonal, usu-

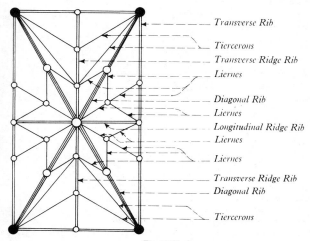

Transverse Rib

Tiercerons

Transverse Ridge Rib

Liernes

Diagonal Rib

Liernes

Longitudinal Ridge Rib

Liernes

Liernes

Transverse Ridge Rib

Diagonal Rib

Tiercerons

Fig. 23. Vault

ally curved, braces starting from the short inner sides of the overhanging wings and rising parallel with the front wall of the

Fig. 24. Waterleaf capital

hall towards the centre of the eaves.

WEATHERBOARDING: overlapping horizontal boards, covering a timber-framed wall.

WEATHERING: sloped horizontal surface on sills, buttresses, etc., to throw off water. Also called Set-off.

WEEPERS: small figures placed in niches along the sides of some medieval tombs. Also called Mourners.

WHEEL WINDOW: *see* Rose Window.

INDEX OF PLATES

INDEX OF ARTISTS

INDEX OF PLACES

THE BUILDINGS OF ENGLAND
COMPLETE LIST OF TITLES